Medieval Islamic Swords and Swordmaking

Kindi's treatise
"On swords and their kinds"
(edition, translation, and commentary)

Robert G. Hoyland and Brian Gilmour

Introduction by
James Allan

Gibb Memorial Trust

Published by
The E. J. W. Gibb Memorial Trust

© The E. J. W. Gibb Memorial Trust and individual authors, 2006
Paperback edition 2012. Reprinted 2018

ISBN 978-0-90609-457-0

A CIP record for this book is available from the British Library

Further details of the E. J. W. Gibb Memorial Trust and its publications
are available at the Trust's website

www.gibbtrust.org

*Front cover: Artisans at work on the defences of Iskandar (Alexander) against
Gog and Magog; early Bukhara style ca. 915/1510 to 955/1549
(courtesy of the Bodleian Library MS Elliott 340, fol. 80a).*

Typeset by Oxbow Books, Oxford
Printed and bound by CPI Group (UK) Ltd, Croydon, CR0 4YY

Contents

List of Figures

Introduction

James Allan

One of the problems pervading the study of medieval Islamic technology is the lack of surviving technical treatises. Artisans were essentially practitioners of an inherited skill. They worked in industrial quarters, in the narrow confines of the *suq* or bazaar inside a city, or in more spacious surroundings outside the city walls, where smoke and debris would be less inconvenient for the local population. Rarely able to read or write, they were men of inherited wisdom and experience. Change, if it was required, came through experiment, through trial and error. It was slow and uncertain. Tradition was handed down by example and by word of mouth, and apprenticeships could last for decades. There was therefore no need for texts or manuals.

Fortunately, however, occasional treatises do exist. These are most commonly in the form of lapidaries, like those of Muḥammad ibn Aḥmad al-Bīrūnī (d. 440 AH/1048 AD; see appendix 2 below), Naṣīr al-dīn al-Ṭūsī (d. 672/1274), and Abū l-Qāsim ᶜAbdallāh Kashānī (fl. 700/1301). Such lapidaries are not confined to precious and semi-precious stones. In the first place they include the magical and medical properties of the stones discussed, reflecting the market for such works. Secondly, and more importantly for our purpose, they often include technical details of metals and their alloys – on the basis that metals, like medicaments, are derived from particular stones or ores (for a general introduction to mineralogies see S.H. Nasr, *Islamic Science. An Illustrated Study*, Westerham 1976, ch. 4 "Natural History").

Another written source of information is the manual of the *muḥtasib*, the market inspector. This source has never been fully investigated, though some of the manuals have been published, e.g. the *Maᶜālim al-Qurba* (published by R. Levy in London 1938) of the Egyptian *muḥtasib* Ibn al-Ukhuwwa (d. 729/1329). *Muḥtasib*s were on the look out for fraudulent activities in the market place; thus Ibn al-Ukhuwwa says of blacksmiths: "Blacksmiths must not hammer out knives, scissors, pincers and the like from soft iron, which is of no use for the purpose; some assure the purchaser that it is steel, and this is fraudulent". So though specific information on metal technology is seldom included, it can sometimes be deduced from the warnings given out. A further source is alchemy. Again, accurate conclusions are comparatively rare, even though it was the motivation behind so much scientific research in early Islamic times. Occasionally, however, nuggets of worthwhile information do crop up, as for example

in the piece of Jābir ibn Ḥayyān (fl. late second/eighth century) quoted in the first appendix to this book.

Yet other treatises reflect the interests of particular wealthy or powerful patrons. Thus Murdā ibn ᶜAlī al-Ṭarsūsī (fl. 6th/12th century) wrote a treatise on weapons for the Ayyubid ruler of Egypt and Syria, Ṣalāḥ al-dīn (Saladin), which reflects the defensive and offensive interests of his patron. This work includes some valuable recipes for watering on steel. The Arṭuqid ruler of Diyarbakir (in modern southeast Turkey), Nāṣir al-dīn Maḥmūd (596–619/1200–22), was more interested in mechanical toys, especially clocks, hence the treatise on mechanical devices composed for him by Ibn al-Razzāz al-Jazārī (written in 602/1206). Here again, however, technical information is included so that the clocks could actually be built, and the author also included a fascinating description of how to cast a bronze door. How common were scholar-craftsmen like Jazārī is unfortunately unknown, but his existence raises many interesting questions about the craft industries, and indeed about the view of artisans offered at the start of this Introduction.

The treatise of Yaᶜqūb ibn Isḥāq al-Kindī (henceforth Kindi) on swords was also the result of an interested patron, the Abbasid caliph Muᶜtaṣim (218–27/833–42), one of a line of caliphal patrons of scholarship and translation. What might have motivated him to commission this text is an intriguing question. Like any ruler, Muᶜtaṣim would have had a general interest in his army and its equipment. However, in the aftermath of the fourth Arab civil war he also had a more particular interest in building up a well-trained and well-equipped army. As a result, he imported large numbers of slaves from Central Asia and had them trained as a fighting force. He is in fact generally credited with making slave soldiers into an Islamic institution. This, together with Kindi's scientific curiosity, may help to explain why the latter's treatise is so specific. It discusses the difference between iron and steel, it distinguishes different qualities of sword blade, and different centres of swordsmithing. It refers to the Indian Ocean trade in steel ingots and to the distinctive character of European swords of the period. It includes technical terms used by the makers, and distinguishes swords by their physical features – form, measurements, weight, watered pattern, sculptured details, or inlaid ornaments. If the text reflects the patron's specific interests, then Muᶜtaṣim was a man with a fascination for technical matters, as well as a concern for military capability. This seems even more to be the case since the discovery of Kindi's second treatise on swords: "On the making of swords and their quenching" (see ch. 1 below), which suggests that Muᶜtaṣim wanted to know the full details of the recipes used by the smiths for this part of the process.

Other sources of information on swords are diverse and very patchy. Nevertheless, when brought together they can throw important light on the subject, be it from an economic, social, or technical point of view. For this reason, we decided to include a translation of Friedrich Schwarzlose's work on Arab swords, which is based on the hundreds of references to them found in early Arabic poetry. This extraordinary compendium of information, written in German, was published some 120 years ago, and it seemed appropriate to recognise its importance by republishing it in English, to bring it to the attention of a much wider, contemporary and future, scholarly audience.

Publication of the texts of early treatises, with or without translations, and re-publication of works by Orientalists, are not enough in themselves, however. For in both cases interpretation is needed. In two particular areas this is true. Firstly, the Arabic itself needs interpreting, so that the most relevant possible translations of particular words can emerge. Consequently, there was a need for a collaborative effort such as this, and it was our good fortune in having Robert Hoyland available to undertake this part of the project. Secondly, interpretation of a text must focus on, and explain, the technical details. Kindi approached his subject from a scientific point of view, but science was not what it is today. The world has moved on, and if we are to understand what he is saying we have to interpret it in today's language. That need, however, raises its own problems. Technical studies and chemical analyses of early Islamic metals, both ferrous and non-ferrous, exist, but they are patchy and leave so many questions unanswered. The study of technical treatises has therefore to go hand in hand with the scientific research that will lead to greater understanding of the nature of the materials described. Fortunately, Brian Gilmour's work over the last few years has pushed deeper into the technology of steel in the Near East, and we can now understand a great deal more about the medieval Islamic tradition than would have been possible even ten years ago. Nevertheless, the present publication will inevitably be but one leap in a continuing game of leapfrog. It will only be a matter of time before future research, both practical and theoretical, throws new light on the history and development of steel, and takes the subject a further leap forward.

Acknowledgements

Robert, Brian, and I are grateful to the British Institute of Persian Studies for the financial support which it has given to the Persian Steel project over the years; to the Department of Eastern Art in the Ashmolean Museum and the Oriental Faculty at Oxford University for financing the translation of Schwarzlose's text; to the Universities of Leiden, Uppsala, and Turin and the Chester Beatty Library, Dublin, for allowing us to see and publish the manuscript pages appearing in the third appendix to this book; and to the Gibb Memorial Series for undertaking to publish this work. We would also like to thank Keith Bennett for producing the figures and for his patience over the many changes, Lauren Gilmour for her invaluable editorial advice on the commentaries and support generally for this project, Chris Salter of the University of Oxford's Department of Materials for his advice on technical aspects, and various friends and colleagues for ideas and advice.

Chapter 1

Kindi and Islamic Swords

Robert Hoyland

Kindi's time and scholarship

Though he acquired fame as "the philosopher of the Arabs" and lived through one of the most intellectually creative periods of Islamic history, details about the life of Yaᶜqūb ibn Isḥāq al-Kindī (in this book: Kindi) are hard to come by. In their brief notices about him biographers like to give his full genealogy, for Kindi hailed from the elite of the renowned tribe of Kinda and counted among his ancestors al-Ashᶜath ibn Qays, one of the Companions of the Prophet Muḥammad and king of Kinda, and his father Qays ibn Maᶜdikarib, also king of Kinda and celebrated in pre-Islamic poetry as a great warrior. The family had maintained their prestige and Kindi's own father had been governor of Kufa for the caliphs Mahdī (158–69/775–85) and Hārūn al-Rashīd (170–93/786–809). The birth date of Kindi is usually placed around the turn of the eighth century (*ca.* 184/800), but we do not hear anything of him until he turns up a couple of decades later at Baghdad in the court of the caliph Maʾmūn (198–218/813–33), whose favour he is said to have enjoyed. This continued into the reign of Muᶜtaṣim (218–27/833–42), who also made him tutor to his son Aḥmad. The latter two commissioned learned treatises from him, as is attested by a number of them that survive (Kindi's most well-known work, "On first philosophy", is addressed to Muᶜtaṣim). He initially prospered under Mutawakkil (232–47/847–61), but then he attracted the envy of the sons of Mūsā ibn Shākir, themselves able scientists, who "would plot against anyone who was reputed to surpass them in knowledge". They reviled Kindi before Mutawakkil, who had him beaten, and they seized his library, though when the caliph heard of this he had them restore it to him. We hear no more of Kindi and it is generally assumed that he died in the late 250s/860s or early 260s/870s.[1]

The caliphs under whom Kindi and his father served were famous for their patronage of scholarship, commissioning translation into Arabic of foreign works and original research in Arabic. An important stimulus for this activity was the transfer of

[1] This paragraph is based on Ibn Abi Uṣaybiᶜa, *ᶜUyūn al-anbāʾ*, 285–87 (ch. 10). For further references see *E.I., s.v.* "Kindi".

the Muslim seat of government from Syria to Iraq (in 132/750) and the building of the new capital of Baghdad (in 145/762). This placed the Abbasids, the dynasty that had implemented the transfer, in the heartlands of the former Sasanian Persian empire (224–652). Whereas in Damascus, only a provincial and in any case semi-arabised city of the Byzantine empire, the Muslim Arabs had been able to withstand pressure to assimilate, in Baghdad they felt very strongly the pull of Sasanian Persian ideas and style of government. One feature of this was an interest in alien wisdom:

> Ma³mūn used to spend time investigating astrological rulings and prognostications, to follow what the stars prescribed, and to model his conduct on that of the past Sasanian emperors like Ardashir son of Babak and others. He worked hard at reading their ancient books; he was keen on their study and assiduous in their reading to the point that he became skilled in their understanding and proficient in their comprehension.[2]

These ideas lived on, especially among the well-educated Aramaean Christian and Iranian Zoroastrian populations, which had been the mainstay of the Sasanian Persian empire and were very willing to serve the new Muslim administration. The Abbasids were happy to accept their help, for they sought to create a great empire after the Persian model instead of the loose conquest society of the first century of Islamic rule (*ca.* 29–132/650–750), and the expansion of the court and the bureaucracy were key elements in the attainment of this goal.

There had of course been some translations made of foreign texts during the time in office of the Umayyad dynasty (40–132/660–750), the predecessors of the Abbasids,[3] but they were few and random, carried out at the whim of certain interested individual members of the ruling elite. Muslim historians are unanimous in attributing the beginnings of the translation movement proper to the early Abbasid sovereigns:

> He (Manṣūr, 136–58/754–75) was the first caliph to have books translated from foreign languages into Arabic, among them (the wisdom compilations of) Kalila wa-Dimna and Sindhind. There were also translated for him books by Aristotle on logic and other subjects, the Almagest by Ptolemy, the book by Euclid (on geometry), the Arithmetic (by Nichomachus of Gerasa), and other ancient books from classical Greek, Byzantine Greek, Old and New Persian, and Syriac. These translations were published among the people, who examined them and devoted themselves to studying them.[4]

> Ma³mūn revived it (the teaching of medicine) by favouring the most excellent of men. But for that, all the sciences of the ancients, including medicine, logic, and philosophy, would have been forgotten, just as they are today in the lands in which they were once most especially cultivated, I mean Rome, Athens, the Byzantine provinces, and many other lands.[5]

[2] Masʿūdī, *Murūj al-dhahab*, 8.300–301.
[3] See Hoyland, *Seeing Islam as others saw it*, 231–36, which analyses one example and gives relevant secondary literature.
[4] Masʿūdī, *Murūj al-dhahab*, 8.291.
[5] Ibn Riḍwān, *Al-kitāb al-nāfiʿ*, 107–108.

Although a wish to emulate Sasanian Persian emperors may have done much to provoke the initial interest of the Abbasids in scholarship, a number of other reasons soon came to the fore that impelled them to promote it. In particular, there was a need to portray themselves as defenders of Islam. This became increasingly important as ever more of their subjects converted to the new faith, and absolutely crucial after the civil war of 193–98/809–13 had revealed rifts in the ranks of the ruling elite and weakened the dynasty's claims to legitimacy. Ma'mūn, who defeated his brother Amīn in this civil war, saw it as essential to demonstrate his Islamic credentials, to which end he adopted the title of "God's deputy" (*khalīfat Allāh*) and instigated debates to determine truth from heresy. In achieving these aims the Abbasids enlisted the aid of Greek logic and eastern (Persian/Indian) wisdom, a policy that was also pursued by the critics of Islam:

> Mahdī devoted all his efforts to exterminating heretics and apostates. These people appeared in his days and publicly proclaimed their beliefs during his caliphate on account of the wide dissemination of books by Mani, Bardesanes, and Marcion, which had been translated from Old and New Persian into Arabic... In this way Manichaeans increased in number and their opinions came out into the open among people. Mahdī was the first caliph to command the theologians who used dialectic disputation in their research to compose books against the Manichaeans and the other infidels we have just mentioned. The theologians then produced demonstrative proofs against the disputers, eliminated the problems posed by the heretics, and expounded the truth in clear terms to the doubters.

> He (Ma'mūn) held sessions with theologians and admitted to his company scholars who had distinguished themselves in dialectic disputation and debate... He had jurists and the learned among men of general culture attend his sessions; he had such men brought from various cities and stipends for them allocated. As a result, people developed an interest in conducting theoretical investigations and learned how to do research and use dialectic; each group among them wrote books in which it championed its cause and through it supported its doctrines.[6]

A second very significant motive of the Abbasids in patronizing scholarship was, quite simply, the demands for applied and theoretical scientific knowledge made by those engaged in running the vast Muslim empire. Although they have received drastically less attention than the illustrious subjects of philosophy and medicine, perhaps as many, if not more texts were composed in the fields of engineering, agriculture, veterinary science, alchemy/chemistry, astrology/astronomy, geometry, administrative studies, and so on – all essential aids to the smooth workings of an empire:

> In addition to these works of mine (on linguistic, literary, and religious training), it is indispensable for the secretary to study geometrical figures for the measurement of land in order that he can recognise acute-, right-, and obtuse-angled triangles, where stones will land, the different sorts of rectangles, arcs and other circular figures, and perpendicular lines, and (it is also indispensable) in order that he can test his knowledge by applying it to the land, not only to the survey-registers, for

[6] Mas'ūdī, *Murūj al-dhahab*, 8.292–93, 301.

theoretical knowledge is nothing in comparison to practical experience. The Persians used to say that he who does not know the following would be deficient in his formation as state secretary: the principles of irrigation, opening access-canals to waterways and stopping breaches; measuring the varying length of days, the revolution of the sun, the rising-points of stars, and the phases of the moon and its influence; assessing the standards of measure; surveying in terms of triangles, rectangles, and polygons of various angles; constructing arched stone bridges, other kinds of bridges, sweeps with buckets, and noria waterwheels on waterways; the nature of the instruments used by artisans and craftsmen; and the details of accounting.

He (Ma'mūn) encouraged me to compose a compendious work on algebra, confining it to the fine and important parts of its calculations, such as people constantly require in cases of inheritance, legacies, partition, law-suits, trade, and in all their dealings with one another where surveying, the digging of canals, geometrical computation, and other objects of various sorts and kinds are concerned.[7]

There was a close link between new research and translation of earlier foreign texts, as is well illustrated in the work of Khwārizmī, the scholar just quoted. To write his famous book on algebra, he drew for inspiration on the translation of Euclid's *Elements*. And Khwārizmī's masterpiece in turn gave rise to the Arabic translation of Diophantus' *Arithmetica*, accomplished in the light of Khwārizmī's book and using technical terms borrowed from it.[8] We can also observe this process in Kindi's own work. For example, the optical books by Diocles, Anthemius of Tralles, and Didymus were translated into Arabic in response to the practical interest of scholars and rulers in burning-mirrors. On the basis of these translations Kindi wrote his own study on this subject, correcting and furthering the work of the Greek authors.[9] And Kindi's writings on philosophy were dependent on a number of Greek works that were translated for him or under his guidance, especially: Aristotle's *Metaphysics, Meteorology* and his *De caelo*, selections from the Neoplatonists Plotinus, Proclus, and John Philoponus, Nichomachus' *Introduction to Arithmetic*, and Plato's *Timaeus*.[10]

Kindi's work was of relevance to both of these motives behind the Abbasid promotion of scholarship, providing arguments for defending the Islamic faith and practical know-how for running the Islamic empire. He demonstrates the consistency of the rational sciences with the true creed of Islam, the oneness of God (*tawhīd*), and indeed engages philosophy to defend the creed of Islamic monotheism against the temptations of dualism. The perennial and universal wisdom of the ancient philosophers is linked with the divine wisdom (*ḥikma*) of the Qur'ān and is shown to give guidance towards unequivocal and irrefutable knowledge, which itself leads the way to a virtuous life and ultimate happiness. Moreover, though he is most famous,

[7] Ibn Qutayba, *Adab al-kātib*, 10–11; Khwārizmī, *Algebra*, 2/3.
[8] *E.I., s.v.* "Riyāḍiyyāt".
[9] Rashed, "Problems of the transmission of Greek scientific thought into Arabic".
[10] Endress, "The circle of al-Kindi: early Arabic translations from the Greek".

both now and in his own time, for his contribution to philosophy, Kindi was a real polymath and wrote on a vast range of practical subjects as well. His receptivity to knowledge of all kinds and all provenances is stated in his own writings:

> We ought not be ashamed of appreciating the truth and of acquiring it wherever it comes from, even if it comes from races distant and nations different from us. For the seeker of truth nothing takes precedence over the truth, and there is no disparagement of the truth, no belittling either of him who speaks it or of him who conveys it. No one is diminished by the truth; rather the truth ennobles all.[11]

And from the list of treatises composed by him and preserved by the bibliographical compiler Ibn al-Nadīm (d. 380/990), we get some impression of the diversity of Kindi's studies and of his contribution to the applied as well as the theoretical sciences:

> He was the most distinguished man of his time and unique during his period because of his knowledge of the ancient sciences as a whole. He was called "the Philosopher of the Arabs". His books were about a variety of sciences, such as logic, philosophy, geometry, calculation, arithmetic, music, astronomy, and other things. He was miserly.[12] We are mentioning him with the natural philosophers so as to indicate his preeminent position in science. We shall mention everything that he compiled about all of the sciences, God willing:

> Philosophical works: …22 titles. Works on logic: …10 titles. Arithmetical works: …11 titles. Works on spherics: …8 titles. Musical works: …7 titles. Astronomical works: …19 titles. Geometrical works: …23 titles. Cosmological works: …16 titles. Medical works: …22 titles. Astrological works: …10 titles. Works on disputation: …17 titles. Works on the soul: …5 titles. Political works: …11 titles. Works on natural phenomena: …17 titles. Works on distances: …8 titles. Works on premonitions: …5 titles.

> Miscellaneous works: on jewels, stones, glass, dyes, "the kinds of swords and iron", "that with which swords and iron are treated so that they are not broken or blunted", domestic birds, crossbreeding the pigeon, hatching eggs, bees, making a mixing vessel, perfumes (x2), making foods from different ingredients, obscure place names, the deceit of alchemists, the principles of mechanics, submersibles, the two traces perceived in water, the tides, falling celestial bodies, mirrors (x2), pronunciation, earthquakes, replies to questions on natural science, the cause of thunder, lightning, snow, cold, thunderbolts and rain…[13]

[11] Ivry, *Kindi's Metaphysics*, 58 (translating from Kindi's *Fī l-falsafat al-ūlā*).

[12] This comment derives from a passage in a book on misers (*al-Bukhalāʾ*) by the acclaimed author ʿAmr ibn Baḥr al-Jāḥiẓ (d. 255/869); it may not, however, refer to Kindi and is in any case intended as a fictional work; see Rosenthal, "Kindi als Literat"; Beaumont, "Parody and lying in *al-Bukhalāʾ*".

[13] Ibn al-Nadīm, *Fihrist*, 255–61 (abbreviated); the list is expounded in Atiyeh, *Kindi: the philosopher of the Arabs*. The philosophical texts have long been studied, but now the works on applied science are receiving more attention. See, for example, Bos and Burnett, *Scientific weather forecasting in the Middle Ages: the writings of Kindi*; Rashed and Jolivet, *Oeuvres philosophiques et scientifiques d'al-Kindi*. And *Arabic Sciences and Philosophy* dedicates issue 3 (1993) to Kindi: the relationship of the circle's circumference to its diameter (R. Rashed), on time (J. Jolivet), and catarchic astrology (C. Burnett).

Kindi on swords

As is mentioned in the above list of Ibn al-Nadīm, Kindi composed a treatise on the different kinds of swords. Though this will initially occasion some measure of surprise among Islamicists, who mostly know him as a philosopher, a glance through the above list of his works will soon dispel any doubts. He was evidently interested in most of the phenomena of everyday life as well as abstract matters, and so it should not be wondered at that the caliph Muʿtaṣim chose Kindi to write on this topic.[14] The subject might also seem to modern scholars somewhat esoteric, but the sword was an extremely important artifact of Islamic civilization, both practically and symbolically. It was even a common personal name and featured in honorific titles from the time of the Prophet Muḥammad, applied to his most feared general Khālid ibn al-Walīd (*sayf Allāh*/"sword of God"), to the time of the Ḥamdānid dynasty (4th/10th century), adopted by its most famous ruler (*Sayf al-dawla*/"Sword of the state", d. 356/967), and thereafter too. Its high worth is best illustrated in poetry, both pre-Islamic and Islamic, and for this reason we chose to present the excursus of Schwarzlose (see also Figs 1–2) in chapter 4 below, which gives a good indication of the wealth of material available.

Yet despite this high status of the blade, we do not know much about swordmaking in medieval Islam. We do have some interesting images of swords from around Kindi's time and these at least give us an indication of the form and shape of the sword (see Figs 3–7). Poetry is helpful for providing descriptions, and so giving some idea of the different qualities associated with it, and to some extent offers insights into its constituent parts and its different kinds, but on its manufacture poetry is not very informative. For this topic we have only a few brief references scattered across a wide range of literature. Geographical texts sometimes mention iron mines and their workings, and administrative texts occasionally refer to a government department or inspectorate of foundries (*shadd/naẓar al-masābik*).[15] And useful insights do crop up now and then in literary texts, such as the following comments of the polymath ʿAmr ibn Baḥr al-Jāḥiẓ (d. 255/869):

> Before a sword is put on by its wearer or wielded by its bearer, it has passed through many hands and various classes of craftsmen, none of whom can do another's work or excel in it, and indeed would not claim or undertake to do so. For the man who smelts and refines the metal of a sword is other than the one who draws it out into shape; the latter is other than the one who forges it, smoothes its broadside, and adjusts its blade; the latter again other than the one who quenches and sharpens it. Yet another man fits its pommel and rivets the tang in; the one who makes the studs for the tang, the pommel, and the blade is different from the one who carves the wood of the scabbard, and he from the one who tans the leather for it, and the latter from the one who decorates it; and the one who decorates it

[14] Though of course it may be that he only wrote on this subject because the caliph asked him to, the caliph having selected him for his reputation as the foremost man of learning of his day.
[15] Hassan, "Iron and steel technology", 41–42 (Muqaddasī and Ibn Baṭṭūṭa on iron mines in the mountains above Beirut), 38–39 (Qalqashandī and Ibn ʿAsākir on iron foundries in Damascus).

and fits its tip is different from the one who pierces the holes in its carrying-straps.[16]

Otherwise there is the odd chapter in later works on metals, metalworking, and especially on arms and amour, but most of these are dependent on Kindi.[17] We are, therefore, very fortunate to possess his treatise, which is probably the sole surviving work devoted exclusively to the sword in Islam. From this we are able to learn much about the places and techniques of manufacture of Muslim swords (brought out by Brian Gilmour in chapter 3 below).

A couple of observations should perhaps be made before proceeding to Kindi's text. Firstly, reading through his exposition one gets the impression that Kindi, as a true scientist, gained his understanding of swords mostly from empirical observation, that is, from watching and talking to swordsmiths. And this is confirmed by his statement, preserved in the Istanbul manuscript, that he fulfilled the caliph's request for information about swords by "examination of the knowledgeable people I have found who are versed in sword manufacture". He does not once quote any written source (though it is possible that he had read some relevant material – see chapter 3 below re Kindi/Zaki, p. 35). This is in stark contrast to Bīrūnī (see appendix 2 below), who quotes the Qurʾān and relies chiefly upon poetry and written works, and less commonly turns to oral testimony and eye witnesses, and even then feels free to question their validity. Secondly, and a consequence of the first observation, Kindi is giving us a snapshot of sword manufacture in the mid-ninth century Muslim world. At this time Baghdad was the capital and focus of the world and its face was set to the east, to Iran, whose ancient dynasties provided the model for the court of the Abbasid caliphs and whose men provided the armies that had brought them to power and now maintained their rule. And it is therefore the swords of Iraq and the east that Kindi principally discusses. Bīrūnī, on the other hand, because he also uses earlier written sources, mentions sword types such as the Mashrafi, from the Levant, which were much vaunted in early Islamic poetry, but are unknown to Kindi. Later again, after Kindi's time, when the Levant was once again important under such dynasties as the Ayyubids and Mamluks, it is remarked upon once more particularly for its iron, although steel is also mentioned.[18] In other words, it was an industry that could change

[16] Jāḥiẓ, "Manāqib al-turk", 71–72. There are also lexicographical works that have sections on swords; the earliest extant one is the *Kitāb al-silāḥ* of Abū ʿUbayd al-Qāsim ibn Salām (d. 224/838), which lists names for swords and its parts (pp. 17–18) on the authority of the scholar al-Aṣmaʿī (d. 213/828); this is quoted also by Thaʿālabī (d. 429/1038), who is used and expanded upon by Schwarzlose, pp. 150–53 and 172–200, in ch. 4 below.

[17] E.g. in the "Sum of knowledge about precious stones" (*al-Jamāhir fī maʿrifat al-jawāhir*) of Muḥammad ibn Aḥmad al-Bīrūnī (d. 440/1048), 247–58 (see appendix 2 below); and "On how to stay alive in battles" (*Fī kayfiyyat al-najāt fī l-ḥurūb*) by Murḍā ibn ʿAlī al-Ṭarsūsī (fl. 6th/12th century), 106–108. The text edited by Wüstenfeld, *Das Heerwesen der Muhammedaner*, 28–32 (Arabic section), is directly lifted from Kindi's treatise.

[18] Hassan, "Iron and steel technology", 39 (citing Zayn al-dīn al-Jawbarī and Ibn al-Ukhuwwa). Although iron foundries in Damascus and Damascus steel (*al-fūlādh al-dimashqī*) are mentioned in the Ayyubbid and Mamluk sources, these reports seem to be of only local significance. They do not back up the later European preoccupation with 'Damascened' swords.

much over time, and Kindi is only to be relied upon for the period of the Abbasid heyday.

Kindi's treatise "On swords and their kinds"

This text of Kindi, the first mentioned in Ibn al-Nadīm's list, was edited by ᶜAbd al-Rahman Zaki ("Al-suyūf wa-ajnāsuhā", *Bulletin of the Faculty of Arts*, vol. 14, Cairo 1952) on the basis of two manuscripts:

Ms. Leiden Or. 287, fols. 155–59[19]

Here the treatise forms the sixth chapter of the ninth book of a work entitled "A Compendium of Islamic prose and verse" (*jamharat al-islām dhāt al-nathr wa-l-niẓām*) by Amīn al-dīn Abū l-Ghunaym Muslim ibn Maḥmūd al-Shayzārī (fl. 7th/13th century). The text begins (the Arabic is given in ch. 2 below):

> An epistle (*risāla*) of Yaᶜqūb ibn Isḥāq al-Kindī to one of the caliphs on the natures (*jawāhir*) of swords.
>
> Our lord the imam has ordered me to set out the characteristics of swords in an account that encompasses all their kinds. I have, therefore, set out in this treatise (*kitāb*) of mine all the insights which reveal their secrets and educate in the science of their kinds, both the trenchant and the blunt, as far as my knowledge can attain and my intellect can grasp…

Next to this in the margin there is written: "On the descriptions of swords and their kinds, which should be preserved".

Ms. Istanbul Ayasofia 4832, fols. 170–72[20]

This is a very famous manuscript for Kindi enthusiasts, since it contains twenty-nine treatises of the scholar, of which the one on swords is number twelve. Helmut Ritter states that "its format (22:12 cm), its script (32 lines of old, angular Naskhi-Kufi with almost no diacritical marks), and its dark brown paper reveal to the practised eye its provenance from the fifth century of the Hijra" (11th century AD). The text begins:

> In the name of God the Merciful the Compassionate; success only comes from God Almighty:
> An epistle (*risāla*) of Yaᶜqūb ibn Isḥāq al-Kindī to one of his brethren on swords.

[19] Dozy, *Catalogus*, 1.274. The Leiden text alone was edited, without commentary, by Rana M.N. Ehsan Elahie (Lahore, 1962).

[20] Ritter, "Schriften Jaᶜqub ibn Ishaq Kindis in Stambuler Bibliotheken", 366. Sarraf, "Adab al-Furūsiyya", 137 n. 124, and *id.*, "Mamluk Furūsiyah Literature", 182 n. 151, says that a modern copy of this manuscript, made in 1359 AH (1941 AD), lies in Cairo's Dar al-Kutub (Ms. 3640) and was used by Zaki for his edition, but Zaki makes no mention of this, though there could be a connection here with Ms. Turin (of Cairene origin? – see next page).

May God support you in the attainment of truth and safeguard you from the like of falsehood. May He cloak you in beneficial knowledge and skilful comprehension, which your ultimate desire for good will bring to you in the most excellent health and best protection. I have understood – may God also bring you understanding of all good things and succour in the domain of life and death – your request that I set out a treatise (*kitāb*) on the lore of swords and their kinds and their forging so that you may have knowledge of that from those acquainted with it. In this I have accomplished your wish as far as have allowed my capabilities, my learning, and my examination of the knowledgeable people I have found who are versed in sword manufacture on account of my long-standing desire for noble affairs. And I have set out, may God give you long life, in this treatise of mine all that you have asked me about in this matter together with the insights which reveal their secrets and educate in the science of their kinds, both the trenchant and the blunt, as far as my knowledge can attain and my intellect can grasp.

بسم الله الرحمن الرحيم وما توفيقي إلا بالله العظيم. رسالة يعقوب بن اسحق الكندي إلى بعض إخوانه في السيوف. أيدك الله بدرك الحق وحصنك من شبه الباطل وألبسك علما نافعا وفهما بارعا يبلغك بهما نهاية مرادك من الخير في أكمل عافية وأحسن ستر. فهمت – أفهمك الله جميع الخيرات وأسعدك في دار الحياة ودار الممات – ما سألت من رسم كتاب في معرفة السيوف وأجناسها وطبعها ليكون عندك من ذلك علم تشارك به أهل المعرفة فيها وقد بلغت في ذلك رضاك بقدر طاقتي ومدى معرفتي لذلك وبحثي ذوي العلم ممن أدركت من أهل هذه الصناعة لشوقي كان قدما إلى علم شريف الأمور. وقد رسمت أطال الله بقاءك في كتابي هذا جميع ما سألت عنه من أمرها مع الفراسات الكاشفة عن أسرارها والمخرجة في علم أجناسها والقواطع والكل منها بقدر ما بلغه علمي وأحاط به فكري وبالله التوفيق.

The florid beginning to this introduction may well be part of the original text, which would be standard for a work dedicated to a powerful patron. This was then omitted by Leiden which in general shows a penchant for concision.

Ms. Turin and Kindi's treatise "On the making of swords and their quenching"

There is, however, a third witness to Kindi's text, namely Ms. Turin. While working on this book, I was contacted by Dr. Roberto Tottoli, who kindly informed me that he and his colleague Bruno Chiesa had found another copy of Kindi's epistle among the manuscripts preserved in the "Bibliotheca P. Kahle", which was acquired by the Oriental department of the Humanities faculty of the University of Turin around 1970. On the first page after the cover the manuscript is described as Ms. Meyerhof H241; the reason for this is not known, but may have some connection with the meeting between P. Kahle and M. Meyerhof in Cairo in the early twentieth century. The script is rather non-descript and could date anywhere between the thirteenth and twentieth centuries, though a date towards the latter end of this range is much more likely. Kindi's treatise on the different kinds of swords is found on pages 11–25. The beginning of the treatise is missing and it starts on page 11, without any announcement that this is a new text, with the words "it is steel, meaning refined. It is manufactured from mined iron by adding to it during the melting…", which corresponds to page six of Zaki's edition. For the rest of the treatise it follows very closely the text of Ayasofia 4832, of which it may well be a copy.

The real importance of Ms. Turin, however, is that it also contains the other treatise on swords mentioned in Ibn al-Nadīm's list, "that with which swords and iron are

treated so that they are not broken or blunted",[21] i.e. recipes for quenchings. The title on the first page is: "The thirteenth epistle on the making of swords and their quenching (*fī ᶜamal al-suyūf wa-siqāyatihā*), and steel and iron and the like, which Abū Yūsuf Yaᶜqūb al-Kindī addressed to the commander of the faithful al-Muᶜtasim bi-Amr Allāh, may God have mercy on him". The text itself begins on page 2 as follows.[22]

{In the name of God the Merciful the} Compassionate, may God pray for and protect our lord Muḥammad, his family and his companions.

{A treatise on} swords and their types and their quenchings addressed by Abū Yūsuf {Yaᶜqūb} ibn Isḥāq al-Kindī to al-Muᶜtasim, commander of the faithful, concerning the use of the natures of iron for swords and other weapons and their quenchings, and the types of iron from which swords are forged and their quenchings and what is thrown on them. This has come to us only by description of the efforts of those who have made them (ᶜamalahā rather than ᶜallamahā?), and we have no experience of it. However, I wished that there should not escape you knowledge of what came to us about the nature of that in order that it be[23] something which I can present for examination, and test it and explore its strengths and weaknesses.

Know that, may God make you endure and protect your days, they say that iron is of two sorts, male and female. The male is divided into (one category?)[24] called *shāburqān*, which is deep(?) in colour. The female is divided into two categories; the most flexible of them and the most resistant to breaking is called the *dhl* (?), and it is the most intense of them in brightness and in cleaving. The other kind is called "the marine", which is the quicker of the two to break and is disastrous when it breaks. Belonging to the female iron is another kind called "the crystalline", which is the most noble of them. As for steel, it is processed (iron), and I shall now mention types of it that you can use (for swords) if you wish and that you can employ for other implements if you want. Know that the watered sword is called by the Persians *sarjūd* and by the people of the Ḥijāz ᶜalyān; it is dry, which derives from a paucity of ingredients which are put into the medicament that is thrown onto it during the melting, and parts of it are clear and other parts not.

On the procedure for making iron (page 3)...[25]

[21] This phrase (*ḥattā lā tatathallam wa-lā takill*) recurs with similar wording a number of times in Ms. Turin (e.g. twice on page 32: *fa-lā tankasir wa-lā tatathallam, lā tanqaṣif wa-lā tatathallam*).

[22] Since the manuscript (provided in appendix 3) is clearly written, it is unnecessary to give the Arabic here. We also give the corresponding page of Ms. Chester Beatty AR5655 (see n. 25 below) for comparison.

[23] The manuscript has *lᶜlwk*, which makes no sense; I emend to *li-yakūna*.

[24] A word seems to be missing here; the text has *al-dhakar minhu yanqasim yusammā al-shāburqān*.

[25] Just as I was about to hand the manuscript of this book to the publisher, I saw a copy of David Nicolle's *Companion to Medieval Arms and Armour* (Woodbridge, 2002), which contains an article by Shihab al-Sarraf ("Close combat weapons in the early Abbasid period", p. 151), which also alludes to Kindi's second treatise on swords. He refers to an Arabic article of his ("Adab al-furūsiyyya", 120), where he announces that the section on swords in the famous Mamluk horsemanship treatise of Muḥammad ibn ᶜĪsā al-Aqsarāʾī (749/1348), the *Nihāyat al-suʾl wa-l-umniyya fī taᶜlīm aᶜmāl al-furūsiyya*, contains the second treatise of Kindi. We have obtained the *Nihāyat al-suʾl* as found in Chester Beatty Ms AR5655 (formerly A21; dated 767/1366) where Kindi's second treatise is indeed found on

The rest of the treatise, namely pages 3–33 of Ms. Turin (except for pages 11–25, which contain the other sword treatise of Kindi, the one presented in this book), details a number of recipes for quenchings (or other heat-treatments) for swords and other implements. Some of these may be very short; for example: "Take a portion of sulphur, pour on it portions of wine vinegar, leave it in the sun for seven days, then pour off the vinegar and replace it with radish water so that it drinks, then heat the sword and quench it in ammonia solution, then heat it and quench it with that water, I mean the water of sulphur and radish, then the sword will be trenchant, God willing" (Ms. Turin, p. 5).[26] However, many of the recipes are quite long and complex, in respect of both the ingredients and the processes. Indeed, the whole treatise is quite technical, effectively a chemical text, and as such differs substantially from the more descriptive and factual nature of the treatise studied in this book.[27]

The present edition and translation of Kindi's treatise

Zaki's edition of Kindi's treatise is a valiant attempt at rendering a very difficult text into clear printed Arabic. However, besides a number of misreadings and infelicitous emendations, it is marred by his decision to combine the Leiden and Istanbul manuscripts, selecting readings from each as he thought best, thus creating a new text. I have rectified this by adopting Leiden as a base text, reproducing this and simply noting the different readings of Istanbul in the critical apparatus. The differences between the two manuscripts are so minor as to make it likely that they are copied from the same manuscript. In this case it is not so important which serves as the base text and I have chosen Leiden simply because it is more carefully written in terms of both script and language. Since the principal concern of this book is with the content of the treatise, I have not noted those discrepancies in Istanbul that constitute no more than a different form (whether grammatical or orthographical) of the word found in Leiden. Moreover, for ease of reading I have supplied *hamza*s and *tā-marbūṭa*s, although these are almost wholly absent from both manuscripts. For those experts

folios 172–177 (Fig. 9). The two versions mostly concur word for word except in two places: at the end of the introduction given above Ms. Turin must be missing a couple of folios, for Ms. Chester Beatty (172a–173a) gives six methods for making iron, then a recipe for Sulaymani swords, halfway through which Ms. Turin comes back in again. Secondly, Ms. Turin breaks off at the end of p. 10 to give the first Kindi treatise (pp. 11–25): this break corresponds to a point eight lines before the end of Kindi's second treatise in Ms. Chester Beatty. Ms. Turin then recommences giving quenching recipes after presenting the first Kindi treatise, from p. 25 to p. 33, but this is not found in Ms. Chester Beatty and so may not be part of Kindi's second treatise. However, this question remains to be settled by further research.

[26] Note also that the crucible steel-making recipe for Indian swords ("For the Indian swords one takes a *manna* of *narmāhan* and the same amount of *shāburqān*, break into small pieces, put in a furnace, and add to it one *manna* of magnesia, two dirhams of kernels of myrobalan, five dirhams of *andarānī* salt, the same amount of Khurasani borax, a handful of peel of bitter pomegranate sifted with egg-white", Ms. Turin, p. 3) is also found, almost word for word, in Ms. Berlin We 1859 cited by Wiedemann, "Über Stahl und Eisen bei den muslimischen Völkern", 128, and Ragib, "La fabrication des lames damassées", 68. This may mean that these recipes circulated as discrete units in different collections.

[27] Roberto Tottoli tells me that he hopes to be able to publish a study of this very interesting treatise sometime in the near future.

keen to know the exact formulation of the original, copies of the manuscripts are supplied in appendix 3.

Leiden is written in clear and largely correct classical Arabic, and Istanbul only slightly less so, the only common error being the omission of indefinite accusative endings (particularly common in Istanbul), and yet the treatise remains difficult to understand. This is because diacritical marks are very often not written, and one gets the impression that the copyists of the Leiden and Istanbul manuscripts were unsure how to read certain words, especially as many of them are technical in nature. One, therefore, sympathizes with Hammer-Purgstall, the first European scholar to attempt to make sense of this text, who, after translating the first few pages, breaks off, saying: "N'étant pas sûrs de saisir le veritable sens de ce qui suit, nous nous contentions d'en copier le texte arabe tel qu'il se trouve dans le manuscript".[28] In producing this translation I have been fortunate in having the aid and expertise of Brian Gilmour and James Allan. Yet, though I have benefited much from both the latter, I am not an expert in swords, and so this translation still represents a provisional attempt, for which I hope others more knowledgeable will be encouraged to suggest improvements.

[28] "Sur les lames des Orientaux", 75. And Wüstenfeld says of a text made up of excerpts from Kindi's treatise (see n. 17 above) that he leaves it untranslated "wegen der grossen Incorrectheit der Sprache und einer Menge wenig oder gar nicht bekannter technischer Ausdrücke" (*Das Heerwesen der Muhammedaner*, 27, Arabic section).

Chapter 2

Kindi's "On Swords and their kinds"

edition and translation

Robert Hoyland

Chapter 2

رسالة يعقوب بن اسحاق الكندي
إلى بعض الخلفاء[1] في جواهر السيوف

(5) أمر مولانا الإمام أن أرسم أوصاف السيوف بقول يعم أجناسها[2]. وقد رسمت [أطال الله بقاءك][3] في كتابي هذا جميع [ما سألت عنه من أمرها مع] الفراسات الكاشفة عن أسرارها والمخرجة في علم أجناسها والقواطع والكل[4] منها بقدر ما بلغه علمي وأحاط به فكري [وبالله التوفيق].

[اعلم أن] الحديد الذي تطبع منه السيوف ينقسم قسمين أوليين: إلى المعدني وإلى[5] الذي ليس بمعدني. والمعدني ينقسم قسمين: إلى الشابرقاني وهو المذكر الصلب القابل للسقى بطباعه وإلى النرماهن وهو المؤنث الرخو الذي ليس بقابل للسقي بطباعه. وقد يطبع في[6] كل واحد من هذا الحديد[7] مفردا ومنهما[8] معا مركبين. فجميع أنواع السيوف المعدنية ثلاثة[9]: **(6)** الشابرقانية والنرماهنية والمركبة منهما. وسنحدها نوعا نوعا ونأتي على [جميع] ما يلزم الحاجة إليه من وصفها في موضع ذلك [إن شاء الله].

فأما الحديد الذي ليس بمعدني فهو الفولاذ ومعناه المصفى ويصنع من المعدني بأن يلقى عليه في السبك شيء يصفيه ويشد رخاوته حتى يصير متينا لدنا يقبل السقي ويظهر فيه فرنده. وهذا[10] الفولاذ ينقسم [إلى] ثلاثة أقسام: إلى العتيق والمحدث و[إلى] لا[11] عتيق ولا محدث. وقد تطبع من هذه جميعا السيوف. **(7)** فأنواع السيوف الفولاذية ثلاثة: عتيق ومحدث ولا عتيق ولا محدث.

[1] الخلفاء: ا (إسطنبول) "إخوانه".
[2] توجد هذه الجملة في ل (ليدن) فقط. أعطيت نص مقدمة مخطوطة ا في الباب السابق.
[3] في هذا الباب تشير الأقواس المربعة إلى كلمات توجد في ا فقط (من دون ل).
[4] هذا اقتراح زكي ولكن في ا و ل "النكل" (بدون تنقيط).
[5] هذه الكلمة غير موجودة في ا.
[6] في: ا "من".
[7] هذا الحديد: ا "هذه السيوف".
[8] هكذا في ا و ل ولكن زكي يكتب "فيهما".
[9] في ا و ل تكتب هذه الكلمة دائما "ثلث\ثلثة" (يعني بدون الف).
[10] فرنده وهذا: ا "فرندا وهو".
[11] هذه الكلمة موجودة في ا و ل ولكنها غير موجودة في زكي.

Chapter 2: Translation

A treatise of Ya ͨqūb ibn Isḥāq al-Kindī to one of the caliphs[1] on the natures of swords

(5) Our lord the imam has ordered me to set out the characteristics of swords in an account that ecompasses all their kinds (see Fig. 8). I have therefore set out [may God give you long life] in this treatise of mine all [that you asked about them together with] the insights that reveal their secrets and educate in the science of their kinds, both the trenchant and the blunt, as far as my knowledge can attain and my intellect can grasp [and in God lies success]. [2]

[Know that] iron (*ḥadīd*), from which swords are forged (*tuṭbaͨ*), is divided into two primary categories: mined (*maͨdanī*) and unmined (*laysa bi-maͨdanī*). The mined is itself divided into two categories: hard iron (*shāburqān*), which is male, hard, and able to be quenched (*saqy*) during its forging; and soft iron (*narmāhan*), which is female, soft, and cannot be quenched during its forging.[3] Swords may be forged from either on its own and also from both put together. So there are in all three types of mined swords: (6) those made from hard iron, those made from soft iron, and those made from a compound of the two (*murakkaba*). We shall define them type by type, and [everything] that is necessary for their description we shall mention in the proper place [God willing].

As for the unmined iron, it is steel (*fūlādh*), meaning refined (*muṣaffā*). It is manufactured (*yuṣnaͨ*) from mined iron by adding to it during the melting (*al-sabk*) something which refines it and makes its softness strength so that it becomes firm and pliable, can be quenched, and so that its watering (*firind*)[4] appears in it (see Fig. 10a & b). Steel is divided into three categories: ancient, modern, and [into] neither ancient nor modern, and from all of these swords may be forged. (7) So there are three types of

ولم نذهب من عتقها إلى الزمان لأن عتيقا مطلقا لا يقال إذا قصد به الزمان إلا إلى[12] أحد معنيين إما أول الأشياء فقط والأول واحد في كل مبتدأ صنعه وإما كل واحد من الأشياء إذا أضيف إلى ما هو أحدث منه فيجب إذا أن يكون كل شيء عمل بعده شيء آخر مستحقا أن يسمى عتيقا. وليس العتيق من السيوف بسيف واحد [ولا أصلها كلها إلا واحد] بل إنما يذهب من عتقها إلى الكرم كما يقال فرس عتيق يراد به كريم. فما لحقته خواص الكرم فهو عتيق في أي دهر صنع[13] والطرف الأبعد من العتيق هو ضده في المعنى أعني ما عدم خواص العتيق منه[14] فلذلك سمي [بضد اسمه أعني] محدثا وإن كان قد طبع قبل زمن عاد. وأما الآخذة بعض خواص العتيق وعادمة[15] بعض خواصه ف[هى التى] وجدت فيها بعض خواص المحدث فسميت أيضا باسم متوسط بين الاسمين فقيل ليس بعتيق ولا محدث وإن كان متقادم الزمان أو حديثا فاختار[16] الصياقلة لها اسما لا عتيقا [في بعضها][17] (8) ولا محدثا في بعضها[18]. فلذلك وقع هذا التمييز من الحديد [في الحديد] المعمول أعني الفولاذ [لا] المعدني الذي لم يمزج بشيء غيره كالشابرقان والنرماهن. [لأنه] لو كان استحق اسم العتيق بالزمان لكان في الشابرقان والنرماهن ما [قد] طبع منذ زمن قديم [وما يطبع الآن فيسمى القديم] بالزمن العتيق والمحدث بالزمان المحدث. ولكن لما كان الشابرقان والنرماهن معادن واحدة غير مغيرة بتفاصيل مهينة[19] أدخلت على جواهرها شيئا غيرها[20] إلى الجودة أوالرداءة لم يسم منها شيء بتة عتيقا ولا محدثا بل سمى بأسمائها إما شابرقان وإما نرماهن.

[12] إلى: ا "على".

[13] صنع: ا "كان طبع".

[14] هذه الكلمة غير موجودة في ا.

[15] هكذا في ا و ل ولكن زكي يكتب "عادت".

[16] اختار: ا "اختص".

[17] زيادة عن ا غير مذكورة في زكي.

[18] اللفظة "في بعضها" موجودة في ا و ل ولكنها غير موجودة في زكي.

[19] هذا اقتراحي. في ا و ل "بتفاصل مهنه" (بدون تنقيط) وفي زكي "بعاصل مهته".

[20] شيئا غيرها: ا "أشياء غيرتها".

steel swords: ancient (*ʿatīq*), modern (*muḥdath*) and neither ancient nor modern (*lā ʿatīq wa-lā muḥdath*).

The ancientness of swords is not related to time, for one certainly should not use the term ancient when one thereby intends time, except in one of two cases. These are for the first of things, since the first of anything is unique at the very beginning of its manufacture; or else for anything which is put with what is moderner than it, for if everything is made after it, it must deserve to be called ancient. The ancient among swords does not, however, correspond to a unique sword [nor to the original of them], but rather its ancientness is related to nobility (*karam*), just as when it is said of a horse that it is ancient, it is meant thereby that it is noble. So to whatever there pertains qualities of nobility, then it is ancient no matter in what age it was manufactured. The furthest thing from ancient is its opposite in meaning, that is, what lacks the qualities of the ancient, and it is accordingly called [by the opposite of its name, that is] modern, even if it were forged before the time of ʿAd.[5] As for those swords possessing some of the qualities of the ancient and lacking some of its qualities, [they are those in which] are found some of the qualities of the modern, and hence they are called by the intermediate name of neither ancient nor modern, irrespective of whether they are advanced in age or recent. And the swordsmiths (*ṣayāqila*)[6] have chosen for them this name of [in part] not ancient **(8)** and in part not modern. This distinction, therefore, occurs in respect of processed iron (*al-ḥadīd al-maʿmūl*), that is, [un]mined steel, which is not combined with anything else (once it has been processed), as are hard iron and soft iron (which can be combined with each other). [For] if the term ancient was merited by virtue of time, then it would go to the hard iron and the soft iron, which have been forged since olden times [and which are forged now, and so in this case the old in time could be called] ancient and the recent in time modern. But since the hard iron and the soft iron are single metals, unchanged by base particulars[7] that have introduced something into their natures (*jawāhir*) that would change them for better or for worse, nothing at all from them should be called ancient or modern; rather they are called by their names, either hard iron or soft iron.

[5] An ancient Arabian tribe (cf. Qurʾān 7.65–72, 69.6) who even to pre-Islamic poets were a byword for antiquity (*E.I.*, *s.v.* "ʿAd").

[6] Plural of *ṣayqal*, "one who practises the art of polishing and sharpening swords and the like" (Lane, *s.v.*). On the subject of polishing and sharpening of swords see Schwarzlose, pp. 157–61, in ch. 4 below.

[7] Though the sense is clear here, the exact reading of these two words is uncertain; Zaki simply reproduces them (badly) from Istanbul without attempting to interpret them. The first word may be intended to be a form of *faḍala*, "to be surplus, left over", so superfluities, but if so its form has been corrupted in transmission.

والعتيق ينقسم ثلاثة أقسام: أولها وأجودها اليماني ثم ثانيها القلعي **(9)** ثم ثالثها الهندي وهو المسمى الفاقرون.

وأما التي ليست بعتيقة ولا محدثة فتنقسم قسمين

أحدهما المسمى عند الصياقلة غير مولد وهي سيوف تطبع باليمن من الحديد السرنديبي والسلماني فيقال غير مولد السلماني وغير مولد السرنديبي. وتسمى المعتوقة لأنها تعمل[21] من السرنديبي والسلمانية الصغار أعنى الدقاق القدود فتعتق عرضها أعنى تعرض ويحكى بها اليماني فتسمى معتوقة.

Ancient swords are divided into three categories: the first and most excellent is the Yemeni, the second is the Qala°i[8] **(9)** and the third is the Indian (*Hindī*),[9] which are called the *fāqirūn*.[10]

As for those neither ancient nor modern, they are divided into two categories: the first of them is called by the swordsmiths foreign (*ghayr muwallad*),[11] which are swords forged in Yemen from the iron of Sri Lanka or Salmān,[12] and so are called the

[8] Or Qal°i (Bīrūnī, *Jamāhir*, 248: *q-l-° bi-naṣb al-lām wa-bi-jazmihā*). In his entry on "Qala°a" Yāqūt (d. 626/1229; *Mu°jam al-buldān*) quotes from the account of a journey to China by Mis°ar ibn Muhalhil (fl. 330s/940s; see *E.I.*, *s.v.* "Abū Dulaf"): "I returned from China to Kalah, which is the first country of India from the direction of China and where the boats stop and go no further (probably Kalah in the Malay peninsula). In it is a great stronghold in which is the mine of Qala°i tin, found only in this stronghold, and in which are forged the Qala°i swords, which are the ancient Indian ones". Yāqūt goes on to say that Qala°a is also a place in Yemen, and other authors also mention a mountain in Syria as a contender (see *E.I.*, *s.v.* "Kalah"), but Jāḥiẓ, an exact contemporary of Kindi and an equally famous scholar, says that "as for the people of Hind, theirs are the Qala°i swords" (*Fakhr al-sūdān*, 223); cf. *id.*, *Hayawān*, 3.143: the people of Antioch say of their city's humidity that a sword "would rust here even if it was of (the steel of) Qala°a of Hind and was forged in Yemen", i.e. even if it were of the very best quality. However, Hind could mean anywhere from modern Pakistan to Malyasia (see next note).

[9] Fatimi, "Two letters from the Maharaja to the Khalifa", esp. 122–24, argues that Hind in early Islamic times only signified the coasts and islands of India (from east Pakistan to Malaysia inclusive), not the inner regions.

[10] *Faqara* can mean to dig out (e.g. a well), perforate (e.g. beads or camel's nose for threading a string), and to cleave/rend (Lane, *s.v.*); the term *mufaqqar* is applied to a sword with incisions/notches/grooves (Abū °Ubayd, *Silāḥ*, 17). One of the Prophet Muhammad's swords was called *Dhū l-faqār* (*E.I.*, *s.v.* "Dhu Faqār", and see Schwarzlose, pp. 152–53, in ch. 4 below), because, according to Dhahabī (*Siyar*, 2.429), its blade looked like the vertebrae of a back (i.e. serrated, whether designed thus or a result of continuous use in battle; cf. Schwarzlose, pp. 204–205). It has also been suggested that the term comes from the Javanese *parong*, meaning a sword with extensive watering (Fatimi, "Malaysian weapons in Arabic literature", 216).

[11] *Muwallad* literally means "begotten, engendered, originated", and in particular "born among the Arabs" or "born in the territory of the Muslims" (Lane, *s.v.*). In the latter sense it came to refer to poets writing after the arrival of Islam, i.e. in the wake of the transformation of the pre-Islamic Arab language and culture wrought by Islam and the converts to it, and is used in contrast to the "authentic" poets active before these changes. However, the sense here, applied to swords, is probably "manufactured in the lands of Islam"; see n. 13 below.

[12] Fatimi, "Malaysian Weapons in Arabic Literature", 223 n. 36, reads Bīlmān (saying "it is obvious that the scribe has missed three dots in the first syllable") and relates it to modern Bhīnmāl, near Jodhpur, in modern northwest India. Certainly a Baylamān in Sind (Balādhurī, d. 279/892, *Futūḥ al-buldān*, 440, 442) is mentioned as famous for its swords by Idrīsī (d. 560/1165; *Opus geographicum*, 67) and Yāqūt (*Mu°jam*, *s.v.*, who says "or Yemen"). The problem with this is that Kindi states below that the iron of the small Salmānī "is brought cast from the land of Salmān to Transoxanian Khurasan", which is a long and difficult journey if this refers to modern Bhīnmāl and unnecessary given that Khurasan was a well known centre of iron production. Moreover, does this type of unmined iron/steel sword have the same name as the later mentioned mined iron/compound iron sword (see Kindi/Zaki, pp. 12 and 33 in this chapter)? Since the manuscripts do not give a clear answer (the word is generally written without dots), we have decided here to follow Allan, *Persian Metal Technology* (esp. pp. 83–85), in using the term Salmānī for the name of the unmined iron/steel sword and Sulaymānī for the name of the mined iron/compound iron sword. Note that the Rūs had "Sulaymānī swords" according to Ibn Rusta (fl. 290/903; *A°lāq al-nafīsa*, 146), and according to Asimov and Bosworth, *Civilizations in Central Asia*, 78 and 304, the Sulayman mountains lie in southern Afghanistan/Pakistan south of Kandahar (my thanks to Dr. James Montgomery for this reference), but this is perhaps too far south for our purposes.

وقد تسمى هذه المعتوقة الأولى من الفاقرون [خاصة][22] لأنها أول السيوف في الترتيب مرتبة تلي

العتيق على وجه لأن عنصرها عتق وهي أول ما يحكى به اليماني من السيوف... **(11)** وأما المولد فينقسم خمسة أقسام: منها الخراسانية وهي ما عمل حديده وطبع بخراسان. ومنها البصرية وهي ما عمل حديده وطبع بالبصرة. ومنها الدمشقية وهو ما عمل حديده وطبع بدمشق قديما. ومنها المصرية وهي ما طبع بمصر. وقد يطبع في مواضع غير هذه [كالبغدادية والكوفية] وغير ذلك من المواضع القليلة ولا تنسب اليها [لقلتها]...

... **(9)** والقسم الآخر المسمى غير عتيق وهي السلمانية [والسرنديبية والبيض. والسلمانية] ينقسم أربع أقسام[23]: منها البهانج وهي سيوف عراض يكون السيف منها **(10)** عرضه أربع أصابع وأكثر و[لها] فرندها غليظ كبار جدا ومنها الرثوث وهي في العرض أربع أصابع وأقل من ذلك. ومن[ها] الصغار وهي سيوف دقاق الفرند[24] فإذا طبعت[25] حكى فرندها فرند العتيق فخرج بعضها يشبه فرند اليماني وبعضها يشبه فرند القلعي فتنسب الصياقلة كل واحد منهما إلى شبيهه من [العتيق ويدلسونها ب][26] اسماء أشباهها. ومنها ما يطبع بسلمان[27]. والسرنديبية تنقسم أربعة أقسام: منها التي تطبع[28] بسرنديب. ومنها الخراسانية وهو ما حمل من سرنديب وعمل حديده بخراسان[29]. ومنها المنصورية وهو ما حمل حديده من سرنديب وطبع بالمنصورة. ومنها الفارسية وهو ما حمل حديده من سرنديب وطبع بفارس وتسمى الخسروانية.

[22] زيادة عن ا غير مذكورة في زكي.
[23] الكلمات "ينقسم أربع أقسام" موجودة في ا و ل ولكنها غير موجودة في زكي.
[24] في ا تكتب هذه الكلمة هنا وفي أمكنة أخرى: "الافرند".
[25] هذا اقتراح زكي. في ا و ل "فتقت" ولكنه مكتوب بدون تنقيط كامل.
[26] يكتب زكي "معتيقي ويدلو نهاب" ولكن هذا غير معقول.
[27] في ا و ل "بتيلمان" (بدون تنقيط في ا).
[28] منها التي تطبع: ا "منها ما يقال له التي وهي ما طبع".
[29] حمل من سرنديب وعمل حديده بخراسان: ا "حمل حديده من سرنديب وطبع بخراسان".

foreign Salmāni swords and the foreign Sri Lankan swords. They are called "made ancient" (*maᶜtūqa*), because they are made from the Sri Lankan and the small – that is, the finely-proportoined – Salmāni swords. Thus their presentation is made ancient, that is, they are presented and made to resemble the Yemeni, and so they are called "made ancient". These "made ancient" swords are classified first after the *fāqirūn*, [in particular] because they are the first swords in the order of succession nearest the ancient in accordance with the fact that their constituents are ancient and they are the nearest of swords in resemblance to the Yemeni... **(11)** As for the indigenous (*muwallad*),[13] it is divided into five categories. Among them is the Khurasani, of which the iron is worked and forged in Khurasan (a province of northern Iran). And among them is the Basran, of which the iron is worked and forged in Basra. And among them is the Damascan, of which the iron has been worked and forged in Damascus since olden times. And among them is the Egyptian, which are those forged in Egypt. And they may be forged elsewhere, [like Baghdad and Kufa] and a few other places, but they are not attributed to these places [because of their rarity]...[14]

... **(9)** The other category, called modern (lit. not ancient), comprises the Salmāni swords, [the Sri Lankan (*al-Sarandībīya*) swords and the white swords (*bīḍ*).[15] The Salmāni] are divided into four categories. Among them is the *bahāng*,[16] which are broad swords, each **(10)** having a breadth of four fingers and more, and their watering is rough and very large. And among them are the *rathūth*[17], which have a breadth of four fingers or less. And among them are the small swords, which are swords of fine watering, and when forged[18] their watering resembles that of the ancient. Some come out resembling the watering of the Yemeni and some resembling the watering of the Qalaᶜi, and the swordsmiths attribute them to the ancient sword that they most resemble and [fraudulently give them] the names of those they resemble. And among them are those forged at Salmān.[19] The Sri Lankan is divided into four categories. Among them are those forged in Sri Lanka. And among them are the Khurasani, which are those brought from Sri Lanka and its iron worked in Khurasan. And among them are the Manṣūri, of which the iron is brought from Sri Lanka and they are forged at Manṣūra.[20] And among them are the Farsi, of which the iron is brought from Sri

[13] Note that the places where it is found are all major Islamic centres; see n. 11 above.

[14] This section between full stops, the first part of page 11 in Zaki's edition, logically belongs here, since it details the second category (the *muwallad*) of those swords called neither ancient nor modern (the first category being the *ghayr muwallad*). Since it is displaced in both manuscripts, the error must have occurred early on in the text's transmission. For ease of understanding we have restored the section to its logical position.

[15] *Bīḍ*, plural of *abyaḍ*, "white", often used of swords because of their silvery whiteness (Lane, *s.v.*, and see Schwarzlose, pp. 171–72, in ch. 4 below). It could also be read *bayḍ*, collective noun for eggs (see commentary in ch. 3 below for explanation).

[16] Probably derived from the Persian word *pahn*, meaning "broad".

[17] The root of this word in Arabic means "worn/ragged", which seems inappropriate here; the word may (like *bahāng*) not be Arabic.

[18] This is Zaki's emendation; Leiden and Istanbul are unclear, but appear to have "when rent/slashed".

[19] Though, as Zaki notes, this is most likely what is meant, both Leiden and Istanbul have "in Tīlmān".

[20] The chief city of the Muslim province of Sind, founded in the 2nd/8th century, now a ruin some 45 miles northeast of modern Hyderabad in Pakistan.

والخسروانية تنقسم قسمين: منها ذوات تماثيل وشجر وغير ذلك من الصور ومنها السواذج. والبيض تنقسم قسمين: منها الكوفية طبعت بالكوفة [في أول زمن الكوفة] وهي المسماة الزيدية طبعها رجل يقال له زيد [فنسبت اليه] ومنها الفارسية.

... **(11)** وهذه جميع أصناف السيوف المذكورة من الحديد المعمول أعني الفولاذ. فأما الحديد المعدني فإن منه كما ذكرنا: الشابرقان وهو المسمى الذكر من الحديد [ومنها] النرماهن وهو المسمى [الأنثى] من الحديد[30]. وقد تطبع من الذكر سيوف وهي سيوف يابسة تنكسر سريعا إذا لقيت الكرائه وتسرع في اللحم إلا أنها لا يستوي سقيه لأن الذكر من الحديد تكون فيه عروق لينة نرماهن فتقع في شفارها كثيرا فلا تقبل هذه العروق السقي **(12)** فتجلس[31] عند الضرب. فأما ما قبل منها السقي فتبتر غروبها إذا لقيت الكرائه أو تكسر[32] فليس يكاد أحد أن يطبع منها إلا جاهل بها أو ضرورة في موضع لا يمكن فيه غير الحديد الذكر. وهذه السيوف لا فرند لها في طرح ولا غيره وحديدها كله لون واحد. وهي جاسية لا تنثني ولا تهتز ولا صفاء لحديدها ولا ماء شديدة السن مختلفة الشفار مواضع [منها][33] خشنة ومواضع لينة. وقد تطبع من النرماهن سيوف يتخذها الروم والشراة. وأما المركبة من شابرقان ونرماهن فتنقسم قسمين: منها الفرنجية ومنها السليمانية.

وخواص العتيق الذي يفضله من باقي [الحديد] هي الاكتناز والمتانة واللدانة ما لم يحمل عليه [في] السقي وشدة الصقالة وصفاء المكاسير وميلها إلى البياض وحمرة حمأها وتوبالها كحمأ النحاس وتوباله وجوودة الفرند وتعقده واستواء الفرند في كل السيف لا يكون **(13)** بعضه دقاقا طوالا وبعضه قصارا طوالا غلاظا [وبعضه قصارا غلاظا] وبعضه قصارا دقاقا بل متساويا[34] في قدر قريب من التساوي وفيها عقد صغار كالفلفل كعقد فرند الخشب وسأبين محنه مواضعها التي رسمها فيها أصلح وأبين. وكذلك أرسم جميع معاني هذا الكتاب رسما يكون أوضح وأسهل في فهمه وإن خرج ذلك عن نظمها على ترتيب القسمة التي قدمت. فأما خواص باقي[35] أنواعها فسأذكرها عند ذكرها وخواص كل واحد من أنواع العتيق [أيضا].

[30] اللفظة "من الحديد" موجودة في ا و ل ولكنها غير موجودة في زكي.

[31] هذه الكلمة غير واضحة في المخطوطين ومكتوبة بدون تنقيط كامل. يقترح زكي "فتبتر".

[32] هكذا في ا. في ل "انكسر" ولكن يحتمل أنه تصحيف لأنه غير معقول.

[33] زيادة عن ا غير مذكورة في زكي.

[34] في ا و ل: "بعضه دقاق طوال وبعضه طوال قصار غلاظ [وبعضه طوال قصار غلاظ] وبعضه قصار دقاق بل متساو [ا مستوي]".

[35] هكذا في ا وهو أعقل من قراءة ل "ذكر".

Lanka and forged in Fars, and they are called imperial (*Khusrawānīya*).[21] The latter is itself divided into two categories: those bearing figures and trees and other images, and the plain swords (*al-sawādhij*). The white swords are divided into two categories: the Kufan, which was forged in Kufa [in the earliest period of the city's history], and it is also called Zaydi, forged by a man called Zayd [and attributed to him], and the Farsi (see Fig. 11).

... **(11)** All these sorts of swords mentioned above are from processed iron (*al-ḥadīd al-maʿmūl*), that is, steel. As for mined iron, there derives from it, as we have said, hard iron, called the male type of iron, and [from it is] soft iron, called [the female] type of iron. Swords may be forged from the male type, but they are dry swords that break (*tankasir*) quickly when they encounter adversity and soon have to be welded (*laḥm*). Moreover, they do not quench evenly because the male type of iron contains pliant veins (*ʿurūq*) of soft iron, which often occur in its blades (*shifār*), and these veins cannot be quenched **(12)** and sit[22] in the event of a blow. As for those of them which can be quenched, their cutting edges (*ghurūb*) are severed (*tubtar*) when they encounter adversity or they break, so almost no one would forge from them except one ignorant or in need, in a place where there is only male iron. These swords have no watering, neither upon throwing (*ṭarḥ*) of an etching substance upon them nor without; their iron is all of one colour. They are solid, do not bend or vibrate, and their iron has no purity nor water; they have a strong point (*sinn*), a variety of blades, and parts [of them] are rough and parts smooth. From the soft iron there are forged swords which are adopted by the Byzantines and the Shurat.[23] As for those made from a compound of hard iron and soft iron, they are divided into two categories: the Frankish and the Sulaymāni.[24]

The qualities of the ancient which make it better than the rest [of the swords] are compactness, firmness, flexibility – as long as it is not affected (*lam yuḥmal ʿalayhi*) [during] quenching, an intense polishing (*ṣaqāla*), and purity of fracture surfaces (*makāsīr*). Then there is its tendency towards whiteness, the redness of its slag (*ḥamaʾ*) and its hammer-scale (*tūbāl*) like the slag and hammer-scale of bronze, the curliness of the watering and its knotting, and the evenness of the watering throughout the sword. There are not **(13)** parts of it fine and long and parts of it long and rough, [nor parts of it short and rough] and parts of it short and fine, rather it is very nearly perfectly even. In it are small knots (*ʿuqad*) like peppers, like knots in the grain of wood. I shall explain the testing of it in the places where its exposition will be most

[21] Literally: related to the emperor *Khusraw*.

[22] The same phenomenon is mentioned further on in the text – veins of soft iron remain – and with the same result: "when they are struck a part sits on a part" (Kindi/Zaki, p. 19). The exact sense of the word "sit" is not clear, but Zaki is probably wrong to substitute "they are severed" (*tubtar*), for this is the same word used in the next sentence, and yet the sense would seem to require some contrast between the two sentences.

[23] Literally: "sellers" (i.e. of their souls in the cause of God), a name for the Kharijites, a Muslim religio-political sect notorious for their militancy and uncompromising views.

[24] See n. 12 above and Allan, *Persian Metal Technology*, 83–84. Note that Arabic sources refer to *mudhakkar* swords, which are those whose blades are of male iron and their bodies of female iron (Abū ʿUbayd, *Silāḥ*, 17, and Thaʿālibī, *Fiqh*, 132; cf. Schwarzlose, pp. 139–43, in ch. 4 below).

فأما القواطع منها من غير جهة جواهرها بل بأشكالها ف[هي] قصارها إذا جادت متونها واستوت[36] سطوحها وثخنها. [ولم يكن فيها موضع داخل وموضع خارج] (14) ولم يكن فيها موضع أثخن من نظيره[37]. وغلظ[ت] شفارها ما خلا نفس الحد فإنه ينبغي أن يكون الحد قدر شعرة من كل جانب فهذه أقطع السيوف للكرائه. فأما أقطع[ها] للثياب واللحم فما استجمعت فيه هذه الصفات[38] جميعا ما خلا غلظ الشفرة فان أرقها شفارا أقطعها للحم والثياب وليست بالمحمودة ما رق[ت] شفاره[ا]. واعتدال السقي عون على القطع فإن سقيه إن اشتد انبترت شفاره عند الكرائه [وإن لان سقيه فاشتد شفاره عند الكرائه][39].

وأما قدودها كل نوع منها[40] فسنذكرها إذا ذكرنا كل نوع منها بخواصه فان في ذلك عونا على معرفة أنواعها وإن كان القد يمكن أن يشبه القد بالقد ويحكى في غير ذلك العنصر من الحديد ولكن علمها على حال زيادة في المعرفة بأنواعها. إذا وافق القد الحديد كان أصدق شهادة فإذا اختلف فإن الحديد[41] أصدق شهادة من القد وأولى بأن يحكم به. وقد تستعمل الصياقلة مكان اسم الفرند اسم الحديد فيقولون إذا كان ظاهر الفرند إنه ظاهر الحديد.

فأما الأرض [أعني أرض السيف] فسموها أرضا على حالها أعني[42] الموضع من الحديد الذي لا فرند فيه. فيقولون أحمر الأرض وأخضر الأرض وأكدر الأرض. فمتى وجدتني في كتابي هذا أقول (15) أبيض الحديد أصفر الحديد أو غير ذلك من صفات حديد أضيفه[43] إلى السيف فإنما أعني الفرند. وإذا[44] قلت قبل الطرح أو بعد الطرح فإنما أعني الدواء الذي يلقى[45] على الحديد ليظهر له فرند. وإذا قلت السيف أحمر فإنما أعني المجلي الذي لم يطرح عليه الدواء [بعد] فإن الصياقلة تسمي هذا الدواء[46] الجلاء الأحمر. وإنما استعملت هذه الأسماء لك دون تفسيرها لتعرف معانيها في ألفاظهم لها لئلا[47] يغيب عنك من أمرها شيء إن شاء الله تعالى[48] [فلنبدأ الآن بصفة ما نريد بعون الله وتأييده].

[36] هكذا في ا. في ل "استقوت" ولكن يحتمل أنه تصحيف لأنه غير معقول.
[37] هكذا في ا و ل ولكن يكتب زكي "وفي كل منها موضع أثخن من نظيره".
[38] هكذا في ا و ل ولكن يكتب زكي "الصناعات".
[39] زيادة عن ا غير مذكورة في زكي.
[40] هكذا في ا و ل ولكن يكتب زكي "وأما وقد ورد كل نوع منها".
[41] فإن الحديد: ا "فالحديد".
[42] أعني: ا "وهي".
[43] أضيفه: ا "أضيف" (بدون تنقيط كامل).
[44] وإذا: ا "وإن".
[45] يكرر ل هنا اللفظة "أعني الدواء" ولكن يحتمل أنه غلطة الكاتب.
[46] الدواء: ا "الجلاء".
[47] ألفاظهم لها لئلا: ا "ألفاظهم لأن لا".
[48] هذه الكلمة غير موجودة في ا.

useful and most clear. Likewise I shall set out the meanings of this treatise in such a way as will be clearest and simplest for its understanding, even if that were taken out of its order in the sequence that I have given it. As for the qualities of the rest[25] of their types, I shall mention them in turn and the qualities of each one of the types of the ancient [as well].

As for the trenchant swords, with respect to their forms (*ashkāl*) rather than to their natures (*jawāhir*), [they] are the ones that are short, if they have good bodies and their surfaces and thicknesses are equal. [On them there is not a place inside and a place outside], **(14)** nor a place thicker than its equivalent. Their blades are coarse, except the edge (*ḥadd*) itself, for the edge should be the measure of a hair on each side. These are the most trenchant (*aqṭaᶜ*) of swords in adversity. As for what best cuts clothes and flesh, it is what combines in it all these properties, except for the coarseness, for the thinnest blade is what best cuts flesh and clothes, and it is not praiseworthy if the blades are not thin.[26] Moderation of the quenching is an aid to sharpness, for if the quenching is severe, the blade will be severed in adversity; whereas if it is light, the blade will be strong in adversity.

As regards the shapes (*qudūd*) of every type of sword, we shall mention that once we have mentioned every type by its qualities, for in that is an aid to knowledge of their types. Though it may well be that they resemble each other in shape and also share the component of iron, nevertheless knowledge of these things increases awareness of their types. If the shape conforms to the iron, it is the truest witness; if they differ, then the iron is a truer witness than the shape and more suitable for forming a judgement. Instead of the name of the watering (*al-firind*) the swordsmiths use the name of the iron (*al-ḥadīd*), for when it is of apparent watering then they say that it is of apparent iron.

As for the ground (*arḍ*) [that is, the ground of the sword], they call it ground according to its condition, that is, the place of the iron with no watering. Thus they say "red of ground", "green of ground" and "dark of ground". So when you find me saying in this book of mine "white **(15)** of iron", "yellow of iron", or other descriptions of iron, I am attributing it to the sword and I am only referring to the watering. And if I say "before throwing" or "after throwing", I am only referring to the medicament (*dawāʾ*) which is cast onto the so that a watering becomes apparent. And if I say the sword is red, I am only referring to the place to be polished on which the medicament has not [yet] been thrown, and so the swordsmiths call this medicament[27] the red polish (*al-jilāʾ al-aḥmar*). I have not used these names without first explaining them to you so that you know their meanings in their (the swordsmiths') expressions about them (the swords) so that nothing escapes you of their matter, God Almighty willing. [So let us now begin describing what we wish with God's aid and support].

[25] Thus Istanbul; Leiden has "male", which seems less plausible.

[26] This point is well illustrated by Schwarzlose, pp. 153–54 and 177–92, in ch. 4 below.

[27] This medicament: Istanbul "this polish".

[السيوف] اليمانية

جوهر[ها أعني فرندها] مستطيل معرج متساوي العقد. ليس بعض العقد أكبر من بعض أبيض الجوهر أحمر الأرض أخضر [الأرض] قبل الطرح. على قدر شبر من سيلانه آنك[49] صغار دقاق بيض في مثال الدود يتلو بعضه بعضا في [لون ك] بياض الفضة والآنك آثار في السيف بيض مثل [حلقة] الدود.

(16) [و]القد أربع قدود وهي جميع قدود السيف التي طبعت باليمن. منها العريض الأسفل المخروط الرأس المربع السيلان تربيعا مخروطا إلى طرف السيلان. وأكثر ما يكون من علامات سيلانات العتق التي طبعت في الجاهلية ثقبان [قد ثقبا] بالسنبك وثقب السنبك من أحد جهتيه[50] أوسع أو جهتاه متساويتان[51] ووسطه أضيق وفيه أربع شطب. منها المحفور وهو الذي شطبه شبيها بالأنهار مدورة الحفرة[52] وهو الذي يسمى الابدريكندج ومعناه الموقع فيه الشطب المعمول بالكونزنز ومعنى الكونزنز المبرد المدور الذي يحفر به وهو الذي على طبع الصمصام[53]. ومنها الذي شطبه إذا[54] ذا شكات وهي شطب بزوايا مربعة من داخل الشطب وتكون هذه الشطب متساوية في وجه السيف ويسمى شهادست[55]. ومنها ذو ثلاث[56] شطب واحدة في الوسط و[ا]ثنتان في الشفرتين وهي التي تسمى داست[57] وهذه تسمية الجاهلية.

(17) وأشكال هذه على ما قد صورنا[58] وعلى هذا الشكل صورة الصمصام[59] وأكثر ما يكون منها عرض ثلاث[60] أصابع تامة وأقل ما يكون منها [عرض] إصبعين ونصف وهي الخفاف. منها القبورية[61] [التي لا يوجد منها][62] أكثر من رطلين أو رطلين غير ربع. وهذه[63] الخفاف القبورية تكون سواذج لا شطب فيها مختلفة في الطول ما بين الثلاثة الأشبار وأربع أصابع إلى أربعة أشبار وإنما أقروها على هذا الطول مخافة أن تنقص أوزانها.

[49] تكتب هذه الكلمة في ا بسنينْ غير منقطين بين الألف والكاف.

[50] هكذا في ا. في ل "الجهتيه" (بدون تنقيط) ولكن يحتمل أنه تصحيف لأنه غير معقول.

[51] في ا و ل: "في الجاهلية ثقتين...أو جهتيه متساويتين".

[52] منها المحفور...مدورة الحفر: ا "ومنها المحفورة...ممدود الحفر".

[53] الصمصام: ا "الصمصامة".

[54] هذه الكلمة غير موجودة في ا.

[55] شهادست: ا "سهارداس".

[56] غي ا و ل: "ثلثة".

[57] داست: ا "سهداست".

[58] صورنا: ا "وصفنا".

[59] توجد الجملة "وعلى هذا الشكل صورة الصمصام" ورسم السيف الذي يليها في ل فقط.

[60] في ا و ل: "ثلثة".

[61] هكذا في ا و ل ولكن يكتب زكي "القلجورية" نسبة الى مدينة في الأندلس مشهورة بسيوفها.

[62] تكرر ل هنا اللفظة "تكون سواذج لا شطب فيها" التي ترد في السطر التالي.

[63] وهذه: ا "وهي".

The Yemeni Swords

Their nature, [that is, their watering], is elongated, curved, of equal knotting, there is no knot bigger than another, white of nature, red of ground, green [of ground] before throwing. At the measure of a span from its tang (*sīlān*) are small, fine white bits of lead (*ānuk*), similar to worms, that follow one another, with [a colour like] the white of silver; that is, the lead leaves traces in the sword white like [a chain of] worms.

(16) [Now] there are four shapes and these constitute all the shapes of the sword that are forged in Yemen. The first are those that are broad at the bottom, tapering at the top, its tang very square, tapering towards the end of the tang (*taraf al-sīlān*). Now the most common mark of the tangs of antiquity that were forged in pre-Islamic times is two incisions (*thaqabān*) [incised] at the extremity (*sunbuk*);[28] these incisions may be broader in one direction or the two directions may be equal and the middle narrower. This type of sword has four grooves (*shuṭab*). Secondly there is the carved-out sword (*al-maḥfūr*), the grooves of which are similar to rivers, circular[29] as to the carving. It is called the *abdrykndj*,[30] which refers to the place where the grooves are made with the *kūnaznaz*, which means the circular file which is used for carving out, and it is after the fashion of the *ṣamṣāma*.[31] Thirdly there is the sword with grooves possessing piercings (*shakkāt*), that is, grooves with square angles within them. Such grooves are evenly arranged on the face of the sword. *Shahādāst*[32] is the name of these swords. Finally there are the swords with three grooves, one in the middle and two in the two blades, and they are called *dāst*,[33] and this is the pre-Islamic appellation.

(17) The forms of these swords are in accordance with what we have already depicted, and of this form is the enclosed drawing of the *ṣamṣāma* sword.[34] The most they can be in breadth is a full three fingers and the least they can be [in breadth] is two and a half fingers, and these are light swords. Among them is the Qabūriyya,[35]

[28] Lane, *s.v.*, says that this is "the extremity of the *naᶜl* or iron shoe at the lower end of the scabbard" (known technically as a chape).

[29] Circular (*mudawwara*): Istanbul "extended" (*mamdūda*). Note that the word I translate as "groove" (sg. *shuṭba*, pl. *shuṭab*) can mean a "depressed line" (i.e. groove) or a "raised line" (i.e. a ridge) on the *matn* (broadside) of the blade of a sword" (Lane, *s.v.*).

[30] This is probably related to the Persian words *āb-dārī*, "brilliancy" (*āb-dār* means "of good watering" with regard to swords), and *kandagī*, "engraving, carving out" (cf. Arabic *khandaq*); or else the first part could be simply *andar*, "in, within".

[31] The name for the sword of the Arab warrior-poet ᶜAmr ibn Maᶜdikarib (d. *ca.* 21/641) celebrated for the temper and cutting power of its blade (*E.I.*, *s.v.* "Ṣamṣāma", and see Schwarzlose, pp. 172–74, in ch. 4 below). Note that the word *kūnaznaz* in this sentence is of uncertain reading; many of the technical terms are Persian in this text, but no obvious Persian word suggests itself here.

[32] *Shahādāst*: Istanbul *shahārdās*.

[33] *Dāst*: Istanbul *shahdāst*. The names are probably related to Persian *dās*, "a sickle, reaping-hook" (*dāst* is perhaps an archaic form), preceded by *shah/shahār*, i.e. pertaining to the shah, royal.

[34] This phrase is only in Leiden, which presents a sketch of the sword in question (see appendix 3 below).

[35] Zaki suggests reading Qaljūriyya after the name of a place in Andalucia famous for its swords, though Kindi clearly links these Qabūriyya swords with Yemen and they are also mentioned by Bīrūnī (see appendix 2 below).

فأما العراض فيكون طولها ثلاثة أشبار ونصف وتكون أوزانها ما بين الرطلين ونصف إلى ثلاثة أرطال غير ربع. والذي فيه منها ثلاثة[64] غير ربع **(18)** مضطربة القدود شديدة الالتواء وإنما تترك مضطربة مخافة أن تدخل النار فتنقص أوزانها وإنما أثمانها بأوزانها.

ولا تكاد [أن] تسلم اليمانية من العروق [المفتوحة والعرق] المفتوح هو الذي به سواد أي البوست وهو القشر. وقد توضع على العروق التماثيل لتخفى وتكتب عليها الأسماء لتخفى آثارها. وكل كتاب يصاب في سيف أسفل من السيلان [ب]أكثر من أربع أصابع مضمومة بالعرض فهو على كسر [إن] كان خطا دقيقا وإن كان خطا غليظا فهو على عرق. ومتى أصبت في سيف مثال رجل أو حيوان تاما مذهبا فهو على شيء في السيف يسمى الكياكن وهو فسخ وتفرز من الحديد[65] وهو ينكسر من ذلك الموضع.

وإذا رأيت [في] الحديد اليماني شبيها بالصيبان نقب حديد إلا في أبيضه وهو أبيضه أبيسه وهو يسمى سبوسك أي[66] النخالة فإنه يابس ينكسر **(19)** [و]حديده إذا جلوته أحمر من غير دواء[67]. فإنه كثير العقد جدا صبيح أصبح اليمانية[68] على الجلاء الأحمر. وهو مما يخاف عليه أن يضرب به في اليوم البارد فينكسر وهذا [الذي وصفنا] لا يصاب إلا في اليمانية العتق[69] القبورية. ومنها ما يوجد في صدره[70] الماسات والماس هو العرق اللين الذي لا يكون فيه فرند. ولم ير من يختار[71] من الصياقلة سيفا في عرقه فرند إلا الصمصامة من العتق.

فأما المولدة [البصرية] فموجود ذلك فيها [كلها] وإنما يكون العرق فيها لأن الدواء الذي يطرح على[72] الحديد ليصير يمتزج بالحديد كله على استواء فيبقى[73] فيها مواضع نرماهن لا فرند فيه. فإذا ضربت بعضها يجلس بعضها على بعض فصار الفرند في داخلها خفيا. ومنها ما قد دخل عليه الماء من البطنين فيكون شبيها بالعرق وليس بالعرق[74] أحمر كالسقي فقسها إلى[75] السقي في شفرة السيف[76].

[64] والذي فيه منها ثلاثة: ا "والذي فيها ثلاثة أرطال".
[65] يكتب زكي "وهو فسح ويعود من الحديد" ولكنه غير معقول.
[66] أي: ا "ومعناه".
[67] كل هذه الجملة غير واضحة في المخطوطتين. يغير زكي ترتيبها بدون أي شرح.
[68] هكذا في ا و ل ولكن يكتب زكي "صح أصح اليمانية".
[69] هنا وفي أمكنة أخرى في المخطوطين يحل الاسم "العتق" محل النعت "العتيق".
[70] هكذا في ا و ل ولكن يكتب زكي "صورة".
[71] من يختار: ا "أهل البحث".
[72] هكذا في ا. في ل "عليه" ولكن يحتمل أنه تصحيف لأنه غير معقول.
[73] هذه الكلمة موجودة في ا و ل ولكنها غير موجودة في زكي.
[74] الكلمات "وليس بالعرق" غير موجودة في ا.
[75] هكذا في ا و ل ولكن يكتب زكي "شبيها الى".
[76] السقي في شفرة السيف: ا "السقي الذي سقوه السيف".

[which are not found to be] more than two raṭls or even two raṭls less a quarter. These light Qabūriyya swords are plain, without incisions on them, varying in length between three spans and four fingers to four spans, and they have fixed them at this length for fear that their weights might be deficient. As for the broad ones, their length is three spans and a half, and their weight lies between two raṭls and a half and three raṭls less a quarter. Those that are three less a quarter **(18)** are misshapen and very crooked, but they are left misshapen for fear that if they are put in the fire their weights will be reduced, for their prices are determined only by their weights.

It rarely happens [that] Yemeni swords are free from veins [which are open, and the vein that is] open is the one with black in it, that is, *al-būst*, which is the crust.[36] On the veins are placed images so that they are hidden, and also names are written on them so that their traces are hidden. Any writing is situated on a sword at a point lower than the tang by more than four fingers pressed together crosswise. [If] the handwriting is fine it is put over a crack, if the hand is rough it is put over a vein. When a human or animal image, completely of gold, is to be affixed to the sword, it will be located on a thing in the sword called the *kayākin*,[37] (which is where there occurs) splitting and separation[38] of the iron, and it may break at that place.

If you see [on] the iron of the Yemeni the like of ridges, then it pierces well, and in its white part it is sharp, unless its white part is very dry; and it is called *sabūsak*, [which means] the refuse (*al-nukhāla*),[39] for it is dry, liable to break **(19)**.[40] And its iron, if you polish it, is red without medicament, and it has very many knots, handsome as the handsomest[41] Yemeni of red polish. Its use on a cold day is feared lest it breaks, and this [that we have described] is only encountered with the ancient Yemeni Qabūriyya. Some of them are to be found with *mās* on their forepart, and the *mās* are pliable veins which have no watering in them. The discerning swordsmith will not have seen a sword with watering in its vein except for the ancient ṣamṣāma.

As for the indigenous [Basran] swords, that is also present in them [fully. And the vein is only in them] because the medicament that is thrown on the iron so that it becomes steel does not mix evenly with all the iron, and so there remain in them places of soft iron without watering. And when they are struck, a part sits on a part and the watering inside them becomes hidden. Among them there are some that have water enter them from the inner halves (*al-baṭnayn*), and it resembles the vein but is

[36] Reading *qishr* (any sort of covering: peel, rind, bark, husk, scales, slough), though there are no dots on the first letter in the manuscripts. However, the reading is confirmed by the Persian word given: *post*, which also means "skin, hide, rind, crust, bark" (Steingass, *s.v.*).

[37] This must be the Persian word *kayāgin* meaning "rugged, uneven" (Steingass, *s.v.*).

[38] Though the sense is relatively clear here (cf. the previous note), the exact reading of these two words is uncertain. Zaki gives "it is ampleness and returns from the iron", which is meaningless.

[39] *Sabūsak* (see Steingass, *s.v.* sabos; -ak represents an archaic ending) and *nukhāla* both mean what is to be thrown away after a process like sieving or winnowing: chaff, bran, scurve, etc.

[40] As noted by Zaki, this sentence is extremely unclear in both manuscripts and the reading given here is speculative. Oddly, Zaki changes the order of the sentence, without giving any explanation and without any apparent gain in clarity; I have returned the sentence to the order found in the manuscripts.

[41] Or one might read with Zaki "sound as the soundest Yemeni".

وكل العروق البيض اللينة فهي الماسات والعروق لا تضر السيف شيئاً[77] إلا ما كان على الحد[78] فإنه لا يشرب الماء ولا يقطع سيفه أبداً. والعروق الخفية في نوكات[79] في الحديد فأما الماس فهو ما صغر منها. وإنما يكون الماس قدر إصبعين أو نحو ذلك فأما الكبير فهو عرق لا محالة. وكل عرق أو ماس يكون (20) فوق المضرب إلى القائم بقدر إصبعين فإنه لا يضر السيف [شيئاً][80] والمضرب على قدر شبر من الذباب وقد أمن صاحب السيف الذي فيه العروق الماسات الكسر في اليوم البارد لأنه إنما يخاف على العتيق في اليوم البارد ـ ومن اليمانية الموصول السنان[81] ومنها الموصول الصدر.

وذلك إنما يكون من الضرب بالسيف[82] فيقطع لا لرداءة حديد وليس[83] لسقي دخل عليه من البطنين فإن كل موضع يشرب الماء يبيس وإنما يصير على الشفرتين ليس القطع. وإذا صار إليك سيف فرأيت حديده في موضع السقي شديد الحمرة شبيها بشعل النار وأمررت يدك على الشفرتين فوجدته شديد اللين لا يعض الكف فلا تقدمن به على قتال ولا حرب فإنه لا يقطع كثيراً ولا قليلاً. وإن [ضربت به و] أصاب موضع حديد انبترت شفرته وإن فل ذلك وافته شدة السقي[84]. فعلاجه حتى يصلح أن يؤتى[85] رماد الحمام بعد أن تأتي على الرماد ساعات من النهار وتلين ناره فيدس السيف في الرماد ويتعاهد بالنظر. فإذا صار طاووسي اللون وضع على شفرتيه من الزيت [شيء] وترك حتى يبرد في موضع لا يصيبه الماء ولا الريح (21) فإنه إن أصابته الريح اعوج ولم يؤمن عليه الكسر. فإنه بعد هذا العلاج يقطع ويؤمن عليه الكسر بإذن الله تعالى[86].

وقد يكون مما طبع باليمن ما له شطب دقاق [و] كثيرة وما له شطبة واحدة والخريشة[87] وسواذج غير خريشة. طولها أربعة أشبار وأكثر وأقلها وعرضها أربع أصابع وأقل وأكثر[88] وليس حديدها يماني[89] بل سلماني وسرنديبي وهندي. وبعضها مستوية القدود وأعاليها وأسافلها في عرض واحد. وهذه تعد في العتق وأوزان هذه ما بين رطلين إلى الخمسة الأرطال إلا أن الصياقلة يكنون عن اسم العتيق فيسمونها لا مولد سلماني سرنديبي.

[77] هذه الكلمة غير موجودة في ا.
[78] هكذا في ا وهو أعقل من قراءة ل: "الحديد".
[79] في نوكات: ا "هي توكاز".
[80] في ا: "شيء".
[81] السنان: ا "السيلان".
[82] الضرب بالسيف: ا "الطرق بالسيف" (ولكنه غير واضح).
[83] وليس: ا "ولكن".
[84] وإن فل ذلك وافته شدة السقي: ا "وإن فل الحديد وإنما افته في ذلك شدة السقي".
[85] هكذا في ا وهو أعقل من قراءة ل: "أن يوفي به" وفي زكي "يوتر".
[86] الكلمات "بإذن الله تعالى" غير موجودة في ا.
[87] الخريشة: ا "خريشة الطبع". أو يمكن أن الصواب "خريشته".
[88] الكلمات "وعرضها أربع أصابع وأقل وأكثر" غير موجودة في ا.
[89] في ا و ل: "يماني".

not the vein, red as the quenching, so compare it[42] to the quenching in the blade of the sword. And all the white pliable veins are *mās*, and the veins do not harm the sword at all except for what is on the edge,[43] for it does not drink water and the sword with it does/is not cut, and the hidden veins are on the ends[44] of the blade. The *mās* is the small one of the veins and it has only a measure of two fingers or about that. As for the big one, that is definitely a vein. And every *mās* or vein is above **(20)** the striking-spot (*miḍrab*)[45] towards the handle (*qāʾim*) by a measure of two fingers, and it does not damage the sword [at all], and the striking-spot is at one span from the sharp edge of the tip (*dhubāb*). The owner of a sword with *mās* veins in it is guaranteed against it breaking on a cold day, for it is only to be feared of the ancient ones on a cold day – and among the Yemeni swords there are some with joined iron head (*sinān*)[46] and some with joined forepart (*ṣadr*).

That (breaking on a cold day) is only from striking with the sword with the result that it is severed, not because of the badness of the iron and not because of[47] the quenching that has entered through to the inner halves, for every place that takes in water is dry, and it only befalls the blades because of the dryness of the cut. If you get a sword and you see its iron on the place of the quenching is very red, resembling flames of a fire, and you let your hand pass over the blades and you find it extremely pliable and not biting into the palm of the hand, then do not proceed with it to battle or to war, for it cuts neither much nor little. And if [you strike with the sword and] it hits a place of iron, the blade will be severed. And if it is blunt, in that case severity of quenching has brought it about. The treatment to rectify it is to have the ashes of charcoal brought after hours of the day have gone over these ashes and have tempered its fire, and then insert the sword in the ashes and pay close attention to it. When it goes a peacocky colour [some] oil should be put on the two blades, and then left until it is cooled off in a place where neither water nor wind can reach it, **(21)** because if it is affected by wind it will become crooked and it will not be guaranteed against breaking. After this treatment it will cut and be guaranteed against breaking [God willing].

Among those forged in Yemen there may be some with many thin grooves and some with a single groove, and both filed[48] and unfiled plain ones. Their length is four spans, or a bit more or less, and their breadth is about four fingers, or a bit more or less. Their iron is not Yemeni, but Salmāni, Sri Lankan and Indian. And some of them

[42] Zaki has "similar to" (*shabīhan ilā*), but the manuscripts clearly have "so compare it to" (*fa-qis-hā ilā*). Note that Istanbul continues "the quenching with which they quenched (*saqūhu*) the sword".

[43] Thus Istanbul; Leiden has "the iron", which seems less plausible.

[44] The word is clearly written in Leiden as *nawkāt* (Istanbul is less clear); this is not an Arabic word, but may be from the Persian *nawk*, "point, end, tip".

[45] "The part of the sword with which one strikes…about a span from the extremity" (Lane, *s.v.*).

[46] Iron head: Istanbul "tang" (*sīlān*).

[47] Striking with the sword…and not because of: Istanbul "hammering with the sword…but rather because of…"

[48] Reading *kharīsha*; *kharasha* means "to scratch" or "to take off the top surface", so possibly here "to file". However, the word seems to have a final *hāʾ*; this would be an unlikely form in Arabic, but could be Persian: Steingass and the *Loghat-nama* (CD-Rom version) give *kharishtah* as a kind of armour or weapon. Note that Istanbul has here "filed as to its forging/character".

وليس العتيق إلا القلعي واليماني والهندي هو الفاقرون وأكثر ما يكون من الفاقرون وزنا خمسة أرطال وهي السيوف الأول أعني الفاقرون خاصة. وجوهر الفاقرون يشبه جوهر اليماني أو القلعي فبذلك الجنس يسمى. وهي التي تسمى المعتوقة إذا غيرت إلى القلعي أو إلى اليماني. فمن خالفه أو ادعى أنه يقدر على يمان فيه ثلاثة أرطال أتيناه بسيف من هذه القبورية الصغار فقسناها إلى ما جاء به فإن شاكله فهو صادق وهذا غير موجود. **(22)** وأكثر ما يكون[90] من السلمانية الصغار [و]القلعية الدقاق تطبع ويغير قدها إلى اليمانية وتباع على أنها يمانية.

ومن هذه السلمانية ما يكبس ويعمل بالمنقاش. فيبقى رسم ذلك النقش فريدا وهو الذي يصادف عقده بقسمة معمولة ويباع على أنه يماني. وربما طبعوا القلعية في قد اليمانية فباعوها ب[حساب] اليمانية لأن القلعي إذا كان فيه ثلاثة أرطال غير ربع ساوى عشرة دنانير إلى خمسة عشر [دينارا] على قدر القد والصباحية[91] وإن كان فيه أي فيه عروق يساوي خمسة دنانير فإذا كان يمانيا في هذا الوزن والصباحية ساوى ما بين الخمسين دينارا[92] إلى المائة **(23)**.

القلعية

وليس في السيوف القلعية [ما عرضه] أربع أصابع ولا ثلاث تامة إلا معمولة ويكون [طولها] ما بين الأربعة الأشبار إلى الخمسة أشبار إلا ما قصر فعولج. وقدودها قدود مستوية. أعاليها وأسافلها واحدة [وهي] أدق [سيلانات] من سيلانات اليمانية[93] ومكاسرها ومكاسر اليماني كالفضة البيضاء. فأما المعمولة منها عملا ثانيا من غير سبك فيوجد على كل طبع إلا أنه لا يكون منها مشطب. وهي أصغر من اليماني فرندا [وأكثر تعقيد جوهر من اليماني] وأشد اختلاف عقد [و]ليست بمتساوية في العظم وأشد حمرة جوهر وأرض. ولا يوجد منها سيف يابس وتوجد نقية الحدود[94] من العروق **(24)**.

[90] يكون: ا "يباع".
[91] الصباحية: ا "الصباحة".
[92] في ا و ل: "دينار".
[93] هكذا في ا و ل ولكن يكتب زكي "واحدة [وهي] من [سيلانات] سيلات اليمانية".
[94] الحدود: ا "الحديد".

have an even shape, their highest and their lowest part of one breadth. These were prepared in antiquity and their weight lies between two and five raṭls, however the swordsmiths refrained from the name of ancient and called them foreign Salmāni and Sri Lankan.

The ancient swords only comprise the Qalaᶜi, the Yemeni and the Indian, the latter being the *fāqirūn*. The most the *fāqirūn* can be in weight is five raṭls, and they, that is, the *fāqirūn* in particular, are the first swords. The nature of the *fāqirūn* resembles the nature of the Yemeni and the Qalaᶜi, and thus is the genus named. They are the ones called made ancient if they are changed to the Qalaᶜi or to the Yemeni. And whoever contradicts this or who claims to have a Yemeni of three raṭls, we will bring him a sword of these small Qabūriyya and measure it against what he brought us, and if it resembles it then he is right, but that would never happen. **(22)** And most of the small Salmāni and the delicate Qalaᶜi swords are forged and then their shape is changed to a Yemeni, and they are sold on the basis that they are Yemeni swords.

Among those Salmānis are some that are pressed (*yukbas*) and worked with an engraving tool (*minqāsh*), and the imprint of that engraving remains unique. And this is the one whose knotting is found in evenly-worked portions and it is sold on the basis that it is a Yemeni. Sometimes they forged the Qalaᶜi in the shape of the Yemeni and sold it [for the consideration of] a Yemeni, because the Qalaᶜi if it is three raṭls less a quarter equals ten dinars to fifteen [dinars] depending on the shape and the broadness of the tip (*ṣubāḥiyya*).[49] If there are any veins in it, it equals five dinars, whereas if it is a Yemeni with this weight and broadness of tip it will equal anything between fifty and a hundred dinars **(23)**.

The Qalaᶜi swords

Qalaᶜi swords only have [a breadth of] four or three fingers in total if they are worked, and their length is between four and five spans, except for those which have been reduced and have been treated. They have an even shape, their highest and their lowest parts are one; [they] are delicate in their [tangs], more than in the tangs of the Yemeni, and their fracture surfaces (*makāsīr*), as those of the Yemeni, are like white silver. As for those worked a second time without melting (*sabk*), they are found according to every fashion, though none of them have grooves. They have a smaller watering than the Yemeni [and a more knotted nature than the Yemeni], as well as the greatest diversity of knots. [And] they are not even in size, they have the reddest nature and ground; there is not a dry sword among them, and their edges[50] are free of veins **(24)**.

[49] Broadness of the tip: Istanbul "beauty" (*ṣabāḥa*).
[50] Edges: Istanbul "iron".

الهندية

والهندية جوهرها شبيه بجوهر اليماني إلا أن جوهرها يضرب إلى السواد [ومكاسرها تضرب إلى السواد] ويقع من المولدة ما جاء من⁹⁵ خراسان أجناس⁹⁶ تدخل في القلعي واليماني جميعا. [الهندية في قدود القلعية] فإذا رأيت منها سيفا في قد القلعي أشد تعقدا من القلعي وأكثر تعجرا ـ أعني بالتعجر تداخل الفرند بعضه في بعض ـ فوجدته يضرب إلى السواد ووجدت الحديد مختلفا في الفرند من أوله إلى آخره موضع فرند صغار و⁹⁷ موضع فرند كبار ووجدت الفرند الذي على الموضع الذي⁹⁸ يتركه الصياقلة ولا يسقونه وهو قدر شبر وأكثر مما يلي السيلان⁹⁹ فرند صغار مبين يشبه بالسلم فاعلم أنه مولد. فاجل منه قطعة حمراء فإنك [ترى] تخرج الزيت من تحت المصقلة أسود وترى للمصقلة أثرا [فيه] كأثر المصقلة في الرصاص وترى القطعة نفسها الحمراء [التي جلوتها] لا جوهر فيها وتبين آثار المصقلة فيها [وإن] خفي. وتنظر إلى الآنك الذي وصفت لك في صدر هذا¹⁰⁰ الكتاب وهو الذي [قلت إنه] شبيه بالدود الذي¹⁰¹ يتلو بعضه بعضا فإنك تصيبها¹⁰² في العتيق بيضاء نقية وتكون هذه كمدة تضرب **(25)** إلى السواد. [وتجد] حد كل سيف منها¹⁰³ [إذا] تمر يدك عليه خشنا¹⁰⁴ لا كالعتيق ف[حينئذ] قسه إلى العتيق وهذه [الأشياء] التي وصفنا إمارات المولدة.

وأما اليمانية العتق والقلعية العتق فيخرج حماها وتوبالها أحمر يشبه النحاس والهندية يخرج حماها وتوبالها [أحمر فيه سواد والمولدة يخرج حماها وتوبالها] ومكاسرها مثل الرماد أسود والزيت¹⁰⁵ يخرج من تحت مداوس المولدة أسود. فأما من تحت مداوس اليماني والقلعي [العتيق] فوسخ قليل وكذلك الهندية [أيضا] شبيهة بنقاء اليمانية والقلعية¹⁰⁶.

⁹⁵ هكذا في ا و ل ولكن يكتب زكي "في".

⁹⁶ هكذا في ا و ل ولكن يكتب زكي "وأجناس".

⁹⁷ الكلمات "موضع فرند صغار و" غير موجودة في ا.

⁹⁸ الكلمات "على الموضع الذي" غير موجودة في ا.

⁹⁹ هذا اقتراحي ولكن في ا و ل "ميت" (بدون تنقيط) وفي زكي "ما".

¹⁰⁰ هذه الكلمة غير موجودة في ا.

¹⁰¹ هذه الكلمة غير موجودة في ا.

¹⁰² تصيبها: ا "تصيب هذا الأنك".

¹⁰³ هكذا في ا و ل ولكن يكتب زكي "فيها".

¹⁰⁴ في ا و ل: "خشن".

¹⁰⁵ يقول زكي أن الصواب "الرمث" بدون أي شرح.

¹⁰⁶ شبيهة بنقاء اليمانية والقلعية: ا "شبيهة في النقاء باليمنية والقلعية".

The Indian swords

The nature of the Indian swords resembles that of the Yemeni except that their nature inclines to black [as also do their fracture surfaces]. And there are some kinds of the indigenous that come from Khurasan which encroach upon the Qalaᶜi and the Yemeni totally. [The Indian swords can be in the shapes of the Qalaᶜi]. So if you see among them a sword in the shape of a Qalaᶜi, with a more intense knotting than the Qalaᶜi and more wrinkling (*taᶜajjur*) – by wrinkling I mean interpenetration of the watering – and you find it inclining to black and you find the iron different in the watering from bottom to top, whether the place of the watering is small or it is big, and if you find the watering which is on the place that the swordsmiths leave and do not quench and which is a span or more from what adjoins the tang, to be small, clear,[51] resembling a ladder, then know that this is an indigenous sword. Polish a red piece of it and [you will see that] the oil comes out black from under the polishing tool (*miṣqala*), and you will see pertaining to the polishing tool a trace [on it] like the trace left on the polishing tool by tin. And you will see that the same red piece [which you have polished] has no nature on it and that traces of the polishing tool appear on it, [even if] hidden. You should look at the lead (*ānuk*), which I described for you at the beginning of this treatise. It is that which [I said that it] resembles worms which are following one another, and you will come across it (this lead) in the ancient as pure white, but in this one it is like a substance inclining **(25)** to black. [And you will find] the edge (*ḥadd*) of every sword among them, [if] you let your hand pass over it, is rough, not like the ancient. [Then] compare it to the ancient and you will see that these [things] that we have described are the characteristics of the indigenous sword.

As for the ancient Yemeni and the ancient Qalaᶜi swords their slag and hammer-scale come out red resembling copper. The slag and hammer-scale of the Indian swords come out [red with black in, and the indigenous sword's slag, hammer-scale], and fracture surfaces come out black like ashes, and the oil[52] comes out black from under the grinding tools (*midāwis*) of the indigenous. As for what emerges from under the grinding tools of the [ancient] Yemeni and the Qalaᶜi, it is a little bit dirty, and the Indian likewise [also] resembles the purity of the Yemeni and the Qalaᶜi.

[51] It is not clear how this word should be read; Zaki converts it into the indefinite relative particle *mā*, which is definitely wrong, but my "clear" (*mubīn*) is only a very tentative suggestion.

[52] Thus Leiden and Istanbul, but Zaki says *rimth* is the correct reading, though he gives no explanation. A *rimth* is a type of shrub which has "long and slender sprigs garnished with minute leaves overlying one another like the scales of a fish" (Lane, *s.v.*).

السلمانية

فأما [السيوف] السلمانية فإن منها جنسا يسمى السلمانية الصغار وهي سيوف لطاف العروض طوال قصار الفرند فيها بعض الجعودة (26) وشبيهة بجعودة القلعية ظواهر الجوهر من غير طرح. وهي ما حمل حديدها مسبوكا من أرض سلمان إلى وراء النهر من خراسان فطبعت هناك وقدودها قدود دقاق القلعية. فإذا وقع منها سيف جيد الوزن أخذته الصياقلة الحكماء منهم فأدخلوه النار ثم كبسوه حتى يدخل بعضه في بعض ثم يطبع بعد أن يقصر طوله بقدر شبر ليزيد في عرضه[107]. فإن أحبوا أن يشبهوه باليمانية قصروه وخرطوا رأسه على شكل ما وصفنا من اليمانية. ثم سقوا نصفه ليعصم[108] جوهرها لم يشرب الماء منه ويضرب إلى البياض بعد الطرح ويحمل[109] النصف الأعلى مما يلي الذباب من أجل السقي. فإن[110] اليمانية العتق على هذا المثال تكون في سقيها إلا ما لان حديده منها واسترخى من اليمانية وغيرها من الشبه بها فإنهم يسقونه [كله] إلا شبرا [منه] أو أقل منه[111] مما يلي السيلان. وإن أرادوا أن يطبعوها في قد القلعية عملوها سيوفا طوالا [طولها] أربعة أشبار غير أصبعين متساوية الطرفين ملسنة الرؤوس وهذا الصنف[112] من هذه السيوف السلمانية التي ننسبها (27) إلى هذا الاسم من الصغار يجوز في هذين البابين إذا خولف طبعها وجوهرها إذا جلي احمر و[لذلك] نجد فرنده[113] أحمر ظاهرا بينا. يكون الفرند[114] منه واحدة ونصفا من[115] فرند القلعي وأكثر من فرند[116] اليماني قليلا[117]. ويرى فرنده بعد الطلي[118] كالأنبوبة المكسورة غير متصلة بعضها في بعض في مواضع عدة من الكبس [لأن] ليس في كله مختلف الوجهين لحال كبس المطارق.

ومنها السلمانية العراض وهي التي تدعى البهانج[119] والبهانج[120] العريض وعرضها ما بين ثلاث أصابع إلى أربع أصابع وطولها أربعة أشبار. وتكون أوزانها ما بين الثلاثة الأرطال إلى الثلاثة ونصف.

ومنها الجنس الذي يسمى الرثوث وهي قلما توجد إلا وعلى سيلانها[121] طابع مربع فيه اسم الصانع الذي صنعه على قدر إصبعين مضمومتين من[122] طرف السيلان.

[107] عرضه: ا "طوله".
[108] هذا اقتراحي. في ا و ل "يعطم" ولكن هذا غير معقول. يكتب زكي "لينظم".
[109] يحمل: ا "يحمى".
[110] فإن: ا "لأن".
[111] أقل منه: ا "أقل من شبر".
[112] هكذا في ا. في ل "النصف" ولكن يحتمل أنه تصحيف لأنه غير معقول.
[113] هكذا في ا. في ل "حدث فرده" ولكن يحتمل أنه تصحيف لأنه غير معقول.
[114] يكون الفرند: ا "يكون الفرنده". ويحذف زكي "يكون" ويكتب "الفرنية".
[115] هكذا في ا و ل ولكن يكتب زكي "في".
[116] في ا و ل "فرنده" ولكن يحتمل أنه تصحيف لأنه غير معقول.
[117] هذه الكلمة غير موجودة في ا.
[118] الطلي: ا "الطرح".
[119] يكتب هنا في ا و ل "البهنك" ولكنه يعني بلا شك "البهانج" المذكور في بداية الرسالة.
[120] والبهانج: ا "وهو".
[121] وهي قلما توجد إلا وعلى سيلانها: ا "وهي أقل ما يوجد إلا وعلى سيلاناتها".
[122] هكذا في ا و ل ولكن يكتب زكي "في".

The Salmāni[53] *swords*

As for the Salmāni [swords], among them there is a kind called the small Salmāni. They are long swords of fine breadth, long, small watering, with some curliness, **(26)** resembling the curliness of the Qala°i, their nature apparent without throwing. Their iron is brought cast from the land of Salmān[54] to Transoxanian Khurasan and then they are forged there. Their shapes are the delicate shapes of the Qala°i. If there occurs among them a sword of excellent weight, the clever ones of the swordsmiths take it, then put it into the fire and they press it until it is completely blended.[55] Then it is forged after its length has been shortened by a span so that it increases its breadth. If they want to make it resemble the Yemeni, they make it shorter and even out its top (*kharaṭū*)[56] after the fashion of what we have described for the Yemeni. Then they quench half of it so that its nature is safeguarded (*yuʿṣam*)[57] and does not drink water, and it inclines to white after the throwing and the upper half next to the sharp edge of the tip (*dhubāb*) is affected (*yuhmal*)[58] because of the quenching, for the ancient Yemeni is quenched in this way, except for those with pliable iron, those of the Yemeni that have become slack, and other ones like these. They quench it [all] except for one span [of it] or less than one span of what is next to the tang. If they want to forge it in the shape of the Qala°i, they work them into long swords [with a length of] four spans less two fingers, with even tips and with pointed heads. And this type of Salmāni swords, to which we have attributed **(27)** this name of the "small ones", belongs in these two categories if their forging is light and if their nature, when polished, becomes red. [For that reason] we find its watering red, apparent and clear. The watering of it is one and half times that of the Qala°i and a little bigger that the watering of the Yemeni. After the coating (*ṭaly*)[59] its watering looks like a broken shaft (*unbūba*),[60] discontinuous in numerous places of the pressing, [because] it is not throughout different on the two sides on account of the pressure of the hammers.

And among them are the broad Salmāni swords, which are called the *bahāng* and are broad. Their breadth is between three and four fingers and their length is four spans. Their weight is between three and three and a half raṭls.

Among them is the kind called the *rathūth*. These ones are seldom to be found without a square stamp (*ṭābiʿ*) on their tang with the name of the manufacturer on it at a measure of two fingers compressed together from the end of the tang. The best of

[53] Leiden has very clearly Bīlmānīya/Baylamānīya (with dots but not vowels), though when this type of sword was introduced above (Kindi/Zaki, p. 9) it had Sulaymānīya; Istanbul's reading is unclear.

[54] See n. 12 above; Transoxanian Khurasan refers to the central Asian region northeast of the river Oxus, in present day Uzbekistan.

[55] Literally "until a part of it enters a part".

[56] *Kharaṭa* literally means to remove leaves from a branch or the bark from a stick to make it even.

[57] This is my suggestion, which makes better sense; however, the manuscripts have "enlarged" (*yuʿazzam*) and Zaki has "arranged" (*yunazzam*).

[58] Is affected: Istanbul "is heated" (*yuhammā*) or "is protected" (*yuhmā*).

[59] Coating: Istanbul "throwing" (*ṭarh*).

[60] An *unbūba* is "the portion of a reed, cane or the like that intervenes between two joints or knots" (Lane, *s.v.*).

وأجودها ما كان كتاب طابعه قد انحكم[123] في طابع [مربع]. وذكر من أدركت من الصياقلة أنهم لم يروا شقا[124] عليه قد عمروا بالمنصورة إلا [سيفا] واحدا وهو مفقر الظهر. وبعض (28) هذه الرثوث تكون مفقرة وأكثرها خريشة وطولها أربعة أشبار وعرضها ما بين أربع أصابع مضمومة إلى أقل من أربعة قليل[ا] جياد المتون حسان الرؤوس عراض السيلانات [كسيلانات] القلعية الكبار.

وحديدها كلها ظواهر من غير طرح. وإن سقي منها[125] سيف ماء متن وصلب ثم جلى جلى أحمر ومحي الخاتم الذي على السيلان بالمطرقة اشتراه جميع صياقلة خراسان والموصل واليمن والجبال على أنه قلعي ما خلا العراقيين. وتكون أوزان هذه ما بين أربعة أرطال وأربعة[126] ونصف وأقلها ثلاثة أرطال ونصف والذي يطبع بسلمان هي عريضة الفرند [ليست] بظاهرة الحديد[127] أي ليست لها حمرة وهي ارداها.

السرنديبية

[وأما السيوف السرنديبية ف] ما تطبع بسرنديب وخراسان وقد قدمنا في صدر هذا[128] الكتاب ما يطبع باليمن. فأما ما يطبع (29) منها بسرنديب فهو [الذي يدعى] الني والني [هو] الذي لم يحمل[129] عليه بالنار. وذلك أنهم لا يحمون الحديد[130] بفحم القصب بل بفحم الخشب اللين وبفحم الخلاف وما أشبهه فيخرج فرنده دقاقا صفرا خفية. فإذا وقع في أيدي البغداديين فأحبوا أن يظهروا جوهره مرجوه ومعنى مرجوه وضعوه في رماد الحمام الحار حتى لا يبقى فيه من السقي إلا الخفي[131]. ثم يجلى ويلقى عليه [الدواء] فإن خرج فرنده جيدا وإلا سموه الأطلس والأطلس الذي لا[132] ينبل[133] جوهره ولا يعرض لونه مظلما يضرب إلى الصفرة. وما طبع منه بخراسان فانهم يطبعونه بفحم البلوط أو بفحم الغضا. وهما جميعا يأخذان من[134] الحديد أخذا شديدا فيكون[135] أظهر جوهرا شبيها بالبيض. وأقطع هذه الأجناس التي نسبنا[ها] إلى السرنديبي الني.

123 هذا اقتراحي. في ا و ل (وزكي) "الحكم" ولكنه غير معقول.
124 شقا: ا "سيفا".
125 هكذا في ا و ل ولكن يكتب زكي "منا".
126 هذه الكلمة غير موجودة في ا.
127 هكذا في ا و هو أعقل من قراءة ل: "الحد".
128 هذه الكلمة غير موجودة في ا.
129 هكذا في ا و هو أعقل من قراءة ل: "لا يحمى".
130 هذه الكلمة موجودة في ا و ل ولكنها غير موجودة في زكي.
131 هكذا في ا و ل ولكن يكتب زكي "الحصن".
132 هذه الكلمة غير موجودة في ا.
133 هذه الكلمة مكتوبة بدون تنقيط ويكتبها زكي "يبتل".
134 هكذا في ا و ل ولكن يكتب زكي "منها".
135 هكذا في ا و ل ولكن يكتب زكي "فيكون له".

them are those where the writing of its stamp is fixed[61] into a [square] stamp. Those swordsmiths whom I have come across report that they have never seen a crack[62] on them as long as they have lived in Manṣūra except for one [sword], which had a serrated back (*mufaqqar al-ẓahr*).[63] Some **(28)** of these *rathūth* are serrated and most of them are filed. Their length is four spans and their breadth is between four fingers compressed together and slightly less than four. They have excellent broadsides (*mutūn*), beautiful heads and broad tangs like [the tangs of] the big Qalaᶜi.

And the iron of all of them is apparent without throwing, and if a sword of them is quenched with water, it becomes solid and firm, then it is polished red and the seal (*khātam*) which is on the tang effaced with the hammer. Subsequently, all the swordsmiths of Khurasan, Mosul (a city in north Iraq), Yemen, and Jibal (a province of western Iran) would buy it assuming it were a Qalaᶜi, except for the Iraqis. The weight of these is between four and four and a half raṭls, but the least of them are three and a half raṭls. The one that is forged in Salmān has a broad watering and [un]apparent iron, that is, they have no red, and they are the worst of them.

The Sri Lankan swords

[As for the Sri Lankan swords they are what] are forged in Sri Lanka and Khurasan, and we have already introduced at the beginning of this treatise those that are forged in Yemen. As for those of them that are manufactured **(29)** in Sri Lanka, they are [the ones called] raw (*nīy*), and the raw is the one not affected (*lam yuḥmal ᶜalayhi*) by the fire. That is because they do not heat the iron with cane charcoal, but with charcoal of flexible wood and with charcoal of willow and the like. Then its watering comes out fine, yellow, hidden. If it fell into the hands of the Baghdadis, they would want to make its watering apparent by the *marjūh* process. And the meaning of *marjūh* is that they place it in the ashes of hot charcoals until nothing of the quenching remains except the hidden part.[64] Then it is polished and [the medicament] thrown onto it. If its watering comes out well, then good; if not, they call it the "worn away" (*al-aṭlās*); and the "worn away" is the one whose nature is not noble,[65] nor broad, and its colour is dark inclining to yellow. Those forged in Khurasan are forged with charcoal of oak or of euphorbia. They both take the iron intensely and so it has the purest nature, resembling the white swords. The most trenchant of these kinds are [the ones] that we have linked to the raw Sri Lankan.

[61] Reading *inḥakama*, whereas Leiden and Istanbul seem to have *alḥukm*. However, this is a very rare form of the verb *ḥakama* and one should perhaps emend to *ulḥima* ("was welded") or *uḥkima* ("was made firm").

[62] Crack: Istanbul "sword", and one would then translate: "they have never seen a sword like it".

[63] See n. 10 above; this could have been a design welded on to the sword and running lengthwise down its back, parallel to the blade.

[64] Thus Leiden and Istanbul, but Zaki writes "the hardest part" (*al-ḥiṣn*).

[65] This word appears without dots in the manuscripts, and Zaki chooses to read "is [not] wetted".

ومنها ما يطبع بالمنصورة وهي سيوف قصار دقاق رقاق وعراض. **(30)** وأكثر عرضها ثلاث أصابع يشبه بعضها بحديد اليماني إلا أنه لا يخلو فرنده من الرقة والهزال. والمنصوري [أضوأها وأجلها وكلها تضرب إلى الصفرة ما خلا هذا المنصوري] فإنه أضوأها وأنبلها[136] فرندا وأقلها صفرة. وأرض السرنديبي قبل الطرح حمراء تضرب إلى الغبرة وبعد الطرح أرضه حمراء وفرنده دقاق صفر قليلا وقدود هذه المنصورية قدود اليمانية العتق السواذج التي لا شطب فيها.

ومنها ما كان طبع بفارس فيما مضى قد عمل منها[137] منقوشة بتماثيل وطرر تسمى شاه فنخشير معناه "الملك في الصيد" مذهب بالذهب. وكذلك صنف من السلمانية طبعت بفارس تسمى الخسروانية. فأما السرنديبية السواذج من الفارسية فهي أعرض فرندا من هذه السرنديبية كلها وذلك أن أهل فارس كانوا يمطلون البيض لأنفسهم. فأهل سائر هذه البلدان تحمل إليهم الأركازمات[138] [من الحديد] وهي قطع[139] مربعة ربعت في الأصل ذراعا ذراعا [وهي تسمى أيضا الشبابيط]. **(31)**

البيض

فأما البيض فصنفان من السيوف: صنف طبع بفارس وصنف طبع بالكوفة في الزمان الأول. وهي سيوف قصار أعرض ما يكون منها [عرضا] ثلاث أصابع إلا أن يكون قد وقع في أحدها فل فاخرج الفل فرق. وطولها ثلاثة أشبار وأربع أصابع [مفتوحة أعني] مفرجة [كذلك] كلها. وسيلاناتها دقاق أعاليها أدق قليلا رقاق وتقب سيلانها ثقبان ثقبان بالسنبك. ورؤوسها أثقل من أسافلها [أعني بأسافلها] ما يلي القائم. ورؤوسها ملسنة إلى التدوير ملسنة دقاق الأطراف شبيهة[140] بالأمكنة التي في القلعية غير معقدة مستوي [فرندها] كله. [كوفي عتيق مما طبعه زيد الصانع]. ومنها ما فرنده مشجر كله فإن كان فيه موضع تشجير وموضع غير تشجير فهو مولد. ومنها ما سقايته ما بين[141] وما كان كذلك فإن حديده المشجر. فأما ما كان وشاحين على الحد فإنه هو الذي وصفنا في صدر الكتاب.

[136] هكذا في ا. في ل "أقلها" (مكتوب بدون تنقيط) ولكن يحتمل أنه تصحيف لأنه غير معقول.

[137] هكذا في ا و ل ولكن زكي يكتب "فيها".

[138] الأركازمات: ا "الانكاركات".

[139] هكذا في ا. في ل (وزكي) "قطعية" ولكن يحتمل أنه تصحيف لأنه غير معقول.

[140] هكذا في ا و هو أعقل من قراءة ل "مبنية" (بدون تنقيط كامل).

[141] هذا اقتراحي ولكن في ل "ما مين" وفي ا "هامين" وفي زكي "ماين".

Among them are those forged in Manṣūra, which are short, fine, delicate and broad swords. **(30)** Their breadth is at most three fingers, some of them resembling the iron of the Yemeni except that its watering is not free from thinness and leanness. The Manṣūri [is the brightest of swords and the most illustrious. All of them incline to yellow except this Manṣūri]; it is the brightest and most noble of them with respect to watering and is the least yellow. The ground of the Sri Lankan before the throwing is red inclining to the colour of dust, and after throwing its ground is red and its watering fine and a little yellow. The shapes of these Manṣūri swords are the same as the shapes of the plain ancient Yemenis which have no grooves.

Among them are those forged in Fars in the past, on which engravings of images and ornamental borders (*ṭurar*) are worked that are called *Shah pa-nakhshīr*,[66] which means "the king at hunt", gilded in gold. And there is also a type of Salmāni forged in Fars which is called the imperial (*Khusrawāniyya*). As for the plain Sri Lankan swords of the Farsi ones, they have the broadest watering of all these Sri Lankan, and that is because the people of Fars were working (*yamṭalūn*) the white swords for themselves. The people of the rest of these countries brought nuggets (*arkāziyāt*)[67] [of iron] to them, which are square pieces, originally a cubit square, [and they are also called *shabābīt*[68]]. **(31)**

The White Swords

As for the white swords they are of two types: a type forged in Fars and a type forged in Kufa in the earliest times. They are short swords, the broadest of which is three fingers [in breadth]. However there may occur in one type of them notching on the edge (*fall*), and the notching brings out a difference. Their length is three spans and four fingers. All of them [likewise] are [open, I mean,] split. Their tangs are slim, their upper parts a little slimmer, thin. Their tangs are pierced twice, two incisions at the extremity (*sunbuk*). Their heads are heavier than their lower parts, [and by lower parts I mean] what is next to the handle. Their heads towards the rounding (*tadwīr*) are tapered, with fine tips (*aṭrāf*), resembling the places that are in the Qalaʿi, not knotted and all [its watering] even. [The ancient Kufan is one which the craftsman Zayd forged]. Among them are those whose waterings are all floral (*mushajjar*). If one has a floriated place and an unfloriated place, then it is an indigenous. And among them are those whose quenching is not clear, and those like this have floriated iron. As for those with two bands (*wishāhayn*) on the edge (*ḥadd*), they are what we have described at the beginning of this treatise.

[66] Zaki Arabicizes this to *shāh fakhr* ("the shah is glorious" or the like), but it is the Persian for: "the shah at hunt", as Kindi correctly states.

[67] Cf. *rakīza*, "pieces of large size, like stones, of silver, gold…and other minerals" (Lane, *s.v.*).

[68] A species of fish, "slender in the tail, wide in the middle part, soft to the feel, small in the head" (Lane, *s.v.*).

والبيض الكوفي أقطع من الفارسي و[هي] أقطع السيوف كلها وأصبرها على الكريهة.
وبين[142] البيض الكوفي والفارسي إذا تساويا في الوزن والقد في السيف ثلث الثمن. وعلامة
البيض الفارسي أنه أطول من الكوفي بثلاث أصابع وأكثر. فإن أصيبته قد غير لعلة فاعلم أن
سيلانه أطول (32) من سيلان الكوفي التي تسمى الزيدية باصبعين وأثخن وأعرض من سيلان
الكوفية[143] بكثير. وقد تكون هذه الفارسية مختلفة في الرقة والعرض. وهي أعرض جوهرا من
جوهر الكوفي إلا أن جوهر الكوفي أصفى وأنور وأشبه بالعتيق الأول. وليس يظهر فرندها إلا
بعد الطرح إلا شيئا خفيا[144] جدا وهي زرق الحديد إذا كان غير مطروح عليها [الدواء].
والأزرق هو أبيض يضرب إلى الخضرة. والسيوف الفارسية أسافلها التي تلي السيلان أثقل من
أعاليها. وأكثر أثمان الكوفية [منها] الكبار الصباح ثمانية [دنانير] وأقل أثمانها ديناران إلا أن
تكون خفيفة الوزن جدا فتباع بدينار.

الفرنجية

[والسيوف] الفرنجية عراض الأسافل. دقاق الرؤوس في قد اليمانية العتق بشطبة واحدة
عريضة في وسطها كالنهر الظاهر. وجوهرها شبيه بصنعة[145] غريب الثياب الطبري وتركيب
حلق الدرع أبيض الوشي أحمر الأرض بعد الطرح وقبل الطرح لا يظهر منها شيء. [و]في
صدورها (33) أهلة محشوة بشبة أو بذهب أو صليب محشو كذلك [بشبة أو ذهب]. ومنها ما[146]
في أحد تركيبه ثقب قد عمل[147] فيه مسمار ذهب أو شبة[148]. وربما كان ذلك المسمار في اليمانية
العدلى[149] مسمورا أيضا بالذهب في تركيبه أو طرفه. وله حدبة[150] تشبه الداسكتين مما يلي
الشطبة لا يخرج فيه فرند. والشطبة مقصرة عن طرف الذباب بقدر ثلاث أصابع وأقل. وله شبيه
بالثقب[151] في [تلك] الثلاث أصابع [وفي تلك الثلاث أصابع] لا يظهر لها فرند وهي أخرط
رؤوسا من اليمانية.

142 هكذا في ا و هو أعقل من قراءة ل "من".
143 الجملة "التي تسمى...سيلان الكوفية" غير موجودة في ا.
144 في ا و ل: "شيء خفي".
145 هكذا في ا و ل ولكن يكتب زكي "بصفة".
146 هذه الكلمة غير موجودة في ا.
147 عمل: ا "سمر".
148 هكذا في ا. في ل "شبهه" ولكن يحتمل أنه تصحيف لأنه غير معقول.
149 العدلى: ا "العتق".
150 هكذا في ا ويبدو أنه أعقل من قراءة ل: "وله حديد".
151 بالثقب: ا "بالنسب" (بدون تنقيط).

The Kufan white swords are more trenchant than the Farsi, and indeed [they] are the most trenchant of all swords and the most enduring of them in adversity. Between the Kufan white and the Farsi swords, even when their weight and shape are equal, (there is a difference) in price of a third. The mark of the Farsi white is that it is longer than the Kufan by three fingers and more. If you obtain one which has been changed for some reason, then know that its tang is longer **(32)** than the tang of the Kufan called the Zaydiyya by two fingers, and thicker and broader than the tang of the Kufan by a lot. These Farsi swords may be different in fineness and breadth. They have a broader nature than the nature of the Kufan, though the nature of the Kufan is purer, more luminous and resembles more the original ancient. Their watering only appears after the throwing except for a very hidden part. They are blue of iron if there has not been thrown on them [the medicament]. The blue one is white inclining to greenness. The lower parts of Farsi swords, which lie next to the tang, are heavier than their upper parts. The highest price of the large, beautiful Kufans [among them] is eight [dinars] and the lowest price is two dinars, though if they are very light in weight they are sold for one dinar.

The Frankish Swords

The Frankish swords have broad lower parts, fine heads, in the shape of the ancient Yemeni with one broad groove in its middle like a clear river. Their nature resembles the character of the foreign Tabari clothes[69] and the structure of the rings of armour; they are white of ornamentation, red of ground after throwing, and before throwing nothing of it appears. [And] on their foreparts **(33)** are crescent moons filled with yellow copper (*shabba*) or gold, or a cross likewise filled [with yellow copper or gold]. And among them are some that have an incision in one part of their structure into which a nail of gold or yellow copper has been worked. Sometimes in the most well-formed[70] Yemeni swords that nail was also nailed with gold into its structure or tip (*tarkībihi aw ṭarafihi*). It has a curvature[71] resembling the *dāsaktayn*[72] in the part next to the groove, and no watering comes out in it. The groove stops short of the end of the sharp edge of the tip (*ṭaraf al-dhubāb*) by three fingers and less. There is the like of an incision in [those] three fingers, and [in those three fingers] there is no watering apparent. Their heads are more tapering than those of the Yemeni.

[69] i.e. clothes of Tabaristan, which were renowned for their embroidery work.

[70] Most well-formed: Istanbul "ancient".

[71] Thus Istanbul; Leiden has "iron", which seems less plausible.

[72] Presumably the name of a type of sword; *dāsak* is probably *dās* (see n. 33 above) with the archaic ending – *ak*; -*ayn* could represent the dual ending (i.e. double-bladed or double edged).

السليمانية

فأما [السيوف] السليمانية فإن حديدها على مثال حديد الفرنجي إلا أنه أصفر وشيا وأجلى وأغرب صنعة. وأول السيف وآخره مستويان[152] ليس بمخروط. فان دق الرأس عن الأسفل فقليل ما. وليس فيه تمثال ولا صليب. وسيلاناتها تشبه سيلانات اليمانية. وكذلك سيلانات الفرنجية [إلا أن الفرنجية] أوفر سيلانات وجميع معانيها سواء.

المولدة

وأما [ما] سوى ما وصفنا فالمولدة وهي [سيوف] في كل طبع. منها جنس يقال له المحرر وهو ما عمل بخراسان في قد القلعية وهو[153] معقد عقدا صغارا (34) واحدة إلى جنب صاحبتها من أوله إلى آخره يعمل بالمنقاش عملا ثم يداس بالمداوس فيستوي فترى [عقده] صفوف بعضها يتلو بعضا يشبه القلعي وحديده أسود. وأعرض ما يكون منه إصبعان ونصف وليس يظهر [جوهرها] إلا بعد الطرح فإن ظهر منها شيء قبل الطرح رأيت حديدا رخوا مظلما بعضه يتلو بعضا وعلاماته أن ثقب سيلانه[154] دقاق ويطبع طبع القلعي وتبلغ أثمانها ثلاثين درهما.

ومن المحدثة البصرية ما يظهر حديده قبل الطرح معقد بعقد تشبه جوهر السلماني جوهر ناعم تتبين لك الرخاوة فيه [مع] سواد وظلمة تتبينها في الشمس أضعاف ما تتبينها في الظل حسن الشفرة تنبو اليد[155] عنها تظهر اثار المصاقل فيها مختلفة القدود من عراض ودقاق وقصار وطوال. لم يطبعها[156] أحد من البصريين إلا [رجل يقال له] سليمان. طبعها سنة خمس وتسعين وقطع العمل سنة مائة وتسعة[157]. وهي بعد الطرح تذهب عقدها ويخفى جوهرها. وإنما كانت تحمل (35) إلى الجبال وتباع بسعر اليمانية وكانت تباع بدينارين[158] ونصف. ومنها ما طبع[159] بالبصرة أيضا ما لا يزداد ثمنه على ستة دراهم وأربعة دراهم وهي صغار السيلانات دقاق مضطربة القدود.

152 في ا و ل: "مستويين".

153 هذه الكلمة غير موجودة في ا.

154 وعلاماته أن ثقب سيلانه: ا "وعلاماتها أن ثقب سيلاناتها".

155 هكذا في ا و ل ولكن يكتب زكي "إليه".

156 هكذا في ا. في ل "يطهر" ولكن يحتمل أنه تصحيف لأنه غير معقول.

157 في ل لا ترد هذه الجملة في السطر التالي وتبدأ "عملها" بدل "طبعها". وهي مكتوبة في ا بأرقام.

158 وكانت تباع بدينارين: ا "وأثمانها دينارين".

159 هكذا في ا و ل ولكن يكتب زكي "صنع".

The Sulaymāni[73] swords

The iron of the Sulaymāni [swords] is like the iron of the Frankish swords, except that it is yellow of ornamentation, more lustrous, and more foreign of manufacture. The first and last part of the sword are even, not tapered. If the head is very fine at the bottom, then it is only slightly watered. There is no image or cross on it. Their tangs resemble the tangs of the Yemeni. Thus also are the tangs of the Frankish swords, except that [the Frankish ones] have more amply endowed tangs and all their good qualities are equal.

The indigenous swords

As for [what] has not yet been described, it is the indigenous, and they are [swords] of every fashion. There is a kind called the liberated (*al-muharrar*), which is the one worked in Khurasan in the shape of the Qalaᶜi. It has small knots, **(34)** one next to the other from top to bottom, worked with a chisel, then ground (*yudās*) with a grinding tool so that it becomes even. You will see [its knots] in rows, one following another, resembling the Qalaᶜi sword, and its iron is black. The broadest it can be is two and a half fingers, and [its nature] only appears after the throwing. If anything of it does appear before the throwing, you will see a supple dark iron, part of it following part. Its distinguishing marks are that the incisions of its tang are fine, it has the same forging as a Qalaᶜi, and its price can reach thirty dirhams.

Among the indigenous[74] Basran swords are those whose iron appears before throwing, knotted with a knotting resembling the nature of the Salmāni. They have a smooth nature in which suppleness is patent to you, [with] blackness and darkness that is twice as patent in the sun as in the shade, a fine blade which the hand will recoil from.[75] Traces of the polishing tools are apparent on them. They vary in shape, broad and slim, short and long, and none of the Basrans forge them except for [a man called] Sulaymān. He forged them in the year ninety-five (714 AD) and stopped this work in the year one hundred and nine (727 AD). After the throwing their knots disappear, and their nature is hidden. They were brought **(35)** to the Jibal and sold at the rate of the Yemeni swords. They were sold for two and a half dinars. Also among them are those forged in Basra, the price of which did not exceed four to six dirhams, and they had small thin tongues and distorted shapes.

The Damascan [swords] are all filed and they are the ones forged in the past. They are very trenchant if they are on their first quenching. They are long, filed in a shape we have already described of the Salmāni forged in Mansūra. Their iron resembles the

[73] Both Leiden and Istanbul have very clearly Sulaymānīya (with dots and vowels).

[74] Both manuscripts have "modern" (*muhdatha*), but above Kindi says that the Basran belong to the indigenous (*muwallada*) and this section is on the indigenous, so it is likely that we should read indigenous here.

[75] i.e. because the blade is so sharp. Read *al-yad* (the hand) not *ilayhi* (to it), as Zaki has.

[والسيوف] الدمشقية كلها خريشة وهي ما طبعت فيما مضى. وهي قواطع جدا إذا كانت على سقاية[ها] الأولى. وهي طوال خريشته في قد ما وصفت من السلمانية التي تطبع بالمنصورة. وحديدها شبيه بالبيض إلا أنه مختلف الجوهر وهي أقطع ما يكون من المولدة. وأثمانها ما بين خمسة عشر درهما إلى عشرين [درهما][160].

ومنها ما يطبع بمصر مما يبرز بالطول طولا فتستوي وجوهه ويشتد لاستوائه قطعه. فأما حديده فحديد بصرى. وأثمانها عشرة دراهم[161]. يطبع منها الخرشت [والجهارداس] والشهاداست[162] والتيه داست[163] والساذج وغير ذلك **(36)**.

النرماهن

ومنها أسياف نرماهن تقع من سيوف الشراة والروم جميعا ومن سيوف الهند. فما كان من سيوف [الهند] يسمى مندلي ويعرف سيفها[164] باضطراب قده والتوائه وأثر المبرد في شفرته. وهو في مثال طبع الفاقرون وليس يظهر في النرماهن كله قليل ولا كثير.

فأما سيوف الروم والشراة فسيوف سواذج دقاق طوال مضطربة القدود. إذا نظرت إلى السيف نظرت إلى مواضع داخله ومواضع خارجه. وهي تسمى بالفارسية كهر بلام[165]. هذا أطال الله بقاءك فيما أمرت بايضاحه والله أعلم[166].

[160] هذه الكلمة غير موجودة في ا.

[161] ترد هذه الجملة في ا في نهاية هذه الفقرة.

[162] الشهاداست: ا "الشهداست".

[163] هذا النوع غير مذكور في ا.

[164] هذه الكلمة غير موجودة في ا.

[165] كهر بلام: ا "طهربلام".

[166] هذه الجملة موجودة في ل فقط. تنتهي مخطوطة ا بالكلمات "تمت الرسالة والحمد لله رب العالمين والصلوة على رسوله محمد".

white swords, though it has a different nature, and they are the most trenchant of the indigenous swords and their prices are between fifteen dirhams and twenty dirhams.

Among them are those forged in Egypt, which stand out for their length. Their faces are even and on account of this evenness they have a strong cut. As for their iron it is Basran. Their prices are ten dirhams. From them is forged the *kharishat*, [the *jahārdāst*], the *shahādāst*, [the *tīhdāst*], the plain one, and others **(36)**.

The soft iron (narmāhan)

And among them there are soft iron swords that are found among the swords of both the Shurat and the Byzantines, and among the swords of India. And among the swords [of India] are those called Mandali, and [this sword] is recognised by its distorted shape, its curvedness and by the trace of the file on its blade. It was forged like the *fāqirūn*, and neither little nor much (watering) appears in the soft iron.

As for the swords of the Byzantines and the Kharijites they are plain, thin, long swords with distorted shapes. If you look at the sword, look at places inside it and outside it. In Persian they are called *kahr balām*.[76] This, may God extend your life, is what you ordered to be set out, and God knows best.[77]

[76] The first word of this is probably *guhar*, the Persian for Arabic *jawhar*, but the second word is uncertain and why the phrase is in Persian is unclear.

[77] This last sentence is only in Leiden; Istanbul concludes: "The treatise is finished, praise be to God, Lord of Creation, and peace upon His messenger Muhammad".

Chapter 3

Kindi's "On swords and their kinds" Commentary

Brian Gilmour

Introduction: Kindi's contribution to the study of iron and steel technology

We do not have very much evidence of how or when the exploitation of iron and steel on any scale began, or of how the technology behind it developed, nor do we have a very clear understanding of what iron and steel meant to earlier societies. Nevertheless it was clear to researchers, even a hundred years or more ago, that this technology developed along rather different lines in different regions of western, central and eastern Eurasia. The study of early iron and steel has undoubtedly been hampered by a modern dual perception of this metal as being first a utilitarian, mass-produced commodity, which, secondly, is transformed in the ground into rusty lumps which do not tend to stimulate our interest, or bring out quite the same sense of awe as do well preserved gold, silver or even copper alloy objects from earlier times. This has led to an assumption that iron technology, unless proved otherwise, was carried out at rather a rudimentary level until relatively recently.

Swords are an exception to this view of iron, but unfortunately even here we have many modern myths about the qualities, composition, development and use of these weapons. The manufacture of swords tends to be thought of as a secret art (now lost), only passed from generation to generation by a select few practitioners who may be thought of as having almost supernatural skills and abilities, a view reflecting a merging of a modern view of iron and its products with a much earlier (Western epic) story-telling tradition left over from a pre-literate era. Although there are some Roman and pre-Roman European sources, little survives until a millennium later.

It is not known when iron or steel use on any scale – what is commonly known as the Iron Age – began, nor do we know exactly where this took place, or indeed why or how it started, although it seems that this process began somewhere in the region of Asia Minor (modern Eastern Turkey) about four thousand years ago. All we actually do have is a few fragments of evidence, some dated better than others, with which to reconstruct the development of an entire industry across large parts of the world.

Understandably the gaps in our knowledge tend to be passed over, or at least downplayed in scholarly books or articles, in favour of attempting to create a

framework of knowledge based on the scraps of evidence that have been recovered. Despite this, we can at least be sure that iron became the dominant metal to be used both for utilitarian purposes as well as for more special uses such as swords, even if we do not know when the special properties and potential of steel began to be exploited systematically. Much early ironwork still exists buried in the ground, although unevenly distributed and often in poor physical condition. The overall survival of ironwork, and of other metalwork, is also largely dependent on intentional burial practises. Much early ironwork, now to be found in museums and other archaeological resource centres, has been discovered in the course of archaeological investigations over the past two hundred years, and more is being recovered all the time, either during archaeological excavations or by accidental discovery. The distribution of the places where this ironwork has been found is very uneven and, to a large extent, reflects the distribution of archaeological sites rather than the original distribution of the metal itself.

Once the use of iron became more widespread we also begin to get a few mentions of iron from written sources but these mostly do little more than tell us that it existed and was of some importance, although progressively more of the surviving references to iron and steel mention it in relation to swords. Kindi's sword treatise finally gives us enough contemporary information to enable us to construct a framework for how iron and steel were made and exploited over much of the known world at that time. Also, Schwarzlose's work (see next chapter) brings together numerous references to swords and their (claimed) attributes from late pre-Islamic and early Islamic poetry. These provide much information in small snippets which, despite Schwarzlose's analysis, are difficult to see in context without access to Kindi' sword treatise, and Bīrūnī's chapter on iron.

Bīrūnī's chapter on iron (written in the mid 5th/11th century) is a mixture of much earlier written information, mostly relevant to the Middle East, and contemporary oral information from relatively near his base at Ghazna in what is now eastern Afghanistan. Fortunately his descriptions from written sources match material from early poetry quoted by Schwarzlose, enabling the beginnings of a framework to be suggested for iron and steel manufacture and use in the Middle East in the late pre-Islamic and early Islamic period. This is very helpful in understanding Kindi's sword treatise as it gives us some of the background to the manufacture of the iron and steel for swords in the Middle East, information that Kindi leaves out in his much more wide-ranging description which is mainly relevant to contemporary practices of the earlier 3rd/9th century. Bīrūnī's iron chapter also gives some useful clues about the identity of some of the earlier sword-making centres in the regions further east, places not mentioned by Kindi, although probably already important by his time. It now seems likely that one of the sources of high quality Indian steel and swords that were being brought to the Middle-East in Kindi's time was Kanūj in central northern India.

Despite initially confusing terminology and textual problems Kindi has provided a clear, well thought out, wide-ranging and detailed description of various aspects of sword technology of the day. Nothing is portrayed as mysterious or secret. It is of great value not only for the light it throws on the Middle East and Greater Iran, but also on India, and is

also by far the most informative medieval source for understanding iron and steel manufacture and use in Europe.

Before our work on Kindi began it was already clear that a great deal of early ironwork survived, mostly from Europe, as well as considerable written evidence, mostly from the late pre-Islamic and (more particularly) the early Islamic Middle East. Given the potential of this evidence, it is perhaps surprising that it has not previously been looked at in more detail. We still know little about the working of iron and its alloys in pre-modern times, before about 500 years ago. The reason for this is perhaps obvious, and is that we have not sufficiently identified, translated and interpreted much of the existing written evidence and made it available to a wider audience, nor have we analysed, identified and reported on more than a tiny fraction of the available ironwork that is known to survive. Consequently we have little more than a rudimentary idea of how, when and why specialised developments in iron manufacture and use took place, or what were the driving forces behind these changes, and how and why these developments varied in different parts of the world.

Nowhere is this overall problem more evident than in our (lack of) understanding of the early steel industry. We have no idea, for instance, what role the early discovery of steel and its properties may have played in the development of the widespread adoption of iron. Also the impact of prevailing cultures and the implications for early trade networks have often not been considered. Although iron and steel technology may ultimately have derived from a common origin in Asia Minor, it is clear that this developed along different lines in three wider regions: Europe; the Middle-East and central southern Asia; and China. It would appear that iron and steel technology developed separately in China, although it is possible that early developments in central Asia were influenced by contemporary Chinese practises. Much of the development of ferrous technology in China is being reconstructed from a wide variety of Chinese written sources, backed up by analytical work, which gives us a good idea of how this progressed over much of the two millennia following the introduction of cast iron technology there about 2500 years ago.

In Europe a very different mass of evidence exists for reconstructing developments in iron and steel technology over this same 2000–year period. Europe furnishes few useful written descriptions before the 16th century AD, but a great deal of ironwork relating to this long time-span has been recovered from European sites, although very little systematic analytical work has been carried out on it. The complexities of iron and steel production and use here are only now beginning to emerge. Although less ironwork has so far been recovered, for the same 2000-year time-span there is much more useful written evidence in the Middle East, central Asia and the Indian subcontinent, particularly that of the earlier Islamic period, and mostly written in Arabic. Kindi's sword treatise is outstanding in the information it gives and framework it provides in helping us to understand early iron and steel use, particularly when compared with evidence from other written sources.

Interpretation of the treatise

(5).[1] When Kindi sets out the two main categories of iron (*ḥadīd*) – mined (*maᶜdanī*) and unmined (*laysa bi-maᶜdanī*) – he is describing the two ways in which iron or steel was made, not just in the Iranian region, but elsewhere as well. Although the terms mined and unmined may seem rather obscure descriptions at first, their meaning is actually clear and unambiguous.

Mined iron must refer to the production of iron (soft or hard) as a one-step (or primary) process direct from its ores. This is a good description of iron or steel produced directly by the solid-state reduction of iron from its ores in the smelting method now usually known as the bloomery process. By contrast, unmined iron must not refer to iron or steel made directly from its ores in a one-step process, but rather to the eventual product of a secondary process in which one form of bloomery iron or another is converted into a very specific form of steel.[2] Mined iron can also refer to the production from its ores of liquid cast iron.[3]

The soft and hard sub-categories of mined iron simply refer to iron (low in carbon) and steel produced in a bloomery furnace fired under different conditions. These types of iron and steel must have been widely known and it is likely that specific bloomery sites at this time, at least in certain regions, would have specialized in the production of different types of iron or steel. *Shāburqān*, the hard iron able to be quenched during its heating and forging cycle, refers to bloomery steel in this instance but can refer to cast iron as well. *Narmāhan* (soft iron) refers to plain or low carbon bloomery iron, the carbon content of which is too little (below 0.3%) to be hardened by quenching. Essentially all 'mined' iron is made directly by smelting and can be classified according to Kindi's definition as either *narmāhan* or *shāburqān*. Kindi defines these two types of iron to distinguish them from *fūlādh*, the products of which make up the main part of this treatise (see Fig. 8).

(6). *Murakkab* refers to composite sword blades made from various combinations of bloomery iron (*narmāhan*) and steel (*shāburqān*) welded together in different ways to give identifiable types of both pattern-welded and non pattern-welded sword. It is clear from early Islamic and pre-Islamic poetry that iron and steel, and the composite blades they were used to make, were common[4] from pre-Islamic times.

Fūlādh comes under Kindi's unmined category of iron and he defines it as steel that is made by a specific secondary refining process that takes place in small clay crucibles where the iron is converted into steel which becomes liquid in the process. Kindi's description makes it fairly clear that this steel was generally regarded as a purified form of iron. He reports that the iron becomes harder although is still

[1] This and subsequent numbers refer to the page numbers of Zaki's edition, also given in ch. 2 above.

[2] Effectively iron containing between approximately 0.3 and 2.0% carbon. Iron containing less than 0.3 carbon cannot in practice be quenched and can be regarded as low carbon iron (see glossary).

[3] The most carbon-rich form of iron (see glossary).

[4] Although Schwarzlose surprisingly came to the unlikely conclusion, and one unsupported by evidence, that steel of any kind was not used by the Arabs before the introduction of 'Indian steel': see Schwarzlose, pp. 136–137, in ch. 4 below.

malleable, and that the process makes the steel susceptible to producing a watered surface pattern (*firind*) on a sword forged from the cast steel ingots made this way. Apart from an unspecified added ingredient he mentions only mined iron as being placed in the crucibles and simply notes that the iron melted and became steel.[5] This accurately describes what happens when firing a crucible charged with a mixture of low carbon bloomery iron and (white) cast iron, both these being the product of smelting.

Both Bīrūnī (d. 440/1048) and Ṭarsūsī (fl. 6th/12th century) describe crucible processes where it is clear that a mixture of bloomery iron and white cast iron is being used to charge the crucibles, with the addition of magnesia or manganese dioxide presumably in powdered form.[6] This would have combined with any sulphur present in the cast iron (which would otherwise cause embrittlement), rendering it harmless as tiny particles of manganese sulphide dispersed through the resultant cast steel (*fūlādh*). It would appear highly likely therefore that Kindi's added ingredient was powdered manganese dioxide too, which in effect, during the melting and fusion process in the crucible, would have 'purified' the iron and helped leave it with the desirable physical properties Kindi then describes (i.e. harder but malleable metal which could then be quenched and further heat-treated).

'Its watering' refers to the inherent property of the type of *fūlādh* (crucible steel) Kindi says was used for sword blades, where the steel contains certain impurities (such as vanadium or phosphorus). Their presence on solidification gives rise to a segregation effect within the metal that persists through subsequent heating/cooling and forging cycles and results in a watered effect on the surface of the blade after this has been polished and etched (see Figs 10a & b).

(7). Kindi groups the various types of sword made of crucible steel according to their quality, the highest quality being called 'ancient' (*ʿatīq*), and the lowest quality being called 'modern' (*muḥdath*). Most important was the specific variety of steel used and the fineness of watered surface pattern produced, but the style of sword and the skill and place of forging were also important factors. Kindi's use of the terms suggests that 'ancient' and 'modern' are likely to have been widely used for describing the quality of swords made of crucible steel. Where swords were reckoned to have some of the attributes of the highest quality swords, but not all, they were classified by an intermediate name, 'neither ancient nor modern'. In contradiction to the present-day use of term the antique, Kindi makes it clear that that it was the quality of the steel that counted in judging the quality; the age of the sword was irrelevant.[7] This classification is not a division into 'poor', 'medium' and 'good' quality swords, but rather into

[5] In one steel recipe given by Kindi himself (see ch. 1, n. 26 above) it is said that one *manna* (two *raṭl*, ca. 1.5 lb or 0.6 kg) each of *shāburqān* and *narmāhan* were used in the crucible. Iron used alone is also mentioned in the crucible steel process described by Jābir ibn Ḥayyān (see Appendix 1 below).

[6] Bīrūnī, *Jamāhir*, 248 and 252; Cahen, "Un traité d'armurie composé pour Saladin", 106–107.

[7] For this reason we decided to translate *ʿatīq* as ancient (as in Allan, *Persian Metal Technology*, 82), rather than antique, although either could be used.

'standard', 'better' and 'best', with the assumption that all swords were of a certain basic serviceable quality.

(8). Kindi further emphasises that *fūlādh* was a processed form of steel – not to be confused with the combining of hard and soft iron (*shāburqān* and *narmāhan*) as in a composite, welded construction. He makes it clear that this was a crucible product; the actual crucible methods being described elsewhere.[8] Kindi says that unmined (crucible) steel can be divided into three categories of quality based upon finished sword blades. To avoid confusion Kindi explains that the categories for quality cannot apply to any swords forged from hard and soft iron (*shāburqān* and *narmāhan*) because these are smelted directly from their ores, what Kindi describes as 'single metals unchanged by base particulars that have introduced things into their natures'. He means that these have not been through any subsequent process that would noticeably change their basic composition, mainly their carbon content. Kindi is specific that the terms 'ancient' and 'modern' can only be applied to the processed form of iron or steel known as *fūlādh* or to the swords made from it.

Of Kindi's three categories of 'ancient' or finest quality swords the best are said to be the Yemeni variety, these being swords forged in the Yemen using crucible steel of that region. The second category of fine quality swords, the Qalaᶜi, appears to originate in Kalang, an ancient port near Kuala Lumpur on the Malay Peninsular.[9] The reported presence of a Nestorian Christian community here suggests the activity of Sasanian merchants by the early 7th century AD in a place which became an important trading centre on the long-distance route to China in the Islamic period.[10] In the mid 4th/10th century the traveller Misᶜar ibn Muhalhil also identified Kalah as the place where Qalaᶜi swords were made.[11]

(9) and **(11)**. A particular kind of Indian (*Hindī*) sword referred to as *fāqirūn* (possibly 'cleavers'),[12] was the third in the topmost rank of swords and must originate somewhere in the Indian subcontinent. Although not mentioned by Kindi, Kanūj in the Upper Ganges basin of central north India is one likely contemporary source of high quality crucible steel and the swords made from it.[13] In this context *Hindī* can only be referring to steel of crucible origin, although towards the end of the treatise Kindi also mentions that some Indian swords of non-crucible steel origin were known.[14]

Many more swords from a wide variety of places were classified by Kindi as being of the second or medium quality category, 'neither ancient nor modern' (*lā ᶜatīq wa-lā muḥdath*). This category is divided into two groups called *muwallad* and *ghayr*

[8] One of the crucible processes described in his recently rediscovered treatise on the making and heat-treatment of steel is quoted here, see ch. 1, n. 26 above.
[9] Fatimi, "Malaysian Weapons in Arabic literature", 211–215.
[10] Whitehouse and Williams, "Sasanian maritime trade", 48.
[11] See ch. 2, n. 8 above.
[12] See ch. 2, n. 10 above.
[13] See Kindi/Zaki, p. 21, in this chapter.
[14] See ch. 2, Kindi/Zaki, p. 36.

muwallad, initially puzzling terms with several possible interpretations.[15] The places Kindi names indicate that *muwallad* means 'indigenous', referring to one of the central Islamic lands. *Ghayr muwallad* means 'foreign' and refers to steel imported from outside the main Islamic area. Of *ghayr muwallad*, Kindi says that these were made in the Yemen using imported Sri Lankan, Indian and Salmāni crucible steel. These swords were evidently made by Yemeni sword-smiths and many resembled the best quality Yemeni blades, but were still classed in the medium quality category ('neither ancient nor modern') because they were made from the 'modern' (imported) Sri Lankan and Salmāni steel.

Written sources indicate that the Yemen had become an important region for sword making by the later Himyarite period (6th century AD), and hint that the basis was crucible steel, partly locally made and partly imported from the Indian region.[16] Kindi reports that this industry was still thriving in the Yemen in the 3rd/9th century and confirms that it was based on crucible steel, the best of it being made locally, and the rest imported from further east. The Yemeni sword-smiths forged the best swords from locally produced crucible steel, and others from imported Sri Lankan and Salmāni crucible steel cakes, and also sometimes modified swords brought in from these areas to resemble swords forged in the Yemeni style.

Suggestions for the origin of Salmāni steel and the swords associated with it vary, but the evidence seems to favour the important iron-working region of Transoxiana, north of the River Oxus, especially Bukhara and the Ferghana valley to the northeast, although a more exact geographical location for Salmān is uncertain.[17]

Kindi now[18] lists the five sub categories of *muwallad* or indigenous swords, which are given as the Khurasani (north Iranian), Egyptian, Damascan,[19] Basran, and a group of other less numerous types, including the Baghdadi and Kufan. He says that iron was worked and forged in these places, which in this context must also mean local production of the crucible steel. Kindi's comments that steel-making and sword production had been carried out in 'olden times' at Damascus, suggesting much earlier production here, possibly in the late pre-Islamic and/or early Islamic period. He later states that it had more or less ceased by his time.[20]

[15] *Muwallad* could be taken literally as meaning 'born' or 'created' (in the sense of innovative or new) as opposed to 'non-created' (in the sense of well established or not new); see also ch. 2, nn. 11 and 13.

[16] See Schwarzlose, ch. 4, 127–134; Bīrūnī, *Jamāhir*, 252 – 253.

[17] See discussion below under Kindi/Zaki, p. 26; but also see ch. 2, n. 12 above, and Allan, *Persian Metal Technology*, 83–84.

[18] Or at least in the reordered version of the text which we give and which we feel is necessary for the text to be understood in the way originally intended by Kindi.

[19] See discussion below, Kindi/Zaki, p. 21; and also in ch. 2, n. 12 above. Occasional later references to iron foundries and iron/steel manufacture or use in Damascus do exist but there seems to be very little evidence to back up the widely held claims for Damascus continuing to be a major medieval steel and sword producer. A recent detailed examination of the claims, in Elgood *Arms and Armour of Arabia*, Appendix II, 103–109, concludes on the basis of the available evidence, that while some iron/steel and sword production is likely to have continued, it was of relatively minor importance.

[20] See ch. 2, Kindi/Zaki, p. 35.

(9–10). The 'modern' or 'basic' quality category of sword blades, nearly all of which were evidently imported into Islamic areas, are divided by Kindi into three groups: Salmāni, Sri-Lankan and 'white' (*bīḍ*) swords. Not only finished swords were imported from Salmān and Sri Lanka, but also cast steel cakes came from both these regions for forging into sword blades.[21] Cast steel cakes from Sri Lanka were brought to certain coastal areas, such as Fars, in southwest Iran, and also up the River Indus to Manṣūra[22] probably via the port of Banbhore[23] (Fig. 12). More surprising is Kindi's report of the import of Sri Lankan steel cakes to the Khurasan region of northwest Iran. This trade only seems feasible if the Sri Lankan crucible steel was much less expensive than the equivalent Salmāni steel.[24]

The identity of the third variety of 'modern' steel sword blade is slightly uncertain, and can be read either as *bīḍ* meaning 'white', or as *bayḍ* meaning eggs, conceivably referring to raw crucible steel from some regions being more recognizably egg-shaped than that produced elsewhere. However *bīḍ* meaning 'white' or 'bright' fits better with the text and was also used this way by early Arab poets to describe some sword blades.[25] 'White' may mean bright or shiny with reference to an especially high degree of polish typifying this particular group of swords, or it could simply be used here to describe a metal with a silvery appearance, an apt description of a freshly polished but otherwise untreated piece of iron or steel, although a later description of these swords suggests that many of them had watered surfaces.[26] Some of these white swords were made in Farsi sword-smithing centres of southwest Iran. Kindi only later mentions that imported (Sri Lankan) steel was used for them. Of the less numerous swords of this type Kindi indicates the use of locally produced crucible steel for the 'white' swords made by the sword-smith Zayd in Kufa, in southern Iraq.

Kindi's emphasises the trade in the standard quality, 'modern' type(s) of crucible steel, particularly that from Sri Lanka. The best quality Indian steel was also traded, particularly to the Yemen, but perhaps on a lesser scale. Some Sri Lankan steel was used locally to make swords, but much was exported to sword-smithing centres further afield, such as those mentioned by Kindi at the widely separated Iranian steel centres of Khurasan and Fars,[27] and also Manṣūra in Sind.

[21] See Kindi/Zaki, p. 26, in this chapter.

[22] See Fig. 12, which shows a crucible steel ingot or egg found at the site of Banbhore, the extensive ruins of which are now west of the Indus, approximately 75 km (45 miles) northeast of modern Hyderabad.

[23] Now ruinous, but a major port at the mouth of the river Indus during the 2nd/8th–5th/11th centuries. Banbhore (formerly Daibul) was the first city captured during the Arab conquest of Sind in 93/711; see Whitehouse and Williamson, "Sasanian Maritime Trade", p. 43.

[24] Kindi does not say how this took place but the route, via Banbhore, up the Indus, then via Peshawar, through the Khyber Pass and across the mountains via Bamyan to Balkh, and possibly Merv, would seem likely. This must also be the route along which the Bamyani *zāj* was transported to the sword-making centres of Multan in Bīrūnī's time; see Bīrūnī, *Jamāhir*, 253.

[25] See Schwarzlose, pp. 171–72, in ch. 4 below.

[26] See Kindi/Zaki, p. 31, in this chapter.

[27] An earlier example of one of these Iranian swords is shown in Fig. 11 above. The recently analysed blade of this sword has been found to be made of ultra-high carbon steel consistent with Kindi's crucible steel category of *fūlādh* (see Craddock, "New Light on the Production of Crucible Steel in Asia").

(11). Kindi next contrasts the swords he has just described, those made from 'unmined' or processed iron (*fūlādh*), with those swords forged from the directly smelted or 'mined' varieties of iron, which he now discusses. He explains why the directly smelted 'hard' (or male) iron (*shāburqān*) is not suitable on its own for the forging of swords, saying that swords like this would be too brittle, inhomogeneous, and would not quench evenly as the quenching process would not affect the 'veins' of soft iron within the metal. An inhomogeneous steel sword like this would probably have warped badly on quenching, largely because of the uneven overall carbon content. Localized cracking could also be expected where the uneven stresses within the metal were at their greatest.

(12). A sword made like this would have been vulnerable when struck, particularly along its edges where the metal was thinner. Kindi emphasises that no competent smith would be likely to forge a sword out of this form of steel (*shāburqān*), unless unaware of its properties or without alternatives. He explains that no sword made of this type of steel alone would produce a watered pattern irrespective of subsequent treatment.

At about this time there was a shift towards the much greater use of steel for swords made in northwest Europe,[28] so Kindi's comments may refer to these, as is suggested by the description of these swords as solid, unable to 'vibrate' or be bent, an apt description of many surviving contemporary western sword blades from northern Europe, although there is a conflict in the description. A stiff sword would have been more likely to vibrate (ring) but would not bend, whereas a softer sword would damp-out vibrations quickly. Kindi's reference to 'hard iron' swords being all of one colour also suggests the existence of swords made of made of relatively homogeneous bloomery steel, and given a final etching or patination. Although the finish would not have been watered this form of iron would have been sufficiently inhomogeneous to yield a mottled finish on etching.[29] Kindi is clear that an inhomogeneous form of steel like this was generally considered to be highly unsuitable on its own for making sword blades.

Kindi states that the Byzantines and Shurat[30] were also known for their routine use of 'soft' iron (*narmāhan*), low carbon and unaffected by quenching, for making swords. But in his chapter on iron Bīrūnī (d. 440/1048) reports that Byzantine swords were made of hard iron (*shāburqān*),[31] although there is no reason to think that the Byzantines radically changed the iron from which they made swords in the intervening two centuries, but Bīrūnī is a less reliable witness than Kindi whose research is much more detailed and thorough, possibly suggesting an error in this part of Bīrūnī's account.[32] It is perhaps surprising that these groups of people would have not have

[28] See Gilmour, "The patterned sword", 115–116.

[29] Although swords with a soft iron core and outer 'skin' of steel would look much the same.

[30] A Muslim religio-political sect also known as the Kharijites; see ch. 2, n. 23 above.

[31] Bīrūnī, *Jamāhir*, 248.

[32] Bīrūnī's description may have become slightly corrupted at this point, and possibly soft and hard iron (i.e. iron and steel) was meant, with some swords being a welded composite of the two.

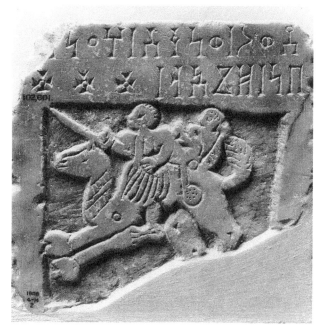

Fig. 1: Image of sword from a pre-Islamic Arabian context. A funerary relief, Yemen, 1st–3rd century AD showing a man on horseback bearing a sword.

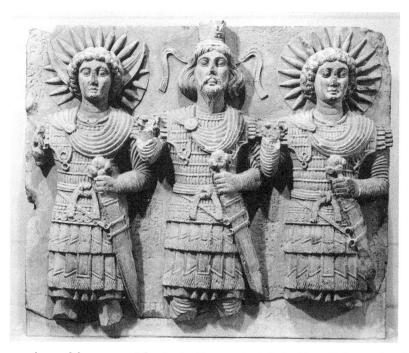

Fig. 2: Image of sword from a pre-Islamic Arabian context. Relief from Palmyra, 1st–2nd century AD, showing the divine triad of the city, each bearing a sword.

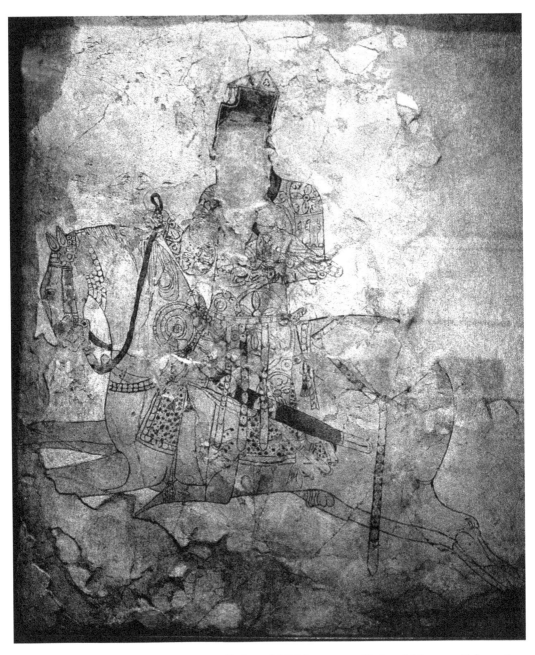

Fig. 3: Wall painting at Nīshāpūr ca 3rd/9th to 4th/10th century; National Museum, Tehran, Iran (phototography courtesy D. Nicolle).

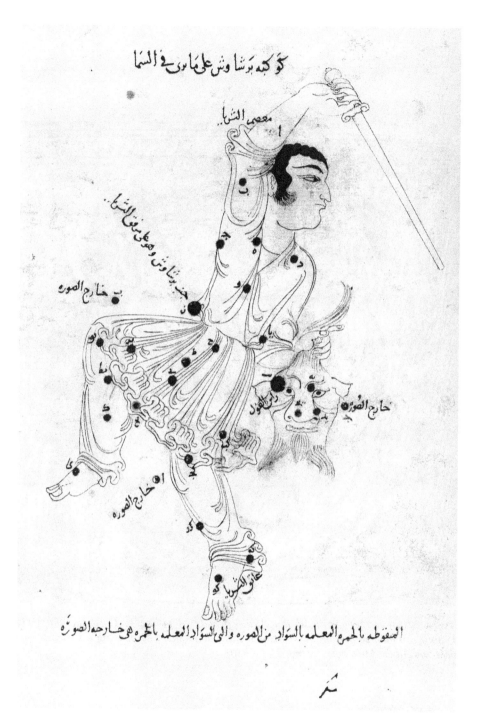

Fig. 4: Perseus as seen in the sky; from p. 111 of a copy of the 'Book of fixed Stars' (Ṣuwar al-Kawākib al-Thāitah) by 'Abd al-Raḥmān b. 'Umar al-Ṣūfī 290–375/903–986. (Bodleian Library, MS Marsh 144).

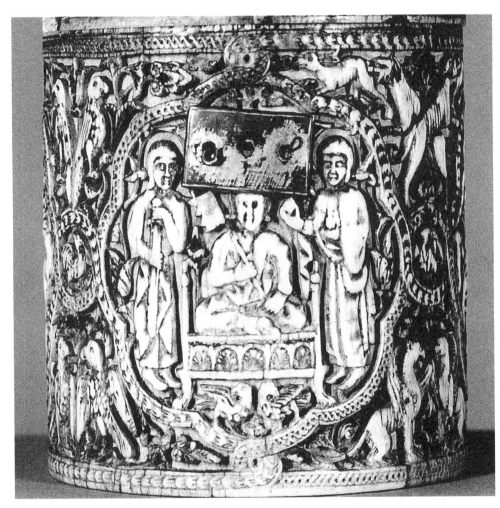

Fig. 5: Ivory casket made for Ziyād ibn Alfaḥ, prefect of police in Cordoba, dated 359 AH (970AD); image of man seated on dais between two attendants, one bearing a sword (courtesy of the Victoria and Albert Museum; inv. no. 368–1880).

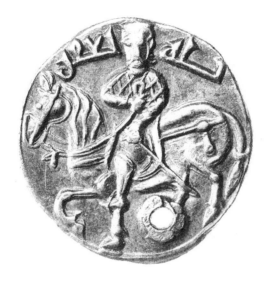

Fig. 6: Coin of Calif al-Muqtadir Billah (295–320/908–932) seated on horseback and bearing a sword. Legend: "Pardon is with God" (courtesy of the British Museum; ref. no. 1847–2–16–20).

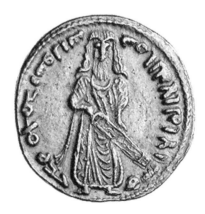

Fig. 7: Coin of Calif (ʿAbd al-Malik (65–85/685–705) showing long haired robed person (assumed to be the caliph) bearing a sword (courtesy of the Ashmolean Museum).
Around the rim is written the Muslim confession of faith 'There is no god but God and Muḥammad is the messenger of God'.

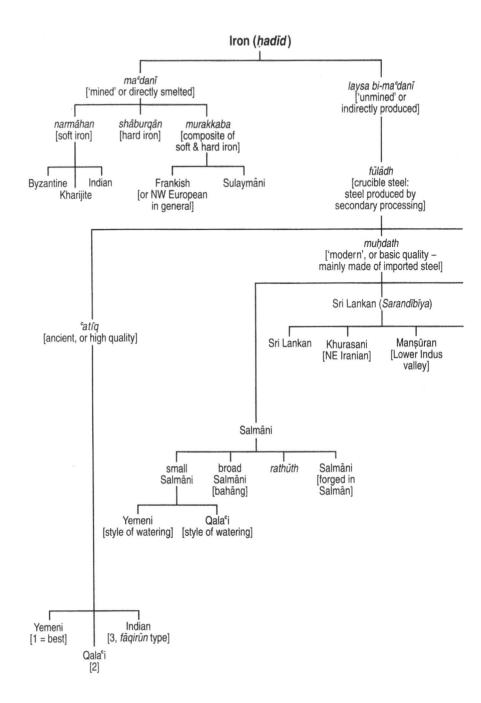

Fig. 8: Diagrammatic representation of Kindi's classification of swords and the types of iron and/or steel from which they were made.

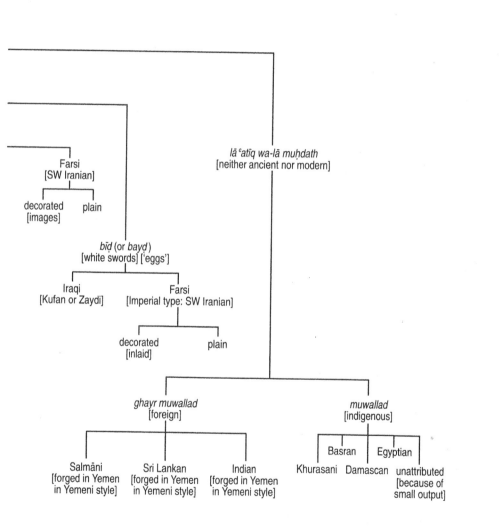

Farsi
[SW Iranian]

decorated plain
[images]

lā °atīq wa-lā muḥdath
[neither ancient nor modern]

bīḍ (or *bayḍ*)
[white swords] ['eggs']

Iraqi Farsi
[Kufan or Zaydi] [Imperial type: SW Iranian]

decorated plain
[inlaid]

ghayr muwallad *muwallad*
[foreign] [indigenous]

Salmāni Sri Lankan Indian Basran Egyptian
[forged in Yemen [forged in Yemen [forged in Yemen Khurasani Damascan unattributed
in Yemeni style] in Yemeni style] in Yemeni style] [because of
 small output]

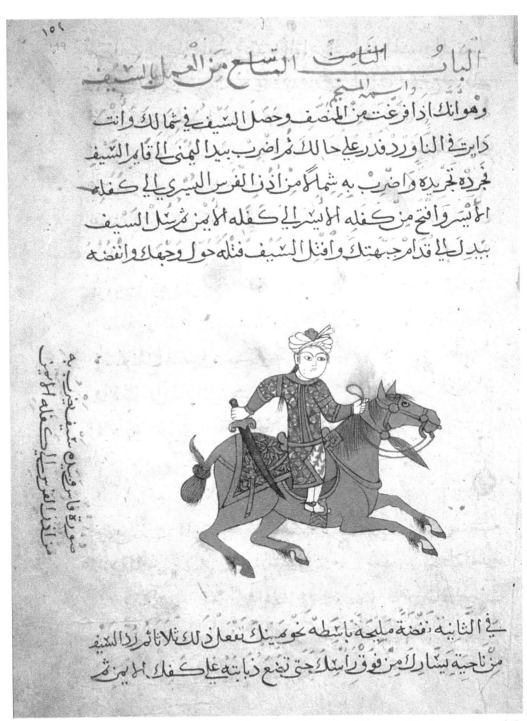

الباب الثامن التاسع من العمل بالسيف
واسمه المنبج
وهو انك اذا رفعت من المنصف وحصل السيف في شمالك وانت
دائر في النار ورد قدر علي حالك ثم اضرب بيدا اليمني الي قائم السيف
تجرده تجريده واضرب به شمالا من اذن الفرس اليسري الي كفك
الايسر وافتح من كفك الايسر الي كفك الايمن ثم سل السيف
بيد لك قدام جبهتك واقتل السيف فتله حول وجهك وانفضه

في الثانية نفضة مليحة بباسطه خوميك سعاد لك ثلاثا ثم رد السيف
من ناحية يسارك الايمن فوق راسك حتي تضع ذبابته علي كفك الايمن ثم

Fig. 9: Mounted figure holding a sword, illustration from the Nihayat al-Su'l (courtesy of the Chester Beatty Library, Dublin; ref. no. CBL A5 5655, fol.149).

used some steel for swords but there seems little doubt that Kindi meant what is written here as the same information is repeated later.[33] Perhaps many of these swords were almost but not quite classifiable as 'hard' or steely iron (*shāburqān*) according to Kindi's strict definition, but others may have used the terms more loosely.

There is no confusion about the composite, forge-welded swords referred to by Kindi as made from a compound (*murrakaba*) of hard iron and soft iron'. Kindi says these swords fall into two groups, the Frankish and the Sulaymāni,[34] but does not explain any difference between them. The Franks, although dominant in northern Europe at this time, would appear to be a term used by Kindi for more or less any people of northwest European origin, and would probably have included the Rūs, Slavs, and/or Vikings, who (rather than the Franks) are mentioned by later writers such as Bīrūnī.

Kindi next discusses the properties and qualities of the various types of swords categorised in his treatise, beginning with the best quality ('ancient') ones. 'Compactness', 'firmness', flexibility, intensity of polish, and degree of 'purity' are the five attributes that he says makes the 'ancient' swords better than the rest. Compactness may have been linked to a combination of aesthetic and handling qualities. Firmness and flexibility more obviously relate to the metal, the poorer quality blades being adversely affected by quenching whereas intensity of polish relates to the finished surface. Purity may relate to the final surface appearance of the blade with certain kinds of watered appearance being particularly well thought of, or to the appearance of the fracture surface of the steel as Kindi also states, or both to the depth of contrast between pale (white) areas and darker (muddy coloured) areas within the patterns, and the sharpness of the boundary between them.

(13). High quality patterns looked regular and, and had certain decorative characteristics like the 'knotted' appearance supposedly resembling peppercorns or the knots on a piece of wood, or other variations. Kindi emphasises that he is setting out his descriptions in the most simple, logical, and clear way that he can, and in this he is remarkably successful both here and throughout the rest of the treatise. The qualities of each type of sword are discussed later, but brief mention of certain overall differences in form as opposed to differences in their 'nature' or physical properties is made here.

[33] See ch. 2, Kindi/Zaki, p. 36; possibly many of these swords were similar in structure to an earlier Roman *spatha* reported in Tylecote and Gilmour, "The metallography of early ferrous edge tools and edged weapons", 144–147, where the iron and smithing was of relatively high quality but the carbon content was just low enough that this blade would come under 'soft' iron according to Kindi's classification.

[34] Sulaymāni is used here rather than Salmāni, because it is clear that Kindi is referring to swords made of welded composite blades made of 'directly' produced iron alloys rather than 'indirectly' produced crucible steel. Since he does not make it clear, it is uncertain whether Kindi is referring here to swords from a different area to the crucible steel and related swords made in the Transoxianan region, but the assumption seems to be that they were made in the same region. See also ch. 2, n. 12. above.

(14). As for short swords, their blades should be 'the measure of a hair on each side', suggesting he is discussing double-edged swords. Swords with thinner blades were considered the best, with the sharpest, although the degree of quenching was also an important factor. Too intensive (fast) a quench results in a blade that is unnecessarily hard and brittle, and therefore very likely to break during use, whereas if the quenching is moderated (slowed down) then the steel can be hardened sufficiently to give a good edge without being brittle.[35] This suggests the use of slack quenching in which a red hot piece of steel is plunged into a liquid like oil, which being less thermally conductive than water slows down the rate of quenching, although the thickness of the steel and its carbon content also governed the rate or effectiveness of the quenching. The brittleness of a piece of steel quenched in water can also be moderated by tempering, that is, limited and gentle reheating. Slack quenching may also be meant here as a 'moderation to quenching', although a delayed or interrupted quench is also possible.[36]

Kindi stresses that the properties of swords are closely linked to their types, and that types similar in shape can be distinguished by recognizing the type of iron used. The skill lay in distinguishing the form of watering which the sword-smiths who etched the blades knew by particular names, the watering also being thought of as being a measure of the purity of the iron.

This must mean that sword-smiths knew by experience how to distinguish the best blades by their patterns, as well as being able to spot visible defects, even when looking at swords that looked very similar in other respects. If 'purity' related to the crucible processing for this kind of steel, it also referred to the visible watered effects, the watering apparent on the surface expressing the nature or essence of the metal beneath; in other words Kindi correctly believes that the patterns represent the internal macro- structure of the steel.

Therefore purity was a reference to quality, as judged by the watered pattern. The underlying quality or metallurgical structure of the sword gave rise to a particular background effect to the watered pattern on etching, possibly paleness or darkness rather than the red or green colour mentioned. The allusions to colours could also refer to ways in which a blade had been heat-treated.

(15). Kindi attempts to differentiate these background 'colours' from the white and yellow tones of iron. These colours are linked specifically to watering and seem to refer to the pale part of the pattern. When saying for example that a sword is red, he is referring to the part of the blade that will be etched; sword-smiths would also refer to a 'red' etching substance. This suggests that the red etching substance produced a reddish or reddish-brown background effect. Induced patination would have been an

[35] For the ultra high carbon watered crucible steels brittleness would also have been influenced by the form and distribution of the larger cementite particles, which is independent of quenching, being instead a function of the thermo-mechanical history of the steel (as pointed out to me by CJ Salter, Univ of Oxford).

[36] Auto-tempering caused by residual heat in a steel object – usually the result of incomplete quenching – may also have been exploited.

inevitable effect of etching, different parts of the structure reacting selectively to produce the darker and lighter shades of an overall watered effect.

While a dark brown colour can be achieved on iron or steel, surviving watered steel sword blades almost invariably have grey to black backgrounds to the watered patterns. A dark blue surface can also be produced using chemical compounds. Reddish and yellowish colours have been achieved with modern chemical compounds, but would have been more difficult to achieve. The red, green and yellow colours here may refer instead to the colour of the particular etching substance.

Kindi does not give any of the names by which the etching chemicals or compounds were known, other than simply as medicament (*dawā'*). The etching medium *zāg* or *zāj*[37] reported two centuries later by Bīrūnī, mentioned at various times since[38] and identified in the early nineteenth century as naturally occurring impure ferric sulphate,[39] was already known by name from various recipes. Bīrūnī reports that Indian armourers or sword polishers favoured the yellow variety from Bamiyan (now in central Afghanistan) and the white variety from Multan[40] (now in central Pakistan). It seems unlikely that the colour the polishing medium took on during polishing was being referred to, because Kindi deals with this effect separately when describing authenticity tests for Yemeni and Qala'i swords.[41]

Bīrūnī's reference to red sand being used for iron smelting at Kanūj, in central north India, suggests that sometimes the colour of the original iron ore was meant, although Bīrūnī states that the colours on sword blades usually varied in shades between white and black. Neither Kindi not Bīrūnī mention brown despite this being relatively easy to achieve as an induced patina on iron,[42] unless some references to red actually mean brown.

The Yemeni swords

The length and detail of this section on Yemeni swords presumably reflects the continued scale and significance of the Yemen as a main centre for both crucible steel and sword-making, which was carried out using both locally produced and imported steel. Swords made in Yemeni workshops from Yemeni crucible steel were regarded as the highest quality swords (see Fig. 8), whereas those made by Yemeni sword-smiths using imported crucible steel were classified only as medium quality. This classification was absolute; the best Yemeni sword-smith could only achieve a medium quality blade even if the best quality imported Indian crucible steel was used.

Yemeni swords are described as having an elongated, wavy, regular knotted pattern, showing up as white against a 'red' background. These swords were thought

[37] See glossary.
[38] Allan and Gilmour, *Persian Steel*, 67.
[39] Smith, *A History of Metallography*, 22–23.
[40] See Bīrūnī, *Jamāhir*, 254; Multan was also well known to Bīrūnī as a steel and sword-making centre
[41] See Kindi/Zaki, pp. 24 and 25, in this chapter.
[42] See Bīrūnī, *Jamāhir*, 254; Angier, *Firearm Blueing and Browning*.

of as being green before etching. The small, worm-like white bits of lead occurring about one span from the hilt would seem to represent a special inlay which contrasted with a darker background.

(16). Virtually all the swords described here by Kindi, including the early Yemeni examples, must have had straight blades, as the more familiar curved form of sword blade (like the roughly contemporary early example excavated in 1939 at Nīshāpūr, in northern Iran with its only slightly curved blade, which must be a very early example; see Fig. 13a) was probably only first introduced from central Asia at about this time.[43] The Yemeni swords span the late pre-Islamic and early Islamic period (sixth to ninth centuries AD). Some of these swords are described as having parallel grooves (or fullers) running down their blades, a feature apparently typical of pre-Islamic blades. The required profile and depth of the grooves was achieved by differential engraving or filing. Apparently such grooves of this kind featured on *ṣamṣāma*, a legendary sword of surpassing quality and cutting power said to have belonged to pre-Islamic Yemeni kings, and subsequently to the Arab warrior-poet ᶜAmr ibn Maᶜdikarib (d. *ca.* 21/641) and reported later to have been in the possession of the great caliph Hārūn al-Rashid (170–193/786–809).[44]

(17). The weights of the Yemeni swords are in *raṭl*, which approximates to between about 0.75 and one pound (lb) on the avoirdupois scale[45] (0.35–0.45 kg). Both the *raṭl* and the pound ultimately appear to derive essentially from the same unit in a Bronze Age system of weights in use in the Eastern Mediterranean. Like the pound the *raṭl* was part of a system originally based on twelve units (1 *raṭl* = 12 *ūqīya* = 144 *dirham*). A comparison of Kindi's sword dimensions and weights with a series of post-medieval swords from Iran and elsewhere in this region of southern Asia[46] suggests that 0.75 lb (0.35 kg) is a close equivalent to Kindi's *raṭl*, and very close to the equivalent figure (0.338 kg) given by Hinz[47] for the medieval *raṭl*. On the basis of the range of sword weights given by Kindi in this section, 1.75 to 2.75 *raṭl* would have been equivalent to approximately 0.6 to 1.0 kg (1.3 to 2.2 lb). In a steel-making recipe quoted by Kindi in his other word related treatise[48] the main ingredients are measured as *manna* and this would appear to have been equivalent to two *raṭl*.[49]

[43] Possibly originating in central Asian or eastern European Avar workshops in about the 2nd/8th century, as a development of long straight swords current in the Transoxianan region during the previous century (these being similar to the late Sasanian example illustrated in the present volume, see pl. 4), see Gorelik, "Europe and Western Asia", 129 to 131.

[44] See Schwarzlose, 129 and 194, in ch. 4 below, and also above, ch. 2, n 31.

[45] Used in Britain until metrication in 1971.

[46] Mostly in the collection of the Royal Armouries, Leeds, U.K.

[47] Hinz, *Islamische Masse und Gewichte*, 28.

[48] See ch. 1, n. 26 above.

[49] The ancient *mina* was equivalent to two *raṭl*.; see Kisch, *Scales and Weights*. The *Mina* is a version of *mann* or *manna*, terms for weights of some of the main ingredients in steel recipes given by Kindi and Tarsūsī; see also Allan and Gilmour, *Persian Steel*, 64 and n. 86.

However, according to Agricola (in 962/1555) the old Islamic *raṭl* was equivalent to 0.468 kg or close to one pound,[50] slightly more than the equivalent (0.406 kg) given recently for the earlier medieval Iraqi *raṭl*.[51] As recently as the early twentieth century the pound (0.45kg) and the Iranian *raṭl* seem to have been very similar weights. It should be possible to work out a more reliable approximation of the modern weight equivalent of the *raṭl* once more swords of this period have been identified and the original weights calculated.[52]

(18). Open veins with black in them must be a reference to flaws, usually present according to Kindi on the surface of Yemeni swords. Evidently these were disguised by covering them with designs or inscriptions, with smaller flaws referred to as cracks which only required fine lettering to mask them. This part of the text seems muddled with some words of the original description missing, but the sense is clear. It would appear that the part of the swords Kindi is describing here were prone to surface imperfections, in particular, a place referred to as *kayākin*, evidently where the steel tended to split and separate. These imperfections were masked by gilded designs in the form of men or animals.

The fact that these imperfections appear to occur near the hilt suggests that they relate in some way to the forging from the roughly hemispherical, raw crucible steel ingots, cakes or billets.[53] Each sword must have been forged from a single crucible steel cake or ingot.[54] One of the steel cakes (Fig. 14) produced at about this time in the recently identified crucible steel-making workshop at Merv (one of the furnace bases of which is shown in Fig. 15) would have weighed approximately 1.3 kg or 2.9 lb.[55] Allowing for a loss of at least approximately 25% of the ingot metal during forging, this cake, which was rather more bun- than egg-shaped, would have been approximately the right weight for making a sword blade. The size of some of the steel cakes from Merv can be guaged by reconstructing fragments of steel-making crucible found near the site of the workshop (Fig. 16). As is made clear by Bīrūnī two centuries later these cakes were forged in a very specific way so that it was known from the outset which part of the cake would end up as which part of the sword. It seems that usually they were turned on their side and progressively flattened out, a process which would inevitably, as Bīrūnī makes clear, have left a largish flaw where the forging process resulted in the flat upper part of the original cakes being closed up. Kindi also reports (in what may now be an incomplete description) an apparent property of

[50] Kisch, *Scales and Weights*, 223

[51] See Sarraf, "Close Combat Weapons", 154.

[52] See Flinders-Petrie, "Standards of weight", 475–78, for a discussion on the development of early systems of weights in this region, as well as Hinz, *Islamische Masse und Gewichte*, and Kisch, *Scales and Weights*, appendix 3.

[53] From fragments of crucibles found at the recently discovered, more-or-less contemporary steel making workshop at Merv it is clear that ingots large enough to produce a sword blade would have been of this form (see Figs. 15–16).

[54] The steel ingot produced by the crucible steel recipe quoted here from the other Kindi text would have weighed approximately 4 *raṭl*, therefore approximately 3lb or 1.4 kg; see ch.1, n. 26 above.

[55] Allan and Gilmour, *Persian Steel*, 51.

brittleness, known as *sabūsak* (possibly scaly in appearance), as the cause of the tips of these swords being liable to break off.

(19). Apparently the knotted pattern for which the Yemeni swords were well known was visible once the sword blades had been polished, but before any etching medium (or medicament) was applied, when the iron used for these swords is described as having a red tone. Given that the iron cannot have had any particular colour at this stage, an inherent property of the metal inducing a reddish background effect upon etching maybe being referred to, or possibly the etching solution took on a reddish tinge.[56] The appearance of the knotted pattern in very slight relief, caused by the differential polishing away of the softer parts of the metal matrix before etching, is to be expected for fine hand polishing. This effect would have been greatly enhanced by etching.

That the soundest or finest quality ('ancient') *qabūriyya* type of Yemeni sword was prone to breaking in cold weather may be due either to it being a thinner blade more prone to breaking when exposed to extreme cold, or perhaps this was the result of a different type of heat treatment. According to Bīrūnī,[57] writing two centuries later, all crucible steel (*fūlādh*) swords exposed to the more extreme cold of Russian winters suffered embrittlement.

The term *mās* refers to a variation in the surface pattern of some Yemeni blades, such as the *ṣamṣāma* variety, here both high in quality and early in date, and also of the indigenous (medium quality) swords from Basra, in southern Iraq. This variation consisted of vein-like areas where the watered pattern was missing and Kindi explains that these vein-like areas consisted of soft iron, these being the result of incomplete mixing of the iron and other ingredients (in the crucible) that he refers to as medicaments, so that the resulting steel still contained some soft iron.

It is not clear of what the substance referred to as medicament in this case consisted. That it was 'thrown on to the iron' suggests that it was a non-metallic addition, and the description suggests an inorganic substance possibly placed in a small bag before being added to the iron in the crucible.[58] No organic ingredients are mentioned so the iron in this case would probably have been a mixture of soft (bloomery) iron and cast iron, rather than the alternative soft iron plus wood pieces and/or other organic ingredients.

Unlike the vein-like cracks, vein-like variations to the watered pattern were more desirable as they apparently made the blades less brittle and hence much less prone to breaking in cold weather, a drawback to which swords of crucible steel, particularly the early (possibly pre-Islamic) *qabūriyya* type of Yemeni sword blades were prone, even though they were known as ancient or high quality. From Kindi's description it appears that a normal and intentional variant of crucible steel used for Yemeni and Basran swords, resulted the soft iron veining. This could only have been achieved regularly by careful control of the crucible process, both over the length of time the

[56] See Kindi/Zaki, p. 15, in ch. 2 above.
[57] Bīrūnī, *Jamāhir*, 254.
[58] As in Bīrūnī, *Jamāhir*, 256.

crucibles remained in the furnace and also over the size of the soft iron pieces for the crucible charge before the crucible was placed in the furnace. For any given crucible charge the timing would have been critical: too long and all the remaining soft iron would have been converted to steel; too short and many bigger lumps of soft iron would have remained.

The reference to the two insides or halves of this type of Basran sword may have been another way of describing an incomplete mixture of the soft and hard iron (i.e. bloomery and cast iron) used to make the steel of these blades, with the cast iron being the first to melt, and hence behave like water. Perhaps Kindi reflects a wider contemporary view in thinking that an incomplete mixing of the hard (cast) iron and the soft (bloomery) iron was cause of the watered pattern on the surface of the finished sword blade. Comparison with Bīrūnī's chapter on iron suggests that the water mentioned by Kindi also referred to the cast iron in the crucible, the first part of the iron to become liquid on heating. Recent research[59] has shown that certain impurities need to be present in the steel for a watered pattern to be achievable. Cast iron had to be smelted from the right ores and under the correct conditions for making steel that would produce a watered pattern when forged the right way.

Untangling this part of the description is made more difficult by the reference to a further variation in an otherwise regular surface pattern on these blades. They 'resemble the vein [but are not the vein]' suggesting a similar shape but different appearance when etched. Possibly partially carburised pieces of iron – steel relatively high in carbon (up to approximately 1%) but not yet molten – could be meant here. Such vein-like inclusions would look much darker when etched, and no watered pattern would be present in these areas.

The curious statement that the soft pliable iron veins (*mās*) will not drink water when they occur on the edge, seems to relate to what happens to the edge when this kind of blade is quenched in water. If the intention was to harden the edge by these means then the presence of any soft iron would have harmed the blade (as Kindi states), because the quenching would have no effect on these areas, except possibly to promote distortion. This effect may have been visible on the edge of one of these blades and very obvious if only the edges were quenched.[60] The heat-treatments used for sword blades in Kindi's time will remain unknown until contemporary descriptions are revealed,[61] or when blades in sufficiently good condition to be examined metallographically come to light.

(20). Some of these swords are said to have had a single larger vein-like soft iron imperfection (*mās*) occurring on the upper part of the blade near the hilt (*qāʾim*).

[59] In particular see Verhoeven *et al.*, "Wootz Damascus Steel Blades", and *id.*, "The Key Role in Impurities in Ancient Damascus Steel Blades".

[60] Probably done in the same way as was used for selectively quenching in medieval and later (traditional) Japanese sword making; discussed more fully in this chapter under Kindi/Zaki, p. 31.

[61] Some of these heat-treatments are likely to emerge when Kindi's second treatise 'On the making swords and their heat-treatments' is fully examined (see ch. 1 above).

Most of this section is concerned with quenching and tempering. Among the Yemeni swords there were some prone to damage (possibly cracking or fracture, although this is not clear from the words used) brought about by the striking of the blade, but not the result of poor quality steel or the quenching process used on the blade. Apparently it was thought that when the blade was quenched it took in water, and also that somehow it became it dry, hence brittle as dry wood tends to be brittle. Kindi says that this susceptibility of a blade could be forecast from both the appearance (the effect of the quenching in some way making it too red) and the feel of the blade to the palm of the hand, although the description here is confusing and possibly garbled in transmission.

It is apparent that quenching left these blades too brittle in places, and Kindi describes two types of sword defective in this way. The 'joined' iron head of one of these may refer to the end of the blade next to the tang, rather than the tang itself, whereas the 'joined' forepart of the other may be a part further down the blade. What is meant by 'joined' is not clear. Possibly major differences in the steel at these points made it more difficult to quench the blade successfully, or possibly there were weak points due to larger flaws, perhaps associated with the way the associated crucible steel ingots were forged. Whatever the particular reason for failure, the remedy indicates that the weakness was the result of localised over-hardening/brittleness caused during quenching, presumably in water.

The remedy was a tempering process in which the sword blade was laid in charcoal embers of the hearth when it had burnt right down at the end of the day's work, after dark as the warming blade had to be watched very carefully and wiped with oil as soon as the surface turned a peacock blue colour. An iridescent blue is one of a series of well-known temper colours still used to judge the correct temperature of a piece of steel being warmed up to alleviate the embrittling effects of rapid quenching.

A plain carbon steel takes on a pale straw yellow (iron oxide) colour at about 220°C and changes from yellow to brown, then to purple and eventually to a bright, then dark, blue. Peacock blue is reached at a temperature of about 300°C. Afterwards the sword blades were protected from wind and water, either of which could adversely affect the blade by cooling it too quickly or unevenly, and risk distorting or weakening it.

(21). Kindi goes on to describe another type of sword forged in Yemen, this time one whose surface has either a series of smaller grooves, most probably parallel and running down the blade, or a single groove together with a *kharīsha*, an as yet unidentified form of surface decoration, probably either engraved or forged, or just possibly etched. Swords of this type with plain blades were also forged from imported steel, of Salmāni, Sri Lankan, and Indian origin. The way this is phrased suggests that the steel was already in the form of crucible steel cakes or ingots ready to be forged into blades by local Yemeni sword-smiths. Hence these particular swords fell under the non-indigenous (*ghayr muwallad* or 'foreign') category of the 'neither ancient nor modern' or medium quality of sword.

Evidence for contemporary large (industrial) scale iron production and the secondary manufacture of crucible steel, has recently been found for the first time in the course of archaeological work in Sri Lanka.[62] The discovery and identification of comparable Indian sites can only be a matter of time and detailed archaeological investigation. Bīrūnī for instance tells us that Kanūj, an ancient city in the upper Ganges region of central north India, was a centre for the best Indian crucible steel and the swords made from it. The antiquity of this industry can be gauged from a description in the *Shāhnāmeh* that mentions the gift of what are likely to be watered Indian steel swords to Khusrau I Anūshīrvān, the Sasanian emperor of the mid 6th century AD.[63] Multan was known as a lesser sword and steel-making centre in Bīrūnī's time, but as yet we are unsure of its antiquity.[64]

The identity and origin of the Salmānī steel is more of a problem and opinions on this have differed, but what clues exist suggest that Salmānī steel is most likely to have originated in central Asian northeast of the river Oxus, either in Transoxiana or in the area of the Ferghana valley to the northeast, although other suggestions have been made such as the mountain range of that name on the present day border between Afghanistan and Pakistan, and also the Jodhpur region or somewhere else in northwest India.[65]

Kindi is also at pains here to explain that the forging of Yemeni swords from the three varieties of imported crucible steel had been going on since earlier times (and by antiquity he presumably means sometime in the pre-Islamic era), and that they measured nearly four spans (possibly about 90 cm[66] or 36 inches) in length by four fingers in breadth. This suggests that the blades could have been up to about 4 to 6 cm wide, much wider than any surviving (mainly much later) swords made of crucible steel. To judge by their weights, two to five *ratl* (approximately 0.6–1.5 kg or 1.5–3.75 lb) they varied widely in size, although however old the blades made of Salmānī and Sri Lankan steel might be, they were known to the sword-smiths as *ghayr muwallad* (foreign or imported), which Kindi described earlier as being one of the groups of medium quality ('neither ancient nor modern') swords.

He separates these lesser blades from the high quality (referred to as ancient) swords, which include only the Qalaᶜi, Yemeni, and a particular type of Indian blade known as *fāqirūn*. Of these the Yemeni sword was apparently considered the best followed by the Qalaᶜi and then the Indian. He goes on to say that the nature of the *fāqirūn* resembles that of the Yemeni and the Qalaᶜi and that they are (also) called 'made old' (antiquified) when they are changed to (the form of) the Yemeni or Qalaᶜi blades. This suggests that the term *fāqirūn* refers also to the Indian sword steel as well as the finished blades, and also that blades copying the style of the Yemeni and Qalaᶜi

[62] Juleff, *Early Iron and Steel in Sri Lanka*, 40–54.

[63] This is part of a well known passage, in which various prized things, including a chess set are said to have been sent by the Rajah of Kanūj with the embassy to Iran (Rabb, *National Epics*, 227; Levy, *The Epic of Kings*, 327).

[64] Bīrūnī, *Jamāhir*, 254.

[65] See discussion of Salmānī swords in this chapter under Kindi/Zaki, p. 26; but also see ch. 2, n 12 and 54.

[66] As estimated in Sharraf, "Close Combat Weapons", 173.

were being made from this steel apparently with the fraudulent intention of passing them off as genuine and therefore more valuable. Apparently it was often quite difficult to tell the difference, but the critical difference related to the small *qabūriyya*. What that meant is not clear but can probably be assumed to be some particular feature of the decoration of the blade that was difficult to reproduce on counterfeit or fake blades, possibly some subtle attribute of the watering which was found only on the best Yemeni sword blades.

(22). It seems doubtful that Kindi really means here that most of certain types of Salmāni and Qala°i swords were brought into Yemen and then altered to resemble the best Yemeni blades. Either most of the small Salmāni swords and the more delicate forms of Qala°i blade were imported to the Yemen with the specific intention of altering them, so as to sell them as if they were the best Yemeni blades; or that once imported they tended to be bought up with this in mind. Either way this fraudulent practice was clearly rife. In describing one of the ways this was done for the (small) Salmāni swords he says that some are pressed (*yukbas*) – probably marked or decorated with a punch of some kind – and also worked with an engraving tool leaving a particular, unique mark. Those who knew what to look for could thus identify the fraud. One of the reasons that this fraud was possible would appear to have been that the 'knotting' was a feature of the surface watered pattern that occurred on many types of sword made of certain types of crucible steel, including the best Yemeni swords as well as on imported Qala°i and Salmāni blades. Clearly there were rich rewards to be made from this practice as a Qala°i sword of 2.75 *raṭl* (approximately 0.9 kg or 2 lb) would fetch 10 to 15 *dinars* for a blade of good quality, or 5 *dinars* for one with veining visible on the surface, whereas the equivalent Yemeni blades would fetch 50 to 100 *dinars*.

(23). The Qala°i swords

Kindi compares these to the Yemeni swords, and first of all describes the main variations in the shape and size of the Qala°i sword, then says that the tangs were more delicate (perhaps narrower) than those of the Yemeni swords, and goes on to compare aspects of the steel used for the Qala°i blades with that used for the Yemeni and Indian blades. He says that the fracture surfaces of both the Qala°i and Yemeni blades were silvery-white, and comments that this property was unchanged by further forging of the blades. He also says that further forging, in this case, could be done without casting (*sabk*), indicating that if a blade was forged too much it would need to be broken up, melted down, and recast as a cake/ingot (or perhaps bar) and the whole forging process would begin anew. This was unavoidable if a sword had broken and the steel was to be re-used for another blade.

It appears that, unlike the Yemeni swords, none of the Qala°i blades had grooves forged into their blades. Also the surface watered effect on the etched blades was different with a smaller overall pattern and a more knotted look, the individual knots on the surface more variable in appearance than those visible on the Yemeni blades.

The Qala°i swords are said to have varied in size, and to have had the 'reddest' nature and ground, probably referring to the tendency of this steel to produce reddish slag and hammer-scale described on comparing these to the Indian swords.[67] Kindi also reports that the Qala°i were not brittle ('dry'), suggesting that they were known not to suffer from the brittle flaw problem encountered in some of the Yemeni blades described earlier.[68]

(24). The Indian swords

Kindi now discusses the properties of Indian steel, one of the varieties imported and used for forging some of the sword blades made in Yemen. He says that the nature of the Indian swords, by which he must mean the inherent properties of the steel from which they are made, is similar to that of the Yemeni blades, except that their 'nature inclines to black', probably a reference to the darker background of the watered surface for which many surviving post-medieval Indian sword blades are still notable. However, this may be owing not to a property of the Indian steel(s), but to the etching process or solutions used, seems doubtful. He also describes the fracture surfaces of these Indian blades as being darker in appearance than those of the Qala°i and Yemeni blades, suggesting the Indian sword blades to have a darker and quite different microstructure to these, probably indicating variations in composition and heat-treatments.

Some of the indigenous (*muwallad*) swords found in Khurasan were evidently barely distinguishable from the high quality ('ancient') Qala°i and Yemeni blades, and Kindi explains how to identify them. Some peculiarities of the watered pattern visible on these blades were evidently recognisable to those who knew what to look for. Kindi says that the knotted pattern – compared to peppercorns or (small) knots in wood[69] – was more intense on the Khurasani than the Qala°i sword blades. Also of the Khurasani blades, he says these 'knots' occurred more frequently, and stood out in greater contrast in the pattern, than was the case for another pattern known as *ta°ajjur* (wrinkling, or knobbling), also a characteristic of the Qala°i blades.

His explanation of wrinkling as 'interpenetration of the watering' is difficult to understand without surviving patterned surfaces to look at, but may be describing a type of curvy pattern variation that repeats at regular intervals along the length of the blade. This was a particular feature of the sword blades from Khurasan appears to have involved differences in pattern shapes as well as being nearly black in colour.

Kindi reports that only some parts of the surface of these blades were etched to reveal the watered pattern. Other parts of the blades, presumably the edges, were quenched by the sword-smiths who therefore must have carried out heat-treatments on

[67] See Kindi/Zaki, p. 25 in this chapter.
[68] See ch. 2, Kindi/Zaki, p. 20.
[69] See ch. 2, Kindi/Zaki, p 13.

sword blades as well as polishing and etching and maybe other surface decoration. The size and position of the watered areas of the surface, at least on these indigenous or *muwallad* blades from Khurasan, varied greatly, being one variation for which these blades were known was the ladder pattern, possibly the same as the so-called 'Muhammad's' ladder pattern visible on many surviving post-medieval watered steel swords from this region and elsewhere.

He goes on to describe other methods of testing swords so as to identify the modern blades. When a 'red' part was polished with an oilstone the oil came out black, and marks similar to those produced by lead were left on the stone. Additionally the rubbing of the polishing stone started to bring out the watered nature (internal structure) of a genuine Qalaʿi blade (and possibly the Yemeni too), but not for these medium quality indigenous blades, on the surface of which only the marks from the polishing stone were left. Only etching would finally reveal that the worm-like part of the pattern of the genuine 'ancient' (top quality) blades was white, whereas this part appeared duller or darker in the medium quality indigenous type of blade.

(25). Another way of identifying the medium quality 'indigenous' (*muwallad*) swords was evidently that the edge felt rough to the hand unlike the genuine top quality or 'ancient' blades. Kindi emphasises that there were various ways of identifying the medium quality sword blades, contrasting these with certain characteristics of the 'ancient' Yemeni, Qalaʿi and Indian sword blades, which were known for producing reddish slag and hammer-scale (when forged) whereas the slag and hammer-scale of the Indian swords was more blackish-red. The slag, the hammer-scale and the fracture surface of the indigenous swords apparently had a very different, blackish ashy appearance. The oilstone polishing test described above for the Yemeni and Qalaʿi resulted in oil only a 'little bit dirty'; likewise for the Indian blades, this result being equated to the purity of these blades.

(26). The Salmānī swords

This category was divided into several types one of which was the small Salmānī sword, with a long, narrow blade and a fine watered surface pattern with a curly appearance similar to that seen on the Qalaʿi blades, which appeared after polishing, even before the surface was etched. The location of Salmān is uncertain; Kindi implies that the Transoxianan region is the source of the steel for making them and available evidence suggests a location in the extensive and important early iron-working region northeast of the River Oxus. One suggestion is that Salmān could be a corruption of Marsmanda and Mink, noted by other medieval observers as iron-making centres in this region.[70] There were a variety of types of Salmānī sword and these, as well as the raw steel ingots or cakes also made here, were traded widely. Kindi says that this

[70] Allan, *Persian Metal Technology*, 84.

'small' type of sword had delicate shapes similar to the Qala°i blades. Despite their name, Kindi tells us that Salmāni blades were made in a part of Khurasan north of the river Oxus, using imported Salmāni steel cakes.

Transoxiana is known from early written sources[71] to have been important for iron resources and iron production from before Kindi's time, and this area seems the more likely source for the Salmāni steel. Evidence from more recent archaeological work in the Ferghana valley, in the eastern part of this region, indicates the large scale production of crucible steel at this time, and this could also be the origin of Salmāni steel, which may have become a kind of trade name, coined by importers in Iran and further west, for this particular variety of crucible steel.

Alternatives for the identity of Salmān have included Sind (in the southeast of modern Pakistan) and the area of Jodhpur, across the Indian border to the northeast. Salmān (as applied to a larger area) may also derive from the name of a range of mountains now in western Pakistan, bordering Afghanistan,[72] but it seems inconceivable that Kindi could be referring to any of these alternatives, which are separated from Khurasan by more than 1200 km (780 miles), much of it very difficult mountainous terrain. Production of swords in Sind at Manṣūra is discussed elsewhere by Kindi,[73] but the imported Sri Lankan steel in this instance must have come via the long established sea-borne trade routes then up the River Indus, beside which Manṣūra was situated.

In this case the Salmān in question here would seem to refer to somewhere much more accessible in the Transoxanian region northeast of the River Oxus, perhaps in the wider area of Bukhara, which Massalski reported still to be producing traditional of cast steel and swords in the early nineteenth century; or (perhaps more likely) the Ferghana valley further east, rather than the mountains of eastern Afghanistan,[74] unless the steel-making traditions of two separate regions have become conflated. It is already becoming clearer from archaeological work that the Ferghana region had become a large-scale producer of crucible steel by about the tenth century[75] and was probably important in Kindi's time. Salmān may also be the origin of the crucible steel described in a recipe by Ṭarsūsī in *ca.* 596/1200 as *fūlādh Salmāni* ; he also says that it is used to make *Salmāni* swords.[76]

What follows may be slightly corrupted and could be interpreted in two different ways. Kindi seems to be suggesting that the blade of a sword of excellent weight (a heavyweight blade) could be forge-welded to itself, although it would have to have

[71] In particular Abū l-Qāsim ibn Ḥawqal, Muḥammad al-Muqaddasi, and Muḥammad al-Narshakhi who emphasised the early importance of Ferghana; see Allan and Gilmour *Persian Steel*, 19–21.
[72] See ch. 2, n. 12.
[73] See ch. 2, Kindi/Zaki, p. 29.
[74] See ch. 2, n. 12.
[75] Papakhristu and Swertschkow, "Eisen aus Ustruschana"; Papakhristu and Rehren, "Techniques and technology", 69.
[76] Allan and Gilmour, *Persian Steel*, 64; Cahen, "Un traité d'armurie composé pour Saladin", 106–107 126–127 (Cahen translates *slimani*, but Ragib, "La fabrication des lames damassées", 43, amends this to *Salmāni*).

been folded along its length, before being forged out again to produce a shorter, wider blade, seemingly an unnecessary and difficult procedure for sword that could have been forged to this shape in the first place. More probably when a particular type of heavyweight sword was required by the armourers or sword-smiths, two of the imported Salmāni steel cakes would have been re-melted in a crucible to produce a cake large enough to be forged out to the desired shape of sword blade.

Salmāni smiths wanting to imitate the Yemeni swords made a shorter sword in the Yemeni style, then applied treatments expected for a Yemeni blade, including quenching the half of the blade that included the tip. The half of the blade towards the hilt was probably protected from the effects of the quenching, by a partial coating of a clay compound, as has long been used by traditional Japanese sword-smiths.[77] Kindi now reveals that a similar quenching process was often used for the 'ancient' Yemeni sword blades, although more of the blade was quenched in the case of the Yemeni swords, leaving only the part nearest the tang (perhaps about a quarter of the blade) protected from the effects of quenching.

(27). The 'small' Salmāni swords, made to resemble the longer, narrower Qalaᶜi blades, were given equal (symmetrical) ends and (more) pointed tips, and their length is said to have been slightly less than four spans (approximately 90 cm[78]). This type of Salmāni blade belonged to one of two (main) types of Salmāni sword, which could be differentiated, even if both were lightly forged, by the way the watered pattern formed on the etched surface. He describes the pattern as having a clear, red quality, but as before, the meaning of red in this context is unclear. As suggested above,[79] it may have referred to the type and colour of etching solution that was most effective on this type of blade. In any case the basic element of the watered pattered that resulted on this 'small' type of Salmāni blade was one and a half times coarser or bigger than the watering visible on the Qalaᶜi sword blade, and slightly bigger than that on the Yemeni swords.

After the coating or throwing, presumably of etching compound, the watering of the Salmāni blades looked like a broken *unbūba*, the internodal section of a cane or reed, discontinuous at the places of the 'pressing'. This may have been a variation of the ladder pattern, already noted for some swords from Khurasan,[80] in which the 'rungs' of the ladder were formed during the forging process by using a fuller, effectively to squash or compact and thereby interrupt the otherwise continuous pattern at intervals producing the 'rungs' of a ladder on the finished blade.[81]

Among the Salmāni swords were the wide or broad-bladed type of sword called the *bahāng*, four spans long and three to four fingers wide, weighing between three and three and a half *ratl* (approximately 1 kg or 2.2 lb). Another type was called the

[77] Kapp and Yoshihara, *The Craft of the Japanese Sword*, 85–87; Yumoto, *The Samurai Sword*, 105.
[78] As given in Sarraf "Close Combat Weapons", 173.
[79] See ch. 2, Kindi/Zaki, p. 15.
[80] See ch. 2, Kindi/Zaki, p. 24.
[81] Panseri, "Damascus Steel in Legend and Reality".

rathūth, usually with a neat, square makers-mark stamped on the tangs, near the end. Sword-smiths from Manṣūra, and Kindi assures us they knew what they were talking about, said that the only *rathūth* sword they had seen with a crack (possibly again a main flaw associated with the forging of a crucible steel ingot) had a serrated back, possibly a reference to a single-edged sword blade which really did have a serrated back, or possibly referring to the appearance of an unusual pattern along this part of the sword.[82]

The lack of a visible flaw on most of the *rathūth* swords would not necessarily mark them out as being of high quality, rather the reverse if the position of the flaw was considered important (assuming it was an inevitable by-product of the forging of a cast steel ingot). Bīrūnī seems to suggest that it was considered important to have this flaw showing,[83] perhaps a blade was considered suspect and possibly prone to failure if one could not see the way in which the flaw was incorporated into the design of the blade.

(28). Kindi goes on to state that while some of the *rathūth* type of Salmāni swords had serrated backs, most were simply filed (*kharīsha*), again suggesting single-edged blades. These are said to be of a similar length, with blades of about four spans (approximately 90 cm/36 inches) to those of the previous group but, at four fingers or slightly less in width, they were generally wider and they seem to have been particularly noted for their beautiful tips and broad tangs, like those of the broad-bladed Qalaᶜi swords.

The iron of all these types of Salmāni sword blades is said to be 'apparent without throwing', which probably means that the watered pattern was becoming visible even before the blade was coated with the etching preparation. This is perhaps to be expected if the steel was essentially of the same kind in each case. Kindi says that if a sword of this type was quenched with water and made 'hard and firm', probably tempered, then red etched, and its stamp removed with a hammer, the armourers of Khurasan, Mosul (in northern Iraq), Yemen, and Jibal (the westernmost province of Iran), but not of Iraq, might mistake it for a Qalaᶜi blade.

These swords weighed between 3.2 and 4.2 *raṭl* (approximately 1.3–1.2 kg or 3–3.2 lb), mostly near the upper end of this range, and the imported blades actually forged in Salmān were considered the poorest quality (of all the swords made of Salmāni steel), as shown by their coarse watering and 'unclear iron'. Possibly this latter quality was judged by the oilstone test yielding darker oil as before, but it seems unreasonable that the same steel should react differently to this test just because it had been forged in the area of origin. It therefore seems more likely that this clarity refers to the background of the watering, suggesting that the problem with the Salmāni swords, exported ready forged, was either that they were not forged to the same high standard as those made

[82] A serrated form of pattern did exist in this period although it has so far only been identified on some examples of (the *seax*) a large single-edged form of European dagger, as for example in Davidson, *The Sword in Anglo-Saxon England*, fig. 17.

[83] See Bīrūnī, *Jamāhir*, 255.

in Khurasan using the same steel, or that the Salmāni crucible steel would not form such a fine pattern.

The Sri Lankan swords

Kindi reports that these were forged in Sri Lanka, Khurasan and (as already discussed) in Yemen.

(29). Those reputedly made in Sri Lanka were said to be 'raw' (*nīy*), explained as not affected by fire, suggesting that they were left unfinished and only partially heat-treated when exported. This suggests that the sword-smiths who received them preferred to carry out any final heat-treatments, polishing and etching, retaining some control over the final quality of the blade, although not as much as if they had forged the blades themselves. Several interpretations are possible for what Kindi describes next.

Before these swords were exported they may have been both quenched and lightly tempered. That the watering is fine yellow and hidden would seem to indicate that these blades were indeed lightly tempered, using willow charcoal or the like, only as far as yielding a yellow surface colour (220 to 240° C), but not fully polished, the watering remaining hidden at this stage. Alternatively they could have been tested with a yellow etching preparation, again either yellow in colour, or thought to bring out yellow properties. The contrast of this gentle tempering with the more severe treatment favoured by the Baghdadi armourers suggests that the account here is slightly muddled or telescoped at this point and means to say that the Sri Lankan blades were exported to Khurasan and elsewhere in an un-heat treated state and were quenched and tempered at the sword centres they eventually reached.

Evidently the sword-smiths of Baghdad preferred to submit these Sri-Lankan blades to a more drastic heat-treatment (the *marjūh* process) of their own to bring out the watering (i.e. make it visible). After quenching, the blade was placed in the embers of a charcoal hearth until it was tempered or annealed sufficiently to have mostly softened the quenched blade, leaving just one section as 'the hidden part'. It is uncertain whether part of the blade (possibly the tip) was left untempered intentionally, possibly thereby obscuring the watering. The surface of the blade was then polished (clarified) and treated with an etching compound (medicament) to bring out the watered pattern.

Where the watering did not form in the way expected, a blade was referred to as *al-aṭlās* or 'worn away'. The description suggests that the etching preparation failed to bring out a watered pattern throughout, and that the pattern may also have been misshapen or sub-standard, with the metal in some areas appearing a darker colour, with a yellowish tinge. Again it is unclear whether this really referred to the actual appearance or perhaps the effect of a particular yellow etching agent.

The swords made of imported Sri Lankan crucible steel cakes at sword making centres in Khurasan were forged in hearths fuelled with oak or euphorbia charcoal. Kindi reports that these hearths 'took the iron violently and gave it the purest nature',

suggesting that they burnt hotter when using this type of charcoal. However this affected the purity or structure of the iron, it is likely to mean much the same as it did for the Baghdadi smiths' treatment of the imported Sri Lankan blades, which underwent a relatively more drastic heat treatment. Possibly quenching was followed by prolonged tempering or annealing at a temperature higher than was used for normal tempering (approximately 300 to 500° C), which would further modify the background steely matrix of the metal. Up to a point this would be likely to have had the effect of making the background matrix to the watered pattern paler on etching,[84] possibly to be equated with the idea of it having been made purer. A prolonged heat treatment may also have changed the structure in another way by favouring the growth of the white etching (iron carbide or cementite) elements of the watered pattern at the expense of the darker areas. This might also account for Kindi's remark that the sharpest of sword blades related to the 'raw' Sri Lankan steel, perhaps either ready forged or forged elsewhere from Sri Lankan crucible steel.

This steel was also exported from Sri Lanka to Manṣūra, the Arab capital of Sind. According to Kindi, Sind was known for a variety of sword blades – short, fine, delicate and broad – forged here from Sri Lankan steel.

(30). Even the wider Manṣūri swords are said to have measured only three fingers in width, apparently much narrower than the four fingers quoted for many of the Yemeni and Salmāni swords, or even the three to four fingers width of the Qalaᶜi blades described earlier. Of all the sword blades made in various places of Sri-Lankan steel those made in Manṣūra seem to have been considered the best, with the highest quality watering. They were thought to be the brightest and least 'yellow' of this type of blade, a testament to the skill of the Manṣūri sword-smiths both in their forging and in their heat-treating and finishing methods.

Before an etching preparation to bring out the watering was applied ('thrown' on) to the surface, the Manṣūri blades made of Sri Lankan steel were said to resemble a dusty red colour. Kindi reports that after etching, the background was red and the watering fine, with a slightly yellowish appearance. These Manṣūri swords were similar in shape to the plain Yemeni blades without grooves; but it is not stated if they were also narrower. Among them also were ones closely similar to a type once forged in Fars, in southwest Iran, but apparently no longer made there in Kindi's time, although surviving examples must have been recognisable. These sword blades were evidently famous for their engraved and gilded images representing 'the king at hunt', comparable to another type of sword made in Iran, 'the imperial' (*khusrawāniyya*), made of Salmāni crucible steel (*fūlādh*).

Kindi emphasises that it is the swords made in the Fars region of Iran from Sri Lankan steel that were reputed to have the broadest form of watering known for sword blades made of crucible steel, resulting from the manufacturing techniques of the Farsi

[84] A tempering or annealing effect in which the carbon of the steely matrix ends up dispersed as a mass of fine granular particles of iron carbide or cementite dispersed in alpha iron (ferrite).

sword makers who were using both locally produced crucible steel and imported varieties.

One form of iron apparently being brought to the steel and sword-making centres of Fars was not crucible steel, but one of the raw materials for steel-making. This iron is reported to have been brought in as large pieces of one cubit square (approximately 45–50 cm or 18–20 inches), but Kindi's description is slightly corrupted here and should perhaps read something like 'square section pieces, originally one cubit in length', as large square plates seem improbable; trade iron in bar form being almost certainly what was meant here. The Istanbul manuscript preserves the additional remark, that these pieces of iron were also known as *shababīt*, a type of fish, wide in the middle, with a small head and slender tail,[85] aptly describing an ancient form of trade iron of which examples known from several Assyrian sites (see Fig. 17). These bars typically had a pointed head end and a wider central part tapering to a narrower fish-like tail; most also having been pierced through the middle of the bar nearer the pointed end, perhaps to enhance the fish-like appearance[86] while demonstrating that the iron of this thick central part was of good enough quality to be pierced in this way. These are very likely to be bars of soft iron (*narmāhan*) brought to Fars to be cut up as feedstock for crucible steel making.

Steel or (white) cast iron in bar form is also mentioned in the passage on steel-making in the roughly contemporary text of Jābir ibn Ḥayyān, quoted by Jildakī in the 8th/14th century.[87] If white cast iron was also brought to the Farsi steel-processing centres it would be likely to have come as cast 'pigs', possibly in bar form, but is most unlikely to have been in fish-shaped pieces whose elaborate shape was probably linked both to quality and forgeability. A link to the production of crucible steel (*fūlādh*) for the manufacture of swords would seem most likely, since this is the subject of the treatise.

The description of sword-making in Multan reported by Bīrūnī two centuries after Kindi was writing, involved the very careful forging of the raw steel cakes.[88] A Russian visitor to Bukhara, Massalski, described much the same forging of steel cakes into sword blades eight centuries later[89] when he saw what may have been a surviving

[85] See ch. 2, n. 68 above.

[86] Bi-conical bars shaped exactly like this, also measuring about a cubit (approximately 0.5 m) in length, were found amongst a huge (160 ton/162,700 kg) store of iron found in a store at the short-lived palace of Dur-Šarrukin (the palace of Sargon II) excavated at Khorsabad, (approximately 30 km/ 20 miles) north east of Nineveh, built in the late 8th century BC, other examples having been found at Nimrud and Susa; see Pleiner and Bjorkman, "The Assyrian Iron Age", 293–295, and especially fig. 8. These authors also point out the widely held (and probably correct) view that the bars were forged to this shape so as to demonstrate the quality of the iron from which they were made, but the suggestion (p. 295) that the 'eye-holes' were to assist lifting seems much less likely as these were often pierced through a thicker part of the bars, an operation perhaps also linked to quality of manufacture – or the skill of the maker, whereas a lifting loop would have been more easy to forge from one end. Kindi's description suggests that this form of trade iron – that can also occur as 'bi-pointed bars' – had changed little in the intervening 1500 years.

[87] See appendix 1 below.

[88] Bīrūnī, *Jamāhir*, 256

[89] Allan and Gilmour, *Persian Steel*, 535–39.

example of the medieval crucible steel-making process still operating in the old Transoxianan (?Salmāni) steel making region, northwest of the River Oxus (now in Uzbekistan), shortly before this industry finally disappeared. Steel may have been traded in bar form as well as in the form of raw cast cakes. The Jābir text suggests that steel was sometimes cast into bar form before being forged into the shape required. The Jābir passage relating to white cast iron manufacturing mentions that it was cast into bars either for the direct manufacture of (cast) iron objects, or for further processing into steel, as Jābir goes on to describe.[90]

(31). The White Swords

Of Kindi's two types of 'white sword', only the Farsi variety was still being produced. The other he says was made early on at Kufa (in southern Iraq). Presumably 'the earliest times', refers to the fact that Kufa was founded soon after the Arab conquest of Iraq in the *ca* 14/635 as a garrison city for troops, and so was likely then to have been important for weapons manufacture. Kufa was eclipsed once the city of Baghdad to the north was founded in 145/762, becoming the capital of the Muslim world. Kindi only describes their appearance, not how they were made, suggesting that the manufacture of this type of sword in Kufa was short-lived and had already ceased by his day. A short production span may have made them rare.

Some of the Kufan blades had a dent-like depression that evidently brought out a different characteristic of the blade. Maybe what is meant is a depression forged into the blade causing a disruption in the otherwise even watered surface pattern. Kindi describes them as short delicate swords, with blades three spans and four (open) fingers long, clearly also narrow, at most being three fingers wide, with correspondingly slim tangs pierced twice near the end. These blades were thicker towards the tip of the blade, which was also tapered along its edges, towards its rounded point or tip described as the *tadwīr* or 'rounding'. The edges are described as being fine, like those of the Qalaᶜi, suggesting that they were marked out and possibly selectively quenched.[91]

The Kufan blades were particularly known for their even watering without the knotted patterning characteristic of the Qalaᶜi swords. Kindi tells us that these early Kufan swords were among those forged by Zayd, a well-known and respected sword-smith and perhaps also the figurehead of a school of sword-smiths in Kufa. The watering on these Kufan white swords is described as looking like flowers (*mushajjar*), indicating a repeating flower-like pattern.

These Kufan white sword blades apparently had a watered pattern in which the floral (*mushajjar*) appearance was interspersed with watering of a non-floral appearance; indicating the sword to belong to the indigenous (*muwallad*) medium quality category. This section of the treatise appears to be dealing mostly with the

[90] See appendix 1 below.
[91] By protecting the central parts of the blades from the effects of quenching – see also the commentary to Kindi/Zaki, p. 19 in this chapter.

details of the 'modern' or standard quality (*muḥdath*) category of swords. Among this group of early swords he describes some of which 'the quenching is not clear', described as having 'floriated' iron, perhaps relating to the particular appearance of the quenched parts of some of these blades, these presumably being of not such high-quality appearance. The additional surface patterned effects described here depend on the quenching, and possibly further heat-treatment, and can be best compared to the traditional Japanese sword-smiths' variations in selective quenching of the edges of blades to produce different decorative effects, for some of which floral would be an apt description.[92] The effects may also have been varied either by the rate of quenching (i.e. fast or slow/slack quenched) or in the degree or extent of heat-treatment following quenching.

Others of this early category of Kufan white swords had two bands (*wishāhayn*) along the edges. Either the sword blades were selectively quenched along their edges, or selectively resist etched, bands along their edges being protected from the effects of etching by a greasy or waxy preparation. Both selective quenching and resist etching could of course have been used.

Clearly these Kufan white swords were double-edged, and straight, and they were also reputed to be the most enduringly sharp during battle, more so than the Farsi blades and all other swords. The quality of the steel and the skill of the early Kufan sword-smiths in (partial) quenching and tempering, giving the maximum balance of resilience and hardness ensured this reputation, probably judged on appearance, another reason why the etching procedure was so important. Consequently the Farsi swords, resembling the Kufan swords of the same type in weight and shape but not in surface appearance or length, fetched a much lower price. The Farsi white swords were at least three fingers longer than the equivalent Kufan blades and unscrupulous smiths were not above altering a Farsi blade, which must also have been straight and double-edged, to resemble the Kufan variety more closely.

(32). To those suspecting the fraudulent sale of a Farsi sword altered to look like one of the Kufan blades, Kindi advises first dismantling the hilts to reveal the very different tangs, those of the Farsi swords being not only two fingers longer but also thicker and wider than the tangs of the Kufan white swords, also called the *Zaydiyya*, after their most acclaimed maker. As well as other differences in 'fineness and breadth' between the Kufan and Farsi types of white sword, the Farsi sword blades could be distinguished by qualities of the metal here referred to as their 'nature'.

The 'nature', presumably the watering, of the Farsi blades is said to be broader than that of the Kufan blades. By contrast, the 'nature' of the Kufan blades is said to be purer, more luminous and to resemble that of the 'ancient' (*ʿatīq*) or highest quality type of blade, probably referring to the best Yemeni blades spoken of in these terms earlier on.[93] The watering on the Kufan blades evidently did not appear during

[92] For a description and discussion of this process as used in traditional Japanese sword-making see Kapp and Yoshihara, *The Craft of the Japanese Sword*, 85–123.
[93] See commentary on Kindi/Zaki, p. 8 in this chapter.

polishing,[94] but only after application of the etching substance. What is meant by the hidden bit is not explained, but it seems likely to have been an area intentionally left unwatered by protecting it from the effects of the etching preparation. He says earlier 'the place of the watering can be small or large'[95] indicating that only parts of some blades were treated to reveal the inherent watered pattern.

Kindi goes on to say that they are blue of iron before being treated with, or in the areas left untreated by, any etching preparation used to bring out the watering, and also that this blue iron is greenish-white. Blue here may refer to the colour temperature of the tempering treatment used following quenching. After polishing off the surface oxide film the steel may still have been thought of as having a blue quality, but with an eventual greenish-white surface along the edges, which were probably, left unetched. The greenish aspect is more difficult to interpret but may relate to the colour of the etching preparation.

Unlike the Kufan white swords, the Farsi blades were thicker and heavier towards the tang than towards the tip. The largest and best looking of the Kufan white swords would fetch as much as much as eight *dinars*,[96] whereas the least well regarded would fetch as little as two *dinars*, or even, for those considered very underweight, one *dinar*. The Farsi white swords were worth less than the Kufan variety, and the care with which Kindi differentiates between these varieties suggests that the whole range of Kufan swords was considered better.

The Frankish swords

Kindi uses 'Frankish' as a general term to refer to people from northwest Europe, including Vikings living in Russia. 'Frankish' swords are described as having 'broad lower parts', referring to most of the blade, but also a well-shaped tip similar to that of the best Yemeni swords. The 'single broad groove in its middle like a clear river' refers to the wide fullered (after the tool used to forge it with) groove found in the great majority of northwest European swords of the third/ninth century. The term 'river' refers specifically to those swords in which the fullered central part of the blade was also pattern-welded.

The likening of the pattern-welded, fullered parts of these blades to 'strange Tabari (brocade embroidered) clothes, and to rings of mail armour, aptly describes the appearance of the pattern-welding on the surface of many well preserved swords of this period, recovered from waterlogged locations like river-beds. By now European pattern-welding for swords, was becoming simpler and usually consisted of a chevron pattern occupying just the fullered part of these composite blades. From the slightly distorted appearance of the surface patterns on better preserved examples it is clear

[94] In contrast to the Salmāni blades – see in this chapter, Kindi/Zaki, pp. 26 and 28.

[95] See ch. 2, Kindi/Zaki, p. 24.

[96] This is about half the price Kindi quotes earlier for the better Qalaᶜi swords, which fetched 5 to15 *dinars* depending on quality, and much less than the 50 to 100 *dinars* that the best Yemeni blades would fetch (see ch. 2, Kindi/Zaki, p. 22).

that some degree of grinding usually took place, before the final polishing and etching of these blades, presumably to remove surface imperfections along the fullered grooves. Each element of the chevron consisted of a twisted composite rod, hammered flat, but an undistorted chevron effect achieved by welding two rods side by side would only remain if none of the surface was removed. As more of the surface was removed the elements of the chevron became more distorted to reveal distorted shapes, many resembling brocade work or the rings of mail armour. Kindi reports that none of the patterns were visible before etching, but afterwards the pattern-welded areas were 'white of ornament and red of ground'.

Analysis of contemporary examples reveals that the standard technique for producing the pattern-welded elements of swords was to make up a twisted laminated piece consisting of up to about eight interleaved layers of highly phosphoritic iron and low carbon iron (the latter roughly equivalent to modern mild steel).[97] It was the phosphoritic iron that gave the white elements to the pattern described by Kindi, whereas the low carbon iron would have provided a contrasting darker background. Again it is unclear why this was regarded as reddish. Perhaps it refers to some associated quality, like the colour of the etchant used or the surface discolouration it produced before any excess was removed.

(33). The blades with wide pattern-welded fullered grooves were also known for having additional ornamentation consisting of applied pieces of gold or 'yellow copper' (brass) in the form of crescent moons and crosses. These pieces may have been fixed in place by by incising lines and hammering in gold or brass wire ('nails'). A similar technique was evidently used for some of the Yemeni blades Kindi discusses. The Frankish swords, the blades (at least the parts on either side of the fullered central zones) are described as being curved (convex in profile), similar to the *Dāsaktayn* swords (probably another type of double-edged sword).

Kindi reports that the parts of the blades of Frankish swords on either side of the central fuller were not pattern-welded, confirming surviving evidence of pattern-welded sword-manufacture in northwest Europe at this time. Here the use of pattern-welding for swords had already begun to decline and many high quality swords were no longer made using this technique, but Kindi's remark implies that this form of pattern-welded sword was still considered the 'standard' form of 'Frankish' sword. The form of blade profile, with a wide central groove or fuller had become the most common shape for sword blades across northern Europe, perhaps progressively in the course of the previous century.

Interestingly Kindi says that for these pattern-welded blades the central groove or fuller stops short of the actual tip of the blade by three fingers or a bit less and adds that 'in those three fingers is the like of an incision'. Most likely this line would have marked the site of a weld line between the two halves of the cutting edges of these blades, in the area between the end of the pattern-welded hollow groove and the tip of the blade. Analytical work has shown that the cutting edges were hammer-welded on

[97] See Gilmour "The patterned sword ", 117.

to either side of the composite pattern-welded core, although this lower weld is not normally visible on the corroded surfaces.

By defining the 'Frankish'[98] and (one form of the) Sulaymāni swords as two sub-types of a larger category of composite sword made of 'hard' and 'soft' iron, this in turn under the main category of 'mined' iron (by which he can only mean iron of bloomery origin). Kindi has said succinctly that these Frankish and (this type of) Sulaymāni swords have composite blades made using a combination of bloomery iron and steel. The few pattern-welded swords of this period to have been analysed suggest that it was even usual to weld edges of steel, or composite iron and steel, on to a composite pattern-welded core, mainly consisting of laminated phosphoritic iron and low carbon iron pieces.[99] The tips of these 'Frankish' blades are also said to be more tapering than those of the Yemeni swords, so the latter must also have had straight double-edged blades.

The Sulaymāni swords[100]

The comparison to 'Frankish' swords implies that these were also straight double-edged swords, although different in other details. They are described as composite blades made of combinations of bloomery iron and steel; little more is known. The reference to the 'ornamented' parts of the 'Frankish' swords must refer to the pattern-welded central section, implying the same for this type of Sulaymāni sword, indicating that they were pattern-welded. They were 'more lustrous', probably meaning more highly polished, and also 'stranger of manufacture', and they looked different in style, with proportions that looked awkward, misshapen or unbalanced by comparison.

Both ends of these swords were evidently even and not tapered, therefore not at all pointed, which seems to mean that the end of the blade (and perhaps the hilt) was blunt, but curved. The tangs were similar to those of Frankish swords. Iron pommels of a 'cocked-hat' or a lobed style were typical for contemporary northern European swords, so Kindi may well be comparing them to something like this. The yellowness of the composite pattern-welded construction is unlikely to refer to the colour of the metal, but may refer either to the colour of the etching preparation, or to the colour taken on during its application.

Kindi found the ends of these blades too narrow and/or too thin compared to the proportions of the hilt. Little pattern-welding was incorporated into the end part of the blade. No non-ferrous decoration was used nor was there an iron cross guard. The tangs were similar to those of Yemeni and Frankish blades, but thinner or more

[98] See ch. 2, Kindi/Zaki, p. 12.

[99] See Fig. 20 (under pattern-welding in the glossary below) for a diagram showing a reconstruction of the structure and appearance of a series of (probably 6th/7th century AD) Anglo-Saxon pattern-welded swords.

[100] Here meaning swords of bloomery iron/steel, not crucible steel. If the terms Salmāni and Sulaymāni do refer to the same area, then this area, presumably in Central Asia, must have produced swords using crucible steel related and bloomery smelting/composite welding techniques (see also ch. 2, n. 12 above).

spindly than the Frankish tangs. Despite their appearance these sword blades were regarded as being of quite good quality.

The indigenous swords

Kindi returns to the group of indigenous (i.e. not foreign) swords made of crucible steel. The medium quality indigenous Khurasani blades were of a type referred to as 'liberated' (*al-muḥarrar*) – possibly in the sense of stolen design – and were forged in Khurasan, presumably from local ores (hence indigenous) to the shape of certain Qalaᶜi blades, probably intentionally being made as counterfeit or fake Qalaᶜi blades.

(34). They were covered with transverse rows of small knots, a particular variation of the watered pattern inherent in these blades, probably achieved by making a series of indentations in the red-hot blade with a narrow, circular punch (which Kindi calls a chisel). The upstanding surrounding metal was then ground down to the level of the bottom of the indentation.

For most watered blades the watering forms as a result of the tendency for a layered structure of (white cementite) iron carbide particles to develop within the steel during the heating and forging cycles necessary for forging out a sword blade (or another type of object).[101] The effect of making an indentation with a circular punch is to compact the layers that have formed in the steel in a localised area. Once the surrounding part of the blade had been ground down an increasing density of layers would remain in this localised area. After polishing and etching the watering would appear denser and hence knot-like in these areas. The use of a very fine punch would yield a smaller 'knots' like peppercorns, as observed by Kindi. The rows of 'knots' were so designed that these blades closely resembled the knotted pattern for which the Qalaᶜi swords were known.

As explained earlier,[102] the blackness of the iron related to a testing procedure in which the surface of the blade was rubbed with an oilstone. If the oil ran black (as opposed to being left much clearer), the blade was identified as a counterfeit Qalaᶜi blade made in Khurasan. These blades were narrow, the broadest of them only two and a half fingers wide, narrower than the three to four fingers given earlier.[103] There may have been no clear dividing line between the width of the genuine Qalaᶜi blades and the counterfeit blades made in Khurasan.[104] The Qalaᶜi blades were probably up to three to four fingers wide, some being less. Elsewhere it is said[105] that a Qalaᶜi blade of two and three-quarter fingers in width would generally fetch ten to fifteen *dinars*.

[101] A series of detailed investigations carried out recently (see Verhoeven *et al*, "The Key Role of Impurities", 58–64) has revealed that this effect is almost certainly largely the consequence of the dendritic segregation of certain trace impurities, particularly vanadium, during the solidification of the steel cake in the crucible during the manufacture of the steel, followed by subsequent heating and forging cycles during which this segregation persists.

[102] See ch. 2, Kindi/Zaki, p. 24.

[103] See ch. 2, Kindi/Zaki, p. 23.

[104] See ch. 2, Kindi/Zaki, p. 24.

[105] See ch. 2, Kindi/Zaki, p. 22.

Kindi adds that the watered structure (which he calls the nature) did not usually appear during the polishing (unlike in some swords) but only after the polished surface has been treated with the etching medium (after 'the throwing'). But a hint of the pattern might be visible before etching with darker areas beginning to appear. He says that these blades had small cuts or holes in the tang, and that when successfully forged to look like a Qalaᶜi blade could fetch as much as thirty *dirhams*.

Kindi's description of indigenous Basran swords indicates a 'knotted' structure already in evidence during polishing and before etching. The 'knotted' patterning was similar to that typical of Salmāni swords and, perhaps to a lesser extent, to Yemeni blades. This pattern is described as 'smooth' and 'supple' with a darkness (of background) revealed in bright sunlight. The marks of the polishers – forging, grinding, or polishing marks – were still visible, suggesting that a better standard of finish might have been expected. The blades were broad but thin in section and of widely varying lengths, different in shape to the Salmāni or Yemeni swords to which they were nevertheless compared.

The only Basran sword-smith to forge this kind of sword was Sulaymān, in the period 95–109/714–727. The next part of the text is difficult to interpret and has possibly become slightly corrupted. In similar contexts 'throwing' referred earlier to the etching procedure used on a polished sword blade to bring out the patterned structure or 'nature' of the blade, but this interpretation seems not make sense here as Kindi would appear to be referring to additions to the iron in the crucible during the steel manufacturing process. What is perhaps meant by their nature staying hidden is that no coherent pattern will form on these blades when they are etched. In his earlier description of the indigenous type of Basran sword[106] Kindi says that the watered pattern failed to form in some places in these blades because of incomplete mixing of the initial iron charge in the crucible resulting in some parts of the steel ingot still containing areas of soft iron within it.

(35). Some of these swords fetched two and a half *dinars*, as much as some Yemeni swords. Those with thin tangs and 'distorted'[107] shapes did not fetch more than four to six *dirhams*. All the description relating both to the making and selling of Basran swords appears to be referring to some hundred or so years earlier.

Another of the indigenous category of sword was the Damascan,[108] but it was one that had not been made for a long time to judge from Kindi's reference. Earlier on

[106] See ch. 2, Kindi/Zaki, p. 19.

[107] Possibly meaning curved.

[108] This reference should not be confused with the misleading modern notion of Damascus as being the source of much watered crucible steel from which this type of steel is supposed to have taken its name. The mainly western preoccupation with Damascus as an eponymous steel and sword making centre appears to stem from the (mis)reports and experiences of European visitors to Damascus, probably no earlier than the 9th/15th Century when this idea seems to have taken hold. As early as the 11th/17th Century Dr Robert Boyle of the Royal Society of London sent an envoy to Damascus to investigate these claims but he failed to find any evidence that this fabled industry existed, or had done in living memory (see Moxon, *Mechanick Exercises*, 57). Much more recently Dr Robert Elgood (see *Arms and Armour of Arabia* appendix 2, 103–107) has explained this problem in detail, but he could find no textual evidence

Kindi had previously stated[109] that they were made in Damascus in 'olden times' the implication being that these swords, although still available in Kindi's day, had ceased to be forged before any of the other swords discussed. The type could have been made in the late pre-Islamic or very early Islamic era, 6/7th century AD, if not earlier.

Unlike much of the detail Kindi describes for swords his information for both the Basran and Damascan indigenous types of sword clearly came from written sources. This is also suggested in the case of the Damascan swords by Bīrūnī writing two centuries later, who refers to Kindi's treatise as being included with another written source describing the manufacture and use of crucible steel, attributed this to an earlier sword-smith of Damascus called Mazyad ibn Alī.[110] The Damascan swords looked similar (presumably in shape) to the Manṣūran swords made from Salmānī steel; but although the steel resembled that of the 'white' swords in appearance, it had different physical properties. They evidently had the reputation for being the sharpest of the indigenous swords and would therefore fetch fifteen to twenty *dinars*.

Indigenous Egyptian swords were apparently exceptionally long and were noted for having even or equal faces – perhaps referring to a smooth, symmetrical double-edged appearance – and they are reported to have been made from imported Basran steel. This type of steel (perhaps rather than the swords) cost ten *dirhams* (probably for each cake) and from it were forged other presumably watered types[111] as well as a plain type and others not named.

(36). The soft iron swords

Kindi says that all swords of the Byzantines and Kharijites,[112] as well as some from India, were made solely of this 'soft' form of directly smelted (i.e. bloomery) iron, presumably including any bloomery iron whose carbon content was too low to be hardened by quenching. Indian swords made of this type of iron were also noted for their distorted and curved shape, very unusual at this time in the Middle East. It appears these particular Indian swords normally had file marks left on the surfaces of their blades, which were also plain in the sense that they were not of composite, pattern-welded construction. By contrast the Byzantine and Kharijite swords, which were also reputedly distorted (unusual?) in shape, were long and narrow and would have had straight, double-edged blades. The character of the iron of these blades was also referred to by the Persian term *kahr balām*.

for the idea that Damascus was ever a noted sword or crucible steel-making centre. This idea (and the various other adoptions of Damascene as a descriptive term) seems to originate with late medieval Western contacts with Damascus as a key trading centre and focal point for material coming from much further east, including watered steel swords. This term is little if ever used in medieval Arabic texts, and the name Damascus does not seem in any way to imply watering, as stated by some recent authors (for instance Sachse, *Damascus Steel*, 13); see also the entry in the glossary below.

[109] See ch. 2, Kindi/Zaki, p. 11.

[110] Bīrūnī, *Jamāhir*, 256.

[111] Kindi mentions several swords with Persian-sounding names.

[112] Or the Shurat, see ch. 2, Kindi/Zaki, p. 12.

Chapter 4

Swords in Arabic Poetry

Mark Mühlhäusler and Robert Hoyland

F. W. Schwarzlose's
"The weapons of the ancient Arabs as presented in their poetry":

A contribution to the history of the Arabs and to Arabic lexicography

[54][1] The sword enjoyed the highest prestige among the weapons of war. On the way to battle or while travelling, the Arabs carried the sword in a container (*qirāb*), as is shown in this line from Imruʾ al-Qays[2] [d. *ca.* 550]:

> "As if I were sitting, with saddle, container and pillow/
> when at noon the pebbles are set ablaze, on a snorting ostrich…//"

When a man put on his sword, he would wear it on a belt (*nijād, ḥamīla*) strapped over both shoulders.[3] In the early period, this way of carrying the sword may have been the only one, so that the poets could say (Jawharī, *s.v.* "q-m-r"):

> "Know that there will not be a truce between you and me as long as my shoulder will carry/
> my sword, as long as we are still in Najd, and as long as the turtle dove coos on top of the branches//"

and al-Ḥutayʾaʾ[4] [d. *ca.* 40s/660s]:

> [55] "Brave young men from the tribe of ʿAdi/
> carrying swords from Buṣrā on their shoulders//"

This would also explain the use of the verb of *irtidāʾ* as a trope in the sense of "to wear a sword".[5] The expression *taqallada al-sayf* is to be understood in the same way,

[1] What is in square brackets, whether dates, page numbers (of Schwarzlose's book), or comments, has been inserted by me (RH). See figs 1–2 for swords from a pre-Islamic Arabian context.
[2] *Diwans* 6, Imruʾ al-Qays, 34, 9 [First number refers to no. of the poem, the second to the line no.].
[3] Freytag, *Einleitung*, 255, supported by the explanation of *muqallad* in Fīrūzabādī, *s.v.*
[4] Iṣfahānī [d. *ca.* 363/972], II.48, 17.
[5] Mutanabbī [d. *ca.* 354/965], 211, 9 from the bottom.

for [the lexicographers] Jawharī [d. 398/1007] and Fīrūzabādī [d. 817/1415] state explicitly that *muqallad* is the part of the shoulder that is touched by the shoulder belt. However, the sword was also worn on a waist-belt, although this may be a later custom. The terms *tawashshaha* and *ittashaha bi-l-sayf*[6] ("to don the sword-belt") were used, and in the corpus of the *Hudhaylī* poets [who lived between *ca.* 550 and 81/700] the sword is called *wishāḥ al-ṣadr* ("the belt of the breast") in an apposition. *Al-wishāḥ* was also a name for a sword; according to Fīrūzabādī this was the name given to the swords of Shaybān al-Nahdī and that of ʿUmar ibn al-Khaṭṭāb [the second Muslim caliph, r. 13–23/634–44] – unless the sword of the latter was called *dhū l-wishāḥ*, for the relevant passage is not clear on this point (*wa-l-wishāḥ bi-l-kasr sayf Shaybān al-Nahdī wa-dhū l-wishāḥ min Banī Sawm ibn ʿAdī wa-sayf ʿUmar ibn al-Khaṭṭāb raḍiya Allāh ʿanhu*). Finally, by way of metonymy, the word *al-wishāḥ* acquired the meaning "sword" in general. Both ways of carrying the sword are described appropriately by the verb *kasā*,[7] which was used in poetry to refer to the act of putting on a sword as well as armour.

I mentioned above that the Arabs would at times carry more than one spear. From this verse by ʿAlqama[8] [fl. 1st half 6th c.], one may conclude the same about the sword:

> "Clad in two layers of mail, and on top of these/
> two swords, called Rasūb and Mikhdham//" [56]

One would assume that one sword was worn on the right, and the other on the left. From a later period we have a report that whenever the caliph Muqtadir [r. 295–320/908–32] rode out, he would wear another sword on his left (*taḥta fakhdhihi al-aysar sayf li-l-rukkāb*)[9] in addition to the sword of the Prophet. It appears that this would have been an exception in the early period. In general, the Arabs carried only one sword of superior quality in which they could trust completely, and which was therefore sufficient for them. In a sense, a sword became a part of its bearer. Such a close relationship – which also exists in German legends between the heroes and their (only) sword – would not have permitted the use of more than one weapon. Although we may be dealing here with an exception to this, we have to bear in mind: first, that the early poets repeatedly took license to use the dual instead of the singular,[10] a particularity which is even found in the Qurʾān; and second, that the poet's aim was to glorify his hero, and that therefore he exaggerated. Thus we conclude that ʿAlqama merely builds on the motif of duality which was so popular among the poets, even though he gives two names for the swords. It is possible that this was prompted by the reference to the double coat of armour in the same verse.

[6] Mubarrad [d. 285/898], 599, 10.
[7] *Ḥamāsa*, 188, 5 from bottom, and commentary, 189, 1.
[8] *Diwans 6*, ʿAlqama, 2, 27.
[9] Kosegarten, *Chrestomathia*, 108, middle.
[10] *Hudhayliyyīn*, 124, 20 [First number refers to no. of the poem, the second to the line no.].

The fight with the sword followed after the battle with the spear, as in the following line by ᶜAntara [fl. 2nd half 6th c.].[11]

"On that ill-fated day we fought the second round with our swords".

The battle began with the cry *nazāl*, "dismount!",[12] and was conducted[13] on foot[14] [57]. Various lines of poetry clearly attest to the fact that a descent from horseback was meant here, and not from the back of a camel. The latter was used only on the way to battle, while the horse rode empty alongside the camel.[15] Compare this line by ᶜAntara:[16]

"And trustworthy men without number fight/
on horseback or on foot, with the steel of Mashraf//"

and also Zayd al-Khayl [fl. early 1st/7th c.]:[17]

"My sword inspires fear when I call:/
Dismount! And Salāma knows this//"

And most clearly Ḥātim al-Ṭāʾī [fl. late 6th c.]:[18]

"Those who fight with their swords, while standing close to their reins/
who thrust their spears from the backs of graceful swift horses//"

Only the bravest participated in this battle, while the others fled.[19] The opponents were closer to each other, and the increased danger required a greater degree of bravery than all the other stages of battle: man stood against man, and there was no chance of escape. Ibn al-Aḥmar [fl. 1st half 7th c.] said (Jawharī, *s.v.* "gh-r-r"):

"With his sword he encircled them from all sides/
like eagles circling around chickens and hens on a field//"

The poets like to refer to this topic when trying to emphasize the superiority of their own tribe over its opponents. For although we sometimes find equal praise for both parties in the so-called *munṣifāt* ["equitable poems"] – of which the *Muᶜallaqa* [the name applied to seven poems considered to be the best of those composed before

[11] *Diwans 6*, ᶜAntara, 15, 6.

[12] Mubarrad, 269, 2; ᶜAntara, *Muᶜallaqa*, v.47: "One bristling with weapons, whose dismounting the brave watch out for".

[13] Mubarrad, 66, 19 (Kaᶜb ibn Mālik [d. *ca.* 50/670]); cf. *Ḥamāsa*, 57, 9.

[14] *Hudhayliyyīn*, 30, 2.

[15] Cf. the description: "It (the horse) nudges with its shoulders the sides of the camel, like a tender bough bending from side to side among the branches" in *Diwāns 6*, Imruʾ al-Qays, 65, 14.

[16] *Ibid*, ᶜAntara, 20, 15.

[17] Mubarrad, 269, 2.

[18] *Ibid*, 452, 6.

[19] *Diwans 6*, ᶜAntara, 20, 15; 19, 11: "When to us no other goal is known except descent to battle/ those unqualified for combat and the weak think only of flight//".

Islam] of ʿAmr ibn Kulthūm[20] [fl. 6th c.] is considered one, **[58]** because of its verses in praise of the swords of both parties – it was still customary to give preference to one's own tribe. This preference was expressed not only through praise of bravery in battle, but also in descriptions of weaponry or lesser or greater speed in moving to battle.[21] As for weaponry, the sword is usually associated with the favoured party. ʿAbd al-Shāriq[22] let the enemy return from battle with spears, while his own tribe returns with swords, thereby giving higher praise to the latter. Kaʿb ibn Zuhayr[23] [fl. 1st/7th c.] praised the companions of Muḥammad by using *ḍaraba* [strike (with a sword)] for them and *ṭaʿana* ["thrust" (with a spear)] for their enemies. And Zuhayr [d. 609] praised his hero in the following words (*Diwans* 6, Zuhayr, 9, 31; cited in *Ḥamāsa*, commentary, 221, 5 from the bottom):

> "When they thrust, he shakes his spear, when they strike/
> he reaches for his sword, until they strike at him, and he grabs their waist//"

The highest stage of battle, that of wrestling (ʿ*ināq* "to grab s.o. at the waist or the neck in battle", Rasmussen, *Additamenta ad historiam Arabum*, 59, last line; *iʿtināq*, Wellhausen's edn. of *Hudhayliyyīn*, Arabic text 32, poem no. 184, v.6; *muʿāniq*, *ibid.* 125, v.75.), is also mentioned elsewhere. Compare, for instance, the verse of Ibn al-Ruqayyāt [d. *ca.* 80/699] quoted below, as well as that of Muslim ibn al-Walīd [d. 207/823], 66, v.38: "They greet each other with the points of their spears, and embrace with an embrace of hatred, not of love"; and finally, Jawharī's commentary on the word *ḥarb* ["combat"]: "Combat is shooting arrows at one another, then thrusting at one another with spears, then contesting with the sword, then wrestling if there is a crush" (cf. the list in Mubarrad [d. 285/898], 647, 5: "Combat begins with shooting arrows, then casting spears, then drawing swords"). Compare further the passage in Kosegarten, *Chrestomathia*, 69, 12 ff.: "And when he did not achieve his aim, he threw his spear aside, and sought to draw near to his foe; he unsheathed his sword, swung it in his hand **[59]**, and attacked his enemy, screaming loudly. The hands of his enemy trembled at his cries. But Jundaba attacked him and stretched out his hand towards him. He got hold of his armour, pulled it off, then lifted him from his saddle, and threw him into the air. Then he went to him and bound his hand on his back with the head cover". The opponent in this case was a woman called Qattāla al-Shujʿan, who had never been vanquished by any man. In fulfillment of her vow, she later became the wife of her victor.

In one of his verses[24] Mutanabbī [d. *ca.* 354/965] went further than the early poets in that he not only ascribed a glorious victory to the use of a sword, but also exposed the spear to ridicule, which led his commentators to call the spear the weapon of

[20] (ed. Kosegarten), 60, commentary on v.43.
[21] *Ḥamāsa*, 219, 17; 221, 3; *Hudhayliyyīn*, 49, 5: "They moved on like a cloud of hail, while we rushed like the wind chasing the clouds".
[22] *Ḥamāsa*, 221, 7 from the bottom.
[23] *Carmen*, v.57–58.
[24] Sacy, *Chrestomathie*, III.12, 11.

cowards.[25] This kind of hyperbole, which would be more justified with regard to the bow and arrow,[26] is not found in early poetry. On the one hand, swords were considered the fortresses of the brave[27] (*khanādiqunā suyūfunā* "our swords are our trenches",[28] *maᶜqilī fī l-barāz* "my fortress in the desert"[29]). On the other hand, death by the sword was thought to be the most honorable way of dying. Al-Samawᵓal [fl. 6th c.], for example, praises his tribe by saying:[30] "Our life-blood only flows over the edge of swords".[31] **[60]** The commentator, however, took this verse to refer to death in battle in general, in contrast to the treatment of ᶜAbīd al-ᶜAṣā by Ḥujr [ibn al-Ḥārith, father of Imruᵓ al-Qays].[32] Yet the poet may well have intended higher praise by his focus on the sword to the exclusion of all other weapons, just as the sword-fight was the most prestigious part of battle.

Zuhayr likened the hovering fog in the desert to a sword-fight:[33]

"I crossed it, while the hovering fog looked like swords/
which, raised for battle, clash in the air//"

And indeed, the term *ẓilāl al-suyūf* ["shadows of the swords"], which is based on the image of an intense (and therefore perilous) battle, was often chosen by the poets of the period. In a verse by Ibn al-Ruqayyāt,[34] this motif is found side by side with a reference to wrestling:

"My hair has gone grey in the shadow of swords/
and because of wrestling among the blond-haired people//"

A verse in *Ḥamāsa*, 773, 1 [this is a corpus of poems compiled by Abū Tammām, d. *ca.* 232/845] likens swords to a cover against the sun, a simile that is based on the same idea. However, in *Ḥamāsa*, 788, 7 from the bottom, a *real* sunshade (created from a mat suspended over swords) is meant.

So much for the early poets. The later ones based their descriptions of battle on the image of swords sparkling amid the dust of battle, at times substituting them with spear-points. Bashshār ibn Burd [d. *ca.* 167/784] has this line:[35]

[25] *Ibid.*, 53.

[26] *Ḥamāsa*, 63, 4 (a verse by al-Ḥārith ibn Hilāl, a contemporary of Muḥammad).

[27] *Diwans 6*, Zuhayr, 15, 43; Iṣfahānī, II.165, 4 from the bottom (Ḥassān ibn Thābit [d. *ca.* 40/661]); *ibid*, 168, 16 (Dirham ibn Zayd).

[28] Mubarrad, 627, 14. These words are attributed to ᶜAbd al-Rahmān ibn Mikhnāf, in response to al-Muhallab's warning that he should entrench himself during the wars with the Kharijites.

[29] Mutanabbī, 305, v.8; cf. the verse by Kaᶜb ibn Mālik (Mubarrad, 282, 10): "The people have become our enemies because of you/ only our swords and spear protect us//".

[30] *Ḥamāsa*, 52, 17.

[31] Compare a similar verse in the commentary and Ibn Durayd, v.88.

[32] Delitzsch, *Jüdisch-arabische Poesieen*, 23, bottom.

[33] *Diwāns 6*, Zuhayr, app. XII.1.

[34] Ḥarīrī, commentary 128, 8 from bottom. The same verse is in Mubarrad, 303, 7, with the variant "spear battle" in the second hemistich.

[35] Mutanabbī, commentary 121, 12 (also cited by Mehren, *Die Rhetorik*, 22) from Iṣfahānī (entry "Bashshār") III.22, 9 from the bottom; 48, 1.

"The dust above our heads, and our swords in it/ **[61]**
resemble the dark night with shooting stars//"[36]

And the commentators to Mutanabbī quote the following line:[37]

"A sky is raised by the horses' hooves around us/
in which the points of spears twinkle instead of the stars//"[38]

Less appealing to us is the image of "a cloud of dust so black that it makes the sword seem like the smile or the white-haired nape of an Ethiopian".[39] However, the ancient poets already alluded to this image when they described a fierce battle as "a day shrouded in darkness, in which the stars appear".[40] It is even clearer in the verse of Jarīr [d. 111/729]:[41]

"On the day that a cloud of dust concealed the sun/"

The sword stands out from among all other weapons not only because it was the weapon of the bravest of the brave, who resisted the enemy in a man-to-man fight; there was also a special relationship between the sword and its owner. This relationship between sword and man was a close one, unlike that of all other weapons. For example, we find examples of real personification of swords, while other weapons only receive attributes of living beings, like liveliness (*murūḥ* – for the bow) and competitiveness (*rawāʿif* – of spears). A sword, on the other hand, was not only a witness to man's bravery,[42] but is also his steady companion in danger.[43] It saved its owner, when everyone else had fallen[44] **[62]**, and offered protection in all circumstances.[45] It was a friend who never disappointed, as in the following line (Jawharī, *s.v.* "ṣm-ṣ-m"):

"A friend, whom I never disappoint, who never disappoints me/
Hail to you, oh Ṣamṣāma, the sword that never fails//"[46]

A sword allowed its owner to make do without other companions,[47] whom he either shuns out of pride,[48] or who have forsaken him. With the sword as his sole ally, he could face the storms of time, and was not betrayed on a day of battle.[49] Hence al-

[36] In the commentary to Mutanabbī, 121, 11.
[37] *Ibid.*
[38] *Ibid.*
[39] Mutanabbī, 175, 17. Compare the battle-scene in Kosegarten, *Chrestomathia*, 77, 3ff.
[40] The day(time) was also called "dark" if the hero of the tribe had died; thus *Hudhayliyyīn*, 128, 4, and cf. another verse in the commentary.
[41] Mubarrad, 692, 17.
[42] *Hamāsa*, 143, 3 from bottom.
[43] *Ibid.*, 48, 3 from bottom; 96, 16.
[44] *Ibid.*, 84, 16.
[45] *Hudhayliyyīn*, 38, 5.
[46] Mutanabbī, 300, v.20 calls his friend "my companion".
[47] *Hamāsa*, 384, 10.
[48] *Ibid.*, 32, 2 from the bottom (Saʿd ibn Nāshib).
[49] *Ibid.*, 161, 7.

Shanfarā [d. *ca*. 550] consoled himself with a brave heart, a clean sword, and a brown bow.[50] In other verses, the camel appears as a companion equal to the sword,[51] as in this line by Imruᵓ al-Qays:

> "Many a land, a wasteland have I crossed/
> with a swift and strong camel as my companion//"

A horse could also appear as a companion, as in Ibn Durayd[52] [d. 321/933]:

> "These two I prepare for the journey/
> as a substitute for those, whom I used to take with me//
> Far be those from me who have abandoned me/..."

A man, his sword, his riding-beast, and perhaps one more piece of weaponry are in a sense one inseparable unit.[53] It is therefore hardly surprising that deeds and attributes of humans were ascribed to swords. A tradition going back to ᶜAlī [ibn Abī Ṭālib, d. 40/661] says that the sword of al-Zubayr, when it was brought to him by his killer, smoothed over the wrinkles on the Prophet's forehead for a long time.[54] [63] The poets usually attributed stamina and desire for battle to the sword as well as to the spear, using images of thirst and drinking.[55] At times, the sword appeared in the role of a man who quenches his thirst in the morning.[56] More often, however, it was compared to a camel complaining of thirst, which is led to the watering hole[57] and left to drink[58] until completely satisfied[59] (Mutanabbī used the word *rayyān* "full, satisfied"[60]). This motif was used in praise of a man equipped with a good sword, who puts his weapon to frequent use, and was extended by the later poets. For example, a poet of the *Ḥamāsa*[61] said of a particular sword that it was led to the watering place not every other day, but daily. And again, the later poets surpassed the ancients, in that they exaggerated the "thirst" of the sword to the degree of insatiability.[62] In doing so, they either retained the original motif or substituted it altogether, like Muslim ibn al-Walīd:[63]

[50] Sacy, *Chrestomathie*, II.136, 12.

[51] *Ḥamāsa*, 345, 12; *Diwans 6*, Imruᵓ al-Qays, 55, 4.

[52] Ibn Durayd, v.70, 74, 85.

[53] Mutanabbī, 23, 8. According to the commentary the same idea was used by Dhū l-Rumma [d. 117/735]; see commentary, 23, 14.

[54] Ibn al-Ṭiqtaqā [fl. early 8th/14th c.], *al-Fakhrī*, 107, 8.

[55] Iṣfahānī, III.48, 21 (Bashshār ibn Burd).

[56] *Ḥamāsa*, 137, 17.

[57] Khalaf al-Aḥmar [d. *ca*. 180/796], *Qasside*, 58.

[58] Mubarrad, 52, 20.

[59] *Ḥamāsa*, 469, 18.

[60] 78, 8. He alludes to the hyperbolic image: "If he spat out the blood that he sucked in/ there would be a sea of blood, with froth-covered waves//".

[61] *Ḥamāsa*, 259, 3; cf. Dieterici, *Mutenabbi und Seifuddaula*, 81.

[62] *Ibid.*, 85, M.

[63] 50, v.28.

"They are a folk who, when the midday heat forbids battle/
let all their swords rest on skulls//"

Or else, they would ascribe a hatred for skulls or necks to the swords.[64] Inverting the previous motif, Ṭanṭarānī [fl. 6th/12th c.] called a period of rest a "fast",[65] and in another verse he calls a sword "insatiable" **[64]** (in avenging, al-ʿatī[66]).

Poetic imagery did not remain restricted to this basic motif. Swords also appeared in other forms of personification. For example, one poet in the *Ḥamāsa*[67] let the sword "explain" the difference between ally and foe to the anxious wife of a warrior, after the two parties clashed in battle. A later poet made the sword "cure" the suffering inhabitants of a border region.[68] Conversely, a man was often compared to a sword, or even called a sword, as it symbolized wit and determination, due to its sharpness and effectiveness. Because of these qualities, a man was able to overcome any obstacle, and nobody and nothing could resist him. Saʿd ibn Nāshib said:[69]

"He achieves his aim without being held up/
just as a sword of watered steel cuts through bones//"

and another (Jawharī, *s.v.* "ḍ-ʾ-l"):

"A man like a sharp, trenchant sword/
no weakling, no laggard, and not cowardly//"[70]

It is for these qualities that the ancients compared the likes of Taʾabbaṭa Sharrā [fl. 6th c.],[71] al-Nuʿmān [d. 602][72] and Hārim to swords. The last mentioned, in particular, was compared by Zuhayr[73] to an Indian sword, to emphasize his position as the noblest of the noble **[65]**:

"He is the likeness of an Indian sword, which has never been brought to shame/
when, amid other swords, it hovers over the heads of heroes//"[74]

Mutanabbī expanded the image in one of his verses, calling the hero a sword and his armour its scabbard.[75] In another verse, he compared himself to a sword:[76]

[64] Al-Buḥturī [d. 284/897] in Mutanabbī, commentary 64, 5 from the bottom.

[65] Sacy, *Chrestomathie*, II.160 last line.

[66] *Ibid.*, II.7 from the bottom.

[67] *Ḥamāsa*, 80, 10.

[68] Dieterici, *Mutenabbi und Seifuddaula*, 155, 3.

[69] *Ḥamāsa*, 325, last line.

[70] Mutanabbī (300, v.21) called his hero: "A sharp sword on the side of every man".

[71] *Ḥamāsa*, 40, 6.

[72] *Diwans 6*, al-Nābigha [fl. late 6th c.], 17, 31.

[73] *Ibid*, Zuhayr, 17, 37. Other attestations of this comparison with a sword: *Ḥamāsa*, 492, 17; 231, 17 (she gave birth to swords); 345, 9; 769, 6 from the bottom; Muslim ibn al-Walīd, 7, v.21; 54, v.19 (ṣamṣāma dhakar).

[74] Cf. Mutanabbī, 300, v.20: "My friend, the Indian one, travels to another sword/ not forged in India, but made by God //".

"The watered steel that I am made of is like the steel of my sword/"

This kind of identification was common not only in poetry, but also in real life. On the one hand, *Sayf* ["Sword"] was a personal name, as in the name of the well-known Himyarite prince Sayf ibn Dhī Yazan, the traditionist Sayf ibn Sulaymān, and the *tābiʿī* [member of the generation after the Prophet Muḥammad] Abū Sayf al-Makhzūmī. On the other hand, we have examples like the following dictum (quoted by Mubarrrad in his *Kāmil*[77]) of Ziyād ibn ʿAmr to Walīd ibn ʿAbd al-Malik [caliph, r. 86–96/705–15] about al-Ḥajjāj [ibn Yūsuf, governor of Iraq, 75–95/694–714]: "al-Ḥajjāj is your sword, which does not waver from the target, and your arrow, which does not miss the mark". Furthermore, Khālid ibn al-Walīd [d. 21/641], the conqueror of Mecca, was granted the name Sayf Allāh ["Sword of God"], an epithet that appears to have remained in use for outstanding military leaders for some time. For example, al-Ḥajjāj said of his sons:[78] "They are among the swords of Allāh". Later, the honorific "Sayf al-Dawlah" became common, as, for example, for the patron of Mutanabbī. Kaʿb ibn Zuhayr praised the Prophet in the same way in which his father praised Hārim, by calling him "the Indian sword of God".[79] As for the expression ʿayn al-muhannad [lit: "the eye of the Indianized (sword)"], one may conclude from examples like **[66]** *inna ʿamūrīya ʿayn bilādihim* "Amorium is their best city" [lit: "the eye of their cities"] (compare *also* ʿayn al-jawād "the most munificent") that this expression refers to the blade as the most important part of the sword.

Later poets moved from the concrete to the abstract sphere, and spoke of qualities such as wit and strong will as embodied in swords.[80] Mutanabbī, for instance, used the expression *sayf ʿazm* ["sword of resolution"].[81] However, when a man and a sword[82] were compared, the former was usually favoured, either because a man would not "become blunt"[83] like a sword, or because the sharpness of the sword was considered no match for the sharpness of the tongue.[84] In the *Kitāb al-aghānī*,[85] Ḥassān ibn Thābit [d. *ca.* 30s/650s] was called a "sharp sword" on account of his sharp tongue, and described himself in the following way:[86]

[75] 312, v.18. He introduces this verse with the oath: "By my sword" and the following one with "By my spear". In the commentary on this verse we are given another example (of Hijri ibn Kulayb) of how the Arabs swore by sword and spear.

[76] 304, v.2.

[77] Mubarrad, 522, 15.

[78] *Ibid.*, 699, 3.

[79] *Carmen*, 51.

[80] Dieterici, *Mutenabbi und Seifuddaula*, 85, last line.

[81] Mutanabbī, 156, 4 from the bottom.; cf. *ibid.*, 148, 8; Ibn Durayd, v.107.

[82] Except in the autonomasia al-ṣārimān (a man and a sword) and a pun in ʿAntara's verse (*Diwans* 6, 20, 28): "I looked death in the eyes many a time/ wearing armour, while my sword was not armoured //".

[83] *Hamāsa*, 129, 9 from the bottom.

[84] Mutanabbī (275, v.28–29) compared the tongue to the tip of a sword or a spear.

[85] Iṣfahānī, II.47, 12.

[86] Cf. *Hamāsa*, 129, 9 from the bottom; Freytag's trans. of *Hamāsa*, I.235 and a verse by Jarīr.

"Both my tongue and sword are sharp and trenchant/
but what my sword cannot reach, my tongue can touch//"[87]

However, the later poets gave preference to the sword, as the symbol of war, over the literary exchange[88] **[67]**.

In the examples quoted above, the basis for comparison was the sharpness of the sword or rather of the blade, without which it served as an image for old age and frailty.[89] Elsewhere, the shining surface of the blade was used as a basis for comparison. The poet would liken it to the resplendent face of the hero, whether because of bravery, as in this verse by Dhū l-Rumma[90] [d. 117/735]:

"It (the camel) races with a man who remains cheerful though his cloak is torn/
like a sword, when everyone is terrified//"

or because of a liberal disposition – this is the motif behind the comparison of Labīd [d. 40/661] to a sharpened sword (*ka-l-sayf al-ṣaqīl*[91]) – or because of beauty or cheerfulness, namely of young men,[92] or because of joy[93] about an unexpected event. Finally, the sword was a symbol not only of bravery, but also of generosity, in that it served to hamstring a camel destined for guests.[94]

A. Terminology[95]

[124] ...The generic name for the sword is *sayf* (pl. *suyūf* and *asyāf*), and is based on the concept of "snatching away". In prose other terms are used alongside *sayf* **[125]** to refer to the sword. Some of these were originally adjectives or participles, like *ḍarība*

[87] Mūsā ibn Jābir called his tongue *mibrad*, "a file" (*Ḥamāsa*, 182, 10); cf. commentary.

[88] Abū Tammām (Ibn al-Ṭiqṭaqā, *al-Fakhrī*, 276, 4–5 = Sacy, *Chrestomathie*, I.88 bottom) said: "The sword speaks the truth like no book;/ the time of jesting is over, now the blade begins in earnest//". Sacy read *al-jadd* in the second verse instead of *al-ḥadd*, and translated: "C'est à son tranchant qu'est attaché le succès, soit qu'il agisse sérieusement ou qu'il badine".

[89] *Ḥamāsa*, 634, 10.

[90] v.37.

[91] Mubarrad, 466, 15.

[92] Sacy, *Chrestomathie*, II.153, 4. Sacy, like Nöldeke, adds an implicit *agharru*, and assumes that the motif for comparison is a different one. He takes it to refer to the tall stature of the youths, which, however, is the standard comparison for spears. See Ḥarīrī, 142, 5; Mutanabbī, 313, v.26. Abū Nuwās [d. ca. 198/813], *Weinlieder*, 6, 4, says of his drinking-companions: "among youths (cheerful) like swords". Iṣfahānī, II.22, M.: "The radiant sons of al-Mundhir, like swords, walk about in al-Ḥīra in the morning".

[93] E.g. that of the sick when visited by the beloved. Mubarrad, 167, 4.

[94] Zamakhsharī, *Mufaṣṣal*, 25, middle; Mubarrad, 653, 9 (verse by Jarīr).

[95] Arabic works about the sword which have not survived are: the *Kitāb al-suyūf* by Abū ʿUbayda [d. 209/824] (see Flügel, *Die grammatischen Schulen*, 70), and the works of Abū Ḥātim al-Sijistānī (*ibid.*, 88) and Shaykh Muḥammad ibn ʿAli al-Harawī (Hajjī Khalīfa, *Lexicon*, 701) and *al-rawḍ al-maslūf* of Fīrūzabādī. Names for the sword are listed in the following surviving Arabic works: Thaʿālibī, *Fiqh*, ch. 23; Zamakhsharī, *Lexicon*, 71. A detailed description of the sword is contained in: Ṭarafa [fl. mid-6th c.], *Muʿallaqa*, 84ff.

or *munṣal*. Others are metaphors, like *ghadīr* or *dhū l-rāḥa,* or general terms like *wiqām* and *silāḥ*[96] or *silaḥ*. Finally, there are terms in the form of personal or family names, such as *Ibn al-ghimd* [lit. "son of the scabbard"]. In more elevated prose, and particularly in rhymed prose or poetic prologues, one can find names for particular kinds of swords, like *mashrafī*, or names derived from its qualities, such as *ṣārim* ["sharp"]. With regard to the usage of these terms in prose as well as in poetry, one may refer to the relevant sections below.

The topical uses of the sword and the similes which it attracts through its sharpness or polish have been mentioned in the first part of this work, whilst more specific uses will be discussed each in its appropriate place. Only the following expression should be added to the above: *salla ʿalā al-Islām sayfan min al-kufr* "to draw the sword of unbelief against Islam".[97]

The following proverbs refer to the sword: 1. *al-sayf yaqtaʿu bi-ḥaddihi* "a sword cuts with its blade" (Freytag, *Proverbia*); 2. *sabaqa l-sayf al-ʿadhl* "the sword forestalled blame" (*ibid.,* XII.1) ; 3. *innī la-anẓuru ilayhi wa-ilā l-sayf*, lit. "I look at him and the sword", i.e. "I hate him so much that I can only think of killing him" (I.138). 4. *kafā bi-l-mashrafīya wāʿiẓan* "the *mashrafī* swords are the best preachers" (XXII.180). 5. *maḥā l-sayf mā qāla Ibn Dāra ajmaʿan* "the sword has obliterated the words of Ibn Dārah" – said of a coward uttering empty threats (XXIV.107); 6. *Māzin raʾsaka wa-l-sayf* "Oh Mazin, your head and the sword" (XXIV.108); 7. *amḍā min al-rīḥ wa-min al-sayf* "more penetrating than the wind or swords" (XXIV.433); 8. *man salla sayf al-baghy qutila bihi* **[126]** "whoever draws the sword of injustice is killed by it" (XXIV.460); 9. *ẓulm al-aqārib ashadd maḍaḍan min waqʿ al-sayf* "the injustice of relatives is more painful than a blow of the sword"' (XVII.35); 10. *al-firār bi-qirāb akyas* "fleeing with a sheath is smarter", i.e. than fleeing without anything after losing the sword (XX.32); 11. *man yashtarī sayfī wa-hādhā uthruhu* "who will buy my sword with this kind of watering", i.e. be cautious! (XXIV.298); 12. *mumāliḥān yashḥadhān al-munṣal* "two foster-brothers who sharpen their swords (i.e. hate each other but pretend to be friends)" (XXIV.358); 13. *aḍyaʿ min ghimd bi-ghayr naṣl* "more useless than a sheath without a blade" (XV.48); 14. *sallū al-suyūf wa-salalta al-muntin* "they drew swords, but you have drawn a worthless weapon" – said about someone who imitates great men in order to become one of them (XII.31); 15. *sammaytuka al-fashfāsh in lam taqṭaʿ* "I shall call you a blunt sword if you do not cut" – said of someone who leaves his business unfinished (XII.103); 16. *fī naẓm sayfik mā tarā yā Luqaym* "Oh Luqaym, on your sword is what you see" – an expression of cunning and treachery (XX.30); 17. *ka-anna lisānahu mikhrāq lāʿib aw sayf ḍārib* "as if his tongue were a wooden toy, or a sharp sword" (XXII.263); 18. *li-kull ṣārim nabwa li-kull jawād kabwa* "every sharp sword can become blunt, and every noble steed can trip" (XXIII.73); 19. *lā yujmaʿ sayfān fī ghimd* "one does not put two swords into the same sheath" (XXIII.365); 20. *yaḍrib ʿannā bi-sayfayn* "he defended us with two swords" – said if someone defends another with all his strength (XXVIII.168); 21.

[96] Mubarrad, 722, 9 (Farazdaq [d. 110/728]).
[97] *Ibid.,* 543, 1.

min ʿadāt al-sayf an yastakhdim al-qalam "it is a habit of the sword to subject the pen to its service" (XXIV.537). **[127]**

B. Provenance of swords

If we are to sum up the qualities attributed by the ancient poets to swords, then it does appear as if the art of swordmaking had already neared its perfection, for these swords did not lack any of the qualities that were later achieved in the watered blades, which continue to be admired in Europe to the present day. The Arabs themselves preferred Indian swords (*suyūf al-hind*[98]) above all others.[99] In India, where the art of weapon making had flourished since the earliest times, swords of excellent quality were cold-forged from so-called woodz-steel (a kind of cast steel [see Glossary below]).[100] This began undoubtedly long before the rise of weapon making among the Arabs. As there were ancient trade connections between both lands, one can presume that Indian swords came to Arabia very early. Its coast-dwellers, encouraged by their geographical position, their country's lack of resources, and their inquisitive minds, engaged in overseas trade, and may have brought Indian weapons back with them. In the Arabian Peninsula only an inferior kind of iron ore was available [[101]], so the Arabs may have obtained Indian steel in a similar way, which was then forged into armour by the Arabs themselves. Likewise, the *khaṭṭī* spear is reported to have come from India, **[128]** but to have been assembled in al-Khaṭṭ [in East Arabia].

An Indian sword [see Kindi/Zaki, pp. 9 and 21], i.e. one forged in India, is called *hindī*, but this word is not found with the six [most celebrated pre-Islamic] poets.[102] They used the word *hunduwānī*,[103] a derivation by *itbāʿ* [intensification by repeating a word with the initial sound changed] from *hinduwānī*, which is synonymous to *hindī* according to Thaʿālibī,[104] though Jawharī (*s.v.* "h-n-d") thought that it meant "forged of Indian ore". Indian craftsmanship was also imported to Arabia. While the word

[98] *Hamāsa*, 492, 17; *Hudhayliyyīn* (ed. Wellhausen), 77, 41.

[99] Commentaries on Ṭarafa, *Muʿallaqa*, v.79, and ʿAntara, *Muʿallaqa*, v.55; Kaʿb ibn Zuhayr, *Carmen*, v.51. See also the relevant evidence in the first part of this work.

[100] Hindustani shields, for example, were all cold-forged in two pieces, a central piece and a fringe piece. This technique survived in Delhi until the great revolution of 1858 (*Buch der Erfindungen, Gewerbe und Industrieen*, VI: the mechanised working of raw materials). This (crucible) steel – usually known as *wootz* – was not actually forged cold but had to be forged at a lower temp range because of its very high carbon content.

[101] [Schwarzlose is almost certainly wrong here, as Kindi stresses that Yemeni swords made from local ores were the best quality of all blades, at least equal to those from India, though he does note that certain types of Yemeni sword were not of Yemeni iron, "but of Salmānī, Sri Lankan, and Indian iron"; Kindi/Zaki, p. 21, cf. pp. 8–11].

[102] But *Hamāsa*, 469, 13; Sacy, *Chrestomathie*, II.160, 11 (Ṭanṭarānī); Mutanabbī, 226, 17.

[103] *Diwans* 6, Zuhayr, 17, 37; ʿAntara, 25, 11 (without *tashdīd* in the rhyme); Sacy, *Chrestomathie*, II.157, 4 (al-Aʿshā [d. ca. 7/629]); *Hamāsa*, 297, 7; Mutanabbī, 287, 23; plural in *-āt* in Mutanabbī, 125, 9.

[104] *Fiqh*, 132 (ch. 23).

muhannad[105] is listed by Thaᶜālibī[106] alongside the two terms above, he states that it is not quite synonymous to the latter, rather it signifies "a sword forged with Indian techniques".[107] The word derives from *hannada* "to indianize", which is always glossed as "to sharpen"[108] when used of a sword. A more appropriate explanation is found in Jawharī, who explains it as "made of Indian steel". The great reputation of Indian swords, which persisted even when the Arabs themselves produced excellent weapons,[109] meant that the expression "an Indian sword" became synonymous with "a sword with an excellent blade".[110] Likewise, the words *hunduwānī* and *muhannad* became names for good blades in general.

In the Arab world and its neighbouring countries, the Yemen [see Kindi/Zaki, pp. 8–9 and 15–22] of the Himyarites [4th-6th centuries AD] and Syria under the Ghassanids [6th century AD] were reputed to produce excellent swords. **[129]** A number of circumstances also point to the influence of the *tubbaᶜ* [the Muslim name for the kings of Yemen] on the art of weapon making. Armour was said to be made by the *tubbaᶜ* themselves, who were compared to King David in this respect:[111]

> "Covered with two armours of solid mail/
> of perfect *tubbaᶜ* craftsmanship, such as David could not forge"//[112]

A certain type of spear was called *yazanī*[113] after Dhū Yazan. Yemeni helmets[114] are mentioned by ᶜAmr ibn Kulthūm in his *Muᶜallaqa*, v.73, while even the word *yaynamīya*[115] "helmet" itself may derive from *yaymanīya*, pointing to its Yemeni origin. The name of the first Yemeni king to adopt the title *tubbaᶜ*, Ḥārith al-Rāʾish [4th c.], may also be of significance, as it signifies "he who attaches feathering to arrows". Another king of the same dynasty, Dhū Aṣbaḥ, gave his name to a kind of whip: *al-suṭ al-aṣbaḥī* (pl. *al-siyāṭ al-aṣbaḥīya*).[116] Given all this, it is hardly surprising that good swords too were produced under these kings. At least the famous sword of king Maᶜdikarib, called *al-Ṣamṣāma*, is said to have been in the possession of king Ṣaḥbān[117] before him. In Fīrūzabādī one finds mention of a type of sword

[105] Ṭarafa, *Muᶜallaqa*, v.79 and 84; ᶜAntara, *Muᶜallaqa*, v.55, and *Diwans* 6, ᶜAntara, 7, 15; *Ḥamāsa*, 168, 11; Kaᶜb ibn Zuhayr, *Carmen*, v.51; Muslim ibn al-Walīd, *Dīwān*, 65, v.33; Mutanabbī, 12, 4 from the bottom, 22, 12 and elsewhere.

[106] *Fiqh*, 132.

[107] Cf. the explanations of *musarraj* and *mudhakkara* respectively.

[108] Commentary on *Ḥamāsa*, 168, 11.

[109] Cf. Sacy, *Chrestomathie*, II.81, 13 (song of the Druzes): *al-suyūf al-hindīya wa-l-durūᶜ al-dāwūdīya wa-l-diraq al-tunbutīya wa-l-rimāḥ al-khaṭṭīya.*

[110] This may explain the use of the compound *al-mashrafī al-muhannad* in Sacy, *Chrestomathie*, I.79.

[111] Zamakhsharī, *Mufaṣṣal*, 48, middle (verse by Abū Dhuʾayb after Mutanabbī, 259, 13).

[112] The word *ṣanaᶜu* in *ṣanaᶜ al-sawābighi* is used in the sense of *ṣāniᶜ* "master"; cf. Mutanabbī, 259, 13.

[113] *Hudhayliyyīn*, 15, 22.

[114] Freytag, *Einleitung*, 256: "armour".

[115] Kosegarten, *Chrestomathia*, 68, 11.

[116] Mubarrad, 541, 5.

[117] Pocock, *Specimen historiae Arabum*, 61.

called *lisān kalb* ["dog's tongue"], the blade of which was partly greenish in colour. It is said that the sword of one of the *tubbaᶜ* carried this name and fitted this description. Undoubtedly this was a special weapon, and we can hardly assume that all Yemeni swords were characterized [130] in this way, even though similar ones may have had the same name.[118] Just as a spear was called *yazanī* after the name of the dynasty, or also *ḥimyarī*, so the swords that were produced under the rule of the *tubbaᶜ* were called *yamānin*[119] or *yamanī*[120] after their country. In a commentary on the *Muᶜallaqa*, v.79, of Ṭarafa [fl. mid-6th c.] one finds mention of another type of sword in addition to the *yamanī* type: this is the *qalᶜī*[121] sword, so named after the Yemeni town of Qalᶜa, though Fīrūzabādī states that this type was of Indian origin. A good proof for the high quality of the Yemeni swords is the fact that the descriptive term "Yemeni" was used in the same way as "Indian", i.e. as an indication that the sword in question was of superb quality. It seems that with time the reputation of the Yemeni swords fell into oblivion, for neither Thaᶜālibī nor the two great lexicographers mention them any longer. The reason for this may lie in the demise of the Himyarite dynasty, the decline of the Yemen to a province of little importance within the Islamic empire, and a general decline in the art of weapon making. Mutanabbī's use of these epithets may be explained by his tendency to revive obsolescent terminology.

If in the Yemen the dynasty of the Himyarites influenced the art of weapon making, we can assume that something similar took place in the Ḥawrān under the Ghassanids [an Arab tribe that rose to prominence in the 6th c. AD as allies of the Byzantines]. Some of the Ghassanid sword-names have survived; for example, *al-rasūb* was the name of the sword of the Ghassanid al-Ḥārith ibn Abī Shamir [fl. early 7th c.] according to Fīrūzabādī. After all, Ḥawrān included those regions of Syria that were [131] famous for their swords: Bostra, with its famous blades (*ṣafāʾiḥ buṣrā*[122]) or swords (*buṣrī*[123]), and the places called Mashārif or Mashārif Ḥawrān,[124] or Mashārif al-Shām,[125] a collective term for villages that lay adjacent to cultivated land.[126] The name "Mashārif al-Yaman" did exist, but according to Fīrūzabādī it was in the Syrian Mashārif[127] that the oft-mentioned *mashrafī*[128] swords were forged.

[118] See Fīrūzabādī.

[119] Defined *al-yamānī*, as in *Diwans 6*, Ṭarafa, 13, 1; ᶜAntara, 25, 5; *Ḥamāsa*, 57, 9; 332, 15; 384, 10; 634, 10; Mubarrad, 524, 7; Mutanabbī, 305, v.9.

[120] Used of a sword in Mubarrad, 625, last line (verse by ᶜAbbās ibn ᶜAbd al-Muṭṭalib).

[121] To be distinguished from *qalaᶜī*, on which see below [Schwarzlose is probably wrong to make this distinction; see Kindi/Zaki, pp. 8 and 21–25].

[122] *Ḥamāsa*, 189, 1; Iṣfahānī, II.48, 17 (al-Ḥuṭayʾa [fl. 1st/7th c.]).

[123] *Hudhayliyyīn*, 33, 3.

[124] Yāqūt, *Mushtarik*, 127.

[125] See Fīrūzabādī.

[126] Thaᶜālibī, *Fiqh*, 132; Jawharī (Abū ᶜUbayda); Zamakhsharī, *Lexicon*; *Hudhayliyyīn*, commentary, 74, 36.

[127] Wāḥidī on the other hand attributed them to the Yemen: Mutanabbī, commentary, 115, 7; likewise the commentator in Mehren, *Rhetorik*, 9, n. 5; cf. Sacy, *Chrestomathie*, III.53.

Therefore, Zamakhsharī[129] [d. 538/1144] called these swords "Syrian". According to the work *Āthār al-bilād*, quoted by Freytag,[130] they originate from the place called Mūta in the region of Mashārif al-Shām. These different explanations can be reconciled by the statement in Mubarrad (639, l.15), that Mūta was an alternative name for al-Mashārif.

The Syrian city of Aryaḥ[131] also produced excellent swords (*suyūf aryaḥ*), which could be referred to by the adjective *aryaḥī*. The existence of swords of this type is proven beyond any doubt by a verse in the *Hudhayliyyīn*. This verse was later quoted by Tibrīzī [d. 502/1109] in his commentary on a verse of the *Ḥamāsa*, where the word appears again.[132] Tibrīzī's commentary is certainly preferable to that of Abū l-ʿAlāʾ [al-Maʿarrī, d. 449/1057], **[132]** who derived the word from *irtāḥa* and explained it as "a sword that strikes without tiring", but in the present context the word requires a different explanation altogether. In the first couple of lines before the verse containing the word *aryaḥī*, all weapons have been described, namely sword and armour in line one, and bow and arrow in line two. One cannot then understand why the sword should be mentioned again in line three, especially as the remainder of this poem, from the middle of line three to the end, refers to horses. It would only be reasonable to assume that the first hemistich of line three refers to horses as well, so that the short poem falls into two parts: two lines containing a description of weaponry, and two lines dedicated to the description of the horse. This is possible, as the word *aryaḥī* can also be used of horses. What stands against this is the fact that the word *ʿaḍab*, which is used only of swords and (figuratively) of people, occurs in the same line. What is more, the following *wāw* would have to be omitted if the description was to be continued. One may, therefore, agree with Marzūqī (see Freytag's translation of the *Ḥamāsa*: I.639) that the word here refers to the rider, and indeed *aryaḥī*" was glossed by Jawharī as "generous" and occurs frequently with that meaning.[133] In general, it signifies "lively, willing", while the noun *aryaḥīya* means "cheerfulness, joviality".[134]

Two swordsmiths were famed for the quality of their swords. The first one was Surayj, whose abode is not mentioned, but who may have lived in central Arabia. He

[128] *Diwans 6*, Imruʾ al-Qays, 52, 29 (ed. Slane, 21, 14); ʿAntara, 19, 8; 20, 15; 27, 8; *Ḥamāsa*, 194, 17; 315, 13; 469, 18; *Hudhayliyyīn*, 74, 36; 107, 15; cf. Mutanabbī, 115, 5; 160, 7. In the first verse by ʿAntara the term *mashrafī* is used collectively, and in combination with *al-washīj al-dhubal*; pl in *āt* in *Diwans 6*, Zuhayr, 14, 9; *Ḥamāsa*, 319, 9; 660, 1; Iṣfahānī, II.59, 20 (one of the Banū l-Nāqa in the time of al-Zibriqān); *ibid.*, 24, 3 from the bottom (ʿAdī ibn Zayd); cf. Mutanabbī, commentary, 208, 9 (al-Baʿīth); Dieterici, *Mutenabbi und Seifuddaula*, 103, 8. On the formation of the *nisba* see Jawharī, *s.v.*

[129] *Lexicon.*

[130] Translation of *Ḥamāsa*, I.348.

[131] *Hudhayliyyīn*, 3, 11 (quoted in *Ḥamāsa*, commentary, 358, 18).

[132] *Ḥamāsa*, 358, 12.

[133] Iṣfahānī, 110, 5; Mubarrad, 40, 12; cf. Dieterici, *Mutenabbi und Seifuddaula*, 80 (Ibn al-Rūmī), Mutanabbī, 174, 4.

[134] Iṣfahānī, I.100, 9 from the bottom.

gave his name to the *surayjī* sword,[135] according to Aṣmaʿī [Arab philologist, d. 213/828].[136] The other swordsmith [133] was Khabbāb in Mecca. The following conversation between al-Zubayr and ʿUthmān [d. 35/656], related by Firūzabādī,[137] refers to him: Al-Zubayr said: "If you want, we can hurl against each other (i.e. fight one another)". ʿUthmān replied: "Hurl what – camel dung?" "No", came the reply, "rather the blows of Khabbāb and the feathers of al-Maqʿad" *(bi-ḍarb khabbāb wa-rīsh al-maqʿad)* [i.e. with sword and arrows].

In addition to the sword types already referred to above, the lexicographers and commentators mention the following:

Qalaʿī (not to be confused with *qalʿi*, cf. above p.130) is the name of a sword from Qalaʿa. This is either a place in the desert, according to Jawharī, or a place near Ḥulwān in Iraq, as stated by Firūzabādī [or more likely Malaysia/Indonesia; see Kindi/Zaki, p. 8]. This name occurs in a *rajaz* verse:[138]

> "Not rich in livestock or camels/
> But blessed with sharp *qalaʿī* swords//"

Diyāfīya: swords from Diyāf,[139] a city in Mesopotamia inhabited by Nabateans, according to Jawharī[140] and Firūzabādī. [or more likely a town in the Hawran in southern Syria; see G.J. van Gelder, "Diyāf: for camels, swords, and Nabataeans" in H.L.J. Vanstiphout, ed., All those nations: cultural encoutners within and with the Near East (Groningen, 1999), 51–60].

Baylamānīya: swords from a place called Baylamān in Yemen, India or Sind[141] [see Kindi/Zaki, pp. 9 and 25–28, and esp. n.11 in ch.2 above].

Ḥanīfīya: swords of the type first forged for Ṣakhr ibn Baḥr al-Aḥnaf ibn Qays, one of the most famous of the generation after the Prophet.[142]

Khusrawānī: a sword produced in the smithies of the Persian king Khusrau[143] [see Kindi/Zaki, p. 10].

In one line of the *Ḥamāsa*[144] David is said to have forged swords. Now this appears to be a misunderstanding, [134] for only armour was attributed to this king. The

[135] *Ḥamāsa*, 325, last line; pl. in *āt* in Khalaf al-Aḥmar, *Qasside*, v.5; cf. Mutanabbī in Khalaf al-Aḥmar, *Qasside*, 58, 1; pl. in *āt* in Mutanbbī, 136, 13.

[136] Thus in Jawharī. Tibrīzī in his commentary on the verse in *Ḥamāsa* gives a secondary meaning "radiant", from *sirāj*. Freytag (trans. of *Ḥamāsa*, I.579) thought this was contradicted by the diminutive form, but it seems that the derivation of *surayj* from *sirāj* is a *taṣghīr al-tarkhīm*. Compare also the term *musarraj* "resembling a *surayjī* sword, i.e. a thin, evenly-shaped nose", used in a verse by Ruʾba ibn al-ʿAjjāj, which was explained by some as meaning "radiant" (see Jawharī, *s.v.*, and quoted in Mehren, *Rhetorik*, 16).

[137] Fīrūzabādī, *s.v.*
[138] Jawharī, *s.v.*
[139] Freytag, *Einleitung*, 255.
[140] Note on the margin of II.25, 6 from the bottom.
[141] Fīrūzabādī, not in Jawharī.
[142] Fīrūzabādī.
[143] Ṭarafa, *Muʿallaqa*, commentary, v.79.

commentator is presumably right in saying that the poets used this name only to underline the antiquity of these swords. For the same reason, Zuhayr[145] attributed a piece of armour to Iram, and al-Buḥturī [d. 284/897] attributed a sword to ʿĀd.[146]

It is impossible to determine how these different sword types related to each other, despite their relatively frequent occurrence together with other descriptive epithets. This is because the description of swords was never an end in itself, but always served the poets in praising heroes (who owned swords of superior quality and origin). What is more, the names of the most common sword types (*surayjī*, *mashrafī*, Yemeni, and Indian) were employed as positive epithets for all blades in general. Hence one cannot attribute any importance to the fact that in our examples explicit descriptions of swords according to the aforementioned epithets is confined to the *mashrafī* and *surayjī* types. Even less can it be supposed that the qualities of these latter two types were common to all famous sword types, for they would then have lacked an essential advantage and would have been less suitable for the praise of the brave.

Likewise, of course, it cannot be maintained that there were no differences between the various kinds of swords; that would be unthinkable. It may be that the differences lay in the watering, which is described in various ways, as we will see below. In support of this assumption one may quote an expression in the *Hamāsa* (313, 10 from the bottom): *fīhā athruhu wa-khawātimuhu* ["in them are its waterings and its stamps"], where *athr* is taken in its original meaning as a synonym for *khawātim*, not as a poetic [135] derivation from *athar*. This passage would also prove that manufacturer's stamps were already common at the time. The expression *bi-l-khayr mawsūm* "marked with the seal of luck", as used by ʿAlqama (*Diwan* 6, 13, 44) is to be taken figuratively, and not as a reference to a real stamp or seal. It means that the owner could trust this sword, and that his past experience with it gave him confidence that future battles would end well. A stallion of the caliph Muqtadir carried a similar name: *al-iqbāl* "fortune"- i.e. "the one that brings good fortune".[147]

According to Tibrīzī there were swords on which the names of those who commissioned them or the kings of the time were engraved. He states this in his explanation to a verse in the *Ḥamāsa* (42, 11). It would be less forced to see *dhawūhā* as a reference to the owners of these swords, and *dhawī urūmatihā* to the smiths who forged them. In Rückert's translation: "whose owners did honour to those who forged them". The same verse is quoted in Zamakhsharī, *Mufaṣṣal* (p. 44, middle) with the variant *abāra*, which should mean: "whose owners destroyed those who commissioned them", so that these swords would have been captured. Since this verse is missing in some manuscripts, it could be a later addition. Despite the remarks by Tibrīzī, one is tempted to discount an attribution of the verse to Kaʿb ibn Zuhayr, if only for its lack of clarity.

[144] 313, 10 from the bottom.

[145] *Diwans 6*, Zuhayr, 17, 24.

[146] Mutanabbī, commentary, 22, 4; cf. Abū Nuwās, *Weinlieder*, 22, 6: "We drink like a people who have suffered thirst since the time of ʿĀd" [ʿĀd and Iram were both allegedly ancient Arab peoples].

[147] Kosegarten, *Chrestomathia*, 108, middle.

C. Methods of production

Even though the poetic descriptions are not detailed enough to enable us to recognize the precise specifications of each sword type, they do contain some direct or indirect information about the production of swords at the time. **[136]** As for the metal used in forging, we have already said above that the art of weapon making among the Arabs developed only after Indian steel was imported to Arabia, and steel swords were forged there [though crucible steel swordmaking technology may just as well have first developed in northern Iran or Central Asia, rather than India].

Addendum: Other kinds of high-quality iron were used later on alongside Indian steel. Jawharī mentions the iron mines of Qusās in Armenia, but Yāqūt [d. 626/1229], *s.v.*, claims that these lay in the territory of the Banū Asad, i.e. in the lands between Baṣra and Madīna. The mine was also called Dhū Qusās, as we learn from a commentary on a verse in Mubarrad (501, 17; commentary, 502, 1), where an iron instrument (*miʿwal*) for the splitting of rock is described. Swords of this type were called *qusāsī*, as in the *rajaz* verse:

> "He defended himself with a sword of *qusāsī* steel/
> stabbing armed warriors despite their armour//"

Furthermore, there was a high-quality kind of iron called *junthī* (according to Firūzabādī; not in Lane). The same name was given to a type of sword, presumably because it was made of this material. The plural *junthīya* occurs in a verse quoted by Jawharī, who explained it as "swords and armour". Given that the remainder of the verse has a term used only of swords, one may assume that the word refers only to them:

> "But it is a market, where people trade/
> in *junthī* swords, sharpened by the swordsmiths//"

The iron that had to be used before the introduction of steel and the development of steel welding **[137]** lacked the hardness and solidity of steel. The latter was therefore called *ḥadīd dhakar* ["male iron"] or just *dhakar*[148] ["male"] by analogy to the similar difference between the sexes. Poets transferred this name to the swords forged from that material in such a way that, after the elision of the generic noun, *dhakar* "male" came to mean "a sword of steel" (= *sayf maflūdh* in prose; cf. commentary on *Hudhayliyyīn*, 14, 1.2). This was not a metonymy like *ḥadīd*[149] and *fulādh*[150] when they

[148] The basic significance appears to be given correctly in Gesenius' *Lexicon, s.v.* "zakhar", as "strong, solid, hence masculine". Lane explains: "what is much talked about, i.e. the man, for the woman was little valued by the Arabs", but he does not take into account that this was the case only after Muḥammad, and that before him the social position of women was better, as is shown in early poetry.

[149] Mutanabbī, 12, 22 and elsewhere; Ḥassān ibn Thābit: *ṣārim al-ḥadīd* (the sharp one among the swords): Khalaf al-Aḥmar, *Qasside*, 63; *ibid.*, 251, 2.

[150] Mutanabbī, 114, 2.

were used in the sense of "sword" (the last term occurs in this sense only with the later poets).

Addendum: dhakar occurs in *Diwans 6*, ᶜAntara, 20, 20; 25, 5; *Hudhayliyyīn.* 56, 3; Muslim ibn al-Walīd, 54, v.18; plural *dhukūr* in Mubarrad, 352, 3 (Muhalhil [fl. 1st half 6th c.]); *Hudhayliyyīn,* 14, 2; *Ḥamāsa,* 168, 11. In this last verse, there can be no doubt about the explanation of the term, as it is combined with *muhannad.* The use of the term remains ambiguous in another verse however (264, 21): *aḥlās al-dhukūr* is explained in the commentary by a reference to the common expression *aḥlās al-khayl* "those who sit on the backs of *qawāriḥ* (i.e. five-year-old horses in the prime of their strength)". This explanation fits perfectly with the praise of horsemen in the remainder of the verse. However, Freytag was led to translate *dhukūr* as "swords", and supported this with other examples of the use of *aḥlās,* such as in *aḥlas al-qawāfī* (*Ḥamāsa,* 143, 18), and in the expression **[138]** *fulān min aḥlās al-ᶜilm.* He rejected the translation "horses", because the word does not occur in that sense elsewhere in the *Ḥamāsa.* But it must be pointed out that this was indeed the case in early poetry (see the end of this section for examples).

A proof of the proposed derivation of this name is the occurrence of the plural *dhukūr* in that sense. This is because all other names for weapons that are derived by metonymy from a name for a material do not form a plural, in accordance with the general principle in Arabic that materials are placed in apposition after the defined noun (e.g. *al-salāsil al-ḥadīd,*[151] *al-tilāl al-ramal*[152]). When used as metonymies, the plural is replaced by the singular in a collective sense; in order to distinguish singular and plural, a collective noun was then derived (e.g. *washīj, washīja*). All other explanations[153] of *dhakar* are untenable from the point of view of etymology, whereas the derivation given above is confirmed by the use of the same word for strong, sturdy horses[154] in poetry.[155] One poet said:[156]

"I have prepared everything for war:/
long lances and horses of steel//"

Muslim ibn al-Walīd combined both meanings in one verse[157] **[139]**:

[151] Commentary on ᶜAmr ibn Kulthūm, *Muᶜallaqa,* v.84.

[152] Sacy, *Chrestomathie,* I.276, middle.

[153] a) *dhū māʾ*: Jawharī and Fīrūzabādī; b) "a blade with edges of steel and a body of forged iron": Abū ᶜUbayd and Jawharī; c) Lane, I.77, col. 2, second verse and translation.

[154] See the explanation of *aḥlās al-dhukūr* in *Ḥamāsa,* 264, 21, commentary.

[155] *Hudhayliyyīn,* 15, 21; pl. in *Diwans 6,* Ṭarafa, 5, 60; Iṣfahānī, II.37, 14 (verse of ᶜAmr ibn al-Ṣalīḥ ibn Hadī ibn al-Daḥā ibn Ghanām ibn Ḥulwān b ᶜImrān b al-Ḥāfī ibn Quḍāᶜa.

[156] Jawharī, *s.v.* "w-z-r".

[157] Muslim ibn al-Walīd, 54, v.18.

"A hero[158] of steel unbending/
riding on a horse of steel (*dhakar*)/
with a steel sword (*dhakar*) in his hand/
splits the skulls of many men//"

The logical opposite to *dhakar* is *anīth* "female", i.e. a sword forged of soft (female) iron (*ḥadīd anīth* or *ḥadīd layyin*);[159] compare *miʾnāth* and *miʾnātha*, which are glossed as *kahām* "blunt" in Fīrūzabādī, but may not have had the same meaning originally. Also *narmāhan* "a soft sword", derived from Persian *narmah*,[160] has the same sense [see Kindi/Zaki, p. 5]. All these expressions are not found in poetry and are only ever attested in a negative sense (*lā afallu*[161]), for only swords made of steel that did not easily become jagged were considered praiseworthy. The same is true of *ḥayyid* "(a sword) forged of male and female iron".

We do not wish to claim that the swords referred to as *dhukūr* consisted only of steel, for in that case they would have lacked an essential quality, that of elasticity, which was praised repeatedly in the poems of the *Hudhayliyyīn*. A sword with this quality was called *layn* or *layyin*, as in the verse:[162]

"Flexible and sharp, it kills whoever it hits/
on its darkish surface there is a reddish sheen//"

It may be that in its manufacture both kinds of metal were mixed, and indeed the other **[140]** explanations found for *dhakar* seem to support this. Yet the term itself does not say this, but draws entirely on the juxtaposition mentioned above. It seems that the poets used this term whenever they wished to emphasize the resilience of a sword.

Mudhakkar ["made male"], on the other hand, was used with *tāʾ marbūṭa* [the feminine ending] of she-camels resembling he-camels in their build and nature,[163] but also of sharp objects made of forged iron and steel (by welding the steel to the iron) that had the same qualities as weapons made entirely of steel. In this sense one finds it as an epithet for different tools for cutting, like an axe,[164] but also for swords as in the following verse, which appears to be pre-Islamic judging from the pagan name it contains:[165]

"The birds leap around ʿAbd Yaghūth/
after the welded sword cut through his neck//"

[158] Namely, Yazīd ibn al-Mazyad, figuratively called a *dhakar* (sword of steel).

[159] *Hudhayliyyīn*, commentary, 14, 2.

[160] *Ibid.*, commentary, 4, 2.

[161] *Ibid.*, 4, 2.

[162] *Ibid.*, 167, 2; 290, v.19, and in Jawharī, *s.v.* "ḫ-l-s", taken from the *Hudhayliyyīn* (ed. Wellhausen, Arabic text, 15, poem 154, v.8).

[163] *Diwans 6*, al-Nābigha, App. XXVI, 26; Jawharī, *s.v.* "w-q-ʿ", verse by Ibn Ḥalza.

[164] *Diwans 6*, al-Nābigha, 15, 3.

[165] Jawharī.

In addition, the term was used as a trope of a stroke of the sword: *ḍarban mudhakkaran*.[166]

In Arab popular lore, the art of swordmaking had a higher, superhuman origin. The pagan Arabs were inclined to attribute it to the jinn, while the art of making mail was attributed to God, who taught it to David (a legend that may indeed be of Jewish origin). Everything extraordinary or miraculous was attributed to the jinn. Just as the Greeks took their formidable heroes to be the offspring of Gods (Achilles was regarded as [141] the son of the sea goddess Thetis), the Arabs assumed that individuals with a superior physique or intellect were related to the jinn. It was believed that the latter were much larger than humans, and that all tools they used were larger than human tools by the same degree:[167] for example, they were said to cook on the tops of three hills instead of three cooking stones. Likewise, a death under mysterious circumstances appeared to them as the work of the jinn. Soothsayers were said to owe their powers to the jinn. The jinn supposedly built the palaces of Palmyra.[168] The Arabs said that the jinn pricked up their ears when they heard a good stroke with a sword.[169] When a group of pilgrims heard the singing of the poet al-Gharīd without seeing him, they said "a group of jinn are performing the pilgrimage".[170] Al-Gharīd himself claimed to have heard his melodies from the jinn.[171] His sudden death was again blamed on them, as an act of revenge for singing a melody forbidden by them.[172] Majnūn ibn ʿĀmir, also called *madraj al-rīḥ*, was believed to have had encounters in mid-air every once in a while with the jinn mentioned in his verse[173] [142]:

> "The deserted campsite in the air is that of the jinn's daughter/
> Its traces have become effaced, and all the friends have dispersed//
> It was the wind that effaced them, blowing from the east and from the south/
> And that raced over it against rain//"

Even the magic of love reminded the poets of the jinn and the ghoul. When Jamīl appeared unexpectedly before Buthayna, who was alone in the company of an ʿUdhrī woman, and the latter asked him what he was looking for, he replied: "the ghoul standing behind you" (*hadhī l-ghūl allatī warāʾak*). It is not surprising, therefore, that the art of sword making was seen as having its origin in the craft of the jinn. *Mudhakkar* ["made male"] and *maʾthūr* ["watered"] were names for swords made by them, and one can assume that these would be swords of the highest quality known to the Arabs, namely watered swords. Indeed, the word *maʾthūr*, which appears in two

[166] *Hudhayliyyīn*, 320, penultimate line: "a strong blow".
[167] Dieterici, *Mutenabbi und Seifuddaula*, 154.
[168] *Diwans 6*, al-Nābigha, 5, 23.
[169] Iṣfahānī, II.165, 3 from the bottom (Ḥassān ibn Thābit).
[170] *Ibid.*, II.130, 17.
[171] *Ibid.*, 135, 19ff.
[172] *Ibid.*, 148, 16.
[173] *Ibid.*, III.17, bottom.

places,[174] is glossed as "watered" [*huwa alladhī fīhi athr wa-huwa firind*, "the one (sword) in which there is watering, i.e. *firind*"].[175] The deviant opinion of al-Aṣmaʿī, who claimed that the word derived from *athar* ["trace/sign"], not from *athr* ["watering"], may be based on tradition; in early times, one regarded the steel waterings only as signs, without recognizing the link to the composition of the metal. This is supported by the use of *athar* for watered steel.

As for *mudhakkar*, there was only one etymological explanation of the term: "a sword with edges of steel and a body of forged iron". See Thaʿālibī, who quoted a verse by Ibn al-Rūmī [d. 283/896] that alludes to this phenomenon:[176]

> "What is the best means of defence? Only a sharp/
> sword with a masculine edge on the blade and a female centre//"

The idea of such a combination of both metals was apparently closest to **[143]** popular taste, even though it may not reflect the real composition of swords. However, the first use of both kinds of metal was attributed to the jinn in this way. The question remains whether *maʾthūr* and *mudhakkar* referred to different types of jinn-swords. I do not think so. These were rather two terms for one and the same thing. The Arabs had the habit of giving several names to an object according to its main qualities, and indeed in this case they chose two names of which one referred to the composition of the blade, and the other to its appearance. This also explains why lexicographers sometimes confused the meaning of both terms. On the one hand, we find that Fīrūzabādī attributed the same meaning to *maʾthūr* that Thaʿālibī had given to *mudhakkar*, namely "a sword with edges of steel and a core of forged iron". As this explanation is wholly unetymological, it must owe its existence to the fact that both *maʾthūr* and *mudhakkar* were believed to be swords made by the jinn. Therefore the meaning of one term was transferred onto the other. On the other hand, Jawharī and Fīrūzabādī explained *mudhakkar* as *dhū māʾ* ["possessing water"], while *māʾ* ("water", a word that is also commonly used in German for watered steel) in turn was used to mean "watering", particularly in combination with *firind* ["watering"] (*māʾ wa-firind* in Slane's edn. of Imruʾ al-Qays, 127, commentary on 49, 13). The word *mahw* derives from the same root, with transposition of the final radicals, and was explained by some as *kathīr al-firind* ["having much watering"].

In reality, swords were produced out of a mixture of iron and steel (cf. *hayyid* above).[177] The pre-Islamic ode by Qays ibn Zuhayr,[178] which also includes **[144]** a reference to the jinn in one verse,[179] contains the expression *dhū ṣanīʿ* which was

[174] *Hudhayliyyīn*, 55, 6, and a variant reading: *ibid.*, 14, 2.

[175] *Ibid.*, commentary, 14, 2; Imruʾ al-Qays (ed. Slane), commentary, 50, 13; Lane, *s.v.*

[176] *Fiqh*, 132.

[177] *Mawṣūl* and *waṣīla* (used of swords) do not belong here, etymologically speaking.

[178] *Ḥamāsa*, 231, 17; this Qays ibn Zuhayr appears to be the same person as Qays ibn Jadhīma, the owner of the horse Dāḥis: see Freytag, *Proverbia*, III, 281.

[179] It may be that the poet wanted to allude to the jinn as the producers of swords when he compared the latter to the sons of Fāṭima ibn al-Khurshūb, who was said to be descended from the jinn: Freytag, *Proverbia*, XXV, 104.

explained by the commentators as *maṣnū^c min al-ḥadīd al-layyin wa-l-fūlādh* ["manufactured from pliable iron and steel"]. Further evidence is found in the poetic corpus of the *Hudhayliyyīn*. This evidence will be used to support the main points in the following attempt to describe the sword making process.[180]

The Arabs used the verb *khashaba* with reference to swords. This word is one of the so-called *iḍdād*, i.e. words that have several opposite meanings... [a brief discussion of this grammatical phenomenon follows, here omitted since it is not relevant to swords] ... **[146]** The original meaning of the word *khashaba* is that of "to mix". When used of swords, it therefore refers to the act of "mixing" the base components. In usage, the meaning developed in the following stages: 1) to forge; 2) to grind; 3) to polish. Of these meanings, the last became the most commonly used. A vestige of the original meaning is preserved in the derived noun *khashība,* denoting "the structure of a sword, its material properties (which are determined by its composition)". In certain expressions the word is glossed as "blade" etc., but this is merely an explanation *ad sensum*. Of course, the term was also used to denote the natural properties of wood that was used for making bows.[181]

Closely related to this is the act of grinding, which followed immediately after the forging process (to which we will return further below). Its purpose was, presumably, to remove uneven parts and hammer-scale. The verb used for this process was also *khashaba*. And hence the Arabs took *khashīb* (or *makhshūb*) to mean "a **[147]** sword in the making, not (entirely) finished, not yet ground".[182] The meaning of "raw, unfinished" was preserved in usage only in reference to arrowheads and bows at a similar stage of processing, while with swords its meaning changed (cf. Iṣfahānī, II.169, 5 from the bottom, where *makhshūb* is glossed as: *al-ḥadīth al-ṭab^c* "newly forged", with the added remark: *thumma ṣāra kull maṣqūl makhshūban*, i.e. that "every ground and polished sword came to be called *makhshūb*"). The result of this process was that on the surface of the blade the various layers of the composite metal became visible as (dark) lines and spots. For this reason, a sword was given the most befitting epithet *mashqūq al-khashība*[183] in a verse of a poem of the *Hudhayliyyīn*, i.e. a sword made with a composite structure (*shuqqat khashībatuhu*[184]), in which the individual components have been separated and made visible. Indeed, the term was explained as *mu^carraḍ al-ṭab^c* ["the nature exposed"] in the commentary on 74, 36.

[180] The Russian engineer Anossov, who claims to have discovered the secrets of the process of production of Oriental watered blades in his experiments, used a kind of cast steel made from purified iron and graphite. He believes that this method must have been the one used in antiquity. However, this is not confirmed by the Arabic sources. One would have to assume that the process remained the secret of swordsmiths, and was unknown to poets and commentators, let alone the common people [though the comments of Kindi, Bīrūnī, and Ṭarsūsī, would suggest that these processes were quite well known]. Finally, one may note that even in Anossov's process there is some separation between two kinds of metal, as carbon-rich iron isolates within the steel and crystallizes, thus causing the watering; cf. *Buch der Erfindungen, Gewerbe und Industrieen*, vol. VI.

[181] *Hudhayliyyīn*, commentary, 9, 4.

[182] Tha^cālibī, *Fiqh*, 132.

[183] *Hudhayliyyīn*, 9, 3; 74, 36.

[184] *Ibid.*, 30, 3.

This kind of structure was thought to be a mark of quality in a sword and was therefore praised.[185] Later, it was referred to as watering. A possible reference to this phenomenon is the phrase: *mā aḥsana mā khushiba* (Freytag, *Lexicon*; cf. Mutanabbī, 320, 15: *mudhish al-ṣayqalayn*, and the explanation in the commentary: *yudhishu l-ṣayqal li-jawharīhi* "that which astonishes the grinder on account of its composition").

The watering (we will use this term from now on) was part of the very substance of a blade [see Kindī/Zakī, p. 6 and passim], but it only became visible (*ubriza athruhu*[186]) after it was filed. This applied to both sides,[187] as is stated explicitly in the verse (Jawharī, *s.v.* "sh-b-th") **[148]**:

> "On both its sides you can see a watering as if/
> many a snake had crept to and fro over it [and left its trace]//"

According to the opinion of Sukkarī, the watering in the metal was already visible at this stage of processing. In the commentary on *Hudhayliyyīn*, 30, 3, he states: *al-naṣl idhā ṭubiᶜa wa-ᶜurriḍa qabla an yuṣqal qad shuqqat khashībatuhu wa-qad khushiba* "when a sword has been forged and is shown before it is ground, its structure is already apparent and it is already filed". This statement undoubtedly confirms the meaning given above for *khashaba*. According to others, the watering appeared only after a sword was hardened and ground.[188] This appears from a verse by Khufāf ibn Nadaba [fl. late 6th/early 7th c.][189] (Jawharī, *s.v.* "ʾ-th-r"; also Lane):

> "The polishers smoothen it so that it becomes free from blemish/
> and light in weight, protecting them with the sparkle [of a watered sword]//"

Both opinions can be reconciled. For although the watering must have been apparent after the first stage of filing, it would have appeared in full only after a further stage of treatment to the blade. In talking about watering, one has to distinguish between the watering in the steel ([often also referred to in the nineteenth century as] moiré) on the one hand, and colour and sheen on the other hand. The former was called *athr* or *uthr* by the Arabs (from this derives the epithet of the sword *dhū l-uthr*[190] "possessed of watering") or *firind* (*birind*), an arabicized Persian word. (One may add also, according to Fīrūzābādī: *ḥaṣīr* ["woven"], *namish* ["speckled/streaked"] and *sayf birind* = *sayf fīhi shuṭab* ["a sword on which are grooves"]). These terms also serve to refer to the whole phenomenon.

The colour and sheen of the **[149]** watering were called *rubad*, and hence swords were given the name of *dhū rubad*[191] "possessed of a dark, shimmering watering".

[185] *Ibid.*, 26, 2 (= 9, 3); cf. Mutanabbī, commentary, 22, 4.

[186] *Hudhayliyyīn*, 30, 3.

[187] *Ibid.*

[188] Commentary on *Hudhayliyyīn*, 30, 3; 9, 3.

[189] Nadaba was his mother; thus vocalised in Mubarrad, 569, 6; cf. also line 10. Khufāf was one of the ravens [outlaws] of the Arabs. Other verses by him can be found in Mubarrad, 569, 12ff.; Iṣfahānī, II.160, 1ff.

[190] *Hamāsa*, 325, bottom.

[191] *Hudhayliyyīn*, 85, 4.

Perhaps one can add here the trope *dhū l-rāḥa* ["pertaining to the palm"], the name of al-Mukhtār ibn Abū ʿUbayd's sword,[192] if it refers to the lines of the hand. But again, it is more likely that it points to the similarity between a sword and the flat (open) hand.[193]

During the forging process, to which we now return, a blade was given its shape through the forging of iron or steel ingots (*zubra*, pl. *zubar* and *zubur*). Compare the verse by Mutanabbī in which he called the process of firing a process of growth (*nashaʾa*), and compared it to the raising and upbringing of virgins living in luxury (*naʿīm*). The commentary on this verse reads: *yurīd annahā (al-suyūf) takhallaṣat min al-khabth wa-ḥussinat ṣanʿatuhā bi-ḥusn taʾthīr al-nār fī takhlīṣihā wa-innamā ṭubiʿat wa-ṭuwwilat baʿd mā kānat zubran bil-nār.* ["He wants them (the swords) to be purified of dross and their manufacture to be improved by the beneficial influence of the fire, in which is their purification; they are only forged and elongated after becoming ingots in the fire"]. During this process the blades were extended,[194] and for this reason they were generally called *ṣafīḥa*, pl. *ṣafāʾiḥ*.[195] Poets called swords *muṣaffaḥ*, pl. *muṣaffaḥāt* (Jawharī, *s.v.* "ṣ-f-ḥ"), as in the following verse by Labīd, in which he describes a cloud:

> "As if drawn-out swords were at their tips/
> or wailing women with their handkerchiefs//" **[150]**

Addendum 1: That *muṣaffiḥa* is listed with the same meaning in Freytag's *Lexicon* is the result of a misreading of the words *wa-yurwā bi-kasr al-fāʾ*, which belong to the following phrase, where the word is explained as "women clapping their hands". If Freytag had not expressly refered to Jawharī, he could have turned to Fīrūzabādī, which only has *wa-yuksar* (see Lane).

Addendum 2: The same double comparison as in the verse by Labīd is found in the following line in the same metre by ʿAdī ibn Zayd [fl. second half 6th c.] (Iṣfahānī, II.24, 3 from the bottom):

> "Mashrafī swords shine on their tips – or rather/
> it may be shiny new linen//"

The following special expressions relate to the dimensions of swords: *ṣafīḥa*, pl. *ṣafīḥ*[196] "a broad sword", i.e. one that surpasses other swords in width; *mikhfaq*,

[192] Fīrūzabādī.

[193] In Anossov's process the watering is formed already while the steel cools gradually in the crucible. After the metal has cooled off completely, a block of steel with an even surface and clear watering remains at the bottom of the crucible. The coloured reflection can already be observed at this stage, if the block is held at an angle; see *Buch der Erfindungen, Gewerbe und Industrieen*, vol. VI.

[194] Mutanabbī, 338, bottom.

[195] *Ḥamāsa*, 189, 1; 769, 6 from bottom; *Dīwans* 6, ʿAntara, 7, 13; Mutanabbī, 86, 10.

[196] *Hudhayliyyīn*, 87, 7; Iṣfahānī, II.165, 4 from the bottom (Ḥassān ibn Thābit); *ibid.* 169, 4 (Qays ibn al-Khaṭīm).

likewise a "broad sword" according to Fīrūzabādī; *mighwal* "a short sword"[197] (not to be confused with *miʿwal* "a pointed iron instrument for splitting rocks" described in the *rajaz* verses of Mubarrad, 501, 17 ff.); *mishmal* "a sword that can be covered with one garment".[198] According to one commentary on the *Muʿallaqa*, v.51, of Ḥārith [fl. 6th c.] *raʿlāʾ* (fem. of *arʿal*) signifies "long swords". The meaning "long" is beyond doubt, although its use is limited, according to Jawharī and Fīrūzabādī. The commentator first added *katība* "a group of riders" (so that the second epithet *mubayaḍḍa* would refer to their faces (= *abyaḍ*, cf. Mubarrad 54, 11; *Ḥamāsa*, 26, v.3) or to their armour (cf. *Diwans* 6, al-Nābigha, 22, 2), but also mentions [151] *suyūf* as the implied noun. This is contradicted by the next verse, however, which refers to a spear fight (*taʿn* in Arnold), which may have induced Jones to translate "spear". Then again we can disregard this argument if we take up the variant reading *ḍarb* given by Vullers (Ḥārith, *Muʿallaqa*, p. 32, for v.52). The only reason to remain sceptical would be that the terms *raʿlāʾ* and *mubayaḍḍa* are not used of swords elsewhere. On the other hand, Arnold's reading only permits the first explanation.

The terms used for "thin swords" are poetic expressions for thin, sharp swords, and will be dealt with below. As for the other qualities of the flat surface of the blade (*ṣufḥ* or *ṣafḥ* – though not listed with *fatḥ* in Fīrūzabādī, according to Jawharī this was the colloquial pronunciation – pl. *ṣifāḥ*, nomen unitatis *ṣafḥa*, always with *fatḥ*; *ṣafḥatān* attested in *Hudhayliyyīn*, 3, 30; *ḍarabahu bi-ṣafḥat al-sayf* "to hit with the flat side of the blade" = *ḍarabahu muṣfaḥan* attested in Fīrūzabādī; poetic: *matn*, pl. *mutūn*: *bīḍ al-mutūn* in *Ḥamāsa*, 644, 13), its lightness was often praised with the epithet *khafīf* (pl. *khifāf*[199]). It is not clear whether this quality was achieved during the forging process giving the surface a concave shape, or whether it was a result of polishing, as it would appear from the verse by Khufāf ibn Nadaba quoted above, p. 148. Its lightness allowed for a sword to be handled quickly, and indeed this is the meaning of *khifāf* according to the commentary on *Ḥamāsa*, 313, 19. Freytag, in his translation, wrongly rejected this commentary, because he did not take the original meaning into account, and took the term to refer to the swords' piercing the body quickly. The first explanation fits in well with the occurence of epithets for the lightness, thinness, and [152] sharpness of swords side by side in the relevant verses (*khifāf murhafāt qawāṭiʿ*: *Ḥamāsa*; *al-khifāf al-ṣawārim*: Mutanabbī).

The sword *mufaqqar* is worthy of mention in this context [see Kindi/Zaki, p. 9], for its blade possessed qualities that were most probably a result of the welding process. According to the commentators:[200] *idhā kānat fīhi ḥuẓūẓ muṭmaʾinna ʿan matnihi*, it had spiral-shaped depressions in the surface of the blade, that is, it had real grooves (*ʿamūd = sayf shaṭībatuhu allatī fī matnihi*: Fīrūzabādī, *sulcus in dorso ensis*). In the absence of other evidence it must remain doubtful if these grooves served to make the

[197] Mubarrad, 358, 7 and 9; Thaʿālibī, *Fiqh*, 132.

[198] *Ibid.*

[199] In a verse of Khufāf ibn Nadaba: Jawharī, *s.v.* "ʾ-th-r" and Lane; *Ḥamāsa*, 313, 10 from the bottom; Sacy, *Chrestomathie*, III.12, 14 (Mutanabbī); also *nashīl* "a thin, light sword" in Fīrūzabādī.

[200] Thaʿālibī (*Fiqh*, 132), Jawharī, and Fīrūzabādī.

sword lighter, but it is most unlikely that they served as bloodgrooves. The sword *dhū l-fiqār* (or *faqār*) possessed the same qualities (thus Thaʿālibī, after mentioning *mufaqqar: wa-summiya minhu dhū l-fiqār*; Fīrūzabādī has *bi-l-fath*; Thaʿālibī supplied both *fath* and *kasr*). This was the name of the Prophet's sword, which he chose as booty for himself after the battle of Badr,[201] and which had belonged to the pagan Munabbih ibn al-Hajjāj (Fīrūzabādī: al-ʿĀs ibn Munabbih) who was killed in battle. The quality of this sword was proverbial among the people of the Hijāz (*lā sayf illā dhū l-faqār*[202]). ʿAlī inherited the sword after him,[203] and later it must have passed into the hands of an Abbasid, for the caliph Hārūn al-Rashīd [r. 170–93/786–809] presented it to his general Yazīd ibn Mazyad.[204] It was owned by the caliph Muqtadir shortly before his death, when Baghdad was besieged by Muʾnis.[205] The museum of Tsarskoe Selo [near St. Petersburg] is said to hold a two-pointed weapon with the name of *dhū l-fiqār*. According to the above, the **[153]** Prophet's weapon was shaped differently. On the other hand, Qays ibn al-Khatīm [d. early 7th c.] in one of his verses[206] used the expression *dhū l-zujjayn* ("two-pointed"):

"With a two-pointed (sword) I severed Mālik's neck"

The term would be more appropriate if used of a spear, but there can be no doubt that this verse refers to a sword, given the use of *darb* ["strike"] and *raqba* ["neck"] and given also that *taʿn* ["thrust"] is mentioned separately in the following verses. The same sword was called *dhū al-khursayn* ("with two rings"),[207] which was its real name. The former was only an epithet inspired by the sword's appearance. It may have looked similar to the sword *dhū al-fūq* "possessed of a notch/a split", which was owned by Mafrūq Abū ʿAbd al-Masīh.[208]

So much for the surfaces of the blade. As for the edges, they were called *shafra* (only used of swords); among the old poets this was frequently used in the dual, as in the expression *raqīq al-shafratayn* ["with two fine edges"] (appears on its own in Mutanabbī, 78, 11; at 116, 8 from the bottom, with *ghirār* ["cutting edge"], which is also used of other sharp objects: Mubarrad, 24, 10ff., in a figurative sense uses *ghirār ʿazmatihi* ["the cutting edge of his resolve"]; Harīrī [d. 516/1122], 23, 1, has *dhukra*, not used by poets, for the metal from which the edges were composed). They are mostly spoken of in pairs[209] (hence *dhū l-ghirārayn*[210]), although terms such as, among

[201] *Hamāsa*, 458, 5 from the bottom; [this is a well known report; e.g. see Dhahabī, *Siyar*, 2.428, citing Ibn Fāris al-Qazwīnī (d. 396/1004)].

[202] Zamakhsharī, *Mufassal*, 16, 1.

[203] Fīrūzabādī, *s.v.* "f-q-r".

[204] Muslim ibn al-Walīd, 56, v.25 – cf. the note; Ibn Khalliqān, no. 830.

[205] Kosegarten, *Chrestomathia*, 108, middle (al-Masʿūdī).

[206] Isfahānī, II.160, 7.

[207] *Ibid.*, 161, 13.

[208] Fīrūzabādī.

[209] As in the verse by Abū l-ʿAlāʾ (Jones, *Poeseos*, 319): "The edges of the swords from Mashraf are like two tongues that cast the spell of death".

others, *aqlaf* [211] (lit. "uncircumcised") – perhaps also one explanation of *mighwal* (a thin sword with a *qafā* "nape"), as also *kall* "back of a sword or knife" – prove that swords with only one edge existed as well.

Sword edges were described as being thin [see Kindi/Zaki, p. 14], and this aspect of their appearance will be discussed in more detail below. It will suffice here to point out that there was a semantic **[154]** overlap between "sharp" and "thin", between "to sharpen" and "to make thin". This makes us realize that thinness at the edges was the result of a separate process, although there can be no doubt that even during the forging process the edges of the blade were made to be thinner on the outside (wedge-shaped). It is not clear whether a hammer or only a sharpening-stone was used during the subsequent stages of the process. In Hebrew, the verb *laṭash* means "to hammer" and "to sharpen by hammering", just as in Arabic *waqaʿa* signifies "to beat, to forge using the tool called *mīqaʿa*" (*waqaʿta al-ḥadīda idhā ḍarabtahā bi-l-mīqaʿa* ["you beat the iron by striking it with the *mīqaʿa*"]) as well as "to sharpen". In both languages, the terms are used of swords in particular. On the other hand, the term *mīqaʿa* [212] itself was explained in two different ways, as "hammer" and as "a long grinding stone".

Although straight swords were the most common,[213] there were also swords that were curved, that had developed some curvature when the edges were hammered out. This is evident from the verse (Jawharī, *s.v.* "ḍ-l-gh"):

> "A man carries his well-tried sword/
> which is sharp despite a curve in its blade//"

Through its use of the term *ḍalaʿ*, which is only used of naturally curved objects, this line excludes the possibility of a temporary deformation. Also the name *dhū l-nūn* (Fīrūzabādī) and the sense of *nūn* suggest, among other things, "sword edge". Blades of this type could also be double-edged, judging from a verse by Khalaf al-Aḥmar, where, according to Ahlwardt (*Qasside*, p. 33), the poet used the image of a **[155]** rattlesnake to describe a sword as being curved and fitted with two sharp sides.

A blade that had been processed up to the stage described above was called *sharkh*, pl. *shurūkh*,[214] i.e. strictly speaking a blade on which work had begun, the root, the beginning or origin of a blade. The term is explained as: *naṣl lam yusqa baʿd wa-lam yurakkab ʿalayhi qāʾima* "a blade that has not yet been quenched and on which no handle has been mounted".

After a blade was ground, the process of hardening was begun. The Arabs described this process with the image *saqā al-māʾ* "it (the sword) drinks water".[215] If

[210] Mubarrad, 365, 13.
[211] *Ibid.*, 619, gloss i.
[212] *Hamāsa*, 207, commentary 3.
[213] *Namasha* "a straight sword": Habicht, *Tausend und eine Nacht*, II.65, 71.
[214] Jawharī.
[215] Commentary on *Hudhayliyyīn*, 9, 3 [though this has *suqiya l-māʾ* "it is given water to drink"].

the procedure was the same during the early and the late periods, then only the edges of the blade were hardened, not the flat surface, for Mutanabbī said:[216]

"It goes to water, but only the edges drink as much as they wish/
Next to them there are gazelles that quench their thirst with grass//"

The commentary on this line explains that not the whole blade was quenched – neither *matn* nor ʿ*ayr* (possibly the inner part of the edges) – but only the edges themselves (*shafratāhu*). The body of the blade was not exposed, so that it would remain solid and not break. The hardening process must have been connected with tempering, which produced the emerging colours on the blade [see Kindi/Zaki, pp. 14–15 and 20–21]. For the early period, as we already pointed out above, Fīrūzabādī informs us of the fact that the blade of [the sword called] *lisān kalb* had the colour of green cabbage at the length of three *dhirāʿ* [cubits]. Mutanabbī mentioned the colour several times (*khuḍrat jawharihi*), and in one verse he contrasted it with the colour of blood running over the blade[217] **[156]**:

"The green coat of life was saved by the green (blade)/
on which the red of death showed like the traces of ants//"

The colour reminded some poets of fresh cabbage, so al-Buḥturī:[218]

"Though old like its sword, dating to the distant times of ʿĀd/
The sword-belt carries a fresh cabbage that never withers//"

Others[219] likened it to the colour of chicory juice:

"An Indian sword, soaked by its Indian smith with chicory-water/"

Alluding to this colour, Mutanabbī called his sword "his daytime pasture, where he drinks".[220] Judging from the information given by Fīrūzabādī, only a part of the blade, not the whole, went green.

It follows from the explanation of *sharkh* quoted above that after the hardening process the blade was fitted with a handle (*rukkiba ʿalayhi qāʾima*). The lower part of a blade onto which the handle was mounted was called *sīlān* ["tang"] apparently because of its long and narrow shape. To hold the handle firmly in place, grains of iron (*shaʿīra*, because of their similarity to grains of wheat; according to Fīrūzabādī these grains could also be of silver) were inserted inbetween. The handle itself was commonly called *qāʾima*[221] or *qāʾim* (Bashshār ibn Burd in Iṣfahānī, III.69, 7 from the bottom: *wa-mā khayr sayf lam yuʾayyad bi-qāʾim* "what is the use of a sword without

[216] Mutanabbī, 304, v.5.
[217] *Ibid.*, 22, 9.
[218] Commentary on Mutanabbī, 22, 9.
[219] Mutanabbī, 305, v.8; cf. commentary.
[220] Commentary on Mutanabbī, 22, 9.
[221] *Ḥamāsa*, 32, 2 from the bottom; Muslim ibn al-Walīd, 7, v.21; Mutanabbī, 118, 11 from the bottom; 226, 19.

a handle"), but according to another opinion, ʿajz[222] was used as well. The following have the same sense: *maqbiḍ* (also *maqbaḍ* and *miqbaḍ*, see Fīrūzabādī), pl. *maqābiḍ*,[223] lit. "place where one holds a thing", used of sword and [157] bow handles;[224] *riʾās* [lit. "head"] (verse in Jawharī, *s.v.* "ḍ-gh-n"); *ghāshiya*, from *ghashiya* "to cover", lit. a piece of hide with which the handle (or the scabbard, according to another explanation) was covered. This piece of skin was rough, like crocodile skin,[225] and was used as a synecdoche for the handle as a whole. Instead of a simple term, one verse in the *Ḥamāsa*[226] has the paraphrase: *minhu mā ṣummat ʿalayhi al-anāmil* "that of which my fingers got hold".

Finally, a blade was subject to two more processes, which were both referred to by the verb *ṣaqala*[227] (hence *ṣayqal*, a swordsmith[228]). The first was that of grinding, and the second that of polishing. The former was carried out with different grinding tools, depending on whether the edges or the broad sides of the blade were treated. For the sides, a wide grindstone (*sinān*) was used. Freytag in his *Lexicon* already noted the word, and Jawharī (*s.v.* "kh-sh-b") attributed the same meaning to *misann*. Lane obviously erred when he said that a spear point was used in this process. The edges were sharpened using a tool called *mīqaʿa*, but as we already mentioned before this was also explained differently. The act of sharpening the edges of a blade was called *ḥaddada*, *shaḥḥadha* (see also the first form, *shaḥadha*, which was used of arrowheads as well; e.g. Mubarrad, 582, note b, where it is explained as *jalā*: *shaḥadhta al-sayf wa-l-sahm idhā jalawtahu* ["you whetted the sword and arrow by polishing them"]), and *afrasha*. As a blade would grow thinner in the process of grinding, the verb *arhafa* ["make thin"] could be used, as well as *maḥḥā* and *amḥā*,[229] which refer to the moisture applied during grinding [158]. The last two verbs prove that moist grindstones were used, and that the edges were treated at least once with this kind of tool.

Addendum: Other names for grinding tools are: a) *miḥaṭṭ*, *Ḥamāsa*, 816, 6 from the bottom. This is an iron tool which, contrary to the commentary on the verse quoted here, was explained differently elsewhere as either an iron needle to puncture skin or an iron tool used by shoemakers to prepare leather; b) *misqala*, glossed in Fīrūzabādī as "mussel", which was used to give a smooth finish to fabric (cf. *qabqāb*); c)

[222] Fīrūzabādī.

[223] Mubarrad, 244, 5.

[224] According to Reiske *miʿdad* also has the significance "sword handle" (cited in Freytag, *Lexicon*) (but: *miʿḍād* = a sword-like tool used to cut trees).

[225] Jawharī.

[226] *Ḥamāsa*, 22, 4.

[227] Also said of polishing jewels, gemstones, etc.; cf. Dieterici, *Mutenabbi und Seifuddaula*, 158, bottom.

[228] Also *ṣīt* and *qayn*, pl. *quyūn*; cf. the verse in the following section, quoted from Jawharī.

[229] Jawharī (Abū Zayd) and Fīrūzabādī. One may add here *tamwīh*, derived from the same root (*Diwans 6*, Imruʾ al-Qays, 45, 9, combined with *ṣaql* (ed. Slane, 49, 4)); *amḥā* "to grind arrowheads until they are thin" (*Diwans 6*, Imruʾ al-Qays, 29, 6 (ed. Slane, 38, 4 – cf. 16, 4 – with the misprint *amḥā*).

sunbādhaj, of Persian origin; said to be a stone used by a swordsmith for polishing (*jalā*) blades and spear heads (see Fīrūzabādī).

The tool for polishing was made of wood and was called *midwas*, pl. *madāwis*.[230] The act of bringing it into contact with the blade during the polishing process was referred to as *kadkada* (*ḍarb al-ṣayqal al-midwas ʿalā al-sayf idhā jalāhu* ["the polisher's striking of the sword with the polishing tool as he polished it"]). The verbs for "to polish" are *jalā*, *dāsa*, and *qashaba*.[231] It appears from the following verse that great care was taken with polishing:

> "A polished sword, resembling a lake; half a month/
> elapsed before it gained its sheen at the hands of those who polished it//"

Of a sword that emerged without blemish from this process, the poets said: *ukhliṣa bi-l-ṣiqāl*[232] or *akhlaṣahā al-ṣaql;*[233] or with reference to the waterings in the watered steel: *ukhliṣat khashībatuhu*[234] (Jawharī, *s.v.* "r-b-d": *ʿaqīqatuhu*). Hence **[159]** swords as a whole were called *mukhlaṣāt* ["purified/freed"] and Mutanabbī, 339, v.5, described their sharpness with the words: "Polished, they left the hands of the sword smiths, which were covered in wounds".

A sharpened, polished sword was called *ṣaqīl*,[235] pl. *ṣiqāl*,[236] or else *maṣqūl*[237] and *muṣaqqal*, pl. *muṣaqqalah*.[238] Furthermore, and with particular reference to the edges, we have *maṣqūl al-ghirārayn*[239] and *maṣqūl al-ghirār;*[240] and of the tip, *maṣqūl al-dhubāb*.[241] The name of ʿUrwa ibn Zayd al-Khayl's sword was *ṣuqal*.[242] *Khashīb* (Jawharī, *s.v.* "s-r-kh"[243]) has the same meaning as *ṣaqīl*. One may add here the epithets *akhlaq*[244] ("smooth, even"), *ṣāfin*[245] ("shining, polished"), *ṣāfī al-ḥadīda*,[246] perhaps also *min māʾ al-ḥadīd*, "of shining iron" (lit. of the sheen of iron[247]). In Mubarrad, 524, 10, one finds the alternative reading *maṣqūl al-ghirār*. The intensive

[230] Thaʿālibī, *Fiqh*, 135.
[231] Fīrūzabādī.
[232] *Hudhayliyyīn*, 107, 15.
[233] *Hamāsa*, 796, 6 from the bottom; cf. Lane, I.18, col 3.
[234] *Hamāsa*, 3, 10; quoted in the commentary on *ibid.*, 358, 14.
[235] *Ibid.*, 231, 3; 353, 11; 459, 9; *Diwans 6*, Imruʾ al-Qays, 45, 9 (ed. Slane, 49, 4).
[236] *Hamāsa*, 93, 5 from the bottom.
[237] *Hudhayliyyīn*, 50, 1; Mutanabbī, 226, 2.
[238] Mubarrad, 244, 5.
[239] *Hamāsa*, 358, 4.
[240] Mubarrad, 524, 7.
[241] *Hudhayliyyīn*, 55, 6.
[242] Fīrūzabādī.
[243] = Mubarrad, 131, 6.
[244] *Hamāsa*, 43, 5.
[245] Freytag, *Lexicon*.
[246] ʿAmr ibn Kulthūm, *Vita* (ed. Kosegarten), 4, bottom; ʿAntara, *Muʾallaqa*, v.55; *Hudhayliyyīn*, 9, 2.
[247] *Hamāsa*, 64, 26; 231, 3.

forms of the term are *ṣanīᶜ* "polished with great skill",[248] *farīd* "exceptionally well polished",[249] with the alternative forms *farad, fardad, farīd,* and the proper name of ᶜAbd Allāh ibn Rawāḥa's sword, *al-fard.* Also *aḥaṣṣ* was used of swords in this sense, as well as of excellent spears without blemish. A well-sharpened and well-polished sword could be drawn from its scabbard quickly (hence *sarīᶜ al-salla*[250]), while making hardly any sound (*khafī al-jars*[251]) [160]. The poets likened sharpened swords (*ṣanīᶜ*,[252] *ṣaqīl*) to the foreheads of noblemen where the friction of helmets had shaven off all hair, particularly when they spoke about princes who had been killed in battle (*ka-anna jabīnahu sayf ṣaqīl* ["as though his forehead was a polished sword"]).[253]

When a sword was in use, it had to undergo these processes repeatedly. At times, the poets praised the frequency with which a sword was sharpened and polished, and at other times the scarcity of this occurrence, depending on whether they wished to underline the quality of the grind or the frequency with which a sword was used. As for the latter, one may add here that the sword of ᶜAmr ibn ᶜAbd Wudd[254] was called *al-miladd* ("the disputatious"). Imruᵓ al-Qays[255] boasted of his sword that it did not remember ever being polished. Zayd al-Khayl, on the other hand, praised his weapon with the words.[256]

> "My sword spreads terror when they shout:/
> Dismount! Salāma knows this//
> For every day it is polished anew/
> and bites the skulls of men with a new tooth//"

Similarly, in the *Ḥamāsa*[257] a sword was praised for being "brought to the watering hole" each day, and not every other day, and for being polished afterwards. The commentator remarked that *ṣaqala* was used metaphorically in this verse, for a sword need only be wiped off after use. That may be correct, but poets love hyperbole, and therefore *ṣaqala* is indeed appropriate in its literal sense. The act of renewing the grind and polish and of a sword was called *ḥadatha*[258] (*aḥdatha*) *bi-l-ṣiqāl,* and swords that had been renewed in this way *muḥdathāt al-ṣiqāl.*[259] These expressions served to emphasize [161] the sharpness of a blade. Compare also *sayf qashīb* (Jawharī, *s.v.* "ṣ-

[248] *Diwans 6,* al-Nābigha, 8, 10; Ahlwardt, *Bemerkungen,* 93.

[249] Mubarrad, 131, 6.

[250] *Ibid.,* 365, 13.

[251] Khalaf al-Aḥmar, *Qasside,* 88 (*Mufaḍḍalīyāt*): *jalīṭa* "a sword that falls from its scabbard"; this was considered a defect, if the reason was a faulty blade, or if a sword had been used so frequently that it fitted loosely into the scabbard; see Jawharī.

[252] Mubarrad, 131, 6.

[253] Mutanabbī, 276, 8; *Ḥamāsa,* 459, 9.

[254] Fīrūzabādī.

[255] *Diwans 6,* Imruᵓ al-Qays, 45, 9 (ed. Slane, 49, 4); a similar motif is used with regard to arrowheads, which are compared to the teeth of dogs.

[256] Mubarrad, 120, 8; cf. the commentary and *Ḥamāsa,* 94, 12.

[257] *Ibid.,* 259, 3.

[258] *Ibid.,* 94, 12.

[259] Khalaf al-Aḥmar, *Qasside,* v.5.

q-l") "a sword that has recently been polished", and its opposites ṣadiʾ[260] "a rusty sword" and *thāmil*[261] "that which has not been cleaned for a long time".

Finally, to end this section, let me list the names given to individual parts of blades:

1. The flat side: *ṣafḥ*, pl. *ṣifāḥ* (see above), also used as a synecdoche for the blade or sword as a whole: *shaharū al-ṣifāḥ*,[262] nomen unitatis *ṣafḥa*; in poetic language *matn*, pl. *mutūn*.

2. The unhardened part of the blade's edge: *ʿayr*; compare the information about the hardening process quoted from Mutanabbī (p. 155 above), which suggests that this is to be distinguished from *matn* and *gharb* (see Ibn Durayd, v.71). It can only be understood as the central section of the edge where it protrudes beyond the curvature of the tip. This would go well with its other meanings, namely: a) a protruding bone in the middle of a limb; b) the protruding middle part of some arrowheads.

3. The edges: *shafra* (often *shafratān*), *ghirār* (*ghirārān* in Mutanabbī, 305, v.7), *dhukra*, *qarn*, *ḍabīb*, *ḍarība* ("sword, swordblade", lit. "that with which one strikes"; etymologically the same as *zaʿīna*).

4. The sharp part of the edges: *ḥadd*[263] (also used to mean "blade" and in a figurative sense, see Mutanabbī, commentary, 289, 3: *lā tafull al-shadāʾid ḥadd maraḥihā* "hardships do not blunt the sharp edges of her (a she-camel's) liveliness"), *ḥidda*, *dhalq* (*dhalq al-sayf*[264]).

5. The part of the blade with which one delivered a blow was, according to Jawharī,[265] about one span of a hand from the top end of a blade, and was called *maḍrib*[266] (*maḍārib*[267]). **[162]**

6. The sharp part of this latter section was called *ẓuba*.[268] As this term was also used for the tips of spears[269] and arrowheads[270] (cf. Mubarrad, 599, note r, where this threefold use of the word is noted), it can equally mean "the very tip of a sword" (*ṭaraf*).[271] In Mubarrad, the word is given the general sense of "the sharpness of a thing" (*ẓuba kull shayʾ ḥadduhu*). However, the first meaning given here seems to

[260] Fīrūzabādī.

[261] Freytag, *Lexicon*.

[262] Kosegarten, *Chrestomathia*, 77, 1.

[263] *Ḥamāsa*, 143.

[264] "the sharp part of a sword"; Mubarrad, 577, note f.

[265] Quoted by Sacy, *Anthologie*, notes to p. 221, no. 157.

[266] *Ḥamāsa*, 129, 19.

[267] *Diwans 6*, Imruʾ al-Qays, 45, 8 (ed. Slane, 49, 3); *Hudhayliyyīn*, 9, 2; Iṣfahānī, II.168, 16 (Dirham ibn Zayd, a contemporary of Qays ibn al-Khaṭīm); *ibid.*, III.48, 21 (Bashshār ibn Burd); Mutanabbī, 14, 9; 121, 9 from the bottom.

[268] *Ḥamāsa*, commentary, 48, 18; Mubarrad, 66, 17.

[269] *Ḥamāsa*, commentary, 48, 20; Ibn Durayd, v.88.

[270] *Hudhayliyyīn*, 107, 20.

[271] *Ḥamāsa*, commentary, 48, 19 (second explanation). Likewise, in the verse by al-Kumayt quoted below, where *bi-l-shafarāt...wa-l-ẓabīn* are juxtaposed, one has to translate "on the blades and the points..."

be the original one,[272] from which all others were derived. In addition, it was used as a synecdoche for: a) a blade, or the part of the blade with which one delivers a blow:[273] *bi-mādī al-ẓubāh* "with sharp blades" (Mubarrad, 66, 18); b) a blade, or sword in general.[274] This made expressions like *ḥadd al-ẓubāh*[275] possible. The latter is an *iḍāfa* ["genitive"] linking the part to the whole or the property to the object in which it is found, and so "the sharp swords". Abū Dhuʾayb [fl. early 1st/7th c.] used this compound in his verse:

> "They stumble into the blades of swords and it seems/
> as if they were covered with the red-spotted garments of Tazīd's women//"

Tazīd was the ancestor of the tribe that was credited with the introduction of red-striped cloth (*al-burūd al-tazīdīya*). According to Jawharī, his full name was Tazīd ibn Ḥulwān ibn ʿImrān ibn al-Ḥāf ibn Quḍāʿa. The term *ẓubat al-sayf* [163] also occurs as an image for a piercing look (*ḥadd ṭarafa*), as in: "he pierced him with the sword blade of his look". Apart from the plural *ẓubāt*, Jawharī mentioned the plural of paucity *aẓbin* and *ẓubūna* (genitive and accusative *ẓubīna*; Mubarrad, 599, note r), in addition to the following verse by Kaʿb ibn Mālik [d. *ca.* 50/670]:

> "And with the sharp edges of their swords, their hands gave a drink/
> from the cup of death to all those whom they met //"

The form *ẓuban* was not listed by Jawharī, although it occurs frequently in later poetry: in al-Buḥturī (Ḥarīrī, commentary, 96, 6 from the bottom); Dieterici, *Mutenabbi und Seifuddaula*, 86, 3; 81 and 103; Mutanabbī 102, 6.

7. The curvature of the tip was referred to as *gharb*, according to Ibn Durayd, v.71, while elsewhere it simply means "sharpness", not only in reference to swords, but also to arrows, men, the tongue (Mubarrad, 577, 11) and other objects (*ibid.*, 90, 2).

8. The tip itself, i.e. the upper portion of the blade which was raised slightly with the curvature, was called *naṣl*, which term was also employed as a synecdoche of blades or swords as a whole (see *Ḥamāsa*, commentary, 52, 13); also attested are *zirr* "button", as in *ḍarabahu bi-zirr al-sayf* ["he hit him with the *zirr* of the sword"], and *ʿajūz*, which has multiple meanings.

9. The extreme tip: *ṭarf* (used also of other objects than swords), metaphorically *makhrim* (lit. "summit"), and *dabīb* with its two meanings (see above no. 3).

10. The sharp edge of the extreme tip: *dhubāb*,[276] used only of swords. The general term for the sharp tip of an object, *shabāt*, was also used (*Ḥamāsa*, commentary, 48, 19; of spears see *Diwans* 6, Imruʾ al-Qays, 35, 13, and in Jawharī, *s.v.* "n-h-d"; of teeth, *shabā nābihā*, see Mubarrad, 236, 5; of nails, *yadmā shabā ẓufurihi*, see

[272] Al-Rijāshī says that *ẓuba* refers to the place four fingers below the *dhubāb* (*Ḥamāsa*, commentary, 48, 20), an explanation that is identical to that of Jawharī.

[273] *Ḥamāsa*, commentary, 48, 18.

[274] *Ibid.*, commentary, 52, 13.

[275] *Ibid.*, 48, 17; 52, 8; Delitzsch, *Jüdisch-arabische Poesieen*, 53.

[276] *Hudhayliyyīn*, 55, 6, and cf. commentary; Mutanabbī, 113, 2 from the bottom; 127, 10 from the bottom; 263, bottom.

Mubarrad, 234, 12; of mountains, *shabā al-ashfā*, see Abū Nuwās, *Weinlieder*, 6, 19) together with the [164] variant *shaban* (Mubarrad, 210, 14), as well as *bādira,* used metaphorically (= *shabāt al-sayf*, see Fīrūzabādī), literally "that which hurries".

D. Descriptions of swords

Descriptions of swords in poetry either focussed on the quality of the ready blade or exceptional success in its use. Both themes are highlighted by epithets, sword-names, metaphors or similes, where a sword could be likened to other things or other things to it.

The sword-handle was sometimes crowned at the very end with a metal cap [pommel], called *qulla* or *qabīʿa,*[277] made of iron or silver.[278] Given the original significance of *qulla* as "hilltop, human head", one may infer that this cap was conical or spherical. A sword thus adorned was called *muqallal.*[279] Fīrūzabādī mentions two long projections from the lower end of the handle [the cross-guard], called *shāribān* ["moustaches"], presumably because of their similarity to the two halves of a moustache. The handle itself had a kind of cover (*safan*) [grip]; this can be deduced from the other meanings of the same word ("tool made of fur for polishing"[280]). Undoubtedly, it served to keep the hand from slipping and to ensure a firmer grip. Handles fitted in this way were duly called *maqābiḍ al-safan.*[281] On *ghāshiya* see the previous section.

The custom of wrapping the sword-handle with the [165] jugular vein (*ʿilbāʾ*) of a camel was presumably more ancient and served to attach the handle firmly to the blade. From this derives the sword-name *maʿlūb.*[282] Both Fīrūzabādī and Jawharī quote *al-maʿlūb* as the name of al-Ḥārith ibn Ẓālim al-Murrī's weapon.[283] The act of wrapping itself was referred to as: a) *ʿalaba*, verbal noun *ʿalb*; b) *jalaza*, verbal noun *jalz*[284] ("attaching firmly or the sinew with which something is attached"; c) *ʿakkā*, verbal noun *taʿkīya* "to wrap with a fresh piece of sinew", *ʿukwa* "sinew". The sinews used to attach sword-handles were called *ʿijāz* (pl.), which appears to be a metonymy developed, *totius pro parte*, from *ʿajz* "handle". A piece of string, or loop (*dhuʾāba*) on which the sword could be hung up was attached to the handle and fixed with a nail (*kalb*[285]). According to other sources, *kalb* was synonymous to *shaʿīra*[286] (see above), or was used of the string itself (= *dhuʾāba*[287]).

[277] Commentary on *Hudhayliyyīn*, 94, 14.

[278] Jawharī.

[279] *Hudhayliyyīn*, 94, 14.

[280] It is mentioned in the following verse (Mubarrad, 399, 9): "When a bad year wipes away one's wealth/ as if it had been wiped off with a polishing-cloth (*ka-baryin bi-l-safan*)".

[281] Mubarrad, 244, 5.

[282] Mutammim in Nöldeke, *Beiträge*, 148, line 2.

[283] Freytag, *Proverbia*, II, 677 (verse of the same poet).

[284] Khalaf al-Aḥmar, *Qasside*, 268, see above.

[285] The same meaning was attributed to *ʿajz*.

Sword handles were rarely mentioned by poets; in *Ḥamāsa*, 21, 11, a handle appears in antithesis to the tip of a sword:

"In the valley of Saḥbal, the enemy/
got the tip of the sword, and I the handle//"

Poets were much more fascinated with the qualities of the blade, from which the whole sword often took its name. Concerning the surfaces of the blade, it seems appropriate to discuss here the various waterings (*āthār al-firind,*[288] "moiré") that appeared in poetry. There were three basic ones [[289]]:

1. The wavy watering. This watering gave rise to two different images. First, it was compared to the traces [166] of ants,[290] or else of snakes (*shibthān*, pl. of *shabath*), as in the verse quoted above (p. 147) from Jawharī (*s.v.* "sh-b-th" and "d-r-j"). One of the verses referred to in the notes is purported to be by Imruʾ al-Qays, although according to Ahlwardt (*Bemerkungen*) it cannot be attributed to that poet. If this simile cannot with certainty be said to be pre-Islamic, than it is at least very early. Second, it could be compared to the waves on a lake, as in the verse by Aws [ibn Ḥajar, fl. late 6th c.] (Jawharī, *s.v.* "sh-b-r"):

"Hālikī gave it to me as a present:/
it is like a pond with a surface rippled by the wind//"

Even though Jawharī lists the variant reading *ashbaranīhā* for this verse – the present would then have consisted of a piece of armour – the use of this image with swords is well attested in other verses,[291] sometimes with even greater clarity. In one of these, a gentle breeze is said to cause ripples on the surface of the waters. The following verse by Kaʿb ibn Mālik has to be understood as referring to the same image:

"With blood-thirsty weapons sharpened[292] by hand/
and with shining Indian swords resembling lakes//"

It was not uncommon for the early poets to introduce a new motif together with a simile. Thus in this line both *abyaḍ* ["white", so shining] and *ka-l-ghadīr* ["like the lake"] illustrate particular qualities of the sword. The image this evokes is not that of a clear and still lake, but that of a [167] turbulent, moving water surface. That this simile was used with reference to swords in early Arabic poetry is beyond any doubt. It is a different matter whether the use of this image with the sword is older than its use with reference to armour or vice versa. The application of the water motif [or surface

[286] Jawharī.

[287] Fīrūzabādī.

[288] Commentary on Mutanabbī, 304, v.4.

[289] [It is clear from all the various descriptions that the patterns on both composite, pattern-welded blades and watered crucible blades are being referred to, but it is not clear to which of the two some of the descriptions refer].

[290] *Diwans 6*, Imruʾ al-Qays, 45, 6 (ed. Slane, 49, 3); Ibn Durayd, v.70; Mutanabbī, 22, 9.

[291] *Hudhayliyyīn*, 78, 16; 83, 2.

[292] Namely spearheads or arrowheads.

pattern] to armour is found already in the *Muᶜallaqa* of ᶜAmr ibn Kulthūm[293] and recurs frequently in later texts. Its application to the sword occurs in the verses already quoted above, and apart from these only in the poetry of the *Hudhayliyyīn*. Hence, this appears to be a reapplication of the same motif to swords. Eventually, this comparison caused *al-ghadīr* to take on an additional meaning of "sword"; this happened too with *lujj* "gust over water".

2. The serpent-shaped watering. The watering in the steel could have the shape of winding snakes; this one may deduce from a verse in the *Hudhayliyyīn*[294] where a sword is called *dhū l-ḥayyāt* ["endowed with serpents"]. Although the commentator simply glossed this with *li-khuṭūṭ fīhi* ["on account of lines on it"] there can be no doubt that this is a reference to the watering in the steel. An alternative reading in the commentary to the same verse is *dhū l-nūnayn*,[295] which is likely to be an alternative name for the same phenomenon. After all, each wavy line can be said to consist of two letter "n"s joined together (one facing up, one down). This was the name of the sword of the poet Mālik ibn Khuwaylid,[296] whose verse it is. The name *dhū l-nūn* is a different case. It was quoted by Fīrūzabādī,[297] who adds that this name is based on the similarity between the blade and a fish. Now *nūn*, when it has the meaning of "blade", requires that blade to be bent, and *dhū l-nūn* would therefore be a curved sword which could indeed be likened to a (wriggling) fish. **[168]**

3. The striped or band-shaped watering: a sword with such a watering was called *dhū shuṭub*,[298] "striped", from *shuṭub* ["groove"] (or *shuṭab*, pl. *shuṭba*[299]), or *mushaṭṭab*,[300] *mashṭūb*,[301] or also *dhū safāsiq*,[302] pl. of the Arabized word *sifsiqa* (or *safsaqa*[303]). The last name occurs already in a verse by Imruᵓ al-Qays (although Ahlwardt contested its attribution to that poet):

> "Whatever was crooked in him, I straightened out/
> with a striped, trenchant sword//"

[293] (ed. Kosegarten), v.78.

[294] 55, 5.

[295] Commentary on the *Hudhayliyyīn*, 55, 5.

[296] *Ibid.*

[297] *S.v.* "n-w-n".

[298] *Diwans 6*, Imruᵓ al-Qays, 14, 4 (ed. Slane, 48, 14); ᶜAmr ibn Kulthūm, *Vita* (ed. Kosegarten), 4, last line (Farazdaq); *Ḥamāsa*, 82, 4 (ᶜAmr ibn Maᶜadikarib); 345, 12.

[299] In Fīrūzabādī *shuṭba* is adduced with the meaning "sword", though it is explained differently elsewhere, cf. the verb *shaṭaba*, "to cut into slices/strips".

[300] *Ḥamāsa*, commentary, 82, 6, and Jawharī.

[301] Fīrūzabādī.

[302] *Diwans 6*, Imruᵓ al-Qays, app. 29, 2; Mutanabbī, 338, v.28.

[303] Fīrūzabādī.

Arab lexicographers state explicitly that *safāsiq* refers to watering in the steel (*firind*).[304] Undoubtedly this is also true for *shuṭub*, as Freytag stated already in his *Einleitung*. This last name was used by Farazdaq [d. 110/728] and ʿAmr ibn Maʿdikarib [d. *ca.* 21/641], so that the existence of swords of this type is attested for the earliest Islamic period, if not for the pre-Islamic era.

We know nothing about the processes by which these different waterings were produced [see Kindi/Zaki, pp. 14–15]. If the process discovered by Anossov is indeed identical with that used in the Orient – which has remained a secret until the present day – then the different waterings result from shorter or longer exposure to fire. According to his research, the metal showed a faint watering on a light background after three and a half hours of firing; after another half hour, a wavy watering; after a further half hour, **[169]** the watering expands, and under greater heat produces a net-like watering. The latter then gradually intensifies and occasionally results in a striped watering.[305] It is interesting that the waterings described here were found already on the swords of the ancient Arabs.

The lines of the waterings (of type 3) were thin; Mutanabbī[306] calls them thinner than the lines on amulets, and compares them with (thin) water stains.[307] Apparently they covered the whole surface, which was completely even. I believe that this is how one has to explain the expression[308] *mutawālin fī mustawin* ["continuous on an even surface"] used by the same poet in reference to these lines.

Not only the watering of the steel, but also its colour and sheen are described in poetry. Both were called *rubad* according to the Arabic commentaries: *rubad ghubra wa-sawād yaʿlūhu*[309] and *rubad fīhi lumaʿ tukhālif lawnahu*[310] "a dark, dust-like colour with bright spots of a different colour". **[170]** The colour reminded the poets firstly of dust settling on the blade, as in the verse:[311]

"I fell over him, my Mashrafī sword in my hand/
its hammered surfaces covered with dust//",

secondly of air-born dust (*habbāʾ*[312]):

"As if the winds had strewn dust onto it"[313]

[304] *Hudhayliyyīn*, commentary, 3, 10.

[305] *Buch der Erfindungen, Gewerbe, und Industrieen*, VI.16.

[306] Mutanabbī, 304, v.2.

[307] *Ibid.*, v.4.

[308] *Ibid.*

[309] *Hudhayliyyīn*, commentary, 3, 10.

[310] *Ibid.*, 85, 4.

[311] Jawharī, *s.v.* "r-b-d" and "w-q-ʿ".

[312] Mubarrad, 457, 10 (verse by Isḥāq ibn Khalaf).

[313] Likewise Mutanabbī, 304, v.4, cf. commentary: "thin dust, like sun-dust, lies on it", to which the commentators remarked that this comparison of the mark of the watering concerned the thinness of the lines".

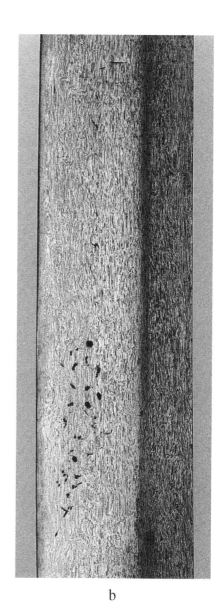

a b

Fig. 10: (a) Single-edged Turkish watered steel sword (qilīc) possibly be made in by craftsmen transferred to Constantinople from Alexandria after the fall of the Mamluke dynasty in 922/1517; this sword is perhaps to be seen as a qaljūrī type of single-edged sword derived from a central Asian khusrawānī type. (Courtesy of the Royal Armouries, Leeds, UK; inv. no. XXVIS–293). (b) Detail of the watered surface pattern visible on the surface of the single-edged sword, the blade of which (although much later) can be classified under Kindi's category of processed (crucible) steel fūlādh. (Photographs by Jeremy Hall)

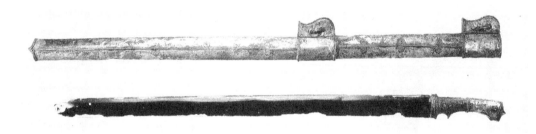

Fig. 11: A straight, single-edged Sasanian sword of the late 6th to early 7th century AD in the collection of the British Museum; length of sword 88cm. (Courtesy of the British Museum WA 135747; scabbard WA 135739; see also Lang et al. 1998).

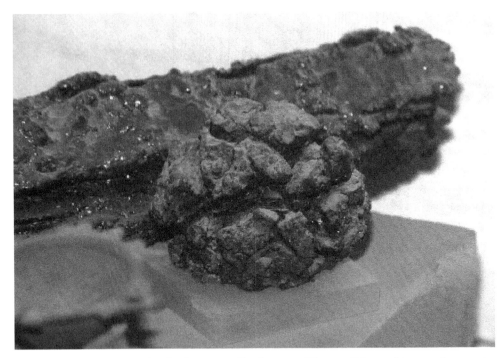

Fig. 12: Corroded remains (in the foreground) of an egg-like crucible steel ingot of approximate 2nd/8th to 5th/11th century date from Banbhore, a major port near the mouth of the River Indus until its abandonment in the 5th/11th century. On display at Banbhore Museum and possibly a nearlycontemporary remnant of the crucible steel industry in Sind mentioned by Kindi. Ingot measures approximately 5 cm across.

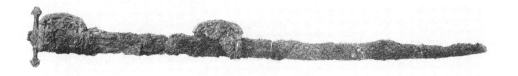

a

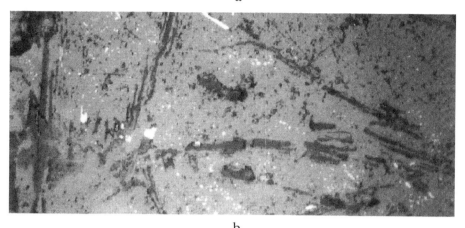

b

Fig. 13: (a) Slightly curved, single-edged sword found in 3rd/9th century archae-ological levels at Nīshāpūr, Northern Iran. Length of blade 71.5 cm (Photo courtesy of the Metropolitan Museum of Art, New York; Inv. no. MMA 40.170.168; see also Allan 1982, 204–205). (b) A fragment of the Nīshāpūr sword (shown in pl. 7) showing a degraded 'relic' ultra high-carbon structure of the now nearly totally corroded blade. This is a more or less contemporary example of one of Kindi's crucible steel (fūlādh) swords, in this case possibly of central Asian or northern Iranian manufacture using Salmāni steel.

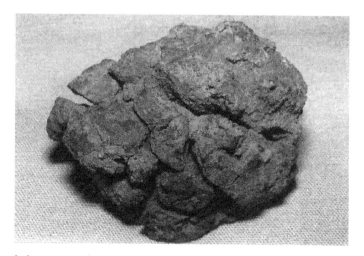

Fig. 14: Corroded remains of an egg-like crucible steel ingot found near the 3rd/9th to 4th/10th century steel-making workshop at Merv. Ingot measures approximately 5 cm across.

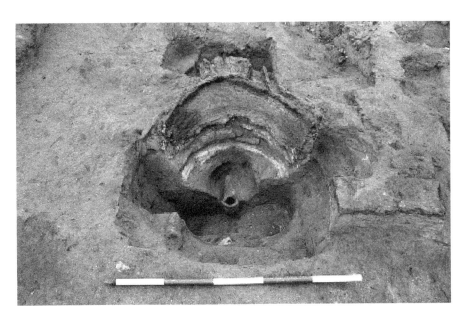

Fig. 15: Surviving crucible steel furnace base in the 3rd/9th to 4th/10th century steel-making workshop found during recent excavations at Merv. The furnace has a central air supply pipe (tuyère) rising out of the centre of the furnace floor and a side exit flue (top of photograph). These features suggest that the furnace had a closed domed roof. After firing, the furnace was left to cool before the crucibles were removed, usually by entering the furnace through the exit flue. Scale 1 metre. (Photo and interpretation of furnace structure courtesy A. Feuerbach; see also Herrman et al 1996, 16).

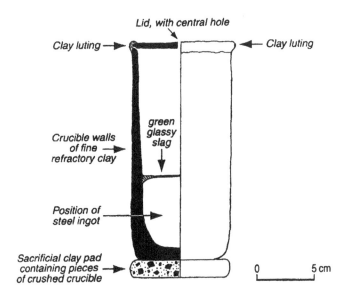

Fig. 16: Reconstructed section through one of the larger steel-making crucibles, fragments of which were found near the 3rd/9th to 4th/10th century steel-making workshop during recent survey work at Merv (based on information from A. Feuerbach and D. Griffiths).

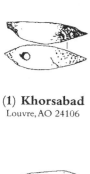

(1) Khorsabad
Louvre, AO 24106

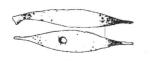

(2) Khorsabad
Louvre, AO 24107

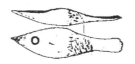

(3) Khorsabad
Louvre, AO 24108

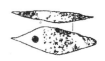

(4) Khorsabad
Louvre, AO 24109

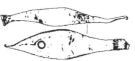

(5) Khorsabad
Louvre, AO 24110

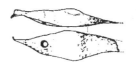

(6) Khorsabad
Louvre, AO 24111

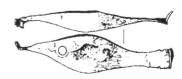

(7) Khorsabad
Louvre, AO 24112

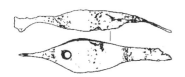

(8) Khorsabad
Louvre, AO 24113

(9) Khorsabad
Oriental Institute Museum,
Chicago, A 12261

(10) Khorsabad
Oriental Institute Museum,
Chicago, A 12462

(11) Susa
Louvre SB, 9159

(12) Nimrud
British Museum, N-1962
(chopped piece)

(13) Nimrud
British Museum, N-1963

0 10 cm

Fig. 17: Fish-shaped bars of trade iron from later Assyrian sites: 1–10 from a very large hoard (approximately 160 tons/162,500 kg) of ironwork from the late 8th century BC palace of Sargon II at Khorsabad (based on an original illustration, Fig. 8 in Pleiner and Bjorkman 'The Assyrian Iron Age', courtesy of the American Philosophical Society).

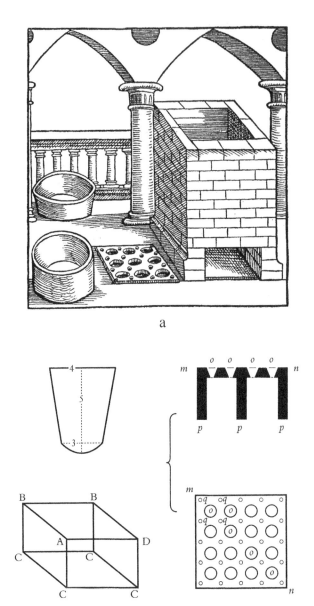

a

b

Fig. 18: (a) A furnace possibly of the form used for the production of crucible steel in medieval Iran and the surrounding region. Illustration from Jābir ibn Ḥayyān (see Russell, The Works of Geber, *241 (under calcination); Hassan and Hill* Islamic Technology, *260, fig. 9.17). (b) Sketches by Massalski (redrawn) of much the same kind of furnace that he observed still being used in Bukhara in 1255/1840 (see Allan and Gilmour* Persian Steel, *535–539). The crucibles, the proportions of which are shown, were reported to be 2 inches (5 cm) apart when placed in the large holes; thus the supporting grid with its smaller gas vents would have measured approximately 60 cm (2 feet) across. The grid stood at three-quarters of the height of the furnace box (see lower left outline sketch) which itself had a lid with vent holes to allow the hot furnace gases to escape.*

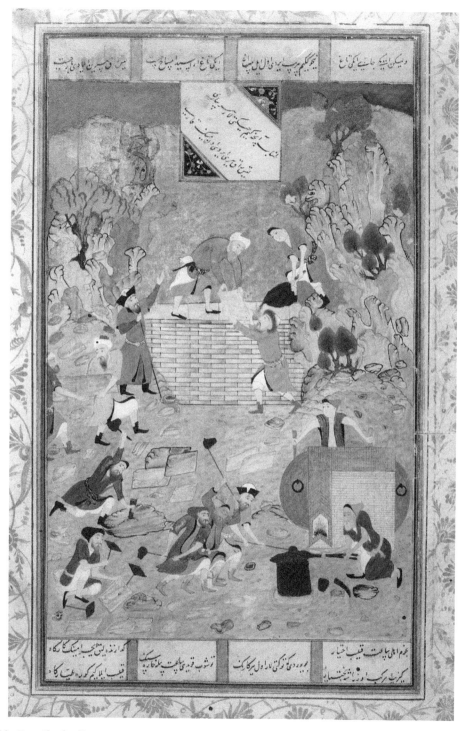

Fig. 19: Detail of a Persian miniature showing ironsmiths and other teams of artisans at work on the defences of Iskandar (Alexander) against Gog and Magog; early Bukhara style ca. 915/1510 to 955/1549 (courtesy of the Bodleian Library MS Elliott 340, fol. 80a).

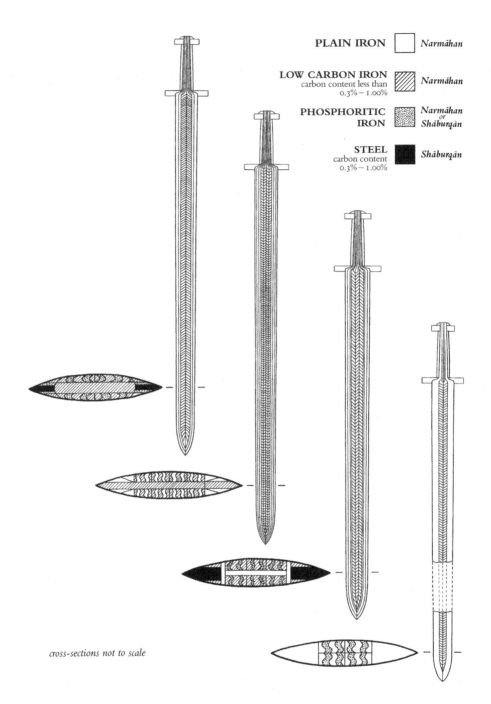

PLAIN IRON — *Narmāhan*

LOW CARBON IRON
carbon content less than
0.3% – 1.00% — *Narmāhan*

PHOSPHORITIC
IRON — *Narmāhan*
or
Shāburqān

STEEL
carbon content
0.3% – 1.00% — *Shāburqān*

cross-sections not to scale

Fig. 20: Diagrammatic reconstruction of the surface appearance and composite structure of four Anglo-Saxon swords of probable 6th–early 7th century AD date (from recent excavations at Park Lane, Croydon, Surrey, UK). Swords similar to this would have been familiar to Kindi as farangī or Frankish, the compound or composite (murrakaba) type made by combining different kinds of 'mined' (directly produced or bloomery) iron and steel – see diagram of Kindi's swords typology (Fig. 8).

thirdly of smoke (Jawharī, *s.v.* "ḥ-l-s") or fourthly of mist in the desert.[314] This may be connected to the sword name *al-saḥāb* (lit. "cloud"), i.e. the cloud-like sword, the name of Ḍirār ibn al-Khaṭṭāb's[315] weapon. On the other hand, the name may be used metaphorically to liken the sword to a threatening, lightening cloud.

At a later period, when exterior decoration became more important, golden lines were produced by using "gold water" (*ṭilāʾ* = *mayyaha al-sayf wa-ghayrahu bi-māʾ al-dhahab*).

The steel of the blade had a reddish reflection, called *athr aḥlas* by al-Muʿaṭṭal (Jawharī, *s.v.* "ḥ-l-s"). It is possible that al-Kumayt [d. 126/744] referred to this in the verse (Jawharī, *s.v.* "ḥ-b-b"):

"Those who look at the tips and blades/
behold fire like that of Ḥubāḥib//"

[171] Al-Kusaʿī, of proverbial fame, spoke in similar terms of the arrow, calling fire itself Ḥubāḥib (Jawharī, *ibid.*):

"What happened to the arrow? It burns with Ḥubāḥib/
I now trust that it will hit its target//"

It may be, however, that the poet only wanted to illustrate the polish of the weapons. It is more likely that Mutanabbī[316] refers to the reddish reflection in his words:

"As if water was drawn on the flames of fire" (*khuṭṭa fī lahab al-nār*)

or in the verse from a commentary to the *Ḥamāsa*:[317]

"When the blade flashes from the scabbard/
the watering sparkles, silvery, next to the hilt//"

As for the place where the reddish reflection appears, we find this piece of information in Ibn Durayd's *Maqṣūra*:[318]

"Between its middle and its curved end there is a furnace/
full of glowing embers, always consuming fuel//"

Using the terms *ʿayr* and *gharb* (see above) in this verse, the poet moves the place above the middle of the blade down towards the cutting edge.

Apart from the waterings in the steel, the poets praised the polished surface of swords. A polished sword was called *abyaḍ*[319] [172] (pl. *bīḍ*)[320] ["white/bright"]; also found

[314] Jones, *Poeseos*, 319: "As he pulled out the sword into the air, the emir noticed a mist upon it".
[315] Fīrūzabādī.
[316] 304, v.2 .
[317] *Ḥamāsa*, commentary, 43, 16.
[318] v.71.
[319] Many instances, amongst others: *Diwans* 6, Imruʾ al-Qays, 10, 15 (ed. Slane, 30, 7); ʿAlqama, 7, 2; ʿAntara, 19, 7; 20, 19; 25, 5; Sacy, *Chrestomathie*, II.136, 3 (Shanfara); *Ḥamāsa*, 231, 3; 259, 3; 318, 17;

are *bīḍ al-mutūn*,[321] *bīḍ al-ṣifāḥ*.[322] Mutanabbī used the metaphor *yatāmā min al-aghmād bīḍan* "bright orphans bereft of their sheaths"[323] for drawn, polished swords. Also, according to one commentary, *mubayyaḍḍa* is used in the sense of *bīḍ* in the *Muᶜallaqa* of Ḥārith, v.51. In general, the context has to determine whether *abyaḍ* and *bīḍ* refer to swords, because these words were frequently used by poets to designate anything bright or shining,[324] like men, beautiful women,[325] the sun,[326] other weapons, or a (clear, level) path.[327] The word *al-layāḥ* (lit. "the white one") had a similar meaning, and indeed this was the name of the sword of Ḥamza [ibn ᶜAbd al-Muṭṭalib, the Prophet Muḥammad's uncle].[328] Furthermore, we have the name *dhū l-rawnaq* ["possessed of splendour/lustre"],[329] which Jawharī glosses with *rawnaq al-sayf māᵓuhu wa-ḥusnuhu* "the splendour of a sword is its sparkle and beauty", by which he may also be alluding to an attractive watering in the steel, and he goes on to quote the verse (*s.v.* "q-n-s"):

> "With a well-proportioned spear free of knots/
> and with a sword both shining and sharp that splits helmets//"

In the biography of ᶜAmr ibn Kulthūm,[330] *rawnaq* appears alone, with ellipsis of the *muḍāf*, although the *dhū* in the genitive is implied from *dhī shuṭab* in the first hemistich.

A polished sword flashes and sparkles, especially when it is **[173]** turned around in use. The following expressions, which describe this phenomenon, may also refer to the waterings of the steel, as is illustrated by the word *ibrīq* (see the explanation in Lane, *s.v.*, and below). A sword could be called *bāriq*[331] "flashing, sparkling", with a plural *bawāriq* (formed in analogy to other words), as attested in the *Ḥamāsa*[332] and elsewhere. In its form *bāriqa* it can stand for both singular[333] and plural, in the latter

469, 13; 590, 13; Dhū l-Rumma in Mutanabbī, 23, 14. Besides these *Ḥamāsa*, 242, 11: *min bayāḍ al-suyūf* "from the shine of the swords", i.e. from the shining swords, an *iḍāfa* [genitive] linking the property to the object.

[320] *Diwans 6*, al-Nābigha, 1, 17; 29, 22; ᶜAmr ibn Kulthūm, *Muᶜallaqa* (ed. Kosegarten), v.36 and 91; *Hudhayliyyīn*, 78, 16; *Ḥamāsa*, 124, 10 from the bottom; 313, 10 from the bottom; 315, 4; 361, 14; 443, 5; 673, 11; Isfahānī, 33, 5; Mutanabbī, 130, 13, and frequently elsewhere; Dieterici, *Mutenabbi und Seifuddaula*, 84; Sacy, *Chrestomathie*, I.82, 8.

[321] *Ḥamāsa*, 644, 13.

[322] Kosegarten, *Chrestomathia*, 76, 3–4 (verses).

[323] 180, 12.

[324] Dieterici, *Mutenabbi und Seifuddaula*, 159.

[325] *Diwans 6*, Imruᵓ al-Qays, 30, 7; app. XVIII, 26; Ḥarīrī, 100, 8.

[326] *Ibid.*, 352.

[327] Compare with the hair braid of the bride: *Hudhayliyyīn*, 290, v.14.

[328] Fīrūzabādī.

[329] *Ḥamāsa*, 283, 3 from the bottom; Sacy, *Grammaire arabe*, II.137; Zamakhsharī, *Mufaṣṣal*, 43, middle, together with a verse from Abū Duᵓād.

[330] *Vita* (ed. Kosegarten), 4, last line.

[331] Freytag, *Lexicon*.

[332] *Ḥamāsa*, 306, 5 from the bottom; Mubarrad, 676, 9 (al-Ṣalatān).

[333] Mutanabbī, 57, 5 from the bottom.

case through ellipsis of *suyūf* (cf. Jawharī, *s.v.* "b-r-q"); but it is not exclusively plural, as stated by Lane, who gives the plural form *bawāriq* without further comment. The second form of the singular produces the plural *bāriqāt*.[334] The word *bawāriq*, like *abyaḍ*, appears to have been used of other weapons, according to a commentary on the *Ḥamāsa*. Likewise, *barrāq*, a derivative form of *bāriq*, was used of swords and of bows (thus Freytag, based on Fīrūzabādī). The word *lawāmiᶜ* "shining swords" was formed like *bawāriq*, and occurs in Mutanabbī.[335] The flashing of the swords in the battle of ᶜAntara[336] is described as follows, with a possible allusion to the hovering dust:

> "They call out for ᶜAntar when the swords are flashing/
> like lightning amid dark clouds//"

The word *khawāfiq* has to be interpreted as "flickering swords". This is proven by a hemistich in a verse by al-Ṣalatān[337] **[174]**:

> "We threw ourselves into perdition, in the shade of flickering [...swords]",

where the combination with *ẓilāl* ["shade"] makes it clear that the verse refers to swords, and not to flags.

An intensification of the concept is implied by *ibrīq* "a very shiny, flashing sword", which Jawharī explained as *al-shadīd al-barīq*[338] (*s.v.* "b-r-q"), while Lane[339] understood it as a shining blade of watered steel (cf. the verse in *Ḥamāsa*, 171). Analogous fomations are *iṣlīt*, and also *ighrīd* ("something new, palm blossom", also a title of a work, *Diwans 6*, p. 163) and *iᶜlīṭ*[340] ("leaf of the March-tree"). We are thus not forced to fall back on the Persian word meaning "ewer", although swords were often compared to its polished silver.[341] Finally, the metaphor *salīl al-nār*[342] "fire-born" also belongs in this context.

According to the Arab commentators,[343] swords flicker; i.e. their shine vanishes and then reappears, fades and becomes visible once more. It is for this reason that the word *hazhāz* (or *huzāhiz*[344]) acquired the meaning of "a sparkling, flashing sword". Originally, it had meant "twisting, turning", and therefore also "flowing water".

[334] *Ibid.*, 173, 5 from the bottom.

[335] *Ibid.*, 247, 10; Mubarrad, 609, 2 (verse of a Quḍāᶜī from the time of the siege of Mecca by Ḥusayn ibn Numayr [d. 67/686]).

[336] *Diwans 6*, Antara, app. XIX, 14.

[337] Mubarrad, 676, 8.

[338] Thaᶜālibī, *Fiqh*, 132, cites a verse of Ibn al-Aḥmar, in which the word is used: "You stand with sparkling sword and well-prepared quiver, craving to annihilate a tribe rich in men and cattle".

[339] I.192, col. 1, *sayf ibrīq*: "a sword having much lustre and much diversified with wavy marks or streaks in its grain (Taj el-Aroos)".

[340] In a verse from al-Nāmir ibn Tawlab, cited below.

[341] *Ḥamāsa*, 43, 16.

[342] Freytag, *Lexicon*.

[343] Mutanabbī, commentary, 304, 15.

[344] *Ibid.*, line 14.

According to Fīrzūzabādī, it was also a name for a dog, alluding to the animal's liveliness (cf. Fīrūzabādī, *s.v.* "h-z-z": *huzza al-sayf wa-l-rumḥ*; also *ihtazza* and *habba*. The active form *hazza* is used of the sword in Mubarrad, 364, 4). An analogy to this is provided by the Hebrew *mithapekhet*.[345] The same explanation also applies to *ruqāriq* (Fīrūzabādī, *s.v.*), and the name of Saʿd ibn ʿUbāda's sword, *al-raqrāq*. [175] As they did with the spear, the poets likened the flickering, trembling movement of lightning to the swords' flashing, flickering complexion and its vibrations when it was swung in the air.[346] ʿAntara[347] says:

> "My sword, like a twitching bolt of lightning/
> is my cover and my armour. It is neither blunt nor notched//"

And Dirham ibn Zayd:[348]

> "In the hands, when the swords flash,/
> lightning appears and flickers//"

Mutanabbī:[349]

> "When the hand raises the Indian sword into the air/
> it is as if a bolt of lightning pierces the clouds//".

For the same reason, the epithet *ʿarrāṣ* "a trembling, vibrating thing" was used for swords. Jawharī states explicitly that the *rajaz* verses of Abū Muḥammad al-Fakʿasī refer to swords (*s.v.* "h-z-ʿ" and "ʿ-r-ṣ"):

> "When the camel herds have dispersed /
> and returned from watering satisfied//
> they are slaughtered with polished swords, free from rust/
> with trembling ones that vibrate when shaken// [176]
> like vulture-feathers, as they descend on the pieces of meat//"

Fīrūzabādī, too, mentions this use of the word with reference to swords. Elsewhere, the poets used images derived from fire or water. Swords could be said to be like a glowing flame,[350] cf. the Hebrew *lahaṭ* "flame, shining blade of a sword", or, in the words of Muslim ibn al-Walīd,[351] like a torch of death (*shihāb al-mawt*). At the same time, it could be likened to a pond, as in the verse by al-Munakhkhal:[352]

> "A polished sword like a pond, penetrating deeply/
> as it plunges into the tumult of battle, mowing down//"

[345] Genesis, III.24.
[346] Cf. Mubarrad, 405, 18: *sayf kaʾannahu ʿaqīqa*, and 676, 7: *kaʾannahu lamʿat barq* (verse of al-Ṣalatān).
[347] *Diwans 6*, ʿAntara, 11, 4.
[348] Iṣfahānī, II.168, 18.
[349] 226, 17.
[350] *Ḥamāsa*, 207, 13.
[351] 8, 13.
[352] Jawharī, *s.v.* "th-w-kh".

Or Mutanabbī:[353]

> "Whenever your eye wants to catch a glimpse of its colour/
> it is concealed by a wave, as if to tease you//"

Abū l-ʿAlāʾ[354] combined both images in the line:

> "The surface gleams like water before your eyes/
> or like a blazing fire when your look at it//"

The poets did not stop at these images. Even in earliest times, the shine of swords was compared to the rays of the sun,[355] or even regarded as the radiating sun itself. This is the basis for a comparison between Muḥammad and a sword in a verse by Kaʿb ibn Zuhayr.[356] Mutanabbī[357] expanded on the motif in this line [177]:

> "They rise like the sun as they emerge from their sheaths/
> only to set on the skulls of men//"

By extension, all bright, shining objects – like mountains[358] for example – could be compared to swords. Al-Nābigha[359] used this image to describe a strong and lively wild buffalo, as it runs over mountains and through valleys (for comparisons with people, see above).

A polished sword was both sharp and shining. Both qualities are meant by the words: *ṣalt*, *iṣlīt* (*ayy ṣārim*[360]), and *munṣalit*. *Iṣlīt* is an intensive form of *ṣalt*, just as *ibrīq* is of *bāriq*. The basic meaning of *ṣalata* is "to pour out" and hence when used of swords it means "drawn". In this sense it is preserved in the expressions: *ḍarabahu bi-l-sayf ṣaltan*[361] ["he hit him with the sword drawn"] and *shadda ʿalayhi bi-l-sayf ṣaltan* ["he attacked him with sword drawn"]. Later the meaning changed to "shining and sharp", and "energetic" when used of men (Mubarrad, 596, n. 1: *rajul ṣalt ayy māḍin*). Mutanabbī[362] used it in the first sense as in *ṣalt al-jabīn* "with a shining forehead".

As for the blades themselves, they were praised first and foremost for their thinness. Swords were forged thin: the thinner the blade [178] the thinner the cutting edge, and the thinner the edge the sharper the sword. Therefore, thinness usually referred to the edge, and "thin" was synonymous with "sharp". Hence *qaḍīb*,[363] pl.

[353] 304, v.3.
[354] Jones, *Poeseos*, 319.
[355] *Hamāsa*, 319, 19; Iṣfahānī, II.115, 6 (Ibn Mayyāda).
[356] *Carmen*, v.51.
[357] 121, 5. In another place (57, 5 from the bottom) the same poet says: "The sharp sword, before which pales the lightning's shine"; also Kaʿb ibn Zuhayr, *Carmen*, 26, v.12.
[358] ʿAmr ibn Kulthūm, *Muʿallaqa* (ed. Kosegarten), v.22; *Hamāsa*, 459, 9; Mubarrad, 131, 6.
[359] *Diwans* 6, al-Nābigha, 23, 23.
[360] Mubarrad, 596, commentary.
[361] *Ibid.*, 596, 13 (verse of Ibn al-Ruqayyāt).
[362] 288, 24.
[363] Mubarrad, 175, 8.

quḍub,[364] "a thin (sharp) sword" (also *quḍbān*: Mutanabbī, 175, 1.12; pl. of paucity *aqḍiba* according to Mubarrad, 238, 11) was interpreted by Jawharī only as "sharp", as is the case in the commentary to Ḥarīrī[365] (= *qāṭiᶜ*) where it appears in one place[366] in connection with *ḥusām*. However, this does not necessarily speak in favour of the other meaning, as we will see below with *ḥusām*. Fīrūzabādī correctly lists both meanings, for the original sense of *qaḍīb* (twig, thin branch) provides the derived sense of "thin", from which in turn the meaning "sharp" is derived, because of its application to swords.

The word *mahw*, which has the same significance (*al-sayf al-raqīq*; thus Thaᶜālibī and Jawharī; in Fīrūzabādī also with the meaning *kathīr al-firind* ["having much watering"]) was explained by the commentator to the poems of the *Hudhayliyyīn*[367] explicitly as "thin at the edges". The same is said of *rahīf*[368] and *murhaf* (*haddada al-sayf* and *raqqaqa ḥaddahu*[369] ["he sharpened the sword" and "he thinned its edge"]), which is by no means contradicted by the expression *murhafāt al-ṣafāʾih*[370] ["thin-edged broadswords"]; its plural forms (called sound plurals in Freytag's *Lexicon*) are *murhafa*[371] and *murhafāt,*[372] the latter also used with additional words: *murhafāt bawādir* "death-bringing" (from singular *bādir* or *bādira,* cf. above.) and *murhafāt al-barq.*[373]

The epithet *raqīq* "thin", pl. *riqāq* (as in *riqāq al-bīd*[374]) occurs only in some compounds; e.g. *raqīq al-ḥadd,*[375] *raqīq al-shafratayn*[376] [179] "with a thin double edge" (compare *māḍī al-shafratayn* "with a sharp double edge")[377] and in the plural: *riqāq al-maḍārib* "with thin edges",[378] with which compare *ᶜaḍban maḍāribuhu* "with sharp edges".[379]

The term *aṣmaᶜ*, "a sharp sword", also belongs here, in that its original meaning was "thin" and in that it was used with this sense of spears: *ṣumᶜ al-kuᶜūb* "with small

[364] *Hamāsa*, 297, 7 (= Dieterici, *Mutenabbi und Seifuddaula*, 160, top); *Hudhayliyyīn*, 14, 2; Mutanabbī, 268, v.24.

[365] 200, commentary 1.

[366] Ḥarīrī, 199, 6.

[367] *Hudhayliyyīn*, 3, 10 (citing *Hamāsa*, commentary, 358, 15).

[368] *Hamāsa*, commentary, 349, 18.

[369] Ḥarīrī, commentary, 116, 13.

[370] Mubarrad, 300, 13.

[371] *Hamāsa*, 93, 5 from the bottom; 349, 17; Mutanabbī, 320, 15 together with the pertinent commentary.

[372] *Hamāsa*, 313, 10 from the bottom; 361, 14; 442, 11; Mubarrad, 333, 12; Ibn Durayd, v.88; Iṣfahānī, III.38, 9 (Bashshār ibn Burd).

[373] Dieterici, *Mutenabbi und Seifuddaula*, 150, bottom.

[374] *Ibid.*, 84.

[375] Mubarrad, 658, 6 (verse of a Khārijite).

[376] *Hamāsa*, 57, 9; 311, 1; Ṭarafa, *Muᶜallaqa*, v.84; Mutanabbī, 58, 8 from the bottom.

[377] See further below.

[378] *Diwans 6*, al-Nābigha, 1, 17.

[379] *Ibid.*, Imruʾ al-Qays, 45, 8 (ed. Slane, 49, 3).

thin heels". Further, we have *khufāf al-naṣl* "with a thin head, blade",[380] *mighwal*, which in addition to the explanation quoted above (p. 153) is glossed as: *sayf daqīq lahu qafan* "a thin sword with a nape", perhaps one with a single edge (p. 153); *nashīl* "a light, thin sword" (see p. 153). Finally, we have the tropes *maʿṣūb* (lit. "tied together"[381]), *nāḥil* and *muntaḥil* (lit. "emaciated", as in the *rajaz* verse (Jawharī, *s.v.*):

> "We overwhelmed them with lean, emaciated swords/
> beaten thin as a leaf by the blacksmiths//"

Mutanabbī, who called the sword *ṭāghī l-shafratayn* "the tyrant of the two blades"[382] (because it kills often), connected the thinness of the blade to the necks of its victims. He did so with the motif of love, as if the blades had been worn thin by their "love" of necks.[383] Because of the thinness of blades, a thin man was often compared to a sword (as a compliment): *shāhib ka-l-munṣul.*[384]

Secondly, the blades had to be sharp, and sharpness was perhaps the most important quality in a good sword. In all likelihood it was to this quality that the first individual sword names referred. It was the **[180]** quality from which the largest number of different names derived. The oldest name of this kind is *ʿaḍb* "a sharp, trenchant sword" [from *ʿaḍaba* "to cut"][385] ...[a grammatical digression ensues on the use of the verbal noun in Arabic in preference to the present participle, here omitted since it is not relevant to swords and is now somewhat dated]... **[184]** Both the form and the meaning show that in the sword the act of cutting reaches its fullest expression, to the degree that it almost personnified this act (cf. Mutanabbī, 288, v.25, where the subject of the poet is praised with the words: *huwa al-karam* ["he is generosity'], which is glossed by the commentator: *jaʿalahu al-karam li-kathrat wujūdihi minhu* "he made him a personification of generosity, because of the abundance of his generosity"). *ʿAḍb* is different both in form and meaning from *ṣārim* "a sharp, trenchant sword",[386] which refers more to the materiality of the sword. Its plural is *ṣawārim*,[387] as in the verse by Farazdaq (Jawharī, *s.v.* "r-b-d") **[185]**

[380] *Hudhayliyyīn*, 85, 4.

[381] Fīrūzabādī.

[382] 132, 11.

[383] 226, 20.

[384] *Diwans 6*, ʿAntara, 20, 1.

[385] Ṭarafa, *Muʿallaqa*, v.84 and 88; *Ḥamāsa*, 27, 5 from the bottom; 283, 3 from the bottom; 353, 11; 674, 6; Mubarrad, 32, 5; *Hudhayliyyīn*, 85, 4; Iṣfahānī, 121, 13; Thaʿālibī, *Fiqh*, 132 (Ibn al-Rūmī) and often elsewhere. It stands in the predicative in *Diwans 6*, Imruʾ al-Qays, 45, 8 (ed. Slane, 49, 3); *Hudhayliyyīn*, 9, 2. Used negatively of man: Mubarrad, 471, 9 (a piece of satirical *rajaz* verse): "If you were a sword, you wouldn't be a sharp one". Used of the tongue: Mubarrad, 32, 7; Ḥarīrī,138, 2; also figuratively in ibid., 64, 1; 75, 4. Mutanabbī, 144, 8, uses *ʿadab* instead of *ʿaḍb* by way of poetic licence.

[386] *Diwans 6*, ʿAntara, 19, 7; 25, 5; *Ḥamāsa*, commentary, 4, 11 from the bottom; commentary, 124, 8 from the bottom; 310, 9 from the bottom; 318, 17; commentary, 590, 14; *Hudhayliyyīn*, 3, 10; 9, 2; 33, 3, 74, 36; Dhū l-Rumma in Mutanabbī, commentary, 23, 14.

[387] *Ḥamāsa*, 124, 10 from the bottom; 231, 8 from the bottom; 349, 21; 644, 13; Mubarrad, 333, 12; Al-Buḥturī in Nöldeke, *Beiträge*, 187, 2; Ibn Durayd, v.70; Sacy, *Chrestomathie*, III.12, 4 from the

"When in the evening at the two Marbidān/
the dust of death hovered past sharp swords//"

This form is found not only in poetry, but also in elevated prose. Ibn Baṭuṭa [d. 779/1377] used it in the prologue to his travelogue[388] with reference to the successor of the Prophet: *amkana ṣawārimahu min riqāb al-mushrikīn* "may God give to his swords the power over the necks of the unbelievers". Further below in the same text,[389] one reads in the description of a prince: *jadāwil ṣawārimihi* "the streams of blood shed by his sharp swords".

On the analogy of *ṣārim* are: *qāḍib,*[390] pl. *qawāḍib*[391] (Mutanabbī, 175, 4, has *qawāḍib al-hind*); *qāṭiᶜ,*[392] pl. *qawāṭiᶜ,*[393] *bātir,*[394] pl. *bawātir,*[395] comparative *abtar,*[396] *bātik* (see the addendum below), for which Lane noted the pl. *bawātik*. Al-*bātik* was said to have been the name of Mālik ibn Kaᶜb al-Ḥamdān's sword. Fīrūzabādī lists *bādik* with the same meaning (not in Lane). According to to al-Aṣmaᶜī (in Jawharī, *s.v.*), *bādiᶜ* is "a sword that cuts off a piece", but according to Fīrūzabādī has the more general meaning of "a sharp sword" (cf. Lane). These formations have their origin in poetry, as the poets used various verbal stems in the same way to vary the term for "a sharp sword".

Addendum: *bātik* is the reading of the commentators of *Ḥamāsa*, 43, 5; the word *al-ṣāʾik* in the text **[186]** is a misprint, as Freytag translated the word "cutting", while *ṣāka* and *ṣaʾaka* have quite different meanings.

Names with the same meaning [sharp] are:

1. *munṣul,*[397] a noun, for which also *munṣal*: the forms derives from the latter by *itbāᶜ* (cf. the similar transformation in *munkhal* and *munkhul*); pl. *manāṣil,*[398] originally "fitted with a tip, head" (*naṣl*), later "a sharp sword". The term *shalḥan, shalḥāʾ,* pl. *shulaḥ* was declared impermissible by Ibn Durayd.

bottom (Mutanabbī); Mutanabbī, 142, 1; 151, 6 from the bottom, and elsewhere. Also used of the tongue, e.g. Mubarrad, 605, 3: *lisān ṣārim* "sharp tongue".

[388] I.3.
[389] *Ibid.,* 14.
[390] See Jawharī and Fīrūzabādī.
[391] *Diwans 6,* Zuhayr, 11,11; *Hudhayliyyīn,* 56, 13; 87,8; Mutanabbī, 122, 6; 214, 12; 329, v.10.
[392] *Diwans 6,* al-Nābigha, 17, 31.
[393] *Ḥamāsa,* 313,10 from the bottom; 318, 14; commentary, 443, 5; Mutanabbī,173, 5 from the bottom.
[394] *Diwans 6,* ᶜAlqama, 7, 2; Mubarrad, 94, 1; Kosegarten, *Chrestomathia,* 81, 4 from the bottom.
[395] ᶜAntara in Ahlwardt, *Bemerkungen,* 56; Mutanabbī, 65, 8 from the bottom; 331, v.25.
[396] Kosegarten, *Chrestomathia,* 76, 5 (verse).
[397] *Diwans 6,* ᶜAntara, 19, 9; 20, 1; *Ḥamāsa,* 334, 5; 336, 13; 661,8 from the bottom; commentary, 673, 1; Mutanabbī, commentary, 14, 4; 97, 1; Muslim ibn al-Walīd, 22, v.9.
[398] Mutanabbī, 74, 1.

2. composite terms: *dhū l-karīha* "a trenchant sword" (see below); *dhū dhukur*, from *dhukur = dhukra* "blade";[399] *wādiq ḥaddahu* "with a sharp blade" (cf. the verse in Jawharī, *s.v.* " r-h-q", quoted below under *ḥusām*).

3. epithets with the same meaning, used in poetry also without the addition of "sayf": *dharib*, *madhrūb* (cf. Jawharī, *s.v.* "ḥ-s-m", quoted below), *maʾbūr*, *khadhim*, *sharith*.

4. as regards the word *mirdan*, it is explained by some, re. *Ḥamāsa*, 206, penultimate line (quoted from *Diwans 6*, ʿAntara, 3, 3 , which has the reading *murdin*) as "sword". However, it appears that by *mirdan* is meant the hooves of a horse [further discussion of this point ensues, omitted here as not relevant to swords]...
[188]

5. The name of the sword of Zuhayr ibn Janāb [fl. mid-6th c.] was *al-bujj* "the splitting, trenchant, sharp one". The concept of sharpness was increased with *ḥusām* "a very sharp sword",[400] as in the line by Abū l-Qays ibn al-Aslat (Jawharī, *s.v.* "j-n-"):

> "A faithful sword with a very sharp blade/
> and a strong, brown shield//"

The term also occurs in prose. When two Arabs met on a journey, one would say to the other: *al-salām qabl al-kalām am ḍarb al-ḥusām*, i.e. "Is it war or peace you are after?".[401] Its plural is *ḥusāmāt*[402] and is formed according to that type of adjectival nouns and participles whose form and meaning deprive them of a broken plural (e.g. *muharram*, pl. *muharramāt*[403]). This is because the broken plurals *fiʿlān* and *fiʿla* belonging to the form *fuʿal* are used of animate objects only, while the plural forms *fawāʿil* (of *fāʿil*) and *fuʿul* (of *faʿīl*) can also be employed with inanimate objects. As **[189]** for the meaning of *ḥusām*, one may note two points. First, the word was used in a narrow sense of the blade itself, as the original sense of "a very sharp object" was applied to swords in particular; thus *Diwans 6*, Ṭarafa, 17, 6: *bi-ḥusām sayfik aw lisānik*, and *Hudhayliyyīn*, 74, 37, and in Jawharī in an alternative reading of a verse of the *Hudhaylīyyīn*:

> "Had it not been for us, Suhayb would have hit him/
> with a sharp, polished blade//"

[399] Jawharī.

[400] Ṭarafa, *Muʾallaqa*, v.79 and 85; *Diwans 6*, ʿAntara, 7, 15; *Ḥamāsa*, 40, 6; 63, 15; 395, 17; 634, 10; 778, 3 from the bottom; *Hudhayliyyīn*, 94, 11; Noldeke, *Beiträge*, 136, middle;
Muslim ibn al-Walīd, 65, v.33; Mutanabbī, 46, 12 (also Kaʿb ibn Zuhayr, *Carmen*, 26, 11) and often; Dieterici, *Mutenabbi und Seifuddaula*, 82, 5; 85, last line; Ḥarīrī, 60, 3.

[401] Kosegarten, *Chrestomathia*, 69, 2.

[402] *Diwans 6*, Ṭarafa, 14, 2.

[403] Sacy, *Grammaire arabe*, I.357–58. Sacy says only that these words are used in the plural as nouns.

Second, *ḥusām* is found in descriptions of swords in (sometimes immediate) conjunction with *ʿaḍib* or *ṣārim*.[404] Al-Khalīl therefore attributed the meaning "that which fends off the enemy" to the word, according to a commentary on one of these verses.[405] Yet such an explanation is not at all necessary, as the combining of synonyms is generally quite common (e.g.: *aqwā wa-aqfara*,[406] *saʾima wa-malla*,[407] *junūn wa-awlaq*,[408] *al-ẓamāʾ al-ṣawādiyā*,[409] *ghayr nazr muqallaṭ*[410]), as indeed in the same verse. This practice is mentioned explicitly in the commentary on *Hudhayliyyīn*, 111, 5 (in the case of *ʿalā jūʿ wa-masbagha,* with reference to *Hind atā min dūnihā l-naʾy wa-l-buʿd*). Its purpose is to give emphasis to the term. It may be that *ḥusām* after the noun is an intensifier, thus "a sharp, nay, a very sharp sword". This fits well with its use in other places, so in Ṭarafa:[411] "its first blow suffices", or in the *Ḥamāsa*:[412] "that which does not content itself with severing" (but, as the commentator adds, continues to strike). [190] An unrelated phenomenon is the linking of two sword names by an *iḍāfa*, as in *mikhdham al-ṣamṣām*,[413] described by the commentators as the genitive linking the specific to the general: "an excellent, sharp sword from among those swords which are neither twisted nor blunt".

Analogous forms to *ḥusām* are: *jurāz*,[414] *hudhām*,[415] *qubāb*,[416] *butār*,[417] *ḥudād* (*ḥuddād*). Intensive forms of a different construction are: *qaddāb* (intensified *qaddāba*), *battār, qaṣṣāl, jammād, sabbāb* (cf. *sabbāb al-ʿarāqīb*), *saqqāṭ* or *saqāṭ* (cf. Fīrūzabādī and the two *Hudhayliyyīn* verses quoted here under the heading of *surāṭī*) "a sword which, because of its sharpness, penetrates through to the far end of an object or beyond", *ṣarūm, batūr, baḍūk*,[418] *ḥadhūm*,[419] *ḥiṣamm, muḥadhdhab*,[420] *mudharrab*.

In addition to these there are words whose intensive meaning is evidenced by the insertion of a letter: *qirḍāb*[421] (*al-qirḍāb* was the name of Mālik ibn Nuwayra's

[404] Ṭarafa, *Muʿallaqa*, v.84–85; Isfahānī, 8, 10 from the bottom; *Ḥamāsa*, 63, 15; 778, 3 from the bottom; Muslim ibn al-Walīd, 18, v.68.
[405] *Ḥamāsa*, 63, 15.
[406] ʿAntara, *Muʿallaqa*, v.5.
[407] *Ḥamāsa*, 775, 3 from the bottom.
[408] Mubarrad, 353, 5.
[409] Zamakhsharī, *Mufaṣṣal*, 66, middle.
[410] Muslim ibn al-Walīd, 26, last line.
[411] *Muʿallaqa*, v.85.
[412] 778, 3 from the bottom.
[413] Sacy, *Chrestomathie*, II.160, last line.
[414] *Hudhayliyyīn*, 4,2; 93,6; Mutanabbī, 304, 2; Ḥarīrī, 138, 2.
[415] Jawharī(Abū ʿUbayda).
[416] Fīrūzabādī.
[417] Lane.
[418] Freytag, *Lexicon*.
[419] *Ḥamāsa*, commentary, 731, 6.
[420] Alternative reading in *Diwans* 6, ʿAntara, 21, 63 (*Muʿallaqa*, v.55) in the list of variants.
[421] Mutanabbī, 59, 7, cf. commentary; Kosegarten, *Chrestomathia*, 82, 5 from the bottom.

sword[422]); Thaᶜālibī[423] explicitly states that it has an intensive meaning (*qarḍaba* = *shadīd al-qaṭᶜ* ["highly trenchant"] on the authority of Thaᶜlab and al-ᶜArabī), and Jawharī explains: "a sharp sword that shatters the bones", with the related form *qirḍūb*,[424] and also *qurṭubā* "very trenchant, very sharp" (cf. *qurāṭib* "multum secans" and *qarṭaba* "secuit ossa in mactato camelo". Al-*qurṭubā* was the name of the sword of Khālid ibn al-Walīd and of Ibn al-Ṣāmit ibn Jusham.[425] Also: *hidhyam* **[191]**.

An even higher degree of excellence[426] was expressed with *mikhdham*[427] "an excellent, sharp sword, that cuts quickly" (*sarīᶜ al-qaṭᶜ*).[428] This word (literally a noun of instrument) gained this meaning as the idea of a tool for cutting became restricted to the sword, inasmuch as it was the most eminent representative of the class. A similar thing happened as regards the action of cutting to the naming *ᶜaḍb*. Mikhdham was called a sword "of the first rank" (*ᶜaqīl suyūf*) by ᶜAlqama.[429] The sword of the Ghassanid king al-Ḥārith ibn Abī Shamir is said to have been called *al-mikhdham*.[430] Analogous forms are: *miqṣal*[431] (dialect *mikhṣal*[432]); *miqṭaᶜ*,[433] *miqḍab*; *mihdham*; *miḥdham*.

The trope *ṣurāṭiyy* (or with poetic license, for the sake of the rhyme, *ṣurāṭī*), lit. "gluttonous", appears in the following verse from the poetic corpus of the *Hudhayliyyīn* in the sense of "a very sharp sword":[434]

> "It is white like salt; its blows cut away the flesh/
> and shatter bones, as they penetrate through to the ground.//
> With it, I protect the one who flees when he calls for me/
> and myself in the event of a sudden attack//"

There is also *al-aqraᶜ* "an excellent, very sharp sword", *al-muqāriᶜ* "the victorious", the name of ᶜUmayra ibn Hājir's weapon,[435] and (*sayf*) *muḥtafid* "cutting quickly".[436] **[192]** A sword passed the hardest test for sharpness, according to Mubarrad,[437] if its tip did not become bloody (*aqṭaᶜ mā yakūn al-sayf idhā sabaqa al-damm*) ["the most

[422] Fīrūzabādī.

[423] *Fiqh*, 25 (ch. 8).

[424] Jawharī.

[425] Fīrūzabādī.

[426] *Li-l-mubālagha*, as is noted of *misajj* in Imruᵓ al-Qays, *Muᶜallaqa*, commentary on v.56.

[427] *Dīwāns 6*, ᶜAlqama, 2, 27; ᶜAntara, *Muᶜallaqa*, v.55; *Hamāsa*, commentary, 731,6; Mehren, *Rhetorik*, 41, middle; Mutanabbī, 179, 3.

[428] ᶜAntara, *Muᶜallaqa*, commentary on v.55.

[429] *Dīwāns 6*, ᶜAlqama, 2, 27.

[430] Fīrūzabādī.

[431] *Dīwāns 6*, ᶜAntara, 20, 19; *Hamāsa*, 40, 6; *Hudhayliyyīn*, 94, 11.

[432] Jawharī.

[433] *Hudhayliyyīn*, 30, 2.

[434] Jawharī.

[435] Fīrūzabādī.

[436] Lane.

[437] 546, 3f.

trenchant a sword can be is when it precedes blood", i.e. it is in and out of the flesh before blood has even begun to flow onto it]. For this reason Imru° al-Qays boasted:[438]

> "Many a time did I strike an unexpected blow/
> So that the tip of my sword was spared from blood//"

Apart from its sharpness, the solidity of swords was praised. The sword *al-ṣamṣāma* (also simply *ṣamṣāma*,[439] variant forms *ṣimṣāma* and *ṣimṣam*[440]) excelled in this respect [see Kindi/Zaki, p. 16]. The verbal root of the word refers to the idea of hardness, or imperviousness to damage.[441] This is therefore a sword that would have remained unscathed whatever material it hit against. *Al-ṣamṣāma* (or, according to Jawharī, *al-ṣamṣām*)[442] was the name of the sword of ᶜAmr ibn Maᶜdikarib, the famous poet and hero; before him, it was in the possession of the Himyarite king Ṣaḥbān.[443] It is mentioned in the verse:[444]

> "The tip of my spear is bluish and without blemish/
> and my *ṣamṣām* penetrates deeply into the bone//"

According to Abū ᶜUbayda[445] [d. 209/824], ᶜAmr gave his sword to Khālid ibn Saᶜīd ibn al-ᶜĀṣ as ransom for the release of his sister Riḥāna, whom the latter had captured during the war against the Zubaydis of Yemen. Elsewhere, it is said that ᶜUmar I[446] had wished to possess it, and that ᶜAmr had given it to him as a present. However, the caliph was then told that ᶜAmr had kept *al-ṣamṣāma*, **[193]** and that he had given him another sword instead. ᶜAmr, when he heard what had been said about him, asked for a sword and stepped into the enclosure where the camels of the alms collection were kept, and decapitated an animal with a single blow. He then said to ᶜUmar: "I did indeed give you the sword, but not my arm". In his lament on his father, who had fallen at the battle of Ṣiffīn [37/657], Nahshal said of this sword:[447]

> "Like ᶜAmr's sword, whose blade never betrayed him//"

The sword went missing during the day called *yawm al-dār*, when ᶜUthmān was murdered, but was found again later. Later, the caliph Mahdī [r. 158–69/775–85] requested *al-ṣamṣāma* from the Banū l-ᶜĀṣ when he was passing through Wāsiṭ on his

[438] *Ibid.*

[439] Jawharī, s.v.; Mutannabī, 146, 3.

[440] Muslim ibn al-Walīd, 55, v.20.

[441] Thaᶜālibī, *Fiqh*, 132; Sacy, *Chrestomathie*, II.515, 1.

[442] Against Jawharī: Mubarrad, 40, 1; Freytag, *Proverbia*, III.495, no. 2969, for him the saying of ᶜAmr ibn Maᶜdikarib himself.

[443] Pocock, *Specimen historiae Arabum*, 61.

[444] Freytag, *Proverbia*, III, 495.

[445] Rasmussen, *Additamenta ad historiam Arabum*, 63, 14.

[446] Sacy, *Anthologie grammaticale*, 221, n.157, cf. Rasmussen, *Additamenta ad historiam Arabum*, 63, 12.

[447] *Hamāsa*, 397; the poem was ascribed by some to Shamardal ibn Shurayk, see Sacy, *Anthologie grammaticale*, 220, n.157; cf. *ibid.*, text, 79, 10.

way to Baṣra. When they replied that they had reserved it for a holy cause, he sent to them a gift of fifty swords, together with a message telling them that fifty swords could serve God's cause more than a single one, whereupon they relinquished it. When it passed into the possession of the caliph Hādī [r. 169–70/785–86], he had it brought out and ordered his poets to compose verses in its praise. One of them said: "Whoever draws it feels no difference whether he strikes out with his right or his left hand". This sword became the subject of legends, and miraculous tales – almost reminiscent of the Nordic epic of Weland the sword smith – were composed about its sharpness.[448] When it became the property of Hārūn al-Rashīd, he gave an astonishing demonstration of this quality.[449] When **[194]** the Byzantine emperor sent him some excellent swords as a present, Hārūn cut through them with *al-ṣamṣāma* as if they were radishes, in the presence of the Byzantine envoy. Not the slightest trace of damage was found on the blade. According to Muslim ibn al-Walīd,[450] Hārūn gave the sword to his general Yazīd ibn Mazyad. Later it was said to have been in the possession of the caliph Mutawakkil [232–47/847–61], and it is supposed that this sword, which he had bought for a high price, was that of ʿAmr ibn Maʿdikarib. The caliph handed it on to a Turk called Jaghyz, who killed him with it. There are no reports where it went after that. *Al-ṣamṣāma* was one of the five swords which the queen of Sheba, Bilqīs, was believed to have sent to Solomon.[451] These were: *al-ṣamṣāma, rasūb, mikhdham, dhū l-nūn*, and *dhū l-fiqār*. The last one was owned by the Prophet Muḥammad, the second and third by the Ghassanid king al-Ḥārith ibn Jabala [r. 529–69], the first and the fourth by ʿAmr ibn Maʿdikarib. The anachronisms in this narrative are quite apparent.

The properties which *al-ṣamṣāma* possessed to such an excellent degree were essential in all other good swords. Poets therefore often boasted that their blade was not bent by a blow (*lam yanʾadi*,[452] *lā yanthanī*[453]), and that it was not deformed when it hit a bone (*lā nābin wa-lā ʿaṣil*).[454] Since a man could trust such a sword, it was given the same epithets as a horse that could endure hardship,[455] such as *akhū thiqa*[456] "trustworthy one", *dhū ḥaqīqa*[457] "one who does his duty"; or the negative of the opposite, *ghayr takhallub*[458] "one who does not betray". One may also add **[195]** *ḍarība* here, in that it acquired the meaning "the tried one" (*jurriba kulla tajārib*[459]).

[448] *Buch der Erfindungen, Gewerbe und Industrieen*, VI.94.

[449] Pocock, *Specimen historiae Arabum*, 61.

[450] Poem 6.

[451] Rasmussen, *Additamenta ad historiam Arabum*, 63, 9.

[452] *Diwans 6*, Imruʾ al-Qays, 14, 14 (ed. Slane, 48, 14).

[453] Ṭarafa, *Muʿallaqa*, v.86.

[454] "Not blunt nor crooked", *Hudhayliyyīn*, 9, 3.

[455] *Diwans 6*, ʿAlqama, 1, 30; 13, 14.

[456] Ṭarafa, *Muʿallaqa*, v.86.

[457] *Ḥamāsa*, 310, 9 from the bottom.

[458] Noldeke, *Beiträge*, 148, v.2.

[459] "That has been put to every test"; addition in *Hudhayliyyīn*, 21, 9; cf. *Diwans 6*, al-Nābigha, poem 1.

Endowed with such qualities, the sword penetrates into its victim; hence the appellation *māḍin*,[460] pl. *mawāḍin*, "penetrating, sharp",[461] or, with specific reference to the cutting blade: *maḍī al-shafratayn*,[462] *māḍī l-ẓubā*,[463] and *māḍī al-ḥadd*.[464] In this respect, swords were compared to the fate of death, or said to have the same effect. Thus, *al-ṣārimān* could refer to a man and his sword or to a sword and fate. Swords were even felt to surpass fate, as in the words of Isḥāq ibn al-Khalaf,[465] who calls the sword *amḍā min al-ajal al-murtāḥ* "sharper than the agreed appointed time (of death)". An intensive sense is contained in *rāsib*,[466] pl. *russab*,[467] and the more common intensive form *rasūb*[468] "a sword that penetrates deeply without getting blunt" (Jawharī and Thaʿālibī: *yarsubu fī l-ʿaẓm lā yanbū*), literally, according to the basic meaning of the verb, "that penetrates through to the bottom". Variant forms are: *rasab, rusab*, and *mirsab*.[469] The sword *Rasūb* was said to be a most excellent weapon by ʿAlqama.[470] This was also the name of: 1. a sword of the Prophet; 2. one of the five (or else seven) swords sent to Solomon by Bilqīs; 3. the sword of al-Ḥārith ibn Abī Shamir.[471] In addition, there is *ṣamūt* "penetrating deeply" (explained in Fīrūzabādī by *rasūb*), which was also used of a blow (*ḍarba ṣamūt*). Given the basic meaning of the verb ["to be silent"], this may also allude to noiselessness. The sword name *al-muṣmat* (the weapon of Shaybān al-Nahdī; see Fīrūzabādī) may well have had the same meaning. [196] Also in Fīrūzabādī is *ḥāṭūra* "penetrating", as in the expression *ḥāṭūra ḥālūqa* "penetrating, trenchant", and finally one might add here *dhū l-karīha*, which according to Jawharī means "a sword that penetrates its victim", literally "that brings ill fortune (death)".

The idea of a sword that penetrates easily in turn inspired the image of agility, hence *dhū habba* "agile, trenchant", literally "alert" (*huzziza fa-habba* "it is shaken and therefore awakes", *hazzatuhu wa-maḍāʾuhu fī l-ḍarība*, ["its liveliness and ability to penetrate are in the blade"], Jawharī). Another image used was that of thirst (Mubarrad, 596, 12: *wa-l-suyūf ẓimāʾ* "and the swords were thirsty", Ibn al-Ruqayyāt). This in turn may have inspired the name of the sword of Abū Mūsā al-Ashʿarī [d. 40s/660s], *al-ṣudā*,[472] which means "the thirsty one" if it derives from *ṣādin*, just as *ṣuqal* from *ṣāqil* and *ʿUmar* from *ʿĀmir*. This etymology is preferable to the one that explains the name as a substitute diminutive form of *ṣudayya* "bird of death". The

[460] *Dīwans 6*, ʿAlqama, 13, 44; *Ḥamāsa*, 384, 18; Iṣfahānī, 10, 10.

[461] Mubarrad, 175, 8; Sacy, *Grammaire arabe*, II.147, middle.

[462] Zamakhshārī, *Mufaṣṣal*, 8, 1.

[463] Mubarrad, 510, 5.

[464] Iṣfahānī, II.169, 6 from the bottom (Abūl-Qays ibn al-Aṣlāt).

[465] Mubarrad, 457, 9.

[466] In Lane with a different meaning.

[467] *Dīwans 6*, Ṭarafa, 14, 12.

[468] *Ibid.*, ʿAlqama, 2, 27; Jawharī, *s.v.* "thākh" (Hudhaylī verse by al-Munakhkhal, cited p. 176 above).

[469] Fīrūzabādī.

[470] *Dīwans 6*, ʿAlqama, 2, 27.

[471] Fīrūzabādī, *s.v.* "b. Jabala".

[472] Fīrūzabādī.

sword would in that case have obtained its name from the bird's call *isqūnī*. The proper name of ʿAmr ibn Abī Salāma's sword, *al-milwāḥ* "he who becomes thirsty quickly" (or "long, slender"), is explained in the same way. Related to this is the name *al-mirghāb* "the greedy one", sword of Mālik ibn Jammāz. A third image is the one contained in the sword name *ḥumat al-ʿaqrab* "sting (lit. "poison") of the scorpion".

The hissing sound of a sword moving in the air reminded the poets of the sound of tearing cloth.[473] Mutanabbī called swords *musmiʿāt* "hissing ones".[474] The sound of **[197]** breaking bones on the other hand was thought similar to the crackling sound of burning reeds, as in the verse by Kaʿb ibn Mālik:[475]

> "He who enjoys a blow that cuts down a foe/
> like the crackling (*maʿmaʿa*) of a reed lit by a spark//"

In a different vein, and more sophisticated words, Mutanabbī says:[476]

> "He knows the language of mashrafī swords/
> even though they speak unintelligibly, and not in Arabic//"

This sound is represented with the onomatopoeic *qab*,[477] the act of producing it with *tarra*[478] and *walwala* (cf. the verse by ʿAbd al-Raḥmān ibn ʿAttāb; Freytag, *Proverbia*, XXIV.319). ʿAntara speaks of the sound of swords (*ṣawt al-mashrafī*), and of spears.[479] The word *ṣalīl*, according to al-Wāḥidī (*ṣawt fī l-darība*), evokes the sound of steel, armour, or a helmet hit by a sword, and was used also of the sword itself. This occurs in the verse by Jarīr:[480]

> "If you had been among our tents when you were deceived/
> you would have heard the deafening noise of swords striking on steel//"[481]

It was considered a proof of exceptional sharpness if a sword could penetrate without noise (or rather, this quality was attributed to it by way of poetic exaggeration). *Al-ukhayris*, diminuative of *akhras* "mute, silent", was the name of al-Ḥārith ibn Hishām's sword (cf. Fīrūzabādī, *s.v.* "kh-r-s"). Some explained *muṣammim*[482] in the same way; cf. also *ṣamūt*, above p. 195.

Furthermore, swords could shatter bones; thus *muṣammim* "penetrating and bone-shattering" in Farazdaq (Jawharī, *s.v.* "f-r-kh") **[198]**:

[473] *Hudhayliyyīn*, 89, 7.

[474] Mutanabbī, 87, 4; cf. commentary.

[475] Mubarrad, 414, 10.

[476] Dieterici, *Mutenabbi und Seifuddaula*, 103, 8–9.

[477] Zamakhsharī, *Mufaṣṣal*, 67, 2.

[478] *Hudhayliyyīn*, 103, 10.

[479] *Diwans 6*, ʿAntara, 27, 5 (swords), v.26 (spears).

[480] Mubarrad, 489, 8.

[481] *Ibid.*, 352, 3.

[482] *Ḥamāsa*, commentary, 362, 2.

"On the day that we sharpened our polished swords for ᶜĀmir/
Our swords which shatter bones and split skulls//"[483]

The verb appears in this sense in Mubarrad's *Kāmil* (p. 625; a verse by ᶜAbbās ibn
ᶜAbd al-Muṭṭalib). The explanation by Jawharī above is preferable to that of Thaᶜālibī,
Fiqh, 132 (*idhā yamurru fī al-ᶜaẓm* ["cuts into the bone"], because it agrees with the
general meaning of *ṣammama* "to be persistent, to carry a thing through to its end".[484]
Indeed, in the *Ḥamāsa*,[485] the persistence of a man to reach his aim is illustrated by a
comparison with such a sword. The caliph ᶜUmar is said to have owned a sword called
muṣammim bi-Allāh "that which penetrates with God's help and shatters bones".[486]
Muṭabbiq[487] means "that which cuts joints"; the basic meaning of the verb "to make
two parts equal, to fold" in its application to swords suggests that it cuts limbs into
parts of equal length, i.e. it severs them at the joint.[488] Both *ṣammama* and *ṭabbaqa*[489]
occur together in the hemistich:

"At times it shatters bones (*yuṣammim*), at times it severs joints (*yuṭabbiq*)"

Ṣaylam follows the pattern *fayᶜal*, like *ḍaygham* and *fayṣal*; its form derives from the
maṣdar [verbal noun] with the insertion of a *yāʾ*, and is used to intensify the sense of
the present participle, i.e. an intensive of *ṣālim*, signifying "sword" in general, literally
one that is mutilating, destroying. Thus Bishr ibn Abī Khāzim [fl. 2nd half 6th c.]
says:[490] **[199]**

"Tamīm were enraged by ᶜĀmir's death/
during the battle of Nisār until they were stopped by the sword//"

Al-ḥatt, the name of Abū Dujāna's sword (and that of Kathīr ibn al-Ṣalt) has a similar
meaning[491] (cf. *ḥatta*[492]).

Having listed the names and epithets relating to the material qualities of the blade, let
us now turn to descriptions of the impact or effect of swords in poetry. We shall begin
with the expressions used of blows of the sword and relevant comparisons. Names for
a sword that struck well are: *ṣadq al-mubtadhal*, like that of Ṭarafa, of which one blow
was sufficient,[493] so that it did not have to be drawn again; *ḍarb mudhakkar* (see
above), a powerful blow; *ḍarba khadbāʾ*, a blow to the stomach (*khadaba* "to wound

[483] Also *Ḥamāsa*, 311, 1; Mubarrad, 549, 13.
[484] In this sense, *Hudhayliyyīn*, poem 93 at the beginning; Ibn al-Ṭiqṭaqā, *al-Fakhrī*, 140, 8.
[485] 361, last line.
[486] Rasmussen, *Additamenta ad historiam Arabum*, 60, penultimate line.
[487] *Hudhayliyyīn*, 290, v.19.
[488] With this meaning, Mutanabbī, commentary, 268, 15.
[489] Jawharī.
[490] *Ibid.*; also *Ḥamāsa*, commentary, 768, 9.
[491] Fīrūzābādī.
[492] Lane: "to rub, to scrape off, to destroy".
[493] *Muᶜallaqa*, v.85.

the flesh without injuring the bones"); *ḍarb ṭilakhf,*[494] a blow that spills blood (cf. *ṭalakha*); *ḍarb kharādil*, a blow that cuts off large pieces: (*kharādil* "large pieces"[495]). In the minds of some poets, an effective blow of the sword conjured up the image of strings of pearls on the neck of a virgin, either because the enemy would be cut down in rows all the way around,[496] or because the sword was seen to encircle the enemy like a necklace on a neck. ʿAntara[497] mentions a blow that forced "the squatting chicklets to fly". Ḥāritha ibn Badr [d. 66/686][498] mentions one "that makes the hair of beardless youths turn grey", and Kaʿb ibn al-ʿAskarī[499] said: "al-Ḥajjāj struck such a blow that a noise broke from the belly of every prince in town" **[200]**.

The effectiveness or impact of swords is illustrated partly in sword names, partly in poetic imagery. These names are: *al-dhāʾid* "that which drives back", the sword of Khubayb ibn Isāf; *al-dhawwād*, with the same meaning, the sword of the Yemeni prince (*al-qayl*) Dhū Marḥab; *al-ṣārid* "the penetrating sword" (from *ṣarida* "to penetrate"; cf. Dhū l-Rumma, v.102), the sword of ʿĀsim ibn Thābit ibn Abī l-Alqaḥ; *al-saffāḥ* "that which sheds blood", the sword of Ḥumayd ibn Baḥdal.[500] *Al-mustalib* "that which snatches lives away"[501] was the sword of ʿAmr ibn Kulthūm, and also that of Abū Dahbal.[502] Among the best poetic images are: a man dons helmet and armour to fend off harm, but no salūqī armour [from Salūq in Yemen] can resist the sword that kindles Ḥubāḥib's fire on slabs of stone[503] [i.e. by striking the slabs so hard that sparks fly]; it cuts through the toughest mail,[504] and the tips of helmets (Jawharī, *s.v.* "q-n-s"); it cuts off the hands of heroes like the fruits of a tree.[505] Bones fly off,[506] and arms take flight like woodchips in a pole-fight.[507] Skulls are split like the gravel by a camel's hooves (Jawharī, *s.v.* "ṣ-r-ḥ"):

> "With the swords in their hands they split the skulls/
> just as camels split gravel on stony ground//"

Or heads are struck off, as in the verse by al-Muhalhil (*ibid., s.v.* "n-q-ʿ")

> "We sever their heads with our swords/
> just as the elder slaughters camels for the home-comers//" **[201]**

[494] Thaʿālibī, *Fiqh*, 25 (ch. 8); Iṣfahānī, II.59, 19.

[495] *Hudhayliyȳn*, 291, v.5.

[496] *Ibid.*

[497] *Diwans 6*, ʿAntara, app. XIX, 13.

[498] (from the time of Ibn Zubayr) Mubarrad, 610, 11.

[499] (Or Farazdaq) Mubarrad, 666,12.

[500] Fīrūzabādī.

[501] Cf. *Ḥamāsa*, 315, 4 from the bottom; Iṣfahānī, II.168, 16 (Dirham ibn Zayd, contemporary of Qays ibn al-Khaṭīm): "swords which steals souls".

[502] Fīrūzabādī.

[503] *Diwans 6*, al-Nābigha, 1, 21.

[504] ʿAntara, *Muʿallaqa*, v.51.

[505] Nöldeke, *Beiträge*, 140, 3 from the bottom.

[506] *Hudhayliyȳn*, 55, 6.

[507] ʿAmr ibn Kulthūm, *Muʿallaqa*, v.89.

Otherwise, necks are harvested, and heads roll like balls in a valley thrown by strong youths.[508] The severed heads seem like camel loads cast onto the stony ground,[509] or like pumpkin heads.[510] As they lie together, they resemble ostrich eggs in the nest.[511] The sword penetrates like the sharp point of a spear,[512] and cuts through the remains.[513] When it is shaken in the bones of an enemy, the back teeth reveal the laugh of death.[514] *Dhū l-yamīnayn* was the nickname of the man who could split his opponents into two (*li-annahu ḍaraba insānan fa-jaʿalahu qismayn*[515]); his real name was Ṭāhir ibn al-Ḥusayn.[516]

The images created by the later poets were not quite as pure and to the point: helmets rest on heads without bodies;[517] the sword has the effect of salt, cutting into everything it falls on;[518] it turns odd (one body) into even (two parts).[519] Armoured warriors were sundered, and nothing was left unscathed except either end of the saddle.[520] The sword does not rest until the interior of the body becomes visible to the eye.[521]

In early poetry, imagery relating to strokes of the sword served indirectly to describe defeat or the pursuit of a fleeing enemy. For example, the victim is said to fall to the ground like a vulture that has eaten poisoned meat (Jawharī, *s.v.* "q-sh-b"):
[202]

"It makes the hero fall on his hands/
You would think him a vulture that has eaten poison//",

or like an uprooted palm trunk.[522] The vanquished party were like the broken horn of a ram, as al-Akhṭal [d. 92/711] says:[523]

"In the morning and the evening the swords of Hawāzin/
left behind them what resembled the broken horn of the ram//"

The fleeing enemy was likened to game, which the pursuer hunts with the sword; once killed, he is like a slaughtered sheep eaten by wolves and hyenas, birds and foxes.[524]

[508] *Ibid.*, v.38 (necks), v.93 (heads).
[509] *Ibid.*, v.37.
[510] Cast onto the ground by swords: *Diwans 6*, ʿAntara, 20, 17; "like pumpkin heads rolled onto the flat earth": *Hudhayliyyīn*, 100, 20.
[511] *Diwans 6*, al-Nābigha, 27, 7.
[512] Iṣfahānī, 10, 10.
[513] *Diwans 6*, Ṭarafa, 14, 12.
[514] *Ḥamāsa*, 43, 18.
[515] Mubarrad, 226, penultimate line.
[516] Iṣfahānī, III.49, 8.
[517] Mutanabbī, 65, 3.
[518] Ibn Durayd, v.70.
[519] *Ibid.*, v.73.
[520] Mutanabbī in Kaʿb ibn Zuhayr, *Carmen*, 26, v.15.
[521] Mutanabbī, 64, 4 from the bottom.
[522] Mubarrad, 639, 2.
[523] Jawharī, *s.v.* "ʿ-ḍ-b" (cf. Mubarrad, 439, 3.).

This very direct and concrete kind of imagery was peculiar to the early poets, but the effect of the sword blow was described in more general terms as well.[525] It is a fire that sends sparks flying among the enemy;[526] it kills quickly like a gust of wind blowing over a dusty plain. The water of death (*mā' al-radā*[527]) runs on the blades of swords. Al-Nābigha[528] speaks of a sword that death itself borrowed; a Hudhaylī poet boasted that nothing could resist a sword or a divine decree[529] (cf. *al-ṣārimān: al-sayf wa-l-qadar*[530]).

We will begin the list of images from later poetry with a quotation from Mubarrad's *Kāmil:*[531] "Your swords are like musk in your hands, because they spread the smell of blood". Al-Buḥturī calls the strokes of the swords thunderbolts that strike the heads of the enemy from the swordtip like five clouds.[532] Mutanabbī **[203]** speaks of squalls of rain that pour down on the people from the clouds, and he boasts that the swords are drenched with souls.[533] After comparing the speed of death with that of his sword, he gives victory to the latter, as if both had entered a race to reach a man first.[534] And Ibn Durayd speaks of the drawn sword of death.[535]

Individual parts of swords are also used for comparison. A poet of the *Ḥamāsa*[536] refers to the handgrips as the pulpits of swords [i.e. they are used to drive home a message], and to the scabbards as king's heads [i.e. because that is where they often come to rest]. Abū Tammām[537] [d. *ca.* 232/845] exclaimed: "Do not search for your swords in your scabbards, for they have been sheathed in necks or in skulls". Mutanabbī[538] once again surpassed his precursors by speaking of swords as combs for the head and jewelry for the neck. Moreover, the sword and its impact served as images for related phenomena. Ṭarafa[539] likened the pain caused by a sharp sword to that caused by an insult against relatives. Later poets ascribed to the glances of the beloved the same effect as swords. Mutanabbī[540] says:

> "They saw the sorceress, the corners of her eyes/
> were like swords with blood-stained blades//"

[524] Hudhayliyyīn, 21, 10–11.
[525] *Diwans 6*, Ṭarafa, 8, 11.
[526] Mubarrad, 239, 1–2.
[527] *Ibid.*, 402, 6.
[528] *Diwans 6*, al-Nābigha, 17, 31.
[529] Hudhayliyyīn, 55, 6.
[530] Ibn al-Ṭiqṭaqā, *al-Fakhrī*, 301, bottom.
[531] Mubarrad, 316, 12.
[532] Mehren, *Rhetorik*, 33; another poet (ibid.) uses "fire" for swords which shine like fire.
[533] 107, 7 (squalls); 97, 1 (souls).
[534] *Ibid.*, 49, 3.
[535] Ibn Durayd, v.33.
[536] *Ḥamāsa*, 137, 11.
[537] Freytag's translation of the *Ḥamāsa*, 372, 7.
[538] 125, 9.
[539] *Mu'allaqa*, v.79.
[540] 102, 6.

Similarly, Abū Ishāq al-Ṣābī[541] said about drinking-cups:

> "The goblets[542] in the hands of those who drink/
> are like blood-stained swords//"

Having discussed the merits of swords, let us now turn to the deficiencies **[204]** that could appear in a sword as a result of its use. In poetry, these occur only in order to extol the praises of a man or in negative propositions. The former is obviously related to the rhetorical device of *istithbāt*, where the proposition itself is negative while the sense is that of praise. Compare the verse:

> "A man of perfect manners, except that he/
> is so giving that nothing remains of his wealth//"[543]

Through long and frequent use, blades developed notches (*fulūl,*[544] pl. of *fall*). It was related[545] that ʿUrwa ibn al-Zubayr asked the caliph ʿAbd al-Malik to return to him the sword of his brother. When several swords without scabbard were brought out to him, he immediately recognized the weapon of his brother. Asked by the caliph how he had recognized the sword, ʿUrwa replied that he had recognized it by that which al-Nābigha described in his verse:[546]

> "There is no fault in their swords, except that/
> in them are notches obtained in constant clashes with battalions//"

Although this was a fault in a sword, it honoured its bearer, inasmuch as it gave proof of his participation in many battles. Compare also the verse by al-Samawʾal ibn ʿĀdiyā:[547]

> "And our swords are notched from the blows/
> we dealt to armoured warriors far to the East and the West//"

And Mutanabbī:[548]

> "Your sword speaks in praise of what I praise/
> that you have fought many a noble man//"**[205]**

A notched sword was called *afall*[549] or *qaṣim*, terms used originally of teeth;[550] in the same sense, one spoke of several swords as *muthallama al-niṣāl*[551] ["with blunted blades].

[541] *Zeitschrift für die Kunde des Morgenlandes* III, 72.

[542] I.e. the full goblet [overflowing with red wine, colouring the drinker's hand red].

[543] *Diwans* 6, al-Nābigha, app. LVII, 2.

[544] *Ibid.*, Zuhayr, 11, 11; al-Nābigha, 1, 19 (cf. Mutanabbī, 82, 6).

[545] Mubarrad, 196, 2ff.

[546] Another example of the aforementioned rhetorical device of *istithbāt*.

[547] *Hamāsa*, 53, 9 from the bottom; likewise *ibid.*, 384, 10: "accompanied only by a notched Yemeni sword".

[548] 248, 18.

[549] *Hudhayliyyīn*, 4,2; Mubarrad, 32, 5; *Diwans* 6, Ṭarafa, app. XIX, 1; Mutanabbī, 121, 9 from the bottom.

In poetry, when defects are not an element of praise, they usually occur in negative propositions. ʿAntara[552] said: *lā afall wa lā fuṭārā* "without notches or cracks" (cf. Ḥassān ibn Thābit:[553] *ghayr al-fuṭur* "no sponge"). The expression *lam yanḥal*[554] "not weakened by illness" is employed in a figurative sense. What has been said of notches also applies to the bluntness of blades. *Nābin*,[555] of several swords: *nābiyat al-ẓubāḥ*,[556] means "blunt" (derived from *nabā*, vebal noun *nabwa*, as in the proverb *li-kull ṣārim nabwa wa li-kull jawād kabwa*[557] "every sword can go blunt and every horse can trip". Mutanabbī[558] said metaphorically: *ʿaṣā li-mawlāh* ["it disobeyed its master"]. And the following terms are also used to designate a blunt sword: *kalīl* pl. *kilāl* ["weary"];[559] *kahām*[560] (cf. *miʾnath* and *miʾnatha* above) and *dadān*,[561] lit. "playful, jesting", from which the opposite meaning of "sharp" is also derived, depending on whether the emphasis is on the lack of usefulness or on the liveliness of the sword. All other terms listed in the dictionaries are likewise tropes: *mabhūr* "exhausted, breathless"; *maʿjūf* "emaciated"; *bildām* "a jester"; *fashfāsh* "a deceitful one"; *qasqās* "stick". In turn, a blunt sword is an image for old age, and for old men who can fight no longer.

Poets do mention that swords become bent [206] or broken, but only with the same intention as above, to praise themselves or their hero. Thus Mutammim [d. *ca.* 20s/640s][562] said:

> "Al-Ḥirmās knows that our swords break/
> on the skulls of kings, and remain stuck there//"

Another defect in swords was rust (*jarab*, also the rust in the interior of the scabbard according to Fīrūzabādī). A rusty sword is *ṣadīʾ* (opposite *qashīb*), *ṭabiʿ*[563] (noun *ṭabaʿ* from the verb *ṭabiʿa*), and *dāthir*. In general, a worthless sword was *muntin*[564] (lit. putrid).

Finally, we turn to the accessories of the sword. It was a custom, although perhaps not in the earliest times, to decorate a sword by attaching various objects to it. This is proven by the meaning of *anqaḥa* "to strip a sword of its decorations in order to

[550] Thaʿālibī, *Fiqh*, 132.
[551] *Ḥamāsa*, 94, 7.
[552] *Diwans 6*, ʿAntara, 11, 4.
[553] Iṣfahānī, II.165, 4 from the bottom.
[554] *Diwans 6*, ʿAntara, 19, 7.
[555] *Hudhayliyyīn*, 9, 3.
[556] Iṣfahānī, II.116, 7 from the bottom.
[557] Mubarrad, 631, note d (another verb, *barada*, "to be blunt").
[558] 46, 14.
[559] Iṣfahānī, II.116, 7 from the bottom.
[560] Thaʿālibī, *Fiqh*, 132; Sacy, *Grammaire arabe*, II.201; Mubarrad, 555, 8, connected with sword.
[561] Thaʿālibī, *Fiqh*, 132; Fīrūzabādī.
[562] Nöldeke, *Beiträge*, 148, v.1; Mutanabbī, commentary, 208, 8, and elsewhere.
[563] Mubarrad, 479, 16.
[564] Freytag, *Lexicon*.

survive in times of hardship".[565] These decorations were called *ḥilya*, pl. *ḥilan* or *ḥulan*, also *ḥaly*; a decorated sword was *muḥallan* (*wa-miʾat sayf muḥallan bil-dhahab wa-l-fiḍḍa* ["a hundred swords bedecked with gold and silver"][566]). In the *Ḥamāsa*[567] one finds *dhū ḥilya* ["endowed with ornamentation"] instead, but this is to be understood, according to the commentators, as a consequence of the blood adhering to it (cf. Mutanabbī, 79, 9), *bi-aḥmar min damm* "by the sword reddened with blood".

The strap, *ḥamīla* or *ḥimāla*, pl. *ḥamāʾil*, also *miḥmal*[568] and *nijād*,[569] insofar as it carried or helped to carry the sword, was long (thus *ṭawīlan ḥamāʾiluhu*[570] and *ṭūl al-nijād*[571]), and it hung over the armour [207]: "a soft armour over which hung the strap of an Indian sword".[572] The length of the strap was also a proof of the height of a man; hence the references to the dragging of the sword, such as: *lā tudhilhu* "do not let it drag on the ground".[573] Abū Kabīr[574] compared one of his companions, who slept curled up on the ground so as to be able to jump up more quickly, with a strap, and Dhū l-Rumma[575] called roots of trees *miḥmal* because of the similarity between the two:

"The winds sweep the coarse gravel from the roots of trees"[576]

According to Ibn Shumayl, the strap had *raṣāʾiʿ* at its lower end (pl. of *raṣīʿa*), meaning "bridle knots" (ʿAmr ibn Kulthūm, *Muʿallaqa*, v.80), that is, tassels (*madfūra*), and hence the expression *sayf muraṣṣaʿ*. Compare the verse of Abū Dhuʾāyb:[577]

"We shot at them until their position became precarious/
and the tassels were torn off their shoulder straps//"[578]

Leather loops served to attach the carrying strap to the scabbard. Later, metal rings (*ṭāq*)[579] were used, hence the epithet *muṭawwaq*[580] "fitted with (silver) rings". *Al-bakarāt* were also rings, by which a sword was suspended from the belt. The piece of leather attaching the strap to these rings was called *qayd*.[581] We have already

[565] Thaʿālibī, *Fiqh*, 34 (ch. 10), on the authority of Thaʿlab and Ibn al-ʿArabī.

[566] Kosegarten, *Chrestomathia*, 118, 3 (Ibn al-Maqrīzī); Jawharī.

[567] 724, 15.

[568] *Diwans 6*, ʿAntara, 19, 4; Imruʾ al-Qays, *Muʿallaqa*, 9, commentary; *Ḥamāsa*, 39, 12 from the bottom; Khalaf al-Aḥmar, *Qasside*, 102.

[569] Nöldeke, *Beiträge*, 168, bottom: *ṭawīl al-nijād*; *Ḥamāsa*, 446, 2; 741, 6; Mutanabbī, 139, 17.

[570] *Ḥamāsa*, 469, 13.

[571] Mubarrad, 510, 5; cf. *ibid.*, commentary, 512, 3.

[572] Jawharī, *s.v.* "nijād".

[573] Mutanabbī, 77, penultimate line.

[574] *Ḥamāsa*, 39, 12 from the bottom.

[575] Jawharī.

[576] Literally: "from the upper surface of the straps".

[577] Jawharī, *s.v.* "r-ṣ-ʿ" and "r-b-th".

[578] *Ibid.* explains "they were hung on the swords so that its lowest part was linked to its upper part".

[579] Kosegarten, *Chrestomathia*, 111, 3: "the blow severed a ring from the sword straps".

[580] *Hudhayliyyīn*, 290, v.19; for an alternative reading cf. comentary, 291, 5.

[581] Freytag, *Lexicon*.

mentioned the sword name *dhū l-khurṣayn* (fitted with two rings) above. In decorating the swords precious stones were also used **[208]**, cf. *sayf muraṣṣaᶜ bi-l-jawāhir* ["a sword inlaid with gems"] (Fīrūzabādī).

Dates of authors commonly cited in this chapter:

Abū Nuwās (d. *ca.* 198/813)
Abū Tammām (d. *ca.* 232/845)
Abū ᶜUbayda (d. 209/824)
ᶜAlqama [ibn ᶜAbada] (fl. 1st half 6th c.)
ᶜAmr ibn Kulthūm (fl. 6th c.)
ᶜAntara [ibn Shaddād] (fl. 2nd half 6th c.)
Aᶜshā [Maymūn] (d. *ca.* 7/629)
Aws ibn Ḥajar (fl. late 6th c.)
Bashshār ibn Burd (d. *ca.* 167/784)
al-Buḥturī (d. 284/897)
Dhū l-Rumma (d. 117/735)
Farazdaq (d. 110/728)
Fīrūzabādī (d. 817/1415)
Ḥarīrī (d. 516/1122)
Ḥārith [ibn Ḥilliza] (fl. 6th c.)
Ḥassān ibn Thābit (d. *ca.* 40/661)
Ḥātim al-Ṭāʾī (fl. late 6th c.)
Hudhayliyyīn (ca. 550 – 81/700)
al-Ḥutayʾa (d. *ca.* 40s/660s)
Ibn al-Aḥmar (fl. 1st half 7th c.)
Ibn Durayd (d. 312/933)
Ibn al-Ruqayyāt (d. *ca.* 80/699)

Ibn al-Tiqtaqā (fl. early 8th/14th c.)
Imruʾ al-Qays (d. *ca.* 550)
Iṣfahānī (d. *ca.* 363/972)
Jarīr (d. 111/729)
Jawharī (d. 398/1007)
Kaᶜb ibn Mālik (d. *ca.* 50/670)
Kaᶜb ibn Zuhayr (fl. 1st/7th c.)
Khalaf al-Aḥmar (d. *ca.* 180/796)
Mubarrad (d. 285/898)
Muslim ibn al-Walīd (d. 207/823)
Mutanabbī (d. *ca.* 354/965)
al-Nābigha (fl. late 6th c.)
Qays ibn al-Khaṭīm (d. early 7th c.)
al-Samawʾal [ibn ᶜĀdiyā] (fl. 6th c.)
al-Shanfarā (d. *ca.* 550)
Ṭarafa [ibn ᶜAbd] (fl. mid-6th c.)
Thaᶜālibī (d. 429/1038)
Tibrīzī (d. 502/1109)
Zamakhsharī (d. 538/1144)
Zayd al-Khayl (fl. early 1st/7th c.)
Zuhayr [ibn Abī Sulma] (d. 609)]

Appendix 1

Jābir ibn Ḥayyān's *Book on Iron*

Brian Gilmour and Robert Hoyland

The Muslim alchemist (literally 'the chemist') Jābir ibn Ḥayyān, known in Europe as Geber, is a shadowy figure, as can be seen from the following extract from the earliest biography of his life by the bibliograher Ibn al-Nadim (d. 380/990):

> People have different opinions about him. The Shiʿites have said that he was one of their great men and one of their divinely inspired leaders. They claimed that he was a companion of (the imam) Jaʿfar al-Ṣādiq (d. 148/765) and a resident of Kufa. Certain philosophers have alleged that he was one of their number and that he wrote compositions about logic and philosophy. Those engaged in the manufacture of gold and silver (alchemists) have asserted that during his time the leadership culminated with him, but his status was kept secret… It is said that he was attached to the circle of the (secretarial dynasty known as the) Barmakids and a confidant of Jaʿfar ibn Yaḥyā (the Barmakid, d. 187/803).

We do not want here to involve ourselves in the intricate debate over the details of his life and the authenticity of his voluminous writings,[1] but rather simply to note that within the corpus of alchemical material attributed to him there are some very interesting nuggets of information. One such nugget is relevant to the subject of this book and so seems worth presenting here. It is found in a commentary on Jābir's *Kitāb al-ḥadīd* ("Book of Iron") by the Egyptian alchemist ʿIzz al-dīn al-Jildakī (d. 743/1342), itself preserved in Ms. Arabic 4121 of the Chester Beatty library.[2] We offer first a translation and then a commentary:

Translation

"Know, o brother, that your companions are those who cast iron (*yasbikūn*) in founding-ovens (*masābik*)[3] made specifically for it, after extracting it from its mine as yellow earth (the ore) in which scarcely visible veins of iron are mixed. (Beforehand)

[1] An overview of the debate is given in *E.I.*, *s.v.*, and thorough discussion by Kraus, *Jabir ibn Hayyan*.
[2] The relevant page of the manuscript is given in al-Hassan, "Iron and Steel Technology in Medieval Arabic Sources", 49–50, with edition and translation on pp. 36–38.
[3] Literally melting-places; *masābik* is a noun of place, i.e. where you do the melting/moulding; in modern Arabic it refers to foundries (see Fig. 18a and b).

they put it in the prepared founding-ovens (furnaces) to smelt it and they set up over them powerful bellows from all directions after pounding these ferrous earths (ore) with a little of oil and alkali.[4] And they fire it with hot coals (charcoal)[5] and firewood and they use bellows on it until they find it has melted and that its body and substance has become free from that earth.[6] Next they let it out in drops through holes like strainers in those furnaces (*akwār*). Thus that melted (cast) iron is purified, and they induce it to become rods from that earth, and they transport it to the horizons and countries and the people use it for whatever human benefits they require.

As for steel specialists, they take the rods of iron and put them in founding-ovens that they have, which are suited to the steel-treatment[7] that they have in mind (see Fig. 18a). They apply the furnaces to the steel and blow fire on it for a long time until they make it like bubbling water. They feed it with glass, oil, and alkali until there appears from it light in the fire and it is purified of much of its blackness by strong melting (*sabk*) for the duration of the night and the day. They continue to watch its swirling for signs until its good condition is clear to them and (this is judged by) the radiance that shines from it. Then they pour it through channels so that it comes out as though it were running water. Then they solidify it like rods or in pits of clay serving as large crucibles (*bawāṭiq*). They bring out of it refined steel like ostrich eggs, and they manufacture from it swords, helmets, lance-heads and all the rest of the implements".

Commentary

It is clear that the first paragraph of this text describes the smelting of cast iron, which is put to a variety of uses including the making of steel, which is dealt with in the second half of the text. The cast iron being made can confidently be classified as part of the category of what Kindi describes as 'hard' or 'male' iron (*shāburqān*), itself a variety of 'mined' iron, i.e. iron or steel (of any kind) made directly from its ores. The oil may have assisted with the correct mixing and binding of the ingredients and would in any case have helped as a fuel in the reduction of the ore to metal. The alkali would have served as an additional fluxing agent together with the iron and silica in the ore. Much of this part of the text has to do with the design and operation of the smelting hearth or furnace and we prefer not to speculate too much on the more exact way that this was intended to function, although this should become possible once a smelting site like this has been recognised archaeologically and the evidence recovered and studied in detail.

[4] The modern English term being derived from the Arabic *al-qalīy*, referring to the calcined ashes of the plants Salsola and Salicornia (see glossary).

[5] Almost certainly charcoal is meant here, as 'coals' in a more general sense very often refers to charcoal, and in any case coal has always been unsuitable for smelting because of its high sulphur content.

[6] That is, the iron has been chemically reduced from the ore and has liquified and separated from the remaining slag and cinders. The description may also refer to aspects of the shape or design of the furnace but as no blast furnaces of this period and region have yet been identified we do not know what this might be.

[7] Reading *muʿāmalat al-ḥadīd*, which seems to me to make better sense than al-Hassan's *maʿāmil al-ḥadīd*.

The second paragraph of this text clearly refers to the processing of iron to make steel using the rods of iron of the kind made as was described in the first paragraph of the text.[8] However, there is no reason to suppose that it was only iron bars of this kind that were used to make the processed/crucible steel described here. Using Kindi's (probably) near contemporary terminology we can deduce that what is being done here is that bars of 'mined' iron (i.e. bars of unprocessed iron produced directly from their ores) are being processed to produce the kind of (crucible) steel Kindi refers to as *fūlādh*. The second paragraph of Jābir's text seems more likely to refer to the use of two types of 'mined' iron namely a mixture of 'hard' iron (*shāburqān*) – in this case cast iron – and 'soft' iron (*narmāhan*), this being what was used in equal proportion in the Kindi crucible steel-making recipe we have included here.[9]

The noise like bubbling or boiling was also noted by Massalski, in 1256/1841, for the mixed (plain and cast) iron crucible steel-making process he observed at Bukhara (formerly in Transoxiana, north of the river Oxus, now in Uzbekistan). In this, the boiling noise was heard when the cast iron melted and continued until the fusion between the two types of iron was complete and the contents of the crucible were completely liquid, at which point the boiling noise ceased.[10] The heating cycle of this crucible steel making process took approximately twenty-four hours which, although much longer than the six hours described by Massalski, is within the range found in the 13th/19th century southern Indian processes, which typically varied between six and twenty-four hours for the heating part of the crucible steel-making cycle, but with times beyond these limits being reported.[11] It is not known how long the medieval crucible steel-making processes described by Jābir or Kindi took, although one of the processes described by Ṭarsūsī is said to have taken several days.[12]

In these more recent crucible steel processes the completion of liquefaction was sometimes judged by shaking the crucibles, while in at least one case this was judged by observation through a hole in the lid. This may well have been one purpose of the central hole in the Merv crucible lids (see Fig. 16), and either shaking (swirling) or observation through a central hole in the lid of an otherwise sealed crucible. Either could have applied in the case of Jābir's description, although it would seem most likely that the completion of liquefaction of the steel was judged by careful observation of the bubbling liquefying metal, and probably this was done through a central hole in the lids that these crucibles are likely to have had.

[8] This second part of the text has been interpreted (al-Hassan and Hill, *Islamic Technology*, 254) as representing a third early steel-producing process linked to crucible production, this time involving the refining of the cast iron bars produced in the first paragraph of Jābir's description, but different to the two crucible methods known to have been used in this period for introducing carbon into plain low carbon bloomery iron to produce a very high carbon steel as a liquid. One problem with this interpretation is that it introduces a new process, which seems to be unsupported by any other clear evidence.

[9] See ch. 1, n. 26 above.

[10] Massalki's description of this process is given in full, including illustrations, in Allan and Gilmour, *Persian Steel*, 535–39 (Appendix 4), although we have included Massalski's diagrams here (redrawn for clarity but not corrected) – see Fig. 18b.

[11] See Bronson, "The Making and Selling of Wootz".

[12] See Allan and Gilmour, *Persian Steel*, 63.

In Jābir's description, once the iron was seen to be fully liquid (i.e. the fusion process was completed and a homogeneous steel produced) and ready (as partly judged by the light it emitted), it was poured out, via channels, into bar or crucible-shaped moulds. Sometimes the steel may have been allowed to cool slowly in the crucibles and only broken out later, a variation in the process that may have been important in the eventual production of watered steel objects and that is likely for much of the metal used for arms and armour, especially swords, if not necessarily for tools. All of these seem to have been among the likely end products of the crucible steel made according to Jābir's description.

Appendix 2

Bīrūnī on Iron

Brian Gilmour and Robert Hoyland

Introduction

Muḥammad ibn Aḥmad al-Bīrūnī was born in 362/973 of an Iranian family in the province of Khwarizm on the southern shores of the Aral Sea. He spent his formative years there, receiving a thorough scientific training, before travelling to seek patronage from a variety of rulers. At the court of Jurjan, southeast of the Caspian Sea, he wrote his first great work, the "Chronology of Ancient Nations" (ca. 390/1000), on the subject of calendars and eras, and important mathematical, astronomical and meteorological problems. Later he was employed at the court of Ghazna, probably as astrologer to the famous Sultan Maḥmūd, and there for many years taught the Greek sciences whilst acquiring the enormous wealth of knowledge, including mastery of Sanskrit, that would go into his perhaps most famous work, the "Description of India" (ca. 421/1030). He wrote on most of the sciences current in his time and had a very lively enquiring mind, and this makes the chapter on iron in his "Sum of Knowledge about Precious Stones" (Kitāb al-jamāhir fī maᶜrifat al-jawāhir) all the more interesting to us. Bīrūnī (d. 440/1048) wrote this work later in his life, probably during the reign of Maḥmūd's grandson, Mawdūd (r. 432–442/1041–1050).

This book is, however, not a straightforward one, and contains much more than the title would lead one to think.[1] The introduction praises the wisdom manifested in the Creation and describes the various ranks of creatures and the way God has given to each just what it is required for its existence. Next come fifteen "invigorating discourses" (tarwīḥa) that move logically through the subjects of humans' relationship to nature, their needs, the necessity for them to live in a community, their provision of goods and services to one another and the desirability of having a common means of exchange to facilitate this, and the way that they settled upon precious stones and minerals and subsequently came to exalt themselves through these, accumulating them and adorning themselves with them. This naturally leads him to the main subject of his book, a discussion of the principal precious stones and minerals, of which the chapter on iron forms a part. Since this text is somewhat diffuse, incorporating anecdotes,

[1] See the articles of Anawati and Qadri in Said, *Al-Bīrūnī*.

poetry and the like, we only treat here what relates specifically to the manufacture of swords and to their different kinds.[2]

Translation

[247][3] God Almighty said: "We sent down iron, which possesses power, strength and many benefits for mankind" (57.25) ... [explanation of this verse and man's need for iron]... **[248]** Mined iron is divided into two types.[4] One of them is smooth and called *narmāhan* and is labelled feminine because of its weakness. The other is hard and called *shāburqān*, and is labelled male because of its strength. It accepts quenching despite its tendency towards lack of flexibility.[5] *Narmāhan* is likewise divided into two types. One is the substance itself; the other is its water, which flows out when it is smelted and purified from the ore. This is called *dūs*, and in Persian "datestone" (*astah*), and on the borders of Zabilstan[6] *raw*, because it comes out [of the ore] very quickly and precedes iron in reaching a fluid state. It is hard and white tending towards silvery.[7]

From *shāburqān* are made Byzantine, Russian (*Rūs*) and Slav swords.[8] Sometimes it is called *qalaᶜ*, pronounced with an "a" on the "l" and also without a vowel [i.e. *qalᶜ*]. Thus it is said: "You hear a ring from the *qalaᶜ*, but a harsh tone from anything else". A type of sword is ascribed to it, hence called Qalaᶜi. Some people believe that their name derives from a place, as is the case with the Indian, the Yemeni and the Mashrafi swords, and they say that they were brought from Kalah, just as tin was brought from there, and so the Qalaᶜi swords are related to this place. They are broad swords and not

[2] The section on iron is on pages 247–57 of the edition of Krenkow, from which I translate, and on pages 403–14 of the edition of al-Hadi, which I use for comparison. The differences between the two editions are few and subtle. The translation of Said is quite good, but is a little free and suffers from a total lack of commentary and annotation (bar identification of Qurʾanic verses).

[3] For ease of reference we have included the Krenkow page numbers [247] to [257] shown thus.

[4] See ch. 2, Kindi/Zaki, p. 5.

[5] Reading with al-Hadi *maᶜa taʾattiyih li-qalīl inthināʾ*; Krenkow has "with/despite a refusal to lack of flexibility" (*maᶜa taʾbīya li-qalīl inthināʾ*).

[6] A region north of Qandahar and southeast of Herat, now in central Afghanistan.

[7] The description would suggest white cast iron is meant here.

[8] The swords of the Byzantine (or Eastern Roman) Empire present no problems as to where they are from, but the identity of the Russian and Slav swords mentioned by Bīrūnī, or the types that can be expected, is more difficult to work out. In Bīrūnī's time the principalities that made up Russia were still ruled (by then from Kiev) by the Riurikid dynasty said to have been founded in Novgorod about 200 years earlier by the semi-legendary (Danish?) Viking, Riurikid, although the Russian population was still predominantly Slavic. Possibly Bīrūnī is referring to this mixed, though mainly Slavic population. Although the etymology still seems uncertain, it has been argued that the name Rus or Rhos is derived from a Finnish word for Swedes, in turn derived from a Swedish word meaning 'rowers' or 'boatmen' (see discussion by Jones, *A History of the Vikings*, 246, n. 3). However it seems to be generally agreed that the Rus were people largely of Swedish Viking ancestry who by Bīrūnī's time had come to dominate large areas of Slavic territory that later became known as Russia. Whether Bīrūnī is referring only to this region, or other Slavic areas as well, is not clear.

improbably are used as a metaphor for whiteness/brightness (*bayāḍ*) in Arab poetry.

[The poet] al-Ḥusayn ibn al-Hamām al-Murrī said: "We bring heavy rocks upon their [helmeted] heads while the Byzantine Qalaᶜi swords are blunted by them". The allusion here is to *shāburqān*, since Byzantine swords are made from nothing else.[9] [The poet] al-ᶜAjjāj said: "Byzantine smiths have created// white blades from black iron water", and again [249]: "When death embraces// I strike them with a Qalaᶜi sword... [*qalaᶜ* and its meanings in poetry are now discussed.

[250]...*Qalaᶜ* means clouds; clouds resemble mountains; and iron is extracted from mountains, and because of this common aspect iron has been connected with the heavens. A Hudhali poet said: "Be content with a heavenly Indianized Qalaᶜi sword, above the forearm and below the elbow, of pure iron that has suffered long working and the stomach of a hungry bird". The first line has only to do with the creation of iron, and concerns its clearly stated descent from heaven. By "Indianized" (*muhannad*) the poet does not mean that the sword is from India; rather he calls the sword thus because it is an essential attribute of it. In the second line he expresses what others have said, that the fire of the thunderbolt penetrates and sinks into the ground, and digging there afterwards would yield the iron from which Qalaᶜi swords are made. As for "the stomach of a hungry bird", this means that this iron is cut up and heated until it becomes like hot coals, and is thrown to the ostrich so that the dross may be removed in its stomach. The ostrich will then excrete it pure and in the proper state to have swords struck from it, and to be ground and polished. Those who have witnessed ostriches swallow the heated iron assert that it does not linger in their stomachs; rather they excrete it immediately. I have also heard concerning *shāburqān*, from a number of sources, that the Russians and Slavs would cut it into small pieces, work it into a powder, feed it to ducks, and then wash it out from their dung. They repeat this action many times, and then they weld it together after immersing it in the fire, and they forge their swords from it. [The poet] Ibn Bābak says: "The darkness of battle is parted with a glittering[10] [of swords] as a veil of clouds (*qalaᶜ*) is dispersed by lightning".

Even if we had not known that *dūṣ*[11] is not deployed on its own for making swords, for it cannot resist a blow, we would have guessed that the sword of Abū l-Abyaḍ al-ᶜAbsī when he says [251]: "I possess nothing but a breastplate and a helmet and a bright polished sword from the water of iron" and also the sword of the one who says: "And when the sword strikes [the enemy] with both sides, you see something like salt spraying out from his mail coat" were forged from *dūṣ*.[12]

It is stated in some books regarding thunderbolts that when they strike, whatever is

[9] See Bīrūnī commentary, 248 below.

[10] Reading *muᵓtamiḍan* with al-Hadi; Krenkow has "consumed by grief" (*murtamiḍan*).

[11] Thus al-Hadi; Krenkow has "Russians" (*rūs*), which is accepted by Said, who translates: "Even if we had not known that the Russians made the swords of iron – which withstood hard struck blows (of other swords)...". But this does not really translate al-Bīrūnī's *law lā annā naᶜlam anna l-dūṣ/rūs lā tanqād bi-infirādih li-ᶜamal al-suyūf minhu wa-lā tuqāwim al-ḍarb*...

[12] Thus Krenkow and al-Hadi, which Said translates: "minted at Daws".

liberated from them goes upwards and whatever fragments are burnt in the atmosphere fall to the ground [discussion of properties of lightning]… Air, together with thunder, lightning and thunderbolts, can remove metal pieces to another place, either [directly] from the surface of the earth or thrown up with mud from within the earth. This is attested to by iron found some years ago in Jawzajan.[13] It was [part of] a ship anchor according to the testimony of one of those who fetched it and on the basis of its resemblance to that (i.e. an anchor), although its shape had changed from the heating it experienced as a result of the severity of its fall. Its substance was not of good quality, since anchors are not made of high quality iron: the purpose of them is merely weight. Similarly, the village of Ṭācūn, one of the villages of Pūnshanj [near Herat], was rained on one cloudless day by metal pieces resembling bad sulphur, pockmarked like iron dross. It was hot when it fell, with water hissing from it, and it was from one to two *mannas* [in weight].

Among the types of mined iron next in rank to *ḍūṣ* is[14] *tūbāl*, which is the peel of iron thrown off by the hammer [that is, hammer-scale] and the dross of iron [that is, non-metallic waste or slag]. The rust of *tūbāl*, called on account of its redness saffron, is related to *ḍūṣ*. The [equivalent] weight of *tūbāl* in relation to a bar of gold is forty-one and a third. Chemists claim that they can soften iron with arsenic[15] so that it melts as fast as tin, and that when it becomes thus as hard as tin and loses **[252]** its squeaking sound, it becomes, however, less white. These are the characteristics of simple iron.

As for the compound of *narmāhan* and its water, the latter being the first to become liquid in the purification process, it is steel (*fūlādh*). Herat is specially noted for steel, and it is [there] called eggs (*baydāt*) on account of its shape. These eggs are long and round-bottomed according to the form of the crucibles [in which they are made], and from them Indian swords and the like are fashioned. According to its composition steel is of two types.

One [such] is that the *narmāhan* and its water are melted equally in the crucible and they blend so that one cannot distinguish the one from the other, in which case it is good for files and the like. This immediately leads one to think that *shāburqān* is of this type and by a natural process is quenched. Second is that the melting of what is in the crucible will be unequal so that the two do not mix completely, but rather their parts remain separate and each part of their two colours can be seen on close inspection. This is called watering (*firind*). Men vie with one another for sword-blades that combine it with greenness, and they expatiate on its description… [verses about watering cited; cf. Schwarzlose, pp. 147–49 and 165–71, in ch. 4 above].

A green shine is preferred for the Yemeni and Indian sword-blades, and white for

[13] A region south of the upper reaches of the River Oxus, now a northerly province of Afghanistan, approximately 500 km (320 miles) north-east of Herat.

[14] There appears to be a bit missing here as *tūbāl* cannot both mean a type of iron and hammerscale, a kind of non-metallic waste product. He goes on to make it clear that *tūbāl* refers to this kind of hammer-scale because of its reddish colour, so that one or more types of iron next in rank to *ḍūṣ* appear to be missing here, a likely copyists error.

[15] See Bīrūnī commentary, 251 below.

the Mashrafi. Al-Bāhilī said in his *Kitāb al-silāḥ* ("Book on Weapons"):[16] watering is the ornamentation on the broadside (*matn*) of the sword, and **[253]** a shine (*lamᶜ*) of varying colour.[17] Grooved swords (*mushaṭṭab*) are those in which paths like channels[18] (*jadāwil*) are made; sometimes they are raised and sometimes they are sunken. The latter mentioned only occurs when there is just one channel. If there is more than one channel, then there would have to be a raised part between every two channels.

The Surayji swords are those attributed to the craftsman Surayj, their maker. Some say that the name derives from the diminutive form of *sirāj* [meaning a "lamp"] on account of their brightness, but this is a false derivation. Qalaᶜi swords are related to the word *qalaᶜa*. Qasāsi swords are associated with *qasās*, a mountain in which there is an iron mine. The Mashrafi swords are said to be related to the Mashārif, which are villages near to the countryside known also as the Mazālif.[19] It is also said that Mashrafi refers to a pre-Islamic smith of the tribe of Thaqīf whose name was Mashraf. They say that the *firind* of the Yemeni swords is crooked, of equal knotting, and white on a red or green ground. Qubūri are swords known by this name, as though they were found in the graves of eminent people.[20] I have heard that the Qubūri swords are those that do not accept equally the medicament (*dawāᵓ*) during the melting (*al-sabk*) [in the crucible] so that there remain soft veins of feminine metal that do not drink [that is they do not melt and merge with the rest]. If this happens on both edges, they do not cut for lack of quenching; and if turns away from both edges, they do no damage. The *muhannad* sword is so-called by virtue of its being made in India, but is sometimes attributed to Sri Lanka in translation into Arabic [verse example given].

Firind is referred to in Khurasan as *jawhar* and pertains to the sword. It may be hidden by heating and polishing. When the people of India want to bring it out, they coat it with yellow iron sulphate (*zāj*) from Bamyan or with white iron sulphate from Multan. The Bamyani [iron sulphate] must be superior or it would not be transported to Multan.

During quenching they coat the broadside (*matn*) [that is full width] of the sword with suitable clay, cow dung and salt in the form of a paste, and test [that is to mark out] the place of[21] quenching at two fingers from the two sides of the cutting edges. Then they heat it by blowing [the hearth with bellows], the paste boils, and they quench it and cleanse its surface from the coating on it with the result that the nature (*jawhar*) appears. Iron sulphate (*zāj*) can also be mixed with the salt.

The cutting power in the watering (*firind*) and the white *ḍūṣ* **[254]** is a result of its

[16] This work of al-Bāhilī is not known to survive but the author may be the same as the Baghdadi philologist and author Aḥmad ibn Ḥātim al-Bāhilī (d. 231/855) – see Ibn al-Nadīm, *Fihrist*, 1.56 – whom Bīrūnī cites in his book on pharmacy and *materia medica*.

[17] This second part of the sentence refers, according to Bīrūnī's quote from al-Bāhilī, to *birind*, but this is just a different spelling for *firind*, not a separate item.

[18] Possibly a wider form of groove or fuller being referred to here.

[19] A mountainous area approximately 90 km (55 miles) southeast of Damascus.

[20] *Qubūr* means "graves" in Arabic. Note that many of these explanations for the names of swords may just be popular etymologies

[21] Or possibly where some of the paste will be removed before quenching.

hardness, but breaking and crumbling are also associated with it. If female black iron covers it on both sides, it remains cutting and is preserved from this defect. This is the characteristic of the watering.[22] You will never find a people more perceptive about its types and its names than the Indian people. Among these waterings there are some that have very fine markings so that they resemble the tracks of ants, and others with coarser and more spread out markings. These latter give rise to varieties of images, as happens in the clouds and in water poured onto the ground and in connection with what we have related about the onyx.

The Russians used to make [the edges of] their swords from *shāburqān* and the channels[23] in the middle of them from *narmāhan* so that they might be firmer when striking and less liable to break, for steel will not stand the coldness of their winters and breaks with a single blow. When they examined the watering, they devised for the grooves a web of stretched threads made from both of the two types of iron, *shāburqān* and the female (*narmāhan*). And there resulted from this web welded by immersion wonderful things, just as they intended and wished for. However [on blades made of crucible steel (*fūlādh*)], the watering does not occur during manufacture by design nor by desire, but rather by chance.

There is no harm here in mentioning what we have learnt from those with insight into the swords used by the Indians.[24] The best kind is called *palārak*, and it comprises their most valuable swords and daggers. They assert that its iron is smelted from the red sand in the regions of Kanūj.[25] They melt it with crystalline borax, as borax paste is only of use to goldsmiths; this is a liquid that congeals as borax. In this kind the white nature (*jawhar*) prevails over the black. Another kind is called *rūhīnā*, forged in Multan from Harawi egg-shaped ingots. There is also a kind called *mūn*, which is likewise forged in Multan from those ingots and which is of three varieties. The best of them[26] is named the *ʿamrānī*, which is close to the *palārak*, and its nature is predominantly black; the coarsest[27] and lowest quality of them is named *harmūn*, and between them **[255]** are those of intermediate character. The Yemeni swords resemble this kind [i.e. the *mūn*], as does a black kind called *nīlah-band*.[28] Another kind is called *bākhirī* and it is of three sorts. There is an original one, which is close to the *rūhīnā*. And there is the *mukhawwaṣ*, which resembles the *mukhawwaṣ* cloth

[22] See Bīrūnī commentary, 254 below.

[23] Or fullers, as the single, wide channel found on each side of such a large proportion of 3rd/9th to 5th/11th century European swords made about either are commonly known (as in Bone, "Development of the Anglo-Saxon Sword", 64), after the smithing technique and tools used.

[24] See Bīrūnī commentary, 254 below.

[25] Kanūj (Kanyākubja) is an ancient and by then ruinous city on the river Ganges visited by Bīrūnī – see al-Bīrūnī, *Taʾrīkh al-Hind*, vol. 1, 199.

[26] Reading with al-Hadi *aḥsanuhā*; Krenkow has "their kinds" (*ajnāsuhā*).

[27] I read here *akhshanuhu*, linking it with the next word *ardaʾuhu*; al-Hadi and Krenkow have *aḥsanuhu* ("the best of it"), which does not seem to me to fit here.

[28] Possibly connected with the Persian words *nīl* (Indigo, blue/black) and *band* (belt, girdle, hilt, chain, etc.: that is, anything by which things are joined/bound).

(*saqlāṭūn*),[29] and that is because the ingot (*bayḍa*) is not forged lengthwise, but rather at its head, so that it spreads out like a plate, then they cut it [then mount it] in a vice (*lawlabīyan*)[30] and straighten out its roundedness. Next they make the sword proportional[31] and its nature comes out *mukhawwaṣ*. The third sort of *bākhirī* is every sword with no nature, and this term is applied without epithet. There is also a kind called *majlī*,[32] which resembles the *bākhirī* except that there occur on it images of animals and plants and the like. It consists of two varieties: one has the whole of the image on one of the sides of the sword, and the other has part of the image on one side and the rest of it continuing on to the other side. The latter is the more valuable of the two and is worth as much as a choice elephant. If the image is of humans, it is the most costly of all.

ᶜAmr b. Maᶜdikārib had a sword called Dhū l-Nūn since it had the likeness of a fish in the middle of it [verse cited in illustration of this].

The sword Dhū l-Faqār was in the possession of Munabbih ibn al-Ḥajjāj. The Prophet Muḥammad selected it and chose it for himself on the day of the battle of Badr.

Everything outside of these types and made of inferior iron is called *kūjarah*. Just as on horses there are circles which portend either good or evil, a censorious circle being known as the *qāliᶜ*, so likewise in swords possessing watering there is a place, black like the patch devoid of engraving, which if it is removed harms the blade. For this reason it is left alone. If it goes through from one side to the other, its purchasers **[256]** regard it as an evil omen. However, they prefer it on both halves of the sword, and if it points towards the edges it is a bad omen for the adversary, and if it points towards the hilt the bad omen reverts to the owner.

Mazyad ibn ᶜAlī, the Damascan smith, has [written] a book on the description of swords, and its characterisations were incorporated into the treatise of Kindi. It begins with the making of eggs of steel, the construction of the furnace, the making and design of crucibles, and a description of the clays and their specifications. Then he instructed that in each crucible there should be put five *raṭls* of horseshoes and nails made of *narmāhan*, together with ten *dirhams* weight of antimony, golden marcasite[33]

[29] In Arabic *mukhawwaṣ* means "ornamented/woven in the pattern of palm-leaves" (Lane, *s.v.*), but of course the word may well not be Arabic (Indian?) and then would be vocalized differently. Said says: "that is, black at certain places and white at others", presumably thinking of a special usage of the root to refer to ewes (not swords) that have one of their eyes black and the other white. *Saqlāṭūn* is some type of apparel.

[30] In Persian *lawlab* means "the staple or place into which a bolt goes, a spring, a screw, a vice, any tube or canal thorough which water flows" (Steingass, *s.v.*).

[31] Reading with al-Hadi *yuqaddirūn*; Krenkow has *yughaddirūn* ("cast into stagnant water/slime/harsh terrain"), which does not seem to fit here.

[32] This would mean "polished" if the word were Arabic.

[33] Referring here to the yellow (cubic) crystalline form of iron sulphide (FeS_2) – iron pyrites – whereas more recently this term usually refers to the white (orthorhombic) crystalline form: see Spencer, "Marcasite", 683. Possibly this was added to lower the melting point of the steel (as suggested to us by C.J. Salter, University of Oxford).

and powdered magnesia.[34] The crucibles are to be plastered with clay and put into the furnace. The latter is to be filled with charcoal and the crucibles then to be blown upon with Byzantine bellows, each bellows worked by two men[35] until the iron melts and revolves. Small bags[36] should be prepared for it, in each myrobalan, pomegranate peel, the salt of dough and pearl shells, in equal quantities and ground up, each 40 *dirhams* in weight. One small bag is to be thrown into each crucible, which is then to be blown upon strongly for an hour without pause. Then it is to be left until cool, when the eggs may be extracted from the crucibles.

One who was in Sind told me that he sat with a blacksmith making swords. He looked at the swords closely, and their iron was *narmāhan*, and the blacksmith sprinkled on the iron a powdered medicament of reddish colour, threw it[37] and welded it by immersion. Then he took it out and lengthened it by hammering, and he repeated the sprinkling and working many times. I asked him about it and he looked at me contemptuously. I scrutinized it and saw that it was *dūs*, which he was mixing with *narmāhan* by hammering and immersion, just as eggs are worked in Herat by melting and similar to what [Mazyad b. ʿAlī] the Damascan mentioned.

It is said about the nature of the sword that it cannot be changed from one type into another, and for that reason the ancient type of it is praised and exalted. Though this is not inconceivable, I note their statement about [257] the aid of fire in changing one of two ingredients into the other so that its whiteness or blackness becomes less, or about polishing to the degree that it reveals, by peeling, what is inside, under the upper surface of the body.

One of the fanciful stories about iron, and often reported in books, is that when Qandahar was conquered [by the Muslims in the 2nd/8th century] a column of iron was found there that was seventy cubits in height. When Hishām ibn ʿAmr[38] excavated its base, it was revealed to be thirty cubits under the ground.[39] He enquired about it and was informed that a king (*tubbaʿ*) of Yemen had come to their land with the Persians.[40] On capturing Sind, they had cast this column from their swords and said: "We do not intend to pass beyond this country to other lands", and they then took possession of Sind. This is the talk of someone with no insight into the study of minerals and the actions of great persons...

[34] Probably manganese dioxide, most likely added to counter the deleterious effects of any sulphur present.

[35] Said translates "two wheels", presumably reading ʿ*ajalayn* rather than *rajulayn*.

[36] Reading with al-Hadi ṣ*urar* (lit. "purses"); Krenkow has ṣ*ur* ("a horn").

[37] Probably meaning forged it.

[38] Appointed by the caliph Manṣūr (136–58/754–75) to Sind (Balādhurī, *Futūḥ*, 431).

[39] Presumably these dimensions are exaggerated.

[40] Suggesting a military campaign many centuries earlier, possibly relating to the establishment of (partial) Parthian control in the Indus region of in the 2nd /1st century BC.

Commentary

Introduction

When looking at the background and setting to Bīrūnī's work, the chapter on iron and its uses, mainly for swords, is striking as much for the omissions as for its descriptions. In order to judge Bīrūnī's actual contribution to the subject, his sources of information need to be considered. Kindi's treatise on swords covers a narrower field exhaustively, including descriptions of types of iron and steel used to make swords over a vast area, southern and central Asia, as well as Europe. Bīrūnī's chapter on iron forms part of a much larger book, in this case on mineralogy, with only a relatively brief summary on the production of iron and steel, with few examples, but frequent use of anecdotes, poetic allusions, and digressions (such his speculation on the question of the origin of Qalaᶜi iron).

Nevertheless Bīrūnī's account confirms some of what Kindi describes, and provides valuable additional information. He draws on written sources including Kindi's treatise, as acknowledged near the end of his account, and which he says includes material from an earlier source, Mazyad ibn ᶜAlī, the Damascan smith, attributing to the latter some of Kindi's information on swords and the crucible steel from which they were made. As far as we know Mazyad ibn ᶜAlī's record has not survived so it is not known to what extent Kindi used him as a source, although Kindi includes a short section on Damascan swords, which he suggests belonged to a much earlier period.[41] Possibly we can best see Mazyad ibn ᶜAlī as a smith and/or steel-maker of Damascus at the period when it was the capital of the Umayyad caliphs (40/661–132/750).

Although Bīrūnī gives some descriptions of processes from further afield, like those taken from Kindi and Mazyad ibn ᶜAli, his information primarily concerns the regions around his base at Ghazna. There is no regional or global picture of the industry or of contemporary practise further afield. Nothing is said of iron and steel making in Transoxiana, Bīrūnī's area of origin, although both Kindi's account and modern archaeological findings[42] indicate that the industry carried on through Bīrūnī's period and continued in Bukhara into the 13th/19th century.[43] Bīrūnī provides virtually no contemporary information outside the region stretching from the upper Ganges valley westwards across what is now central Afghanistan to Herat.

Simple (or a single form of) iron

[247] In the first part of the chapter, after his introductory passage based on the Quʾrān

[41] See ch. 2, Kindi/Zaki, pp. 11 and 35

[42] For instance see Papakhristu and Swertschkow, "Eisen aus Ustruschana"; Papakhristu and Rehren, "Techniques and technology"

[43] For a detailed description by a Russian observer of both the crucible steel production and the forging of the crucible-made cakes or ingots into swords, see the (1841) account by Second Captain Massalski "Preparation of damascene steel in Persia", an English translation of which was included in Allan and Gilmour, *Persian Steel*, 535–539.

and his discussion of our need for iron, Bīrūnī defines the main types of iron. **[248]** The two types of 'mined' iron (directly produced from the ore) are given the same definitions as they were in Kindi's treatise:[44] *narmāhan*, female or soft (more easily malleable) iron, and *shāburqān*, as male or hard (less easily malleable) iron. These definitions are clear enough and not ambiguous in themselves, but it may be (and may always have been) less easy to group some types of iron into one or other category.

A difficulty arises when Bīrūnī classifies *dūṣ* as *narmāhan*, although from the description little else than white cast iron can be meant, suggesting that *dūṣ* should have been classified as *shāburqān*, given that white cast iron is one of the hardest existing types of iron. While Kindi does not mention *dūṣ* in his sword treatise, nor does this mention cast iron as a form of *shāburqān*, this is clearly what it must be. But Kindi does mention small pieces of *shāburqān*, among the recipes for crucible steel (*fūlādh*) in his recently rediscovered treatise[45] on the making and heat-treating of steel, and one of these recipes is included here, and in this recipe two types of iron, *narmāhan* and *shāburqān*, – here clearly meaning cast iron as they are mixed in equal proportions – were the main ingredients.[46]

Bīrūnī next states that Byzantine, Russian and Slav swords were made of hard iron (*shāburqān*). This runs counter to Kindi's classification in which Byzantine swords, said to be made of soft iron (*narmāhan*), were divided from 'Frankish' swords with their (welded) composite blades made of a combination of hard and soft iron. Kindi does not discuss Russian or Slavic sword types and little is known of contemporary sword making or iron use in this region of eastern Europe/western Asia. By Bīrūnī's time there seems to have been a shift to a much greater emphasis on the use of steel for swords, at least in northwest Europe.[47] A similar shift might be expected in the Russian and Slavic regions under Viking dynastic influence, and Bīrūnī's report appears to confirm this. Many Russian and Slav swords are also likely to have been composite blades, combining soft and hard iron, made by welding together pieces of iron and steel, a proportion of these still being pattern-welded. Possibly this part of Bīrūnī's description has become slightly corrupted and perhaps should say that 'Byzantine, Russian and Slav swords are made of soft iron and hard iron'

[249] Bīrūnī next discusses the uncertainties about the nature and origin of the Qalaᶜi swords. This is introduced by a quote taken from an early poet, Ḥamām al-Murrī of the 6th–7th century AD, referring to 'Byzantine Qalaᶜi' swords, and Bīrūnī concludes that the allusion must be to *shāburqān*, the type of hard iron – steel – we know from

[44] See ch. 2, Kindi/Zaki, pp. 5 and 6.

[45] We have not fully examined this second treatise as yet, but it has been reported as containing as many as 35 recipes for crucible steel; see Sarraf, "Close Combat Weapons", 151.

[46] In Ms Turin, p. 3 ("For the Indian swords one takes a *manna* [mann] of *narmāhan* and the same amount of *shāburqān*, break into small pieces, put in a furnace, and add to it one *manna* of magnesia, two dirhams of kernels of myrobalan, five dirhams of *andarānī* salt, the same amount of Khurasani borax, a handful of peel of bitter pomegranate sifted with egg-white", See ch. 1, n. 26 above.

[47] See Gilmour, "The patterned sword", 116.

Kindi to be directly smelted. But Kindi was certain that the Qalaᶜi swords were made of crucible steel (*fūlādh*), grouping them with the Yemeni and Indian as the best (most 'ancient).

Kindi creates the impression that the all the swords of this group, the Yemeni, the Qalaᶜi and the Indian, were still current but of very old type, with a reputation going back for centuries.[48] Bīrūnī's difficulty in attempting to make sense of this type suggests that their import may have ceased well before the time of writing. His discussion of the problem provides useful additional information, particularly the reference by an early Hudhali poet to a *muhannad* Qalaᶜi sword.[49] The poet extols the virtues of a Qalaᶜi (praised by Kindi) and seems to be saying that it is made of (imported) Indian steel.

Bīrūnī seems prepared to believe[50] that these swords originated from Kalah on the Malayan peninsula, better known for the production of tin; this identification being confirmed by other early sources.[51] It seems likely that the coastal regions as far east as Malaysia were referred to as Indian at this time,[52] so Bīrūnī may simply be referring to one of the best known products of the early 'East Indian' trade network – that carried out by Sasanian and early Islamic coastal traders.

[250] While Kindi's work is based upon reliable information and/or written sources, quotations from poetry and dubious oral traditions (like that about Qalaᵓi swords being made of meteoric iron) figure larger with Bīrūnī, who next digresses to explain another quote from the same Hudali poet, that iron was purified in 'the stomach of a hungry bird'.

Bīrūnī thinks that this reference relates to the practise of forging swords that could then be ground and polished, from iron excreted by ostriches, having been cut up and fed to them hot, to remove the trapped dross or slag. Bīrūnī says that 'those who have witnessed ostriches swallow the heated iron assert that it does not linger in their stomachs; rather they excrete it immediately', so this is not an eyewitness account but perhaps a local tradition from the region around Ghazna.

This story sounds remarkably like a description in Norse mythology of the making of a famous sword. Thiðrick's Saga, written down in the 7/13th century, but part of an oral tradition probably including much earlier Scandinavian and German material, tells how the mythical smith Weland forged Mimming.[53]

> Then Velent [Weland] went to the smithy and took a file and filed the sword down to dust. He took the filings and mixed them with meal, and then he took geese and hens, I starved them for three days, and took the meal and gave it to the birds to

[48] See ch. 2, Kindi/Zaki, pp. 8 and 9.
[49] Possibly here referring to a sword made in Yemen of imported *qalaᶜi* steel ingots; see also Bīrūnī *Jamāhir*, 253; and below in this discussion.
[50] See Bīrūnī *Jamāhir*, 248.
[51] See ch. 2, Kindi/Zaki, p. 8, and nn. 8 and 9.
[52] As argued by Fatimi; see ch. 2, n. 9.
[53] H. Davidson, *The Sword*, 159–160.

eat. Then he took the birds' droppings and brought them to the forge and worked out all the soft parts of the iron; and from it he made a sword which was not as big as the first one.

As the two accounts originate 200 years and approximately 5000 km (3200 miles) apart, this story must already have achieved legendary status and circulated widely by the mid 5/11th century.

As it stands the story is rather bizarre and cannot seemingly relate to any viable or real process involving birds eating pieces of iron, despite this being accepted as such by some modern scholars.[54] The usual interpretation put on it is that small iron pieces were fed to the birds to purify the metal by removing slag, and that the same digestive process perhaps also introduced nitrogen, before the resulting scraps of metal were welded together to give a purer, harder metal.[55] But there seems little chance that such a procedure could have had more than a minimal effect on the non-metallic slag (or nitrogen) content of the iron unless it was in such small pieces (filings) that it would not have been possible to (hammer) weld them back together.[56] In any case this unlikely welding process, even if it worked, could be expected to re-introduce as much if not more slag as might have been removed by the birds' digestive tracts, thus rendering the process pointless.

However, in this story we perhaps have several hints that this may have involved a very particular sort of secondary iron processing, partly seen as purifying the metal. If we also accept that sword making was in some way regarded as important to what is being described, then we should perhaps be looking for a single process that might best explain all aspects of what appears to be being hinted at. Perhaps also, the peculiarities of the story's details suggest that it is based on an account of a process that was unfamiliar to Scandinavian (or any other European) observers, and therefore more easily misreported. Certainly the details do not seem to fit with any known European iron making or iron working process, however corrupt the details might have become in transmission.

A possible solution, that would fit all the peculiarities of the description, is that this story was based on an early central Asian steel making tradition, some memory of which was carried into Europe during the great migrations of the early to mid first millennium AD. Some knowledge of this may have come back from northwest Europe with the establishment by Vikings of long distance links to central Asia. We know from Kindi that small pieces of both soft and hard iron (*narmāhan* and *shāburqān*) together with other ingredients, including egg white, were fired in a furnace in one early Middle-Eastern

[54] See Needham, *The Development of Iron and Steel*, 43 n; and see discussion in Davidson, *The Sword*, 160–161.

[55] See Needham, *The Development of Iron and Steel*, 43 n.

[56] A few hours exposure to dilute hydrochloric acid in the stomach of a bird would etch the metal to some degree, and might dissolve a little slag near the surface, but any more than a fairly minimal effect seems unlikely. Similarly, exposure at body temperature to nitrogen containing compounds in the waste products of digestion is unlikely to have had more than minimal (if any) effect as far as nitrogen absorption into the metal was concerned.

process for making crucible steel (*fūlādh*).[57] Bīrūnī describes this steel as being the product of a purification process.[58] He says of the crucible steel made at Herat[59] that it came out of the furnace in the form of eggs (egg-like ingots), which were then made into swords and other things. Kindi also alludes to the idea of the purified nature of this kind of steel.[60]

This explanation of this curious story requires the initial description to have passed into Norse mythology and to have become widespread before coming to the attention of Bīrūnī, who says he heard it from a number of different sources although he gives no further details. It may be significant that mentions of legends of iron-eating animals also appear in early Chinese writings. A report of 29/650 refers to ostriches said to be like camels and able to swallow iron, sent as tribute by Tokharistan.[61] Maybe corrupted reports of a central Asian (crucible secondary) steel-making process current earlier in the first millennium AD or before were carried into northwestern Europe during the migrations, and incorporated into oral tradition.

The Chinese version of the story may be a parallel account that travelled in the opposite direction and was similarly corrupted in the process. It mentions ostriches, reminding us of Jābir ibn Ḥayyān's 2nd/8th-century account of crucible steel-making, in which the steel is said to be produced in the form of ostrich eggs.[62] Tokharistan, a successor state to Bactria, occupied much the same region on either side of the upper reaches of the River Oxus south of the Ferghana valley, spanning parts of modern day eastern Uzbekistan, Tajikistan and northern Afghanistan. Kindi identifies Transoxiana (beyond the Oxus to the north) as an important producer of crucible steel (*fūlādh*) in the 3rd/9th century, and recent archaeological survey and research indicates that the industry was quite widespread, extending across parts of Uzbekistan towards the Ferghana valley (partly now in Tajikistan) to the east.[63]

Here China exerted nominal overlordship for a time in the changing political circumstances of the mid 1st/7th century, hence the sending of tribute from Tokharistan. The report of iron-eating ostriches as part of this tribute combines two separate elements possibly confused in transmission. Ostriches were native to Tokharistan and possibly peculiar to it, particularly if they were rare elsewhere in Asia by this time. This would have made them worthy of the tribute sent to China, which can also be expected to have included other regional specialities like crucible steel ingots, perhaps referred to locally as being ostrich egg-shaped.

Versions of the same general story of birds eating iron pieces or filings are

[57] See above, ch. 1, n. 26.

[58] Bīrūnī, *Jamāhir*, 248.

[59] Now in north-west Afghanistan..

[60] See ch. 2, Kindi/Zaki, pp. 12, 23 and 25.

[61] See Needham *The Development of Iron and Steel Technology in China*, 43 n.

[62] See appendix 1 in the present volume.

[63] Shihab al-Sharraf, "Close combat weapons", 169, places Salmāni steel production in the 'Silmān' mountains of Afghanistan but does not say where. The northern mountainous region of Afghanistan, known in the 1st/7th century as Tokharistan, extending northwards to the Ferghana valley would seem to best match Kindi's account and the available archaeological evidence; see also ch. 2, n. 12, and ch. 3, Kindi/Zaki, p. 26.

curiously persistent. One was mentioned, albeit with reservations, by the Italian Renaissance master craftsman Biringuccio in 947/1540, amongst examples of foreign-made steel thought to be similar to that made then in Italy:

> Outside Christendom the Damascan is praised and the Chormanian, the Azziminian, and that of the Agiambans. They say that they file it, knead it with a certain meal, make little cakes of it, and feed these to geese. They collect the dung of these geese when they wish, shrink it with fire, and convert it into steel. I do not much believe this, but I think that whatever they do is by virtue of the tempering (that is quenching), if not by virtue of the iron itself.[64]

Crucible steel was linked by popular association with Damascus[65] in late medieval and post-medieval Europe, despite northern Iran or the adjacent region of central Asia being the most likely source of the metal. In Bīrūnī's version of this story the type of iron fed to geese is said to be *shāburqān* (hard or male iron), which at least suggests that directly smelted (but inhomogeneous) steel, or cast iron or both is meant. The central Asian region with its long lasting, probably large-scale crucible steel-making tradition seems the most likely origin of all the versions of these stories.

The confusion of exotic egg-shaped steel ingots with the exotic birds to which they are compared is understandable. Bīrūnī goes on to describe the contemporary manufacture of egg-shaped crucible steel ingots at Herat. In medieval and later times crucible steel ingots were very often referred to as cakes, and the connection with food may have played its part in the association of the birds with iron processing.

Bīrūnī seems to have been largely ignorant of production methods in or near his own central Asian home region. Iron smelting, and particularly crucible steel production in the vicinity of Transoxiana, are not mentioned by him, although they probably continued through to the 13th/19th century. His interest in the industry must have developed when already working under the patronage of the Sultan in Ghazna. The Transoxianan crucible steel industry isn't mentioned almost certainly because he knew little about it. Instead he drew on examples from nearer Ghazna, his long-term base, otherwise relying on earlier written sources.

[251] Bīrūnī's account is of more significance where he describes aspects of iron and steel exploitation unknown from other sources. Unfortunately there are errors in the surviving account, such as *dūṣ* being defined as soft iron (*narmāhan*) where the description makes it clear that hard iron (*shāburqān*) is meant. A later scribal error must account for such a basic error as this, particularly as Bīrūnī goes on to say that were it not for previously cited evidence, that *dūṣ* was too brittle to be used on its own for swords, one might imagine it had been used to make the sword of Abyaḍ al-ᶜAbsī, emphasizing that one has to rely on the known properties and recommended uses of types of iron, and not be misled by poetic descriptions.

[64] Biringuccio, *Pirotechnia*, 70.
[65]Damascus being the great entrepôt or market centre where Europeans encountered watered crucible steel swords.

Bīrūnī also took an interest in meteoric iron. An example is given of an anchor-shaped piece of iron meteorite reported some years earlier as having struck what is now northern Afghanistan, and the effects reported of a meteorite shower at a place near Herat.[66] He compares the effects and smell with those of the slaggy or cindery waste from iron working, then digresses into natural phenomena and discusses how thunder, lightning and thunderbolts can transport iron.

Returning to definitions of the main types of iron, Bīrūnī introduces another problem by stating that the type of iron ranked next to *dūs* is *tūbāl,* although the text describes this as hammer-scale, the waste flakes of oxidised iron thrown off the hot metal during forging. This must be an error, most likely a copyists mistake, as hammer-scale is not a type of iron and so the definition makes no sense.

Another probable scribal error follows, where a type of iron, rather than *tūbāl,* the hammer-scale it produced, would seem to be what is meant. This part of the text appears to be both muddled and incomplete, again suggesting later scribal errors rather than mistakes made by Bīrūnī who is normally both accurate and consistent in what he writes. However, despite the errors, this passage still succeeds in confirming Kindi's statement that some iron was distinguished partly by the type of hammer-scale and rust it produced. In connection with these varieties of iron Bīrūnī also tells us that the redness of the rust of *tūbāl* is likened to saffron, and that this is related to the rust colour of *dūs.* He thus gives us a further interesting insight into the detailed ways in which ironworkers differentiated types of iron.

The meaning is uncertain of Bīrūnī's reported claim in the final comment in this section of the chapter, that arsenic (*zarnikh*), most probably in one of several combined forms,[67] was used to modify the melting or solidifying properties of iron. The secondary processing of iron would seem to be indicated as this is said to be a treatment of iron. This cannot be an oblique reference to a variant of the crucible steel process because Bīrūnī makes it clear that only 'simple' (a single variety of) iron is involved. Cast iron is the metal being referred to, and it is the melting properties of this iron that, according to the claim, are modified by the addition of arsenic, in some form. Significantly the process is said to soften the iron and make it less white. Possibly this is a very early reference to the intentional modification of the properties of cast iron not known at least in the West until relatively modern times. Arsenic would have had the effect of reducing the melting point considerably[68] but is not known to have any very significant effect on what form of cast iron is formed on cooling,[69] although some additional additive or impurity may have been involved.

The wording of this claim suggests that central Asian cast iron in its smelted state

[66] Now in northwest Afghanistan, approximately 600 km (360 miles) west of Ghazna.

[67] Arsenic in one of several combined forms is possible here, the most obvious naturally occurring form of which is arsenic sulphide, well known from the Middle-East to central Asia as two early pigments, orpiment (As_2S_3), a yellow pigment, and realgar (A_2S_2), a red pigment – see Gettens and Stout, *Painting Materials,* 135 and 152.

[68] See Smithells, *Metals Reference Book,* Vol. 2, 408.

[69] At least not according to any metallurgy textbook I have been able to consult.

was usually white and hard. Cast iron takes two main forms when it cools, depending upon the rate of cooling, usually known as white iron and grey iron.

White cast iron is one type of hard iron that is clearly referred to in several places by both Kindi and Bīrūnī, and it is probable that this was the type of cast iron (low in silicon) usually formed by the relatively rapid cooling of smaller ingots/cakes/lumps produced by the smelting furnaces. Jābir ibn Ḥayyān's earlier account of cast iron smelting tells us that this metal was used in a variety of ways likely to have included the casting of domestic (and perhaps also decorative) objects, as well as being the raw material for crucible steel making.[70] White cast iron is not as useful as grey cast iron for casting objects because of the greater degree of shrinkage it undergoes upon solidification. Grey cast iron experiences much less shrinkage owing to carbon being present in the form of graphite flakes.

This claim suggests that, for specific uses like the casting of objects, a process involving arsenic for changing white cast iron into grey cast iron may have been developed in central Asia. As Bīrūnī is likely to have taken the claim from a written source, the chemists in question may have been operating earlier and further afield.

Compound iron: the making and use of crucible steel (fūlādh)

[252] Bīrūnī next explains another aspect of iron or steel production not covered in Kindi's sword treatise: that the compound of soft iron (narmāhan) and its 'water' (dūs) – white cast iron according to his earlier definition – is [crucible] steel (fūlādh). The white cast iron, with its lower melting point, is correctly reported as melting first. As careful observation of the contents through the central hole in the lid of a crucible being heated, or merely shaking the crucible with its partially liquid contents would have been insufficient and impractical, it seems likely that steel makers and iron founders tested this by heating the individual types of iron separately. Bīrūnī tells us that Herat was a centre for the production of this steel (fūlādh) and that it was produced in the form of eggs, reflecting the shape of the crucibles.

The extent of this regional production is unknown and Herat may or may not have been its centre. Bīrūnī suggests that Indian and other styles of sword were principal uses for this metal, but he gives no indication whether they were made close to the metal production centre, or whether the metal was exported to sword production centres elsewhere, including India.

Bīrūnī next goes on to describe how crucible steel (fūlādh) is of two distinct types depending upon its composition. This key piece of evidence reveals that fundamentally different types of crucible steel had been produced and used for many centuries. To make the first of these two types of steel the pieces of soft iron (narmāhan) and its 'water' (dūs) – which must refer to white cast iron – are melted equally, and the metal becomes so completely blended that the original constituents are indistinguishable. No surface pattern or watering ever appear on the surface of this

[70] See appendix 1 above.

first type of steel [however it is treated], so that it was incapable of producing a decorative pattern irrespective of how much the metal was forged out when making an object. Although writing without the benefit of modern knowledge of the properties and structure of different types of iron and steel. Bīrūnī speculates that this ('plain') first type of crucible steel [in its properties] has become like *shāburqān*, and that its state in some way is [also] the result of quenching. This non-patterned variety of crucible steel is likely to have been exploited for more utilitarian uses, specialist tools and the like, where a good quality steel was wanted but a surface pattern was not so important.

Of the second type of crucible steel Bīrūnī says that part of the metal present in the crucible does not melt completely and therefore remains separate; that this can be seen on close examination; that the resulting visible pattern is known as watering (*firind*); and also that each of the two different [light and dark] elements of the visible patterning is known or thought of as being of a certain colour. This was the type of crucible steel used for sword blades and other things where a watered surface pattern was desired. Sword blades where the background colour was thought of as being green were especially sought after and were [sometimes] described at length.

We can be fairly sure from the later mention[71] of the surface etching reagent (*zāj*), identified in 1232/1816 as impure iron sulphate,[72] that swords made of this type of steel were etched to bring out the surface texture and colour. Kindi's descriptions[73] of the colour associations of different types of sword blades do not explain exactly what was visible on these blades. To the untutored (modern) eye the patterns and background matrix are most likely to have appeared as different variations of light to dark grey to black, as in the case of many surviving post-medieval Indian blades. Possibly, to the expert observers of the time, the blades described by Kindi and Bīrūnī took on a slight but distinctive hue or tonality when viewed under certain lighting conditions.

Some swords (made of crucible steel) and their attributes and origins

[253] Bīrūnī gives examples or attributes of a few of the swords made using the second, patterned type of crucible steel. He had previously emphasised that swords with a greenish colour were sought after, and he now mentions that Yemeni and Indian swords had this characteristic,[74] while those of another type, the Mashrafi, were thought of as white. Some and possibly all these observations have one source, a book on weapons by al-Bāhilī, in which the colour of the two elements of the watered pattern visible on a sword blade is said to vary.[75]

[71] See Bīrūnī commentary, 253 below.

[72] See Smith, *A History of Metallography*, 22; presumably this was formed by the natural weathering of iron pyrites, a commonly occurring iron mineral.

[73] See ch. 3, Kindi/Zaki, pp. 23, 27 and 30, above.

[74] And we know from Kindi that these were thought of as two of the three highest quality swords.

[75] On al-Bāhilī (d. 231/855) – see n. 16 in this chapter.

Grooved swords (*mushaṭṭab*) are mentioned as are other types, including the Surayji (named after a smith according to Bīrūnī), notable for their bright [surface] finish; the Qalaᶜi swords (their source and the derivation of their name being speculative[76]); and the Qasāsi, taking their name from a mountain with an iron mine; Bīrūnī is unsure of the origin of the Mashrafi type, linked either with a series of villages in an area called Masharif, in the Mazālif region, or a pre-Islamic smith called Mashraf.

Little if any of the information on the sword types named in this section can come from Kindi where the Mashrafi, Surayji and Qasāsi types of sword are not mentioned, nor the grooved swords (*mushaṭṭab*) similarly discussed. The Qubūri swords next mentioned by Bīrūnī must be the same as the Qabūriyya form of Yemeni sword discussed in greater detail by Kindi,[77] because of the puzzling presence of 'veins' of soft iron (*narmāhan*). Bīrūnī's discussion is sufficiently different from Kindi's to suggest that his information comes from a different source; al-Bāhili's book on weapons is perhaps the most likely candidate.

Judging from pre-Islamic poetry, several of the swords mentioned in this section were well known in that era. The most likely source for the Mashrafi swords[78] seems to be the Syrian mountain district of Mashārif,[79] as suggested by Bīrūnī (or his source). A pre-Islamic smith may have taken his name from the same place. Bīrūnī reports that the Surayji swords took their name from a famed sword-smith of that period;[80] their place of origin is unknown although central Arabia has been suggested.[81]

The final sword mentioned in this section, the *muhannad*, is also not named as such by Kindi but is mentioned in pre-Islamic poetry and can be identified as one of the types of swords made in the Yemen. Bīrūnī was uncertain about the *muhannad* swords and suggests (from the written sources he is using) that they are likely to be Indian in origin but reports that a Sri Lankan origin has also been claimed. A literal translation of *muhannad* is 'Indianized', which has been interpreted as meaning 'a sword forged with Indian techniques', but Jawharī (d 398/1007) tells us that what is actually meant is 'made of Indian steel'.[82] This observation confirms what Kindi tells us when he says that some of the swords forged in the Yemen were made in Yemeni style but using crucible steel (*fūlādh*) imported from India and Sri Lanka. Given how loosely the term 'India' appears to have been applied during the first millennium AD the steel for the *muhannad* swords may have come from either India or Sri Lanka, or possibly even further afield,[83] but probably material was being landed at one of the Yemeni ports

[76] See Bīrūnī commentary 248–250 below.
[77] See ch. 2, Kindi/ Zaki, 17 and 18.
[78] Ch. 4, Schwarzlose, 131.
[79] Situated approximately 90 km (55 miles) southeast of Damascus, near the present Jordanian border.
[80] Ch. 4, Schwarzlose, 132.
[81] Ch. 4, Schwarzlose, 132.
[82] Ch. 4, Schwarzlose, 128.
[83] See Bīrūnī commentary, 251 above; and ch. 2, n. 9 above.

which formed part of the Sasanian (controlled) maritime trade with the coastal regions of the Indian subcontinent.

Yemeni and Indian swords were assumed to be of high quality. Kindi recounts in much more detail how Yemeni swords – the term referring to blades made in the Yemen of (relatively) local steel – were still considered to be the best in the early 3rd/9th century. Bīrūnī's reference to the Yemeni and *muhannad* swords when taken with Kindi's more detailed discussion plus the references from early poetry, combine to create a strong impression of how highly regarded the Yemen was as a sword-making centre, and perhaps also for steel, certainly in the later Himyarite period (5/6th centuries AD) and possibly earlier. Although its heyday may have been in the immediately pre-Islamic period, it seems from Kindi's description that the Yemeni industry may have survived for several further centuries. Possibly the industry declined either after the demise of the Himyarite dynasty in *ca.* 577 or following the cessation of direct Iranian rule with the assertion of Muslim control over this region in *ca.* 8/630, and the consequent northward shift of political (and economic?) emphasis.

The watered pattern on sword blades (made of crucible steel)

This section follows on from the series of examples of swords made of crucible steel (*fūlādh*) outlined in the previous section, and explains more about the watered pattern that this type of sword was known for, and how the finished blades were treated to bring out these patterns. However the source material Bīrūnī is using to illustrate this appears to be completely different as he now quotes practices that were relevant to the region stretching from north-east Iran to north or north-west India, as well as giving the impression of reporting nearly contemporary information, whereas the previous section was illustrated with a group of swords apparently belonging to the pre-Islamic production centres of the Yemen and Syria, some five centuries earlier. Perhaps he illustrated the points he was making from a variety of written sources.

Bīrūnī now gives apparently contemporary and possibly orally transmitted information peculiar to the Ghaznavid region of influence. He reports that the watered pattern (*firind*) is known in Khurasan (north-east Iran) as *jawhar* (literally jewel) and he says that 'it may be hidden by heating and polishing'. Maybe there is a copyist's error here as he should have said that the pattern 'remains hidden during heating and polishing' especially as he goes on to say that the iron sulphate etching material (*zāj*)[84] is used to bring out the pattern. His comment, that the 'yellow' etching material (*zāj*) from Bamyan[85] is exported to Multan and used there as well as the locally produced 'white' etching material, and therefore the Bamyani variety must be superior, shows

[84] *Zāj* was analysed in 1232/1816 by Jacquin who found it to be a naturally occurring impure basic ferric sulphate, and ferric sulphate was subsequently confirmed as the active ingredient in analyses by De Luynes and Zschokke – see Smith, *A History of Metallography*, 22–23.

[85] Bamyan is 150km (90miles) north-east of Ghazna, and approx 600km (375 miles) north-east of Multan; this material was presumably transported across the mountains via the Khyber pass to Peshawar, and then down the Indus to Multan.

that different varieties (and compositions or mixtures) of etching material are likely to have been used and favoured in different areas.

He next briefly describes a process of partially protecting the steel of the blade from the full effects of quenching using a clay-based paste, a process similar to that used by traditional Japanese sword-smiths who selectively quench a margin of the blade along the cutting edge, which remains much harder than the rest.[86] The thickness of the clay paste applied to it would have varied, either across the whole blade or along the margin of the cutting edge, depending upon the desired degree of quench, with a thinner coating allowing the effects of quenching to be more marked. Bīrūnī says that the paste consisted of a mixture of clay, cow dung and salt, and that iron sulphate (*zāj*) could also be mixed with the salt as an etching agent.

As usual Bīrūnī has been brief, including nothing about the application of the etching material (*zāj*) to the blade, nor, where he says that the 'iron sulphate can also be mixed with the salt', clarifying whether the etching agent was mixed with the paste before quenching, or whether the salt was mixed with the etching agent to be applied to the blade after quenching.

[254] Bīrūnī discusses properties of the steel responsible for the superficially visible watered pattern (*firind*) and perceives (or repeats) that the cutting power is due to the presence and hardness of white cast iron (*dūs*); this explains the tendency of these blades to break and crumble.[87] This follows on from the definition of the second type of crucible steel (*fūlādh*), in which the main ingredients in the crucible (pieces of soft iron and hard, white cast iron – *narmāhan* and *dūs*) do not mix completely, but rather remain separate, allowing two colours to be distinguished on close inspection.

Bīrūnī effectively interprets the white elements of the watered pattern as being undissolved particles of white cast iron, for he goes on to say that if the soft (female) black iron covers the black on both sides (which it can be seen to do in an interleaved watered pattern) the problem of brittleness is avoided. In other words, the hard pale elements of the watered pattern result in a hard sharp edge to a sword blade, while the soft dark elements prevent the blade being too brittle.

Bīrūnī has correctly surmised that the dark background matrix of the sword blade (in its final etched state) is the softer and hence much less brittle element of the blade, embedded in which is the very hard but brittle constituent, producing the pale portions of the watered pattern (*firind*). Perhaps reflecting views current among crucible steel-making specialists at that time, he concludes that the crucible steel (*fūlādh*) is an inhomogeneous mixture of *narmāhan* (soft or female iron) and *dūs* (white cast iron,

[86] See Kapp and Yoshihara, *The Craft of the Japanese Sword*, 85–86.

[87] Most likely during forging, a problem that was noted by later European observers when they reported on the difficulties of working this steel, which had to be done below the usual forging temperatures employed by Western smiths. For instance Moxon noted in 1088/1677 that 'it is most difficult of any steel to work at the forge for you shall scarce be able to strike upon a blood red heat, but it will red-sear' (ie is brittle when red hot and will crumble unless the temperature for forging is kept below something like a dull red heat); see Moxon, *Mechanic Exercises*, 59.

referred to as water of iron), and that these are the two primary constituents processed in the crucible.

With the benefit of modern microscopy it is now known that, although Bīrūnī was broadly correct, the constituents of the watered blade would have been slightly different. The crucible process left the dark background as a steel matrix in which were embedded the pale elements to the pattern, consisting of very hard iron carbide (cementite). The study of later blades has shown that iron carbide did not take the form of brittle flakes as envisaged by Bīrūnī, but fractured arrays of cementite particles that appear solid to the naked eye on the etched surface of the finished sword blade.[88]

In the final part of this section Bīrūnī goes on to describe the diverse appearance of watered patterns, only detectable with difficulty before etching.

Pattern-welded swords of the Rūs or Vikings

A brief description is given of the manufacture, by the Rūs or Vikings, of pattern-welded swords. Vikings gained control of the eastern Slavic areas sometime after the late 3rd/9th century,[89] so swords much nearer his own time must be referred to. These swords are described as composite blades with edges of hard, or male, iron (*shāburqān*), which we know from Kindi's definition means, at least in this case, directly smelted or bloomery steel.[90] Bīrūnī reports that these swords had a central pattern-welded part forming a wide channel or fuller, running down the blade, made of soft iron (*narmāhan*). This composite design ensured that the blades would be tough and able to withstand being struck, unlike those made of crucible steel (*fūlādh*), which he says were prone to snap in the extreme cold of the Russian winters. The very high carbon content of the crucible steel used to make the blades was no doubt the reason. The problem of steel being prone to brittle stress failure in cold weather has been encountered more recently, and the effect is now known to increase with carbon content.[91]

Bīrūnī reiterates the (possibly widely held) view that pattern-welding was like a web of stretched threads made of a mixture of hard iron (*shāburqān*) and soft iron (*narmāhan*), a viewpoint which is technically correct[92] now that it is understood how the pattern-welded parts of the best Viking-period swords were made. Recent research shows that, for several centuries up to Bīrūnī's time, the pattern-welded parts of

[88]As illustrated in Smith, *A History of Metallography*, fig 12 a and b. The formation of this inhomogeneous layered structure has also been discussed in detail by Prof. John Verhoeven and reproduced by his colleague Al Pendray. See especially: Verhoeven *et al*, "The Key Role of Impurities", 187–200; and Verhoeven *et al*, "Wootz Damascus Steel Blades", 9–22.

[89] See Gorlick, "Arms and Armour in South-Eastern Europe", 144.

[90] See ch. 2 and ch. 3, Kindi/Zaki, p. 5, above.

[91]See Reed-Hill, *Physical Metallurgy Principles*, 783–786.

[92] Given that phosphoritic iron, one of the standard components used, with low carbon iron, for the pattern-welded parts of these sword blades (see Gilmour "The patterned sword", 117–118 and fig. 8); and also given that phosphoritic iron can be, as defined by Kindi, can fall either under the category of 'soft' iron (*narmāhan*) or 'hard' iron (*shāburqān*) depending on its phosphorus content.

western European swords consisted of laminated bars with alternate layers of low carbon (or plain) iron interleaved with layers of phosphoritic iron, steel not being used at all in this part of the blade.[93] Low carbon (or plain) iron is simply soft iron (*narmāhan*) whereas phosphoritic iron can be viewed as soft or hard (*shāburqān*) depending upon the phosphorus content.[94] Phosphorus affects the hardness as well as giving the iron very pale etching optical properties.

Bīrūnī describes these blades as having a watered pattern, but he clearly knew less in detail about their manufacture and how the pale/dark pattern was produced than for those made of watered crucible steel. He was aware that two different types of iron were used and he states that the pattern-welded parts were welded together, but inaccurately speculates that 'welding by immersion' was used.

A possible lacuna follows. Bīrūnī may be contrasting the formation of the watered pattern during the forging of a sword made of crucible steel (*fūlādh*) with the watering on the pattern-welded swords of the Rūs or Vikings, designed and intentionally produced by welding, but a section of text seems to be missing.

Crucible steel and forging methods used for swords in northern India

Bīrūnī next provides invaluable details of apparently contemporary northwest Indian swords and the crucible steel from which they were made. The best steel was considered to be *palārak* and was used for the most expensive swords and daggers. The iron used in the manufacture of this steel was smelted from red sand in the region of Kanūj on the upper Ganges in north India, and the crucible steel (*fūlādh*)[95] made from this iron was produced by melting it with crystalline borax.[96] No carboniferous ingredient is mentioned, which may imply that two different kinds of iron, both smelted in the Kanūj region,[97] were the main ingredients mixed with borax to make this steel. This would fit with the overall impression obtained from Bīrūnī's iron chapter, that crucible steel in northwest Iran to northern India was made by combining soft iron (*narmāhan*) with white cast iron (for which Bīrūnī uses the term *dūs*, a sub-variety of *shāburqān*).[98] This type of crucible steel produced both sword and dagger blades in which the white element in the watered pattern (here referred to as *jawhar*) was more pronounced than the black.

We can gauge the likely antiquity of the crucible steel-making tradition in this central northern part of India by a mention in the *Shāhnāmeh* of watered steel swords

[93] See Gilmour, "The patterned sword", 113–121.

[94] See glossary in this volume, and especially Fig. 20, which shows the type of construction and iron types found recently in a group of 6th century AD Anglo-Saxon swords.

[95] The comparison with the egg-shaped ingots from Multan indicates that crucible steel is meant, which we would in any case expect from the context.

[96] Presumably added as a flux to help separate and remove unwanted non-metallic waste products.

[97] Kanūj was an ancient city visited by Bīrūnī, probably in *ca* 410/1020 following the Ghaznavid sultan Māhmud's military campaigns in North India; see 254 and n. 20 above in this commentary.

[98] See Bīrūnī, *Jamāhir*, 248–250 above, both translation and commentary.

included among the gifts accompanying an embassy sent by the Rajah of Kanūj to the Persian emperor Khusrau I Anūshīrvān, sometime in the mid 6th century AD.[99] The Kanūj region would have been familiar to Bīrūnī following its invasion in 408/1018 by his patron Maḥmūd, the Sultan of Ghazna.

As in Kindi's treatise the Indian sword types appear to be ranked in order of quality although Bīrūnī is less specific than Kindi about this. The second variety, the *rūhīnā*, was made (somewhat more locally) in Multan using egg-shaped ingots brought from Harawi, possibly a district in the mountains near Qandahar.[100]

The third type, the *mūn*, was forged in Multan, apparently using Multani steel ingots. The swords made from this locally produced third type of steel were themselves divided into three categories, the best of which were called *amrānī*. These had the finest watering, closely comparable to the *palārak* swords from Kanūj. The middle type of sword made from *mūn* ingots had watering of intermediate character, neither fine nor coarse; these are not named specifically. The third type of *mūn* sword, with the coarsest watered pattern, is referred to as *ḥarmūn*.

[255] Bīrūnī says that Yemeni swords resemble these Multani swords, but he is not specific about the closeness of the comparison. The other varieties of sword discussed are judged by characteristics of the watered pattern showing on the surface of the blade. Therefore he is probably referring to the watered pattern characteristic of the Yemeni swords and their similarity to some of these Indian swords, at least to one of the *mūn* swords. The comparison of Indian swords with Yemeni swords is instructive. Kindi's treatise shows that Yemeni swords had long provided a kind of benchmark of excellence for observers with a Middle-Eastern or Iranian viewpoint.

Bīrūnī mentions that a black kind of Indian sword, the *nīlah-bānd*, resembles at least one of these *mūn* varieties of sword; perhaps a black background matrix was the dominant feature. Their origin is not discussed.

Another type of Indian crucible steel blade was the *bākhirī*, which similarly to those from Multan, is divided by Bīrūnī into three classes. First is the 'original' kind, by implication the best or 'real' *bākhirī* swords, the type-swords. These are said to be very similar to the *rūhīnā* type, the second best are the Multani-made swords of this kind, those made of imported Harawi egg-shaped ingots. A second class variety of *bākhirī* sword is referred to as *mukhawwas*, so called from the resemblance of the watered patterns on their blades to a palm leaf-like woven pattern found in particular type of cloth called *saqlātūn*.

Bīrūnī now gives some invaluable information about the forging of the crucible steel ingots used to make this *mukhawwas* variety of *bākhirī* sword blade. This is the only description of the forging of steel ingots anywhere in his iron chapter; Kindi does not describe the forging of steel ingots at all in his sword treatise. To achieve the palm-leaf variety of watered pattern, the egg-shaped ingot was not forged lengthwise

[99] A list of exotic gifts that included a chess set (Rabb, *National Epics*, 227; Levy, *The Epic of the Kings*, 327.)
[100] Situated now in Afghanistan, about 580km (350miles) west north west of Multan.

but was struck on its head so that it spread out like a disc. The disc was heated to forging temperature and (one side was) fastened in a vice. The disc was cut into and (the cut part) straightened out to produce a rectangular bar, which was then forged into the desired shape of the sword blade. Some parts of this original description may be missing due to scribal error, but what seems to be implied is as follows: that the disc was heated up, laid flat on an anvil and cut into the shape of a spiral using a chisel, then the disc was heated up again, fixed in a vice and outer part of the metal of spiral straightened out. Because of rapid heat loss this could only have been done a bit at a time and the procedure repeated as necessary to leave a more or less straight bar.

The last kind of *bākhirī* sword reported by Bīrūnī had no watered pattern at all. Unlike the other two types of *bākhirī* sword blade, these plain blades are not given a name. Although Bīrūnī does not discuss the sources of these, the great variety of production suggests it was done at a sword-making centre comparable to Multan; very likely crucible steel was also made there.[101]

Bīrūnī mentions a final plain or non-watered kind of Indian sword, the *majlī*, said by him to resemble the third type of *bākhirī* sword, but distinct in that the blade although not watered was decorated with images of animals, birds and sometimes people, presumably engraved or acid-etched onto the surface. These *majlī* were of two kinds, with images confined to one side of the blade, and with images on both sides. The latter were apparently the most valuable – being worth as much as a good elephant – with the ones showing people being the most expensive of all.

Characteristics of other decorated or watered steel swords and their manufacture

Bīrūnī now abruptly mentions two much earlier named swords that must both be pre-Islamic; their context suggesting they were made before the late the 6th or early 7th century AD, the blade of the first of these being decorated with the image of a fish. This sword had been owned by the famous warrior poet ᶜAmr b. Maᶜdikārib (d.21/641), whereas the other sword seems to have been a comparable weapon, possibly with a blade decorated in a similar way, this sword having been selected by the Prophet Muḥammad before the Battle of Badr (in 3/624).

He next states that everything else (?all other kinds of swords) made of inferior iron – perhaps poorer quality crucible steel – is classed as *kūjarah*.

At the end of this section on watered blades a curious feature is mentioned, a black-coloured blemish that appears on these blades. Depending on how it showed up on the surface of the blade it was apparently thought of as lucky or unlucky, but it certainly seems to have been thought unlucky to try to remove it.

[101] We have not managed to locate this as yet but the description suggests that Bīrūnī was very familiar with these *bākhirī* swords, and therefore it seems most likely that they came from somewhere in north or north-west India, in one of the regions visited by Bīrūnī following their subjugation by his patron, Maḥmūd.

[256] What this blemish might have been is not made clear, but possibly it was a flaw inherent in the forging of a sword blade from a single steel ingot or cake, something described by Captain James Abbott who witnessed just such a procedure in what is now north-east Pakistan in the early 19th century, at Jullalabad, near Lahore.[102] Possibly in order to judge the quality of a sword forged from one of these steel ingots, it was felt necessary to be able to see the flaw, and therefore judge how well it had been integrated into the blade. A flaw like this in the wrong place could seriously weaken a sword blade with potentially fatal consequences for the owner.

The making of watered crucible steel and the forging and qualities of swords made from it

Bīrūnī now makes a single reference to Kindi's treatise, reporting that it incorporates material from an earlier book by Mazyad ibn ʿAli, the Damascan smith. This book evidently covered the whole process of watered crucible steel sword manufacture, beginning with the building of the furnace and design of the crucibles, and including the specific types of clay to be used, as well as recipes and procedures for the making of the steel ingots used in sword production.

Bīrūnī now quotes one of Mazyad ibn ʿAlī's recipes for crucible steel (*fūlādh*). Here the source of carbon is plant matter, myrobalan[103] and pomegranate peel.[104] Once all the ingredients have been placed in the crucible then the lids were luted – Bīrūnī says plastered but a clay paste must be meant here – onto the top of each crucible.[105] The firing time – when the bellows were applied – is given as one hour, very short compared to the 4–9 hours given for comparable southern Indian crucible processes witnessed by Buchanan in 1217/1802.[106] The horseshoes and nails used in this presumably early Syrian process recorded by Mazyad ibn ʿAli are therefore likely to have been cut or filed into small pieces to ensure that they achieve the degree of carburisation necessary for the metal to melt. The crucibles were left to cool once the bellows ceased and the fire in the furnace died down.

This description must antedate Kindi's treatise of 217/833, but it is difficult to gauge by how much. Kindi does not name the Damascan smith but he implies[107] that Damascan swords were much older, either relating to the Umayyad period when Damascus was the centre of the Caliphate (40/661–132/750), or possibly from the pre-Islamic (6th century) era when poetry and Bīrūnī's earlier source attest that the Mashraf area of Syria[108] was a steel and sword-making centre.

[102] See Abbott, "The working of the Damascus Blade", 417–423; especially pl. 9 (opposite p. 419).

[103] The plum or prune-like fruit of an Asiatic tree, commonly used in tanning and dyeing.

[104] This is evidently an ancient process and is similar to that described by Zosimos for the Alexandrian region in the 3rd century AD, in which date skins and similar carbonaceous matter were used in the crucible process described there – see Berthelot, *Collection des Anciens Alchimistes Grecs*, 332; and also Allan and Gilmour, *Persian Steel*, 46, n.34 for an English translation of this recipe.

[105] Similar perhaps to the examples found at Merv – see the reconstructed transverse section in Fig. 16.

[106] Buchanan, "*A Journey through Madras*", 119–123.

[107] See ch. 2, Kindi/Zaki, p. 35, and commentary thereon in ch. 3.

[108] The area now in modern N.E. Jordan/S.E. Syria.

Bīrūnī returns now to local more contemporary practices, recounting information from an observer of sword-making in Sind; although the precise place is not named, Manṣūra, the principal city and sword-making centre named by Kindi, must be a strong candidate. The observer was unfamiliar with the process and the report Bīrūnī repeats is somewhat unclear. Nevertheless it is still a rare eyewitness account of both the making of the steel cakes or ingots and the forging of the swords from them. Kindi reports that swords forged at Manṣūra from imported Sri Lankan steel[109] were the 'least yellow' (and best) of the swords made there, revealing that swords made of other steel were made there too, although nothing else is known about them except that they were more yellow and therefore of not such good quality.

Bīrūnī's informant seems certainly to have witnessed the making of a batch of egg-shaped crucible steel ingots made in Sind, and the forging of a number of swords from the ingots produced. It would appear that these egg-shaped ingots were comparable to those made in the contemporary crucible steel making centre at Herat. In this case the crucible steel (*fūlādh*) was made by the alternative method to the one associated with Mazyad ibn ʿAlī, this time by the mixing of soft bloomery iron with white cast iron (*dūṣ*) to produce the steel with the required carbon content. Although the crucible steel making process linked to Mazyad ibn ʿAlī involved the mixing of soft iron with carbonaceous plant matter to produce the steel, the ingots that were broken out of the crucibles in this much earlier Syrian process were also egg-shaped.

In the final part of this section it seems likely that Bīrūnī is referring to Kindi's sword treatise, which reported an earlier belief that a sword by its nature cannot be changed from one type into another, this being the reason that the ancient types were held in such high esteem. We know from Kindi's treatise that 'ancient' had a subtly different meaning from 'antique', signifying a classic contemporary style as well as one made earlier.[110] Kindi explains that to qualify as a particular type a sword had to be made in the correct way, in the right style and using the specific crucible steel of the place or region giving its name to the type, and he reports various fraudulent attempts to pass off a less well thought of sword for one of the more valuable ancient or best types.[111]

[257] Bīrūnī may have been getting his information from another source as well for he goes on to say (in so many words) that, while he is willing to believe that a sword of one type could not be changed into another, the ingredients of the steel could be changed [in the crucible] so as to produce different watered effects, revealed by final polishing. It would appear from this that crucible steel was sometimes returned to the crucible, perhaps on occasion with the specific intention of modifying the watered properties that a sword blade made from the steel would have. Although Kindi does not discuss it specifically, we might expect the re-melting of crucible steel pieces,

[109] See ch. 2, Kindi/Zaki, pp. 29–30.
[110] See ch. 2, Kindi/Zaki, pp. 7–9.
[111] See ch. 2, Kindi/Zaki, pp. 22–23, and 26–28.

perhaps as the recycling of scrap from broken swords and tools, to have been done from well before his time. Sometimes this could also have involved the addition of something else – say the addition of some pieces of white cast iron to modify the watered pattern. From time to time this could have been done with fraudulent intentions, but this remains to be confirmed from early written sources. In any case as Bīrūnī points out, the watered pattern would vary depending on how much of the surface of the steel of a sword was removed. His use of the term peeling here may imply the use of something like the (two handled) hardened steel-edged draw-knife (*sen*) used by traditional Japanese sword-smiths to shave off irregularities before the final finishing of a blade.[112]

[112] See Kapp and Yoshihara, *The Craft of the Japanese Sword* , 84 and figs 75–76.

Appendix 3

The Manuscripts

LEIDEN Or. 287

وكلما نعمل من نظام ،، في زمان الناصر الامام ،، خلعفه الله ابي العباس ،، ابراهام السمي في الناس ،،
وفي زمان الملك المسعود ،، السرار الا امل المجد ،، وذلك عام اثني وعشرن ،، وستمانة للهجرة الحبين ،،
بصلوه الله طول الدهر ،، ماكر يوم عابر مشهد ،، على النبي المصطفى مين ،، في كل وقت وزمن وروض الدين ،،
والموحد الابرار ،، والناصر يعرف في الانار ،،

الباب ____ السادس رساله يعقوب بن اسحق الكندي

الى بعض الحلفا في جواهر السيوف

مرونا الامام الا رشم اوصاف السيوف بقول يعم اجناسها ،، وفرزسمنع كداي هذا
جميع الفراسات الا شفه عن اسرارها والمجتهد في علم احناسها والقاطع والكلاصفا مقدر
ما لعنه على اخاط به وكوي الجردا الذي يطبع سه السيوف سعم شمل لور لس الى المعرى والى
الذى ليس يعرى والمعدى يسم شمل الى السارفاى وهو المذكر الصلب العا بل للسعي يطبا عه والى
البريا هروهو الموثت الرخوا الذي ليس يثبا بل للسقي بطباعه و فر بطبع في كل واحد س هذا الذى فرعوردا
وسهما معا مركب جميع انواع السيوف المعرفة مثله السارفاونه والرما هنده والمركبه
منها وسيغرفها وعا وعا وا دى على ما برم الحاجة البيامى وصفها في موضع ذلك كما ما الجرديد
الذى ليس يعرى فهوا هولا د ومعناه المصفا وصنع من المعرى بان لى عليه في السكى بصفنه
وسد رخاونه حى يصر مندا اله ناصل السقى وطهر فيه وزبد ،، وهذا الفوا اذ يسم ثلثة اقسام
الى العسو والمحدث ،، ولا عسو كلا محدث وكذلبطع من هذه جمعا السيوف ،، فه ،، وانواع السيوف والبرا الذنه
اسه عسق ،، ومحدث ،، ولا عسق ولا محدث ،، ولم ندهب عنفها الى الزمان لا عسفا مطلفا لقال
اذا فصديه الزمان الا الى الجد معسرا اما اول الا سبا فط ولا ول واحد فى كل مسرا صعه واما
كل واحد من لها سبا اذا اصيف الى ما هو احدث منه فحد ادا ان نكون كل سى على بعده سو احر خفا
ان نسم عنفا ولسا العسق من السيوف سفه واحدا لا ما هو وذهب من عمها الى الكرم كما
نقال ورس عسق مرا دبه كرم ما الحفته جواص الكرم فهو عسق في اى ج د هرصنع والطو والا بعد
من العسق هو صفره والمعلا معى ما عدم حوا صرا العسو مه ولذلك سمى محدثا ،، وان كان دطبع مثل
زمن عباده ،، واما الا خذه بعمزجواص العسق وعاد مه بعمز جوا صه وجدت بها بعمز خواص
المحدث سميت هذا باسم منوسط سر لا اسمين يقال لس عسو لا محدث ،، و انا ن معا دم الزمان
اوحدنا واحبار الصا ياوله لها اسما لا عسفا ولا محدنا في بعضها ،، ولذلك وفع هذا الامهر من الجرديد
المعبر اعنى العلا دا المعدى الذى لم يمرح سى يعمز كالسا برفان والرما هن لو ظل سعق
اسم العسق بالزمان لكان ة السارفان وانه الرما هن ماطبع مد زمر و يم الزمر العسو والمحدث
بالزمان المحدث ،، ولكى لما كان السا ربان والرما هن معا د نه واحده عيرمعيه سفا صل مهنه
ابطع على جواهرما سا عير ها الى الجوده والرد اذ لم يسم منها شى ة عسفا وا لجرديا بل سما سى هايها

إما شابرقان وأما برما هرنه والعسق يعمى ثلثة اقسام أوّلها واجوده الايمان نا مها القلعى
ثم ثالها الهندى وهو المسمى الفاذروب وإما الى ليس تعسقه ولايحزه فعقم قسين للحدد هرا النى
عند الصابله عبر مولدر وهى سيوف تطبع بايمن من الحديد السيزندى والسليمانى فقلاغ عبر مولد السلمانى
وعبر مول لر السريذى سمى المغنو قه لا بها بعمل المسرنيدى والسلماسه الصعار اعوا الروانف
العودد فعنو عرصها اعى بعرض حكى ها الايمان يسى معنو قه وقد سمى هذه المصو فه الا ولى من
العارو ف لا بها اول السيوف فى البرس مرتبه تلى العسق على وجه كانه صر ها عنقى وهى اول
ما يحكى به الحمالى من السيوف ف، والقسم الاخر المسى عبر عسق وهى السلما نيه يعسم أربعه أقسام
سها البهالخ وهى سيوف عراض كون السيف يمها عرضه اربع اصابع واكثر ويد ها علط هذا حدرا
ف يمها الرنوف، وهى فى العرض اربع اصابع وأقل من ذلك ومرا الصعار وهى سيوف دا فى العودد
فاذا فعت حكى وبرد ها فزيد العنق يجرح بعضها سبه ويد الهمانى وبعضها أنسبه ويد القلع ونت
الصابله كل واحد رمنها الى سبه رمن سما اسباوها ومنها أما يطبع بتليمان والسر نز يسه
يعسم أربعه أقسام منها التى يطبع لسر بديب ومنها الخراسانيه وهو ما يحمل من سر بديب وغمل
حديره لحراسان ومنها المصوريه وهو ما يحمل حديده من سربديب وطبع بالمصوره ومنها
الفارسيه وهو ما يحمل حديده من سربديب وطبع بما زس سمى الخشترواينه والخشترواينه ينقم
يعسين سها ذوات نما ثل و بجر وعبرد لك من الصود و منها السواإدج والبيص يعسم يسين منها
الكوفيه طبعت بالكوفه وهى المسماه الزيديه طبعما رجل يقال له زيد ومنها الفارنسه فاما المولد
يعسم حمسة اقسام منها الحو اسانيه وهو ما يحمل حديده وطبع لخراسان ومنها البصره وهو ما
عمل حديره وطبع بالبصر، ومنها الدمسقيه وهو ما يحمل حديره وطبع بدمسق وربما ومنها المصرى
وهو ما يطبع بمصر وقد يطبع فى مواضع عبر هذه وعبرد لك من الموا ضع القليل فلا ينسب البها وهذه جميع
اضناف السيوف المذكوره من الحديد المعمول اعنى المولاد فاما الحديد المعدنى فانه ينما هكا ذكرنا
الشابرقان وهو المسمى الذكر من الحديد والبر ما هن وهو المستى من الحديد وقد يطبع من الذكر سيوف
وهى سيوف ما يسه سكر سرنعا اذا فت القب الكرايه ونسع فى لحم الا انها لاسوى سنها ان الذكر
من الحديد يكون فيه عروق لنه ربما هن وقع فى شفار ها فكثرا اولا نقل هذه العرو ف النى ينى يعنيش
عند العرب فاما ما هل يمها السنى يعسر عزو يها اذا فت الكرايه وانكر وليس لها ذا حفرات
يطبع منها الاجاهل يها وضرورته فى موضع لا يمكر فيه عبر لحديد الذكر وهذه السيو ف
لا نه فريد لها فى طرح ولا عبره وحدر ندر ها كا لها لوث واحد وهى حاسيه لا يستنا ولا ينهز ولا اصفا
لحديرها ولاما شرورية السر يحملقه الشفار مواضع حشنه ومواضع لينه وقد يطبع من البرماهس
سيوف يعذ هذا الروم والنراه واما المركبه من با برقان وبرماهن ويعسم يسين يمها
الفرغيته ومنها السلمانيه وحواص العسق الذى بعصله من افى هو الا اكبار والمانه واللرانه

مام نجما علمه السقى ودسرة الصقاله وصفا الدكاسير ومملها بى المباض وحمزه حماها دنوبالها الجما البجاس
وبماله وجحوده العرند و تعقده واسوا العرند فى كل السمف لا لون لبعمه دفاق طوال و بعمصه
طوال علاظ و بعصه دصازد دفاق بلمساوى فى وفزوس مرالساوى و فهاعقد صعاز كالعلل كعقد
و بد الحنشب وسا بز بحمه مراصعها التى رشمها فيها اصلح وابزوكذلك رسم وحمع معابى هذا
المكاب دسما بكون اوصح واسهل فى فهمه وانحزج دلاعزطها على ترتيب السمم التى فدمت
الا خواصها دكرا بواعها دصادكرها عددذكرها وحواصكل واحدمن انواع العبق فاما
القواطع منها مز عبرحمه جواهرها بلاسكالها ومصارها اذا حادت مثوبها واسقوط سطوحها
و حنها وملم بكن بها موضع الحز من نطبره وعلط سعارها ماخلا سمل الحز فانه سمعى ان بحوب
الحدوفزسعره مزكل جانب فهذا اقطع السوف للكرامه فاما اقطعها المثاب والحم ما اسمعمت
به هذه الصفات جمعا ماخلا علاظ الشعزم فاذا از دهما اشفارا اقطع للحم والببا ب وسار الحمود ه
ماروسعاره واعدل المسفى عون على القطع فازسعدما از اسنرل سفارة عبدالحزابه
واما فزودكل لوع منها مسدركرها اذ ادكرما بها الحزواصه فانزع دلكعوا على معزفه
الواعها وازكارودمكل از سبه القبا مالفذ وحكى دعبدذلك العصر من الحديد والى علبا
على جال زبادة فى المعرفه باوباتها اذاادفى العدل الحدبدكان اصدوسهبادة واذا الحلقاقار الحدبد
اصدوسهبادة من العد اولا باب بحكم به وقد تسمعل البصافده مكانا سم العربى اسم الحدبد
بعولوز اذاكار طاهرا العرند انه لطاهر الحدبده فاماالا رض بهمو ها ازضا على جالها اعبى
الموصع من الحدبد الذى لا فربد فبه بعولوز احمرلا رضزولحمرلا رضزواكدرلا رض فى حدثى
دكما بحصراا نزل اسفل الحدبد اصدر الحدبد او عبدذلك مزصفا بحدبد اصفه الى النبف
فاما اعنى العرند واذا ادلت دبل الطرح اوبعد الطرح فاما اعى الدوالذى بلح علمه اعبى الدوا على
الحدبد لبطهره له دربد واذا ادل والسمف احمرفانماا عى المجلى الذى بلم بطرح علمه دواقان
الصافله سمى هذا الدوا الحلا لا جمزه وا ما اسمعمل هذه الا سمالك دوز بعسبرها العرف
معا بنها فى الفاظهم لها بلا بعب عمل عز امرها شى انشاالله نعالى **البما** نه حزو مسبطبل
معزح متسا وى العقد لبس بعص العقداكبرمن بعض اسفل الجوفزاحمرلا رضزلحصرو الطرح
على وفزشبه بوسبله انكصعازدفاق مصزه منال الدرود سلوبعصه بعصا وبماصزالعصه ولانك ابا فى
السمف سفز سل الدرود الفد اربع فزودج وهى حمسه فزود السمف التى طبعت بالمبز منها العربص
الاسفل الحزواطرافراس المربع السما بز برسعا فمز وطلا الطرف السما بز واكرما بلوز مزعلاما ب
سبلا با ب العقق التى طبعت فى الجاهلبه نفبر بشبنبك وبعب السنك مزاحد الحمسه او سع
اوحمبصه مساو لبزو سطه او صفى و دبه اربع شطب منها المجهوز وهو الذى شطبه سببه
بالانهاز مدوره الحمره وهوا الذى سمى ابرر دكدح ومعناه الموقع فبه الشطب الحمرال الكوبز

و معنى الدوير المبرد المدور الذى حصرنه و هو الذى على ضبع الصمصام و منها الذى ببسطه اذا
ذا اشكلت و هى شطب زو ايا مر بعد من داخل السطب و تكون هذه السطب مننا و به بوجه السيف
و لسمى شها داس و منها و ثلثه شطب واحده فى الوسط و مسان فى السمرين و هى الى سمرد است
و هذه تسمه الحامله و اشكال هذه على ما فد صورنا و على هذا السكل صوره الصمصام ٥

واكثر ما يكون منها معرض عليه اصابع

مامه و اذا ما دكوب منها اصعار و نصف و هى المخفاف منها المتوررة مدون سوادح لا بسط
بها اكثر من طلب و رطلن عبر بع و هذه الحافات المتورره مدون سوادح لا بسط فيها محلقة على
الطول ما بين اللنة الاسبار او اربع اصابع الاربعه اشار فاما مروها على هذا الطول محاف ان
معضل اور ايها و اما العراض و يكون طولها ملة اشبار و نصف و ملوزدر او رايها ما اس ارطاس
و نصف الى ملبه لنطا لعبر بع و الذى فده منها ملنه عبر بع مفرط به الفد و دسبدون الالنوا و ا ما
بركمفط ربه بخافه از بدخل المار فمعض اور ايها و ا ما ا تما بقا با و را ايها و لا يحا دلسلم الفاينه
مر العروف و المفنوح هو الذى به سواد اى البوست و هو العشر و درو ضع على العرق
النفا سل لحفا و نكت عله للاسانى لحفا و كذلك ب نصاب فى سف اسفل من السبلان كبون من
اربع اصابع ممموه بالعرض و هو على كبر كار حطاد دمفا و ان كار حط علظا فهو على عرف
و منى اصب فى سف مال الذجر او حوان تا ما مذهبا فهو على شى فى السبف سمى الكبا كر و هو صبح
و نعور من الحديد و هو سكر من ذلك الموضع و اذا زات الحرد المانى ببها المصان بقد ه حرد
اصطاحدير الا از اسمه اسنه و فهو سمى سبو سبك اى المحا له فا نه با س نبكسر حدبذ اذا
حلونه احمر من عبر د و ا فا نه كسر العقد حد اصبح الما ينه على الجلا لا احمر و هم ما خاف
عليه از بصرب به فى البوم المارد مكر و هذا الا نصاب الا فى الما ينه العتق المتور به و منها
ما موجد فى صدره الما سات و الماس هو العرق الد المر الذى لا يكون و به فرد ل م ر وم ربحا زمر الصاقله
سفا فى عرقه مر بدلا الصما مه مر المعق فاما المولد موجود د لك فيها لا ز الد را والذرى
ببط رح عله الحدر للصدر و لا ذا لمتح مالحدر بكله على استو او ببغى فيها مر اصع مر ما هرا عرد
مه فا ذا صر سبخلس يعضها على يعض فصار العرد فى داحل لخفيا و منها ما ند دحل عله الما مرت
الطير و يكون سبقا بالعرق و بسر ما العرف احمر كا لبسغ و يعسها الى البسغى ه سمر السبع و كالعروق البسف
اللنه دع الماسات و العروق كل نصر السبف سا الا ما كار على الحدبد فا نه لا بسرب الما و لا يعطع
سفه انفا و العروق الحمته فى يو كات و الحدبد فاما الماس فهو ما صعرمنها و اما الموت
الما نرو بدرا صعبر ا فخود لك فا ما الكبر فهو عرف كا بحا له و كل عرو ا و ما بكون ورق المرب
الى الفا نم بعدرا صعبر فا نه لا نصر السبف و المصبخ على عد ربسبر من الد باب و دا من صاحب
السبف الذى فيه العروق الماسات الحرى و البوم المارد با نه اما خاف على العتو فى البوم المارد و من

الما بنه الموصول للسنان وَمنها الموصول للصَّدْرِ وردلاغا لكون مَرَ الصهِ بالسَّيف دو طع لا
لرذاه جديد ولس لسفي دخل عليه مِن البطين فان كل موضع سرُب الماسس دَاعانصر على البَهربن
لسنِ الغِنَظ واذا صارالكَىيسف وراشحديدة في موضع السقي سدرالحمر سها اسع الباز وامر بك
بك على السفرين فوجدته سدرلاللى بعص الْحْتَ فلا فدعَرْبه على قِال وَلاحرب وانه لا يقطع
كمّا ولا قليلا وان اصانه يوضع حديدا اسزتشرعنه وان خال ذلك دا فنه سره السقي بعلاجه حتى
يصلح ان يو في به رما دَ الخمام بعد ان تأبي على الرماد ساعات مرَ البَهار و يلين يارة فيدرس الصنف
ى الرماد ونعاهذا بالنطر فاذا صار طأ و وني اللون وُضَع على شقرته مِن الرْسَ و تركحى يبردى
موضع لا نصبه الماً ولا الرح فانه ان اصانة الرح اعوَج و لم تومَن عله الكر فانه نعرهذا لعلاج
نقط و بومَر عله الكَرِبادراللّه تعالى وفديكون نما طبع با لين لة شبط بوَاقكرَمَ وماله
سطه وَاحده و للخزِنه و سواد رح عرحر نشّه طولها أربعة اشبار واكثرُ اقلها وعرضها
اربعه اصابع و اقل واكثر و لِير جدبدَهَا بما بي بل سليماى و سورنزي وهَدى دعصها بسويه
العدود اغالها واسا فلها ى عرض واحد وهى تغد فى العنوَ وانَ هذه ما سرَ يطلبَن الى الحسْه
لايطالالا الالصافله ذكون تعزّا سم العنوَ وسمو بها لا مولِد سليماى سردىى وليس العنوَلاً
القلعى والباى والهدى و الهدى هو الفايرون و اكثرَ ما بكون مَن الفايرون وَرباحسَه
ارطال دهى الشوف الاول اعنى القا فروَ ماضه وجوهَر القا فروَ يسمه جوهَر الباى الو
القلع و بذلك الحسسى و هى الى يسمى المستوفه ا ذا عبرت الى العلعى الى الباى مرَحالفة ا و
ادعى انه بعدَر على بهار وبه لمه ارطالا اساه سمع عزهذه الفتوربه الصعار وعسا الى ماحابه
فان ساكله وهوصادق وهذا اعير موجود و اكثرَ ما كون مَنَ البُلَها نه الصعار اذ العلعيه
الرفاق يطبع و نعبر فدبها الى الباى نه و نباع على بها با نه ه و مزهذه السليما نه ما بكبس
و نعل با المنفا تِمرَ و يسمى رُسَم ذلك المعس مردا وهو الذى نصا دق عقدِ لفسمه معمو لُه
وساع على انه ما آنَ وزبما طعوا العلعيه فى وبرا المانه فباعو ها با لها بنه لال العلعى
اذا انارقله بلنه أرطال عمرَ بع بساوى عسره د نا ببرالى خمسه عشرَ على وبرالقرَ والصاحثه
وانَ كان عرقا اى مه عروق يساوى حمسه بمابره بمابره فاذ اكان هما سّا فى هذا الوزرَ والصباحة ساوى
ما سرَ الحمسرى سار الحا لمانه العلعته ولسى فى العلعمه اربع اصابع و لا ملت نا نه الا
معموله ونكون ما سرَ لا اربعه الاشبار الى الحمسه اشبار الا ما قصر وعولح و فدودها فرو د
مستو يه اغالها واسا فلها واحبة ادق مَن سبلان نت البها نه و مكا سرها و مكا سرالباى
دا لقصه السظا فاما المعمو له مفا علا ا با نا مَن عرسبك مَن عرسبك مَن و حدعلى كل طبع الانه لا بكود منها
مسطت و هى اصعر و بدامرَ الباى و استد احد الق عقد لست مسا و به فى العظم و استدمره
جوهرو ارضرولا يوحَد منها سيف با بتر و بوحد بعبه للحدود مَن العروف لِهِندلبة والهدلبه

جوهرها سبه لجوهر الماني الا ان جوهرها نصربُ الى السواد ويقع من المولدة ما حامن اسل

احاس يرخل في القلعي والماني جمعا فاذا از ائت سها سفا في فند القلعي اسد بعقدا من الفلعي والبز

تخيرا اعني بالتخير داخل الفريد الذي يعضه في بعض وحدته نصرب الى السواد وحدة للحديد مختلفا

فالعريدمن اوله الى الحزه مو ضع وبرصغار ومو ضع فزبد كغار و وحدن للفريد الذي على الموضع

الذي بركه القفا قله لا سقونه و هو وازشير واكثرما بلى السبلان وبرصغار مسه سبه

بالسيف واعلم انه مولدوفاجل منه قطعة حمر افانك خرج الرين من جنث المصقله اسود دورى لمصقله

ابركانزا المصقله في الرصاصر ونرى القطعة نفسها الحمر الاجوهرفيها ونشر ابرا المصفله فيها

خفي وسطر الى الا شكل الذي وصفت لك في صدر هذا الكتاب وهو الذي يشبهه بالبرود الذي يعلو

بعضه بعضا وانك يصبها في العسو سفا بقيه وبعوتهن حمرة نصرب الى السواد وحد كل شيف

سها نرى برك علمه خشن لا كالعسو فقسمه الى العسو وهدة الى وصغنا ما رات المولده وامّا

الماينه العتو والعلعه العسو فيخرج جماها و نو بالها احمر سبه الخاس في الهندسه تخرج جماها

ونو بالها ومكاسرها مثل الرماد اسود والرشخرج من جنث مداوس المولده اسود و امام لحت

مداوس الماني والقلعي موسع دليل وكذلك الهندبه سبه سقا الماينه والعلعه ه البطام نه

فاما السلماينه فان منها حسا سمى السلماينه الصغار وفى يسوق لطاف العرض وطول الاصار النرند

فيها بعض المحود به وسهه بعو ديه العلعه طواهر الحو هز من عمر وطرح وفى ما حمله جدرها مسو

من ارض سلمان الى وزا النهر من جراسان وطعنت هناك وبرودها وددفاق العلعبه فاذا

وقع منها سبف حدرالورث لحدثه الصا قله الحكما مشم فادحوة الماركم كسوحتى

بدخل بعضه في بعرتم يطبع بعران بهصرطوله بعدرشير لبزبد في عرضه فان الحوا ان سهوه بالماينه

فصوره وحرضوا زاراسه على تهكلنا وصفنا من الماينه ثم سقوا بصفه ليعلم جوهرهالم نشر ب

الماينه وضرب الى الماشي بعد الطرح ولحمل النصف الاعلى ما الى الدباب الى ا الاشعي وان الماينه

العتو على هذا المثال يكون في سغها الا ما لا رجدره منها واستخرجها الماينه وعبرها من

المسنه بها فانهم لسفونه الا سبيئرا او افلبنه ما بلى السبلان وان لاد وان يطبعوها في بعد العلعبه

علوها سبو فاطور الا اربعه اسار بعراصعير بساويه الطر من مثنه الروش وهذا النصف

من هده السبوف السلماينه الى سيسها الهدا الاسم من الا صغان نجوز في هدّ ت الماز او لحو

طبعُها وجوهرها اذا احلى احمر وحدث ورده احمر طاهرا ساكون الفريد منه واحده ونضا

من وربد القلعي واكثر من وربد الماني وللا وبرى وبرد بعد الطلى كالانبو به الملسورّه

عبر منصله نقصها في بعض في مواضع عده من الكسر لسرخ كله محلف الوجهين لحا ا كبس

المطارف ومنها السلماينه العراض فى الى بعى المقبك والمقبك العرض وعرضها من ثلث اصابع

الى ربع اصابع وطولها اربعه اشبار ونكون ذرا ابها اما من اللماينه الارطال الى الملته

ونصف ومنها الجنس الذي يسمى الزئبق وهو قل ما توجد الا وعلى سيلانها طابع مرتفع فيه اسم
الصانع الذي صنعه على قدر اصبعين معمول منى من طرف السيلان وأجودها ما كان ذات طابعه
في الحكم في طابعه وذكر من ادركت من الصاغه وذكر من ادركت من الصاقله انهم يروا
سقعا عليه فرغمروا بالمنصوره الا واحد وهو مفقر الطهوره وبعض هذه الزئوث تكون مفقره واكرها
جونته وطولها اربعه اشبار وعرضها ما بين ارابع اصابع معمومه الى نزل من اربعه فللجلاد النو
حسان الروس عراض السيلان ذات العلمه الكماد وجيدرها لها ظواهر مع ترطح واتى يسمى منها
سيفا ما مس وصلب هم حلو الجمر وملح الخلا هم الذي على السيلان بالمطرقه اشراه جميع صاقله
خراسان والموصل والبيض والجمال على انه فلح ما خلا العزا فين وتكون اوزان هذه ما بين اربعه
ارطال واربعه ونصف ونصف وابها ملته ارطال ونصف والذي نطبع سيلمان هي عزبصه القرير طاهر
الجارئ ليست له جمره وهي ارداها البصر ذريبه ما نطبع سربوب وخراسان وقد فدمنا
في صدر هذا الكتاب ما نطبع بالمن فاما ما يصنع من هاسربوب فهوالتى والتى الذي لا يجي عليه
بالنار وذ لكلامه لا يحوى الجديد ولعم القصد لعم الحسب اللين ولعم الخلاف وما اسبه نجح
فريله دقاقا صغر اخفيته فاذا وضع في اير بى المعراد بين فاحسوا ان يطهر واجو هره مرجو ه
ومعى مرجوه وصعوه في زماد الجمام الخارجى لا يسعى به مرا يستقى الا الحمى حجلا وبلغ عليه
دارجح فربله جيدا والا يسوه اطلس ولاطلس الذي لا سلج هره ولا يعرض وبكون له مطلها
يصرب الى الصفره ة ما نطبع منه لخراسان فامم نطبعونه نجم الملوط ونجم الغش وهما نوعا
لحدان من لمج ولر لخذا شديدا وكون لطهر جوهرا اشبها بابيضزه واقطع هذه الاجناس التى
سبنا الى السردبوي الى ومنها ما نطبع بالمنصوره وهى يسوق قصار دقاق رواق وعراض واكثر
عرضها لاث اصابع نسبه بعضها بجود الماجى لا انه لا خلوا دربه من البرقه والمزال والمنصورى
فانه اصواها واقلها فرتا واوبها اصفر ه وازهن السردبوي ومل الطرح جمرا يصرف الى العبره
وبعد الطرح ارضه حمرا ودربه دقاق صغر قلبلا وقدود هذه المنصوريته نفرد البنانه العفو السوايج
الى لا يشطب فها و منها ما كانطبع بفارس فيا يمى قديعل منها مغونته بما يشاو وطرد سمى شاه
تجسير معناه الملك فى ابيد مذهب الذهب ه وكذلك صنف سلمانه طبعت بفادس
نسى الجسروانبه فاما السردبيه السوايج من الفارسبه فري اعرض ورذا من هذه السردبيه
كلها وذ لك ادلاهل فارس كا بوامطلو ن السهل بسيم واهل سابر هذه البلاد ان يمل الم اركا رابات
وهى قطعته مربعه رتبت فى الاصل دراعا داعا البصر فاما البيض وصفاق السيوف وصف
طبع فارس وصف طبع بالكوفه فى الزمان الاول وهى يسوف قصار اعرض ما يكون منه للاصابع
الانبلون ودوع فى اجدرها اصل فاخرج الفل فرق وطو لها ملته اشبار وارابع اصابع معترحة كلها
وسيلانا نقاد قاق اعاليها ادق قلبلا رفاق يعقب سيلانها بعسان بعسا كا لسنبك ودروسها انعل ين اما فلها

ما يلى القائم وروسها الى النذور يملسته ذ فاق الاطراف صلبه بلا مكه الى في القلعنه عير معقه مستوى كله و منها ما فروده مستجن كله فان كان فه موضع مبنجر و في بوضع غير نتجر يهو منزلد و منها ما سقانه ما مبر و ما كان كد لك فان حرين المتجر فاما ما كان و مناحين على الحدواء و هو الذى فصعنا في صدر الكتاب والسمر البو في قطع من القادسى و اقطع السوف كلها واصبرها على الضربه و من السم اللوى و الفارسى اذا اساوا بى في الورن والقد بى اسيف بلا الممن وعلامه السمر الفارسى انه اطول من اللوى في بلاث اصابع و اكثر فان اصنفه فلد غير لعله فاعلم ان سلاته اطول من سلاك اللوى الى يسمى الزدته با صعو يا احمر و اعرض من سلاك اللوى فيه بكمر و قد كان هذه الفارسه محلقه في الرفه والغرض هى اعرض جوهرا من جوهرا اللوى سلا ان جوهر اللوى اصفا واوزر وا سبه با العنو الاول و لس بطهر فيه رها الابعد الطرج لا سى حرى جدا و هى رف الحديد اذا كان عير مطوخ علها ولا روقهوا سغر يصرب الى الحصره والسمو في الفارسه اساعها الى يلى النشلان اسل مراعماها واكرا بمان الكوفه دالكاز الصلاح ثمانه و املا ما بمادارن لا ان يكون جمفه الورن جداقناع بوسار القر لحمه الفرحيه عراض الاساقل داق والرب في مهالما نه العنو سطه رلحد هرنضه في سطهاكا لمفر الطاهز وجوهرها سبه بصعه عرب الباب الطبرى وبركت ش الدرع انصل الوشى احمر الا دعن بعد الطرج وقبل الطرح لا بطهرمنها ش في صدر وزها اهله يحشو بشه اقنرهب وصلب محشو كذلك و منها ما في حد تركبه تقنب فد عمل فه مسمار دهب اق سبهد وزبما كان لك المسمار ى الى الما بنه العرلى مسنورا اضا بالذهب في تركبه اقطرفه و له حدير ش به الراسكبن مما يلى النشطه لا لمح منها فريد و النتطه معضه عن طرف الداب بقدر بلاث اصابع و اولا له سبه با العب بى اللاب اصابع لى بطهر لها فريد و هى اخرظ رؤسا مرالما نه فاما السلما بانه فان حدرها على نبال حدبد الا فريحى الا انه اصعر و شبا واجلا واعرب بصعه وال والسيف واخره مسنو بن لس يحروط فان خرفت الراس على الا شفل معللما و لبس فه تمثال ولا صلب وسلانا بفاشنه سلانات الباانه ذكلك سلانات القربحه او رسلانات وجمع معانها سى المولده وأما سوى وصفنا فالمولده وهى في كل طبع منها جنس بعاله البحرر وهو ما عمل بخزا اسان ة والعنه وهو معقن عقدا صعار او واحده الى حنب صاحبها بن قوله الى الاخره بعمل يا المفاش علا بن براس با المبرا و س مسوى فرى صنو ه بعضها سلوا بعضا سنه العلع و حدبد ة اسود و لعرض ما بكون سد اصعان و نصف و لبس بطهر الا بعد الطرج فان طهر منها ش دل الطرح را حدبدا رخو مطلما بعضه سلوا بعضا وعلامنه اش و تقنب سلانه د فاق و بطبع طبع العلع بلع انما بفا ى سرح دهما المحدربه البصر ته و من الخزبه المصربه ما بطهر حدبد ة فل الطرج معقدبعقد سبه جوهر السلما فى جوهر نا عم بنبر لك الرخاوه فيه سواد وظلمه تسعنه فى

المثمن اصعا فيما سنه في الطرز حسن السمره بسو البدعنها بطهر انار المصا قل فيها مختلفه
العدودج من عراض رقاق وبصار وطوال لم يطهر احد من المصر سل الا سليمر وبعد الطرح ترهب
عقدها وخفى جوهرها واما اذ اكانت حملا الي الخيال وبباع بسعر الهابنه عملها سنه حمس وسبع
وقطع العلم سنه مابه وشعه وكانت تباع بدنابارين ونصف ومنها ما يطبع بالبصره ايضا
مالا راد قند علي سته دراهم وارابعه دراهم وهي سيلانات صغار السيلانات رقاق مطربه
العدود الدمشقيه الدمسقيه للحرسنه كلها حرسنه وهى ماتطبع فيما متى وهى مواطع جدا اذا كانت
علي سقابه الاولى وهى طوال الحريشنه في فتما وصفته من المسلما نته التى يطبع با لمنصو ربته
وجمردها مسبه بالصرا اله محلف الجوهروهي ما قطع مابكون من المو لاده وانما ها من جنسه
عشر درهما الي عشرين درهما المصورته ومنها ما يطبع بعمرها مرد با لطول طوله وسوى
جوهه وستذلاستواه قطعه قاما احد بله بحرير بصرى انما ها عشره دراهم يطبع منها
الحريشت والسهاذ است واللبه داست والسلادخ وعيرذ لك البر مان ومنها اسات
برماهن يبع من سوف المشراء والروم جميعا ومن سوف الهبد فاكان من سوف يسمى مد لثن
ويعرف سبعها ما صطراب فده والثوابه وانز المرد في سعرته وهو في مثال الطبع القارورك
وليس بطهره البرماهن كله تلل والاكبير فاما سوف الروم والشراه فسوى سوادح دقاق
طوال مطربه العد وداذ انطرت الي السبف نطرت الي المواضع داخله ومواضع خارجه
وهى سمى بالفارسيه كهربلام هذا اطال الله بقاك فيما امرب ... فاصلحه والله اعلم

<hr/>

الساب السابع في الـ ... ملحه
الرسالة في محمد الهاشم بن علي محمد الحريري في النحو

اقول من بعد افتتاح القول لجردى لطول السدراسة والملوك با سالمى عن الكلام المنظم جبرا ونوعا والكم بنسم
اسمهدت الرشد اول الاقول واقمه فنم مله معقول ... علم الكلام ما افاد المسمع ... حووسع ريد وعمر ومبع
ونوعه الذى عله بنى اسم وفعل ثم حروف يعنى فالاسم مابدخله من والى اوكان بعرو والمحى وعلى
مثاله ريد وخبل وعنم ودا وملك الذى ومرو كمو والمنايا برخل ائذوالسمن علذ ثانيان اوس
اذلحقته تا محدث كلوم في لبس لبت انقت اذكان امر اذا السفاق فخ فل ومله ادخل واسط وامر كلا
والحرو ما لبسله علامه فنس علا قولى نترعلا مه ساله حتى ولا ثمنا وهاو از لوولم ولما
والاسم صرا زفسر بنكره واالحر المعرفه المشتهره وكلا مار تعله بدحل فانه مدخو با رحل
جو علام وكتاب وطرقه للمولم رد علام لى اول وما بعلا اذ كرفهوم عرفه اه فتزى بيه العبي المعرفه
مثاله الدار ورد ورانا ودا راست الاى ورد والغباه والاذ النعبل من برد نعربغنسبهم والكرد
والقرم ابن اللام فقط اذ الفلا رصلمتى برح سقط وان اردف سمه الا فعابه لنعلى صنكفا الاشكان
منى لانط لمن اراب ماض وفعل الحال والمصارع وكل ما بطحر بيد اتمنر وفا ما صو دبار لبس

ISTANBUL 4832

بسم الله الرحمن الرحيم

النص غير واضح بما يكفي لقراءته قراءة موثوقة، والصفحة مكتوبة بخط يدوي باهت يصعب تمييزه.

هذه ما واست بها ... سطح بها بكثير ما ملل كو ... ليل ... صمر راضي ... و ... و ... يجب وضع الجو
مرة ... و معلم المهندس ... عارفا ما رأى ما خلا نصر الحديد ... فان ... بوم ... كور الطبعة ... زر ... بمثل ما ... به اقلنا
السيف ... قام الم ... نفعها للسداد ... و ... يجمع ... من الحرار ... جمعها ... على اعلى اتفقه
... و ... بسبب ... هذا الوحدة ... الخبر و الباره و لسف ... باللحم و ... و ... الاعمر ... على الطبع
قار ... تنه ار ... د سئر سنمن ... بمعه الدراهم و ... از ... مظلمت ... سفا ... بمعه الدرايه :: و ... و
... و كل ... من ... محمد ... و ... البر كزير ... مور ... منها الحوص ... و ... بمعها ... انوع ... ها و ... ار ... و
ان بر ... سف الفئر القد :: و ... و من ذلك القد ... من ... و لا يعلم ... طل ... زياره و الصرفه
... جمعها اد او ... و العاليه دارى كاد ... بنهيه ... و ازا ... الحديث الحر بالصدر و ... من الفئر و ... ل
حلقه :: و فير سئمه ... عظمه ... راهنع العرور ... نصر الحديد ... و معلم ... و ... الجهاد ... العريات
... لحد :: قاما الارض ... عن ارض السيف ... صبغها ... رطا ... ها و وجم الوضع من ... حد د لا ... الزير
... مضول ... الصر ... و ... و ... ايضف ... الصرورر الماضر :: ... و ... و فينا ... بمر ... اقوال ... السف ... با صفر
... لحديد او عمر ... للصرين ... ما ... حديد كصف ... السيف فانا تم ... الحديد :: و فى ... على ... الطرح ... و يعلم الطم
فانما الم ... الزير و الرور ... اعلم ... للحديد ... لطم ... له و ... زير :: و اذا ... مار السف احمر ... فاقامع الحمار ... الزر ... و ... منه على ... عليه
الوزن ... و ان ... الصاد ... فليسم ... صد ... الحلا لا ... و ... و ... استمرا ... هذه الاس ... اللون و ... و ... ل الوم
معاطها و الفاطم ... لا يعطى ... اصرها ... از ... انه ... علنا ... الارض ... صفه ... ماور ... بعور ... الله و ... و
... و ... الشنوه ... للمانه ... و ... و ... و ... و ... منطف ... و ... و ... و ... و ... لس بعض العقد ... الطرس
بعض ... انصل ... الصر ... احمر الادر ... اصر ... الارض ... قال ... الطرح على ... قر ... بنتر ... مرسله :: انا ... صفار ... و ... سمر
فى مثال ... الرود ... سلو ... لنصه ... بعضا ... كاد ... القصه ... و ... لا ... اناز ... رم ... السف ... بض ... مطابقه ... الرود
... و العاد ... لبع ... و ... و ... و ... و ... السمع ... الوحدته ... الامر ... من ... العرص ... الا ... بعل ... الطرح ... الرابع ... المربع
السلام ... بعا ... و الطر و السلام ... و ... الترم ... الرو ... و ... علامه ... به ... الا ... العزيز ... طبع ... من ... اهله
... و ... هذا ... السمك ... و ... السف ... اب ... احد ... جهته ... او ... اوسع ... وجهته ... منتف ... و ... زو ... و سطه ... اصر ... و
... فينا ... العسمك ... و ... المحتره ... و ... و ... و ... ور ... بطبع ... بسنه ... لا ... نها ... م ... و ... و ... لكم ... وهو ... الزر ... بسم ... الادر ... كدم
و ... عماه ... الوم ... منها ... السمك ... المعمو ... اب ... و ... ر ... مر ... و ... معر ... الكور ... بر ... المبرد ... لاد ... ور ... المبرد ... حفره ... و هو ... الزر ... عا ... طح
... التصصانه :: و ... منها ... الزر ... سط ... ه ... اسكا ... د ... زه ... بسط ... و ... و الاسر ... به ... مر ... احل ... السطر ... و ... هذه ... القطر
... بسا ... و ... ه ... و وجه ... السمه ... و ... يسم ... سها ... ر ... د ... ر ... و ... منها ... دو ... له ... سط ... واحده ... و ... الوسط ... و ... اسنا ... و ... السطر ... س
و ... الر ... بسن ... سمر ... اشف ... مهز ... مسه ... الحا ... هله ... و ... شكا ... ه ... ن ... علم ... ما ... و ... و ... صعا ... و ... الار ... با ... ون ... ضها
غير ... كله ... احفا ... م ... و ... و ... با ... و ... منها ... بعص ... صسعر ... عرض ... و ... و ... الحقا ... ف :: منها ... العور ... به ... الزر ... لا ... وجد
... منها ... الادم ... و ... طر ... او ... و ... طا ... عر ... بع ... و ... الحقا ... و ... القنور :: و ... و ... سوادج ... لا ... نظر ... ها ... صلقه ... و ... الفور
... اثر ... العلم ... اسف ... ار ... و ... اربع ... اصا ... ر ... او ... و ... اصا ... اشا ... و ... اطا ... و ... هاعل ... هذا ... الطر ... عا ... فه ... ار ... بقصر ... و ... ر ... ها :: ا
... ما ... العرص ... و ... كدر ... و ... ها ... بلله ... اشا ... و ... مضف ... و ... عر ... اور ... ها ... بار ... الطل ... و ... وجه ... ا ... لله ... الطر ... س ... ر ... ع ...
... لطر ... ها ... علنه ... الطا ... فه ... مر ... بع ... مطبر ... العرو ... د ... سريه ... الا ... ل ... و ... لنا ... نر ... ا ... سطر ... ه ... خا ... فه ... از ... ا ... حل ... النار
... بنقصر ... او ... ر ... ها ... و ... ا ... العلقه ... او ... ر ... ها ... لا ... كاد ... لا ... ر ... سام ... العبا ... ره ... و ... مر ... العرو ... و ... المفتوحه ... و ... العر ... و ... المفتح ... هو

[Arabic manuscript page — handwritten text, largely illegible]

TURIN

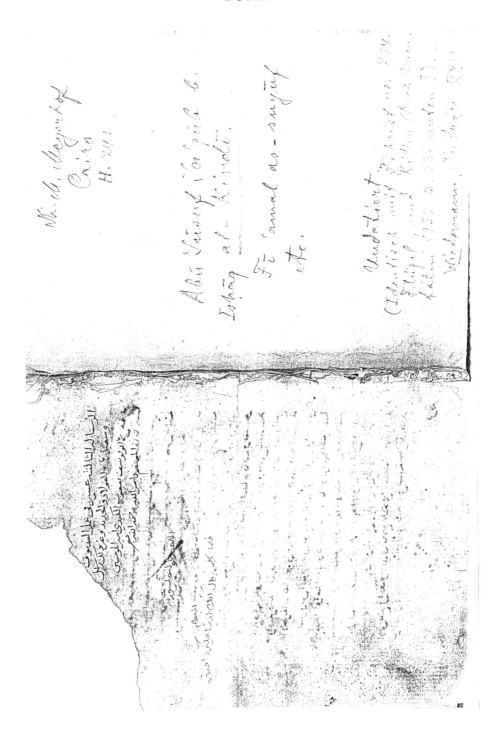

[Manuscript image — two Arabic manuscript pages, text not clearly legible for reliable transcription]

CHESTER BEATTY Ar. 5655

١٧٥

ابن اسحق الكندي لأمير المؤمنين المعتصم وبالله التوفيق في كل الأمور

... السيوف وأنواعها وسقاياتها رسالة ابن يوسف

يعقوب بن اسحق الكندي للمعتصم أمير المؤمنين في اتخاذ جواهر
الحديد للسيوف وغيرها من الأسلحة وسقاياتها وأنواع الحديد
التي تطبع بها السيوف وسقاياتها وما يطرح فيها وهذه أن وقعت
إلينا بوصف معاناه من عملها وليست لنا فيه حجة لكني أحببت
لا يفوتك معرفة ما وقع إلينا بحقيقة ذلك لعلوك بسطت لامتحان
عندذلك وجربته ووقعت على بعضه من سقيمه أعلم إدام الله
تعالى وحرث أبا ملك أنهم ذكروا أن الحديد لونين

ذكر وأنثى والذكر منه بنقسم يسمى السارقات وهو صنفه ي اللون
والأنثى بنقسم قسمين ويسمى النه واضربه على الكسر الرطل وهو
أشدها بياض كسر والنوع الاخر يقال له البحري وهو أشر عهما
أكثار اخشا عند الكسر ومن البرم اهن نوع اخر يقال له البلوري
وهو أشر فها وأما الفولاذ فمخترع وأنا اذكر منها أنواعاً استعمالها إذا
شئت وتخذمنها إلا أن اخر أن أحببت أعلم أن السيف الأزيد
تسميه الفرس سرحرد وتسميه أهل الحجاز علان وهو با بروكون
من قله الأحلاط التي تقع ... الروا الذي يطرح عليه في الشبك
فيصفو أمنه مواضع ولا يصفو أمنه مواضع ... يوخذ مغيب سبا ذكر ويشد وسخا أجزا

Glossary

Alkali

Chemical term derived from the Arabic *al-qalīy* originally referring to the calcined (burnt) ashes of the plants *Salsola* and *Salicornia*. This would now be categorised as potash, alkalis having been redefined in the 18th century as *mineral alkali* (soda) *vegetable alkali* (potash) and *animal alkali* (ammonia) to take account of their origin (see Oxford English Dictionary). Alkalis are the counterpart of acids in their chemical properties.

Annealing

A general term applied to several softening operations affecting crystalline structures within a particular steel. The temperatures applied are higher than those used for tempering and the effects more pronounced. Microscopy of a sample of the metal will reveal which operation has taken place. The steel is heated in a hearth or furnace and held for a while at a temperature just high enough to alter its structure, the length of time depending on thickness, followed by very slow cooling, usually in the furnace. Various annealing procedures are likely to have been experimented with by early ironsmiths.

Arḍ

A term used by Kindi to refer to the darker background matrix visible on a watered steel sword blade.

ᶜAtīq

A term literally meaning ancient or antique but which is used by Kindi to denote the best quality of swords irrespective of their actual age.

Bayḍ

This word meaning 'eggs' is used by Bīrūnī, and in other medieval Islamic references, to describe the lump of solidified steel produced by one or more of the crucible steel-making processes.

Bīḍ

This means 'white things' and appears to be used by Kindi to describe sword blades with a silvery white appearance, presumably because they were highly polished but not (much) chemically etched or patinated.

Bloomery iron

What Kindi refers to as *narmāhan*, one of his varieties of 'mined' iron. It is the product of directly smelting or reducing iron from its ores using charcoal as the fuel and reducing agent. Although pure iron melts at 1535° C, reduction from the ores to give a mixture of iron particles and waste products, mainly non-metallic slag and cinders, is possible at temperatures as low as 800° C. Most of the impurities present in the ore, such as the oxides of manganese, magnesium and aluminium, will be lost in the slag since they are far less readily reduced than the iron oxides, although some impurities such as phosphorus are readily reduced. The production of iron in this way, however, is not practicable until a large proportion of the slag can be separated from the iron in the furnace. This is only possible when the free running temperature of the slag (in most cases approximately 1100–1200° C) is reached. This process results in a 'bloom', a term which derives from the Old English word *bloma* meaning a flower. Anglo-Saxon iron makers thus described the appearance of the resultant mass of metal in the furnace, in this case a semi-congealed, porous or spongy mass of iron still mixed with much non-metallic slag which must be mostly removed by bloom consolidation.

Bloom formation and consolidation

During reduction solid particles of iron are formed and these gradually coalesce to form a spongy lump or bloom after the slag has run to the bottom of the furnace or been tapped away. Most of the slag still present in the very porous, spongy bloom has to be removed by gently hammering the bloom while still hot or after re-heating (above about 1050° C) until the slag becomes fluid enough to be squeezed out. This consolidation is done by forging the bloom at welding heat, although the forging must be done comparatively gently to prevent the bloom breaking up. This process squeezes out the semi-liquid slag and allows the iron to amalgamate into a more compact lump. A bloom carefully consolidated in this way could result in a clean iron, relatively low in slag, although the care taken over consolidation could be rather variable.

16

Bloomery Steel

Belonging to Kindi's category of 'mined' or iron produced directly from its ores, this is one of several varieties of *shāburqān* ('hard' or 'male' iron). The direct production of steel from iron-ore by making the conditions in a bloomery smelting furnace more reducing than is necessary to produce plain or low carbon iron. In practice, the difficulty of maintaining evenly reducing conditions in early bloomery furnaces probably resulted in blooms with a varying carbon content being produced. Often the more steely parts of blooms such as these are likely to have been selected preferentially. A higher charcoal to ore ratio is required and control over the air blast is more critical, these factors making it a more difficult and expensive operation than for

plain iron and the results must always have been rather uneven in terms of carbon distribution.

To achieve a more even carbon content, that is, a more homogeneous steel, a further forging procedure would have been required. The even distribution of carbon found in much early steel would suggest this was done as standard practice. The choice of a low phosphorus ore may usually have been critical, at least to economical success of smelting steel in this way, as the presence of even a small proportion of phosphorus slows down the absorption of carbon considerably. Research to date would suggest that varying the bloomery technique was the standard way to produce steel in except in those areas where crucible or blast furnace technology was available or preferred.

Borax

Naturally occurring as a mineral (*tincal*), di-sodium tetraborate ($Na_2B_4O_7$), borax is used widely in glass and ceramic making, and is still used in metallurgy as a flux to remove or separate out unwanted non-metallic by-products during smelting and secondary processing. Borax probably derives from the Persian *būrah*, via the Arabic *būraq*, and its use as a flux is recorded by Kindi who gives Khurasani borax as an ingredient in crucible steel-making.[1]

Bulat

A corruption of *fūlādh*, or *pulad* found further north, towards Russia.

Cast Iron

It is clear from his descriptions[2] that this is another form of the type 'mined' iron (that smelted directly from its ores) that Kindi refers to as *shāburqān*, 'hard' or 'male' iron.[3] Iron-carbon alloys containing approximately 2–5% carbon are classed as cast irons. Much of the carbon is present either in its combined form, iron carbide or cementite (q .v.) – white cast iron or white iron – or as free carbon, graphite flakes in a matrix consisting of varying proportions of the eutectoid pearlite or ferrite (q.v.) – grey cast iron or grey iron. When liquid cast iron solidifies, white cast iron will form if the cooling rate is sufficiently rapid, grey cast iron if the cooling rate is slower. The cooling rate is dependent on the presence of quite small quantities of certain impurities in the metal. For instance, silicon promotes the formation of graphite, whereas phosphorus (above 0.1%) promotes the formation of cementite. An intermediate cooling rate can result in mottled iron, which has a white iron matrix with roughly spheroidal patches of grey iron dispersed within it. White cast iron would have been necessary to promote the kind of watered structures sought by sword-smiths and

[1] As in the recipe for Indian steel quoted above in ch. 1, n. 26; and it is mentioned elsewhere in early chemical tracts attributed to Jābir ibn Ḥayyān (see Russell *The Works of Geber*, 1, III, 9), and is mentioned in the *Mappae Clavicula* (see Smith and Hawthorne "Mappae Clavicula", 195, 202 and 203).
[2] See Kindi/Zaki, p. 5, in chs 2 and 3 above.
[3] As in the crucible steel recipe given in the other Kindi manuscript; see ch. 1 n. 26 above.

others in Kindi's day and there can be little doubt that he is referring to white cast iron as *shāburqān* in these contexts.

Cast Iron production

In China cast iron was being used for some tools and moulds from the sixth or fifth century BC, and with developments in refining by about the second century BC the first stage in the production of steel and wrought iron occurred there.[4] Cast iron may have become known in Iran soon after the establishment of the first direct links with China in the late second century BC and, as we can see from Jābir ibn Ḥayyān's *Book on Iron*[5] and Kindi's treatise on steel-making and heat-treating,[6] was being produced by the third/ninth century as a first stage in the manufacture of crucible steel. How this production developed is as yet unknown.

Cast steel

A term sometimes encountered in reference to steel in the as-cast condition, that is, before any subsequent heat-treatment or forging. In the context of the present study this would usually refer to the disc or egg-shaped lumps (ingots) of steel removed from clay crucibles after they have cooled, but also could refer to objects (or billets) made of crucible steel cast into moulds as referred to in Jābir ibn Ḥayyān's *Book on Iron*[7] although it is not known to what extent this might have been the case.

Cementite (iron carbide)

A white, very hard, brittle compound of iron and (6.7% by weight of) carbon.

Colour estimation of temperature

As is mentioned by Kindi early ironsmiths would have estimated the correct temperature for forging or quenching a steel by gauging its colour. This becomes a just visible dull red between 500 and 600°C, reaches its brightest red between about 900 and 950°C, and goes through stages of orange and lemon yellow before reaching white heat between 1200 and 1300°C. A different effect is used to gauge when the correct, and much lower, tempering temperature has been reached. Gentle heating of a steel produces a thin film of oxide whose colour varies depending on the temperature reached. Temper colours range from pale yellow at approximately 220°C, through brown/purple at about 265°C to dark blue at approximately 315°C.

[4] See Needham, *The Development of Iron and Steel Technology in China*, 5; Wagner, *Iron and Steel in Ancient China*, 406.
[5] See appendix 1 above.
[6] See appendix 1 above and ch. 1 n. 26 above respectively.
[7] See appendix 1 above.

Crucible

Before the development of modern steel-making processes this referred to a refractory clay vessel (one which will withstand very high temperatures) made to contain liquid metals.

Crucible steel

As the product of a pre-Industrial (revolution) process, this refers to the hypereutectoid steel (with a carbon content in excess of approximately 1% and usually about 1.5%) made as a liquid in closed clay crucibles. It was (usually if not always) the product of a secondary process in which at least part of the raw materials for the crucible consisted of iron, which had already been reduced from its ores by a primary process, smelting. Its very high carbon content meant that it had to be forged at a lower temperature range than was usual for iron or steel.

Damascene/Damascening

A misleading, relatively modern term, which has been used to refer, amongst other things, to a variety of decorative processes linked to the production of iron and steel objects, in particular those made of crucible steel.[8]

Dirham

A twelfth part of an *ūqiya*, itself a twelfth part of a *raṭl* (see also discussion on weights in chapter 3 above).

Dūṣ

A term used by Bīrūnī referring to white cast iron as a sub-category of ***shāburqān*** used as one of the main ingredients in crucible steel making; Kindi simply referring to ***shāburqān*** in this context.[9]

Firind

A term used often by Kindi to refer to the watered pattern seen on many swords of crucible steel origin. These are almost invariably found to have an inhomogeneous, layered macro-structure, which gives rise to the pattern on polishing and etching. See also **watering**.

[8] See discussion under Damascan swords in ch. 3 above (commentary on Kindi/Zaki, p. 35). A search of medieval Middle-Eastern sources by Robert Elgood revealed that this term was not in use then as such (see Elgood, *Arms and Armour of Arabia*, 103–109).

[9] As in the recipe from the Turin ms quoted above in ch. 1, n. 26.

Flux

Material added to a furnace or crucible charge to aid in the removal of unwanted waste products (gangue) such as silica as an easily liquefiable glassy slag which could either rise above the iron, as in a simple early furnace (or steel in a crucible), or be run or 'tapped' off. To produce a usable iron bloom most of the gangue must be removed as a fuseable slag. Iron oxide will work as a flux and react with the silica (and other minerals) present to form a glass-like slag, consisting mainly of fayalite (iron silicate – $2FeO.SiO_2$ – with a free running temperature about 1170°C). There seems to be little evidence before the late Middle Ages for the use of additional fluxing agents such as lime to lower the free running temperature and improve the yield of iron.

Forging, welding and piling

Once bloom consolidation was mastered it must soon have been discovered that two separate pieces of white-hot iron will fuse when hammered together, this being just an extension of what happens when the spongy bloom is consolidated. Pressure welding was in use before the Iron Age[10] and so the technique was not new. Iron cannot be cold worked to any great extent as it soon becomes hard, brittle and unworkable. It can however be very successfully hot worked. When iron or steel is hot worked or forged above the upper critical point the (austenite) iron crystals deform but immediately re-assume an equiaxial shape and in this way the hot metal is self-annealing.

The extensive forging of a piece of iron can result in a long rod or bar. This can be folded and forged out again to the same length and this procedure repeated a number of times. This process is sometimes known as piling (or faggotting) and may result in a layered structure even in objects consisting of fairly homogeneous low carbon iron. Piling is still used during the processing of steel for Japanese sword-blades as part of a surviving medieval tradition.[11] Forging welding and piling would very often have been carried out by teams of smiths, a master smith and two or three assistants (as in Fig. 19).

Fracture surface

The crystalline structure exposed at the surface of a break when a piece of iron or steel fractures.

Fūlādh

Described by Kindi as being the type of steel that is a form of 'unmined' iron,[12] in this case crucible steel made using (a mixture of pieces) of iron rather than ore as the raw material for production, that is steel produced by a secondary process. This steel was produced as a liquid in small clay crucibles and variations in the manufacturing

[10] Tylecote, *The Solid Phase Welding of Metals*, 1–17.
[11] See Kapp and Yoshihara, *The Craft of the Japanese Sword*, 68–78.
[12] See ch. 2, Kindi/Zaki, p. 6.

process are known from a number of medieval 'recipes', one of which we have included from the other Kindi manuscript.[13]

Fuller

type of tool used by an iron-smith to produce a wide shallow groove (orchannel), and the name by which the resultant goove is also known.

Ghayr muwallad

Used by Kindi to indicate foreign or imported swords or steel, those not of indigenous (*muwallad*) manufacture.

Gradient quenching

This occurs when part of a steel object is protected from effects of the quenching medium by a clay envelope which prevents that part of the object from cooling so quickly. The continuing practice of Medieval and later Japanese sword-smiths involves the coating of a blade with a mixture of wet clay and charcoal, then scraping most of this away along the edge which was to be hardened.[14] The blade was then heated (above the upper critical temperature) then quenched in water. The aim was to achieve a hardened edge and a tough unhardened back. Kindi's text suggests some variation on this procedure was carried out on some of the swords he is describing.

Ḥadīd: *see* **Iron**

Hammer welding: *see* **welding**

Hammer-scale (*ṭūbāl*)

A brittle layer of mainly bluish grey-black iron oxide (wüstite, FeO or magnetite, Fe_3O_4) that forms on the surface of iron and steel when it is heated in a smiths hearth, and which then falls off in characteristic flakes during forging, magnetite being so-called because of its magnetic properties.

Iron *(ḥadīd)*

Iron exists as a solid in different crystalline forms (allotropes). The most important are alpha iron and gamma iron. The crystal lattice arrangement of alpha iron is body-centred, with a lattice point at the centre of each unit cell as well as at the corners, whereas that of gamma iron is a face-centred cubic arrangement, with a lattice point at the centre of each face of each unit cell as well as at the corners. The

[13] See ch. 1, n. 26 above.
[14] Kapp and Yoshihara, *The Craft of the Japanese Sword*, 86–93; Yumoto, *The Samurai Sword*, 99 and 144.

importance of the two crystalline forms of iron for steel-making lies in the difference of the solubility in solid solution of carbon between the two. Carbon is virtually insoluble in the body-centred alpha form, the lattice structure of which will accept a maximum of only 0.04% carbon. The face-centred cubic lattice of gamma iron will accept carbon atoms more readily and up to about 2.0% carbon is soluble in gamma iron. Alpha iron is also known as ferrite and that of gamma iron as austenite.

Iron sulphate: *see zāj*

Jawāhir (jawhar)

As used by Kindi this term appears to refer literally to the nature or essence of the steel of a sword blade (as compared to their forms or shapes) but he also makes it clear that the 'watering' visible on the surface of many blades was thought to be an expression of the nature of the metal beneath. See also **watering**.

Laysa bi-maᶜdanī

A phrase meaning literally 'unmined', employed by Kindi to describe iron not 'directly' produced from their ores, i.e. those produced in a process using (usually directly produced) iron or steel as the raw material. In principle this 'unmined' iron could have been (wrought) iron or steel, but Kindi uses the term specifically to refer to crucible steel (*fūlādh*), as he explains early in the text.

Maᶜdanī

A word meaning literally 'mined', employed by Kindi to describe any iron or steel 'directly' produced from their ores, i.e. those smelted in a one-step production process, as distinct from 'indirectly' produced iron (see *laysa bi-maᶜdanī*). *Maᶜdanī* used in this way can refer to bloomery iron and steel as well as cast iron. Kindi divides 'mined' iron into two categories, *narmāhan* (soft or female iron) and *shāburqān* (hard or male iron).

Mann (or *manna*)

A weight equivalent to two *raṭl* used to refer to weights of certain ingredients used in crucible steel recipes.

Martensite

A supersaturated solution of carbon in gamma iron, produced by very rapid cooling such as is obtained by quenching a steel in water. The carbon present does not have time to separate as pearlite and the distorted lattice structure of martensite results. Its structure means that it is very hard and non-ductile: the higher the carbon content, the greater the distortion to the lattice structure and the greater the hardness of the martensite. The hardness increases most markedly for steels with a carbon content of up to about 0.7% but the effect is rather less thereafter. The cooling rate above which

martensite will be formed is known as the critical cooling rate and differs for steels of different carbon content. In practice, steels with less than 0.3% carbon cannot be hardened effectively (see hypo-eutectoid steel). Martensite appears acicular as a result of the diffusionless precipitation of carbon as plates or laths along certain crystal planes.

Muḥdath

A term literally meaning 'modern', but which Kindi uses to denote sword blades thought to be of the most basic quality irrespective of their actual age, in contrast to *ᶜatīq*, which he uses for the highest quality blades. He also says that blades neither *ᶜatīq* nor *muḥdath* are in between in their quality.

Murakkaba

Kindi's term to describe compound or composite swords made by welding together different combinations of hard and soft iron, the two types of 'mined' iron (***narmāhan and shāburqān***).

Muwallad

Kindi's term for swords considered in his time to be of indigenous manufacture, that is, made within the lands of Islam, as opposed to imported or foreign sword steel (***ghayr muwallad***).[15]

Narmāhan

'Soft' iron, one of the products of direct or bloomery iron production referred to by Kindi, Bīrūnī and others as 'mined', that is, produced directly from its ores.

Pattern-welding

A term referring to an intentional, visible surface effect seen on certain, composite iron objects, particularly swords where the method of (hammer or) forge welding used is designed to result in certain patterns after the final polished surface has been chemically etched (see Fig. 20). This term also may be used (as pattern-welded) to refer to the overall structure of an object like a sword, or at least, specific parts of it. Pattern-welded and non pattern-welded composite swords alike fall under Kindi's overall category of compound (***murakkaba***) swords made using hard and soft iron.

Plain iron

The simplest form of bloomery iron found in early objects and largely consisting of ferrite, the body-centered cubic (alpha) crystalline form of iron stable at lower

[15] See ch. 2 n. 11 and ch. 3 Kindi/Zaki, pp. 9–11.

temperatures, plus small, irregular proportions of non-metallic impurities (slags), present as inclusions drawn out along the main direction of forging – and small proportions of alloying constituents, typically carbon (below about 0.1%), phosphorus, nickel, copper and arsenic. Plain iron is often referred to as wrought iron although the term wrought in this context is usually associated more particularly with iron that has been produced from cast iron by a secondary oxidizing process, either fining or puddling.

Poulad (jauherder): *see fūlādh*

Pearlite

A relatively stable dispersion of carbon in ferrite (alpha iron). In ideal circumstances this has a very regular laminated structure, consisting of parallel plates of iron carbide interleaved with ferrite, giving a characteristic 'mother of pearl' appearance, with alternate pale and dark lines showing up after polishing and etching.

Quench hardening (or quenching)

The importance of quenching steel and the problems associated with it were well know by the early ninth century AD as is clear from Kindi's text. We now have a clearer idea of how (or rather why) steels of different carbon contents can be hardened to varying extents by heating the metal, which remains solid, (into the austenite range, above the upper critical point) followed by rapid cooling (i.e. quenching) in liquids of differing thermal capacity. The carbon in solution in austenite (the gamma, or face-centered cubic crystalline form of iron) is nearly all rejected from the crystal lattice structure of iron when it automatically changes into ferrite (the alpha, or body-centered crystalline form of iron), which is the only form stable below about 700°C.

In each case the two main variables are the carbon content and the rate or speed at which the quench occurs, which varies with the thermal capacity of the quenching liquid as well as the mass or shape of the object being quenched. In an air cooled steel the cooling rate is sufficiently slow to allow the structure of the steel to transform to one at least partly made up of **pearlite**. For any steel when its critical cooling rate is exceeded, this transformation no longer has time to take place and, depending on the rate of cooling, one of several less stable structures is the result. The more efficient the quench the less stable and correspondingly harder and more brittle is the resultant structure. When the rate of cooling is rapid enough a fully quenched structure of **martensite** is the result.

Raṭl

A weight in medieval Iran equalling 12 *ūqiya* and 144 *dirhams*. One *raṭl* is approximately equivalent to 0.75 Imperial pounds (lb) or 340 gm.[16]

[16] See ch. 3, Kindi/Zaki, p. 17.

Shāburāan

Hard or male iron. Kindi refers to this as a particular form of 'mined iron', in this case mainly with reference to bloomery steel, the only type of steel directly produced from its ores. In this context *shāburāan* is reported to have been used in the manufacture of what must be European swords (which made extensive use of steel from about the 2nd/8th century AD) and is defined in such a way as to differentiate it from *fūlādh*, steel, which is described as a form of 'unmined iron' and which clearly refers to crucible steel, made by a secondary process, indirectly from its ores. Depending on context *shāburāan* may also mean cast iron, and may also have been used to refer to the kind of highly phosphoritic iron commonly used in European pattern-welded swords, the 'Frankish' variety that fall under Kindi's ***murakkaba*** (compound) type.

Slack/slow quenching

Quenching carried out using a cooling liquid, such as oil, with a lower thermal capacity than a fast cooling liquid like water. Depending on the carbon content of a steel quenched in this way, an intermediate transformation product such as bainite can be formed, rather than martensite, the fully quenched, much harder, and more highly stressed transformation product. More gentle quenching like this can avoid the excessive distortion or even breakage that might otherwise occur, although an insufficiently well quenched steel might be too soft and perhaps liable to being blunted or bent too easily. The matching of a particular steel to the appropriate heat-treatment, as well as carrying it out, must always have been a highly skilled procedure.

Slag

The non-metallic, glassy waste by-product of smelting.

Smelting

To obtain iron from the ore, the iron oxide of the ore must be reduced to metal and the lowest temperature at which this can be achieved is about 800°C, whereas the melting point of pure iron is about 1535°C.

Solid phase welding: *see* welding.

Steel

Steel is usually referred to as alloy of iron and carbon containing up to about 2% carbon. For convenience, in the present work steel is defined as that alloy of iron and carbon that can be hardened by quenching which means a practical lower limit for carbon content of approximately 0.3%. An iron carbon alloy with less carbon than this, would normally be referred to as a low carbon iron or (in a modern context) mild steel, but here is referred to as a low carbon iron.

Tatara

The traditional Japanese form of rectangular box-shaped bloomery iron and steel smelting furnace, named after the sound of the distinctive treddle (foot-powered) form of bellows developed in the 17th century AD. This style of furnace and smelting was probably developed in Japan over the preceding millennium although its origin is uncertain.

Tempering

Process for relieving the highly stressed condition of a fully hardened (i.e. martensitic) steel that is otherwise very hard but also brittle and liable to cracking. The objectives of tempering are to both, a) relieve internal stresses caused by quenching and, b) to toughen the steel. This is carried out by warming the steel for a time between approximately 100 and 300°C. 100 to 200° is sufficient to relieve internal stresses while leaving the **martensite** in an acicular and slightly less hard form, although this becomes very fast and dark etching (with nital). This 'black' martensite is called tempered martensite and although it resembles lower bainite, it is much harder. Between 200 and 300° C further decomposition to **bainite** takes place and above this and up to about 450°C decomposition into a precipitation of fine iron carbide particles in ferrite takes place. This structure is tougher but less hard than martensite.

At higher tempering temperatures, 450–650°C annealing takes place, when the carbide particles coalesce producing fewer but larger carbide particles in a spheroidal form often known as sorbite.[17] In this condition the steel is yet tougher but less hard. The temperature ranges used to be gauged by the 'temper colours' of the oxide film which formed on the surface of the clean metal upon reheating. Tempering and the recognition of temper colours is described by Kindi and undoubtedly would have been a standard and much used procedure in his day for steel (or part steel) objects such as sword blades. By treating steels in this way varying degrees of hardness and toughness can be obtained depending on the use to which it is to be put.

Temper colours: *see* **colour estimation of temperature**.

Watering/watered steel

This term has a very long history as a way of comparing a 'watery' effect, such as the ripples or shimmering on the surface of otherwise still water, with the patterns visible on the surface of a crucible steel object with a slightly uneven, inhomogeneous layered structure. It was known as *firind* to Kindi in the 3rd/9th century and has been referred to thus at various times since, and probably a long time before. Kindi uses this term for the patterns found in many of the swords he describes as made from *fūlādh*

[17] Rollason, *Metallurgy for Engineers*, 186.

(crucible steel), but surface patterns comparable to this have various mentions in pre-Islamic and early Islamic poetry[18] and some of these must refer to pattern-welding.

Welding

Before the late nineteenth century (introduction of liquid phase) welding inevitably referred to the hot, solid phase process for compressing and fusing together two pieces of iron or steel. This process is often referred to as hammer-welding or forge-welding. See also forging, welding and piling.

White heat: *see* **estimation of temperature by colour**.

White cast iron (or white iron): *see* **cast iron**.

Wootz

A corruption of *ukku* (pronounced wukku), a word meaning steel in Telangu-Kannada, a Dravidian, non Indo-European language of central-southern India. Possibly the earliest known reference to *wootz* is in a letter sent in 1209/1794 from Bombay by Dr Helenius Scott to Robert Pearson of the Royal Society of London.[19] It refers to the type of steel made as a molten metal in small clay crucibles (see crucible steel).

Wrought iron

Plain iron produced indirectly (from its ore) by the decarburisation (fining) of cast iron.

Zāj (zāg, zāgh)

An acid etching solution, probably used from ancient times to bring out or make visible the watered pattern inherent in the structure of many objects, especially swords, made of a variant of the ultra high carbon steel often referred to as *wootz* (see discussion above). A sample of *zag* was analysed in 1232/1816 by Jacquin, who found it to consist of a naturally occurring basic ferric sulphate[20] and could have been formed by the natural or intentional weathering and oxidation of any of the many mineral deposits containing iron sulphide or pyrites.

[18] See Schwarzlose, 165–71, in ch. 4 above.
[19] See Pearson, "Experiments and Observations".
[20] See Smith, *A History of Metallography*, 22.

Bibliography

General/Introductory Works

Craddock, P. T., *Early Mining and Metal Production* (Edinburgh, 1995).

Elgood, Robert, ed., *Islamic Arms and Armour* (London, 1979).

Figiel, Leo S., *On Damascus Steel* (Atlantis, Florida, 1991).

Hassan, A. Y. al-, and Hill, D. R., *Islamic Technology: an illustrated history* (Cambridge, 1986): has chapters on "military technology" and "mining and metallurgy".

Nicolle, David C., *Early Medieval Islamic Arms and Armour* (Gladius, special volume; Jarandilla, Spain, 1979).

Zaky, A. Rahman, "Centers of Islamic Sword Making in the Middle Ages", *Bulletin de l'Institut d'Egypte* 36 (1955), 285–95.

— "The Sword in Islamic Art", *Bulletin of the College of Arts, Baghdad* 1 (1959), 93–100.

— "Introduction to the study of Islamic Arms and Armour", *Gladius* 1 (1961), 17–29.

— "On Islamic Swords" in *Studies in Islamic Art and Architecture in honour of K.A.C. Creswell* (AUC; Cairo, 1965), 270–91.

Primary Sources and Dictionaries

Abū Nuwās, *Dīwān*, ed. W. Ahlwardt, vol. 1: *Weinlieder* (Greifswald, 1867).

Abū ʿUbayd al-Qāsim ibn Sallām, *Kitāb al-Silāḥ* (Beirut, 1985).

ʿAmr ibn Kulthūm, *Muʿallaqa*: see Arnold.

ʿAmr ibn Kulthūm, *Muʿallaqa* (ed. Kosegarten) and *Vita* = J. G. L. Kosegarten, ed., *Amrui ben Kelthum Taglebitae Moallaka et vita* (Jena, 1819).

ʿAntara ibn Shaddād, *Muʿallaqa*: see Arnold.

Arnold, F.A., *Septem Moʿallakât carmina antiquissima arabicum* (Leipzig, 1850).

Balādhurī, Aḥmad ibn Yaḥyā al-, *Futūḥ al-buldān*, ed. M. J. de Goeje (Leiden, 1866).

Bīrūnī, Muḥammad ibn Aḥmad al-, *Al-jamāhir fī maʿrifat al-jawāhir*, ed. E. Krenkow (Hyderabad, 1936); tr. H. M. Said as *Al-Beruni's Book on Mineralogy. The Book most Comprehensive in Knowledge* in Precious Stones (Islamabad, 1410/1989).

— *Taʾrīkh al-Hind*, trans E. C. Sachau (London, 1888) as *Alberuni's India*

Delitzsch, F., *Jüdisch-arabische Poesien aus vormuhammedischer Zeit* (Leipzig, 1874).

Dhahabī, Shams al-dīn al-, *Siyar aʿlām al-nubalāʾ*, ed. B.ʿA. Maʿruf (Beirut, 1992).

Dhū l-Rumma = Rudolph Smend, ed., *De Dsu rʾrumma poeta arabico et carmine eius: commentatio* (Bonn, 1874).

Dieterici, F. H., ed., *Mutenabbi und Seifuddaula aus der Edelperle* (Leipzig, 1847).

Diwans 6 = W. Ahlwardt, ed., *The diwans of the six ancient Arabic poets Ennabiga, ʿAntara, Tharafa, Zuhair, ʿAlqama and Imruulqais* (London, 1870).

Ehsan Elahie, Rana M. N., ed., *A Treatise on swords and their essential attributes. A rare and original work of Al-Kindi, the great Arab philosopher* (Lahore, 1962).

Fīrūzabādī, Muḥammad ibn Yaʿqūb al-, *al-Qāmūs al-muḥīṭ* (Beirut, 1995; Schwarzlose cites a Bulaq edition not available to me).

Freytag, G.W., ed./tr., *Arabum proverbia: vocalibus instruxit, latine vertit* (Bonn, 1838–1843).

— *Lexicon arabico-latinum* (Halle, 1830–1837).

Gesenius, F. H. W., *Hebrew and Chaldee Lexicon to the Old Testament* (tr. from German by S. P. Tregelles; London, 1853).

Hajjī Khalīfa, *Lexicon bibliographicum/Kashf al-ẓunūn*, ed. Gustav Flügel (Leipzig, 1835–58).

Ḥamāsa = G. Freytag, ed./tr., *Hamasae Carmina* (Bonn, 1828–47).

Harīrī, Qāsim ibn ᶜAlī al-, *Les séances*, ed. Silvestre de Sacy (Paris, 1822).

Ḥārith ibn Ḥilliza, *Muᶜallaqa*: see Arnold or, if specified, the edition of J. A. Vullers (Bonn, 1827).

Hudhayliyyīn = J. G. L. Kosegarten, ed./tr., *Carmina Hudsailitarum* (London, 1854), poems nos. 1–138.

Hudhayliyyīn (ed. Wellhausen) = J. Wellhausen, *Skizzen und Vorarbeiten*, 1.2 (Berlin, 1884), poems nos. 139–280.

Ibn Abī Uṣaybiᶜa, '*Uyūn al-anbāʾ fī ṭabaqāt al-aṭibbā*', ed. N. Rida (Beirut, 1965).

Ibn Durayd, *Maqṣūra* = Everardus Scheidius, ed., *Abu Becri Mohammedis ebn Hoseini ebn Dorʾeidi Katsijda ʾ lmektsoura* (Harderwijk, 1786).

Ibn Khallikān, *Vitae illustrium virorum*, ed. F. Wüstenfeld (Göttingen, 1835–50).

Ibn al-Nadīm, *Fihrist*, ed. G. Flügel (Leipzig, 1872)/tr. B. Dodge (New York, 1970).

Ibn Qutayba, *Adab al-kātib*, ed. M. Grünert (Leiden, 1900).

Ibn Riḍwān, *Al-kitāb al-nāfiᶜ fī kayfiyyat taᶜlīm ṣināᶜat al-ṭibb*, ed. K. al-Samarraʾi (Baghdad, 1986).

Ibn Rusta, *al-Aᶜlāq al-nafīsa*, ed. M. J. de Goeje (BGA 7; Leiden, 1892).

Ibn al-Ṭiqṭaqā, *al-Fakhrī*, ed. W. Ahlwardt (Gotha, 1860).

Idrīsī, Muḥammad ibn Muḥammad al-, *Opus geographicum*, ed. A. Barbaci *et al.* (Naples-Rome, 1982).

Imruʾ al-Qays, *Dīwān*, ed. and tr. MacGuckin de Slane (Paris, 1837).

Imruʾ al-Qays, *Muᶜallaqa*: see Arnold.

Iṣfahānī, Abū l-Faraj al-, *Kitāb al-aghānī/Liber cantilenarum magnus*, ed. J. G. L. Kosegarten (Greifswald, 1840).

Jāḥiẓ, ᶜAmr ibn Baḥr al-, *al-Ḥayawān*, ed. ᶜA-S. M. Harun (Cairo, 1938–45).

— "Fakhr al-sūdān ᶜalā l-bīḍān" and "Manāqib al-turk" in ᶜA-S. M. Harun, *Rasāʾil al-Jāḥiẓ*, vol. 1 (Cairo, 1964), 177–226 and 5–86, respectively.

Jawharī, Ismaᶜīl ibn Ḥammād al-, *al-Ṣiḥāḥ*, ed. A.ᶜA. ᶜAttar (Beirut, 1984; Schwarzlose cites a Bulaq edition not available to me).

Jones, William, *Poeseos Asiaticae commentarium libri sex* (London, 1774).

Kaᶜb ibn Zuhayr, *Carmen in laudem Muhammedis dictum*, ed. G. W. Freytag (Halle, 1823).

Khalaf al-Aḥmar, *Qasside*, ed. W. Ahlwardt (Greifswald, 1859).

Khwārizmī, Muḥammad ibn Mūsā al-, *Algebra*, ed./tr. F. Rosen (London, 1861).

Kosegarten, J. G. L. *Chrestomathia Arabica* (Leipzig, 1828).

Lane = Lane, Edward William, *Arabic-English Lexicon* (London, 1863–93).

Masᶜūdī, ᶜAli ibn al-Ḥuṣayn al-, *Murūj al-dhahab*, ed./tr. C. Barbier de Maynard and P. de Courteille (Paris, 1866–74).

Mubarrad, Abū l-ᶜAbbās al-, *al-Kitāb al-kāmil*, ed. W. Wright (Leipzig, 1864–82).

Muslim ibn al-Walīd, *Dīwān*, ed. M. J. de Goeje (Leiden, 1875).

Mutanabbī, *Carmina cum commentario Wahidii*, ed. F. H. Dieterici (Berlin, 1861).

Pocock, Edward, *Specimen historiae arabum/Lumaᶜ min akhbār al-ᶜarab* (Oxford, 1806).

Rasmussen, J. L., *Additamenta ad historiam Arabum ante Islamismum excerpta ex Ibn Nabatah, Nuveiro [Nuwayri] atque Ibn Koteiba* (Copenhagen, 1821).

Sacy, Silvestre de, *Anthologie grammaticale arabe* (Paris, 1829).

— *Chrestomathie arabe ou extraits de divers écrivains arabes* (Paris, 1826).

— *Grammaire arabe* (Paris, 1831).

Steingass, F., *A comprehensive Persian-English Dictionary* (London, 1930).

Ṭarafa ibn ᶜAbd, *Muᶜallaqa*: see Arnold.

Ṭarsūsī, Murḍā ibn ᶜAlī al-, *Fī kayfiyyat al-najāt fī/ l-ḥurūb*, ed. C. Cahen in *Bulletin d'Etudes Orientales* 12 (1947/48), 106–108.

Thaᶜālibī, ᶜAbd al-Malik al, *Fiqh al-lugha wa-sirr al-ᶜarabiyya*, ed. R. al-Dahdah (Paris, 1861; Schwarzlose cites a Bulaq edition not available to me).

Yāqūt al-Ḥamawī, *Muᶜjam al-buldān*, ed. F. Wüstenfeld (Göttingen, 1866–73).

— *al-Mushtariq/Lexicon geographischer Homonyme*, ed. F. Wüstenfeld (Göttingen, 1846).

Zamakhsharī, Maḥmūd ibn ᶜUmar al-, *Lexicon Arabicum-Persicum*, ed. J. G. Wetzstein (Leipzig, 1848).

— *al-Mufaṣṣal*, ed. J. P. Broch (Christiania, 1879).

Secondary Literature

Abbott, J., 'Process of working the Damsacus Blade of Goojrat', *Journal of the Asiatic Society of Bengal*, 16, 1 (May 1847), 417–423.

Agricola, G., *De Re Metallica* (1556), tr. H. and L. Hoover (New York, 1950).

Ahlwardt, W., *Bemerkungen über die Echtheit der alten arabischen Gedichte* (Greifswald, 1872).

Allan, J. W., *Persian Metal Technology 700–1300 AD* (London, 1979).

— *Nishapur: Metalwork of the Early Islamic Period* (New York, 1982)

— and Gilmour, B., *Persian Steel: The Tanavoli Collection* (Oxford, 2000).

Angier, R. H., *Firearm Blueing and Browning* (Harrisburg, 1936).

Asimov, M. S., and Bosworth, C. E., eds., *The History of the Civilizations of Central Asia*, vol. 4.1 (UNESCO; Paris, 1998).

Atiyeh, George, *Al-Kindi: the philospher of the Arabs* (Rawalpindi, 1966).

Beaumont, D., "Parody and lying in *al-Bukhalā'*", *Studia Islamica* 79 (1994), 27–49.

Berthelot, M., *Collection des Anciens Alchimistes Grecs*, 3 vols (Paris, 1888).

Bone, Peter, "The development of Anglo-Saxon Swords from the Fifth to the Eleventh Century", in Sonia Chadwick Hawkes, ed., *Weapons and Warfare in Anglo-Saxon England* (Oxford, 1989).

Bos, Gerrit, and Burnett, Charles, *Scientific weather forecasting in the Middle Ages: the writings of al-Kindi* (London and New York, 2000).

Bronson, B., "The Making and Selling of Wootz: a crucible steel of India", *Archaeomaterials* 1 (1986), 13–51.

Biringuccio, Vanoccio, *Pyrotechnia* (Venice, 1540), trans. C. S. Smith and M. T. Gnudi (Cambridge Mass., 1942).

Buch der Erfindungen, Gewerbe und Industrieen, Band VI: *Die mechanische Bearbeitung der Rohstoffe*, 5th edition (ed. O. Spamer; Leipzig, 1864–67).

Buchanan, F., *A Journey from Madras through the Countries of Mysore, Canara and Malabar* (3 vols: London, 1807).

Cahen, "Un traité d'armurie composé pour Saladin", *Bulletin d'Etudes Orientales* 12 (1947–48), 103–63.

Craddock, P. T., "New light on the production of crucible steel in Asia", *Bulletin of the Metals Museum of the Japan Institute of Metals* 29 (July 1998), 41–66.

Davidson, H. R. E., *The Sword in Anglo-Saxon England* (Oxford, 1962).

Dozy, R., *Catalogus codicum orientalium bibliothecae academicae Lugduno batavae* (Leiden, 1861).

E.I. = Encyclopaedia of Islam, 2nd edition, ed. A. H. R. Gibb *et al.* (Leiden, 1960–2002).

Elgood, Robert, *Arms and Armour of Arabia* (London, 1994).

Endress, G., "The circle of alKindi: early Arabic translations from the Greek and the rise of Islamic philosophy" in idem and R. Kruk eds., *The Ancient Tradition in Christian and Islamic Hellenism* (Leiden, 1997), 43–76.

Fatimi, S.Q., "Two letters from the Maharaja to the Khalifa", *Islamic Studies* 2 (1963), 121–40.

— "Malaysian weapons in Arabic literature", *Islamic Studies* 3 (1964), 199–233.

Flinders-Petrie, W. M., "Standards of weight", in *Encyclopedia Britannica*, 11th edition, vol. 28 (1911), 485–488.

Flügel, G. *Die grammatischen Schulen der Araber* (Leipzig, 1862).

Freytag, G. W., *Einleitung in das Studium der arabischen sprache bis Mohammed und zum Theil später zum allgemeinen Gebrauche* (Bonn, 1861).

Gettens, R. J., and Stout, G. L., *Painting Materials: A short Encyclopedia* (New York, 1966)

Gilmour, B., "The patterned sword in medieval Europe and southern Asia", *Proceedings of the Forum for The Fourth Conference on the Beginnings of the Use of Metals and Alloys-BUMA IV* (Shimane, Japan 1996), 113–31.

Gorelik, M., "Arms and Armour in South-Eastern Europe in the Second Half of the First Millennium AD", in D. Nicolle ed, *A Companion to Medieval Arms and Armour* (Woodbridge, 2002), 127–146.

Habicht, M., ed., *Tausend und eine Nacht* (Breslau, 1823–45).

Hammer-Purgstall, D., "Sur les lames des Orientaux", *Journal Asiatique* ser. v, 3 (1854), 66–80.

Hassan, A. Y. al-, "Iron and Steel Technology in Medieval Arabic Sources", *Journal for the History of Arabic Science* 2 (1978–79), 31–52.

Hermann, G., Kurbansakhatov, K, and Simpson, St. J., "The International Merv Project: preliminary report of the fourth season (1995)", *Iraq* 34 (1996), 1–22.

Hinz, W., *Islamische Masse und Gewichte. Handbuch der Orientalisk*, Part 1 (Leiden, 1955).

Hoyland, Robert G., *Seeing Islam as Others saw it* (Princeton, 1997).

Ivry, A.L., *Al-Kindi's Metaphysics* (Albany, N.Y., 1974).

Jones, Gwyn, *A History of the Vikings* (Oxford, 1968).

Juleff, G., *Early Iron and Steel in Sri Lanka: a Study of the Samanalawewa Area* (Mainz, 1998).

Kapp, H. and L., and Yoshihara, Y., *The Craft of the Japanese Sword* (Tokyo, New York, and London, 1987).

Kisch, B., *Scales and Weights: A Historical Outline.* (New Haven and London, 1965).

Kraus, Paul, *Jabir ibn Hayyan. Contribution à l'histoire des idées scientifiques dans l'Islam* (IFAO; Cairo, 1942–43).

Lang, J, Craddock, P. T., and Simpson, S. J., "New evidence for early crucible steel", *Journal of the Historical Metallurgy Society*, vol. 32, no. 1 (1998), 7–14.

Levy, R., *The Epic of the Kings: Shah-Nama the national epic of Persia by Ferdowsi* (London, 1967)

Marshall, J., *Taxila. Volume II: Minor Antiquities* (Cambridge, 1951).

Mehren, A. F. M., *Die Rhetorik der Araber* (Copenhagen, 1853).

Moxon, J., *Mechanick Exercise: or the Doctrine of Handy-Works* (London, 1703)

Needham, J., *The Development of Iron and Steel technology in China* (London, 1958).

Nicolle, D., *A Companion to Medieval Arms and Armour* (Woodbridge, 2002).

Nöldeke, Th., *Beiträge zur Kenntniss der Poesie der alten Araber* (Hannover, 1864).

Panseri, C., "Damascus steel in legend and reality", *Gladius* 4 (1965), 5–66.

Papakhristu, O., and Rehren, T., "Cutting edge technology: the Ferghana process of medieval crucible steel smelting". Metalla 7.2 (2000), 55–69.

— "Techniques and technology of the manufacture of ceramic vessels-crucibles for smelting wootz in Central Asia', in V. Kilikoglou *et al.*, eds., *Modern Trends in Scientific Studies on Ancient Ceramics* (Oxford, 2002), 69–74.

— and Swertschkow, L., "Eisen aus Ustruschana und Tiegelstahl aus dem Fergana-Becken. Forschungen zur mittelalterlichen Eisenproduktion in Mittelasien", *Der Anschnitt. Zeitschrift für Kunst und Kultur im Bergbau* 45.4 (1993), 122–31.

Pearson, G., "Experiments and observations to investigate the nature of a kind of steel manufactured at Bombay and there called Wootz", *Philosophical Transactions* (London, 1795), 322–346.

Pleiner, R., and Bjorkman, J., "The Assyrian Iron Age: The History of Iron in the Assyrian Civilization", *Proceedings of the American Philosophical Society*, 118.3 (1974), 283–313.

Rabb, K., *National Epics* (Chicago, 1896): Knowledgerush book directory Internet edition.

Ragib, Yusuf (with Fluzin, Philippe), "La fabrication des lames damassées en Orient", *Journal for the Economic and Social History of the Orient* 40 (1997), 30–71.

Rashed, Roshdi, "Problems of the transmission of Greek scientific thought into Arabic: examples from mathematics and optics", *History of Science* 27 (1989), 199–209.

— and Jolivet, J., *Oeuvres philosophiques et scientifiques d'al-Kindi: vol. 1, l'optique et la catoptrique* (Leiden, 1997); vol. 2, *métaphysique et cosmologie* (Leiden, 1998).

Reed-Hill, R. E. *Physical Metallurgy Principles* (New York, 1973).

Ritter, Helmut, "Schriften Jaᶜqub ibn Ishaq al-Kindis in Stambuler Bibliotheken", *Archiv Orientalni* 1932, 363–72.

Robinson, B. W., A Descriptive Catalogue of the Persian Paintings in the Bodleian Library (Oxford, 1958).

Rollason, E. C., *Metallurgy for Engineers*, 4th edition (London, 1973).

Rosenthal, Franz, "Al-Kindi als Literat", *Orientalia* 11 (1942), 269–70.

Russell, R., *The Works of Geber* (London, 1678); new edition with introduction by E. Holmyard (London,1978).

Sachse, M., *Damascus Steel: Myth, History, Technology, Applications* (tr. P. Knighton; Dusseldorf, 1994).

Said, Hakim Mohammed, ed., *Al-Bīrūnī commemorative volume* (Karachi, 1979).

Sarraf, Shihab al-, "Adab al-furūsiyya fi l-ᶜasrayn al-ᶜabbāsī wa-l-mamlūkī" in id. ed., *Furusiyya* I (Riyad, 2000), 104–39.

—— "Close Combat Weapons in the Early 'Abbāsid Period: Maces, Axes and Swords", in D. Nicolle ed, *A Companion to Medieval Arms and Armour* (Woodbridge, 2002), 149–178.

—— "Mamluk Furūsīyah Literature and its antecedents", *Mamluk Studies Review* 8 (2004), 141–200.

Sherby, O., and Wadsworth, J., "Damascus Steels", *Scientific American*, 252, 2 (1985), 94–99.

Smith, C. S., *A History of Metallography* (Cambridge, Ma., 1988).

Smith, C., and Hawthorne, J., "Mappae Clavicula: a little key to the world of medieval techniques", *Transactions of the American Philosophical Society* 64, 4 (Philadelphia, 1974).

Smithells, C., *Metals Reference Book*, 2 Vols (London, 1967)

Spencer, L. J., "Marcasite", in *Encyclopedia Britannica*, 11th edition, vol. 17 (1911), 683.

Tylecote, R. F., *The Solid Phase Welding of Metals* (London 1968).

—— and Gilmour, B., *The Metallography of Ferrous Edge Tools and Edged Weapons* (Oxford, 1986) British Archaeological Reports, British Series, 155.

Verhoeven, J. D, Pendray, A. H., and Dauksch, W. E., "The Key Role of Impurities in Ancient Damascus Steel Blades", *Journal of Metals* 50.9 (1998), 58–64.

—— Pendray, A. H., and Gibson, E. D., "Wootz Damascus Steel Blades", *Materials characterization* 37 (1996), 9–22.

Wagner, D., *Iron and Steel in Ancient China* (Leiden, 1993).

Whitehouse, D., and Williams, A., "Sasanian Maritime Trade", *Iran* 11 (1973), 29–49.

Wiedemann, Eilhard, "Über Stahl und Eisen bei den muslimischen Völkern", *Sitzungsberichte der physikalisch-medizinischen Sozietät in Erlangen* 43 (1911), .

Wüstenfeld, F., *Das Heerwesen der Muhammedaner* (Göttingen, 1880).

Yumoto, J., *The Samurai Sword. A Handbook* (Rutland, Vermont, and Tokyo, 1958).

Index

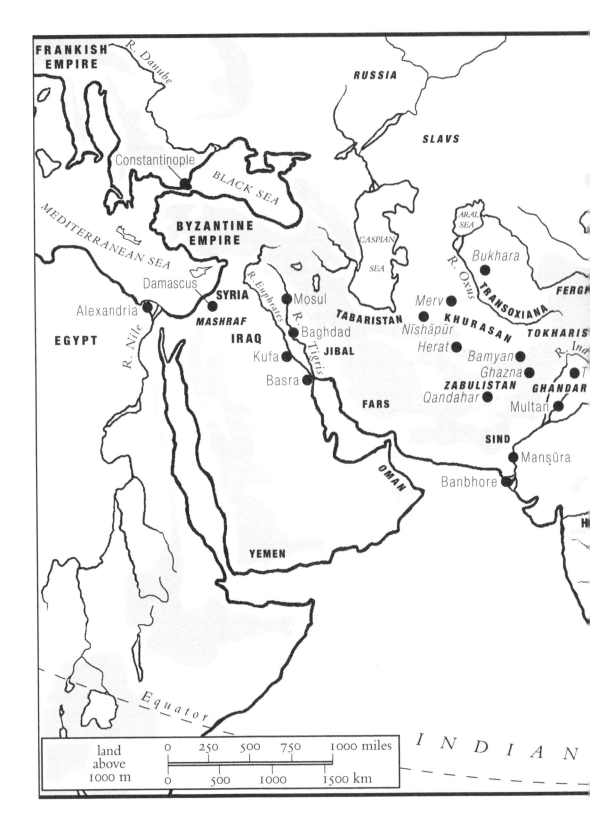

FRANKISH
EMPIRE

RUSSIA

R. Danube

SLAVS

Constantinople

BLACK SEA

ARAL
SEA

BYZANTINE
EMPIRE

CASPIAN

Bukhara

MEDITERRANEAN SEA

SEA

R. Oxus

TRANSOXIANA

FERGH

Damascus

SYRIA

R. Euphrates

Mosul

Merv

KHURASAN

TOKHARIS

Alexandria

TABARISTAN

Nīshāpūr

MASHRAF

IRAQ

R. Tigris

Baghdad

Herat

Bamyan

R. Ind

EGYPT

R. Nile

JIBAL

Ghazna

T

Kufa

ZABULISTAN

GHANDAR

Basra

FARS

Qandahar

Multan

SIND

Manṣūra

OMAN

Banbhore

YEMEN

Equator

INDIAN

land
above
1000 m

0	250	500	750	1000 miles
0	500	1000	1500 km	

CHINA

R. Yangtze

R. Mekong

PACIFIC
OCEAN

nūj
R. Ganges

DIA]

SERENDIB
[SRI LANKA]

Qala [Kalah /
Kalang]

Equator

OCEAN

EU Authorised Representative:

Easy Access System Europe Mustamäe tee 50, 10621 Tallinn, Estonia

gpsr.requests@easproject.com

Printed and bound by CPI Group (UK) Ltd, Croydon, CR0 4YY

04/06/2025

01892474-0001